The Book of Genesis
ILLUSTRATED

The Book of Genesis

ILLUSTRATED

by R. Crumb

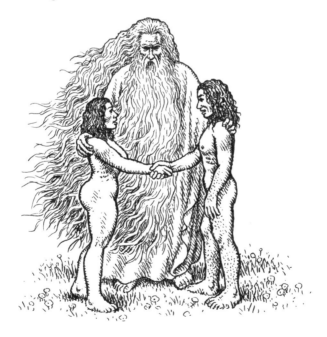

JONATHAN CAPE
LONDON

Published by Jonathan Cape 2009

2 4 6 8 10 9 7 5 3

First published in Great Britain in 2009 by
Jonathan Cape
Random House, 20 Vauxhall Bridge Road,
London SW1V 2SA

www.rbooks.co.uk

Addresses for companies within The Random House Group Limited can be found at:
www.randomhouse.co.uk/offices.htm

The Random House Group Limited Reg. No. 954009

A CIP catalogue record for this book is available from the British Library

ISBN 9780224078092

Printed and bound in Great Britain by
MPG Books Ltd, Bodmin, Cornwall

for Aline

Introduction

I, R. CRUMB, THE ILLUSTRATOR OF THIS BOOK, HAVE, TO THE BEST OF MY ABILITY, FAITHFULLY REPRODUCED EVERY WORD OF THE ORIGINAL TEXT, WHICH I DERIVED FROM SEVERAL SOURCES, INCLUDING THE KING JAMES VERSION, BUT MOSTLY FROM ROBERT ALTER'S RECENT TRANSLATION, *THE FIVE BOOKS OF MOSES* (2004). IN A FEW PLACES I VENTURED TO DO A LITTLE INTERPRETATION OF MY OWN, IF I THOUGHT THE WORDS COULD BE MADE CLEARER, BUT I REFRAINED FROM INDULGING TOO OFTEN IN SUCH "CREATIVITY," AND SOMETIMES LET IT STAND IN ITS CONVOLUTED VAGUENESS RATHER THAN MONKEY AROUND WITH SUCH A VENERABLE TEXT. EVERY OTHER COMIC BOOK VERSION OF THE BIBLE THAT I'VE SEEN CONTAINS PASSAGES OF COMPLETELY MADE-UP NARRATIVE AND DIALOGUE, IN AN ATTEMPT TO STREAMLINE AND "MODERNIZE" THE OLD SCRIPTURES, AND STILL, THESE VARIOUS COMIC BOOK BIBLES ALL CLAIM TO ADHERE TO THE BELIEF THAT THE BIBLE IS "THE WORD OF GOD," OR "INSPIRED BY GOD," WHEREAS I, IRONICAL-LY, DO *NOT* BELIEVE THE BIBLE IS "THE WORD OF GOD." I BELIEVE IT IS THE WORDS OF MEN. IT IS, NONETHE-LESS, A POWERFUL TEXT WITH LAYERS OF MEANING THAT REACH DEEP INTO OUR COLLECTIVE CONSCIOUSNESS, OUR *HISTORICAL* CONSCIOUSNESS, IF YOU WILL. IT SEEMS INDEED TO BE AN INSPIRED WORK, BUT I BELIEVE THAT ITS POWER DERIVES FROM ITS HAVING BEEN A COLLECTIVE ENDEAVOR THAT EVOLVED AND CONDENSED OVER MANY GENERATIONS BEFORE REACHING ITS FINAL, FIXED FORM AS WE KNOW IT DURING THE "BABYLONIAN EXILE," CIRCA 600 B.C.E. IT WAS THE PRIESTLY CASTE WHO, IN THAT PERIOD, COMPILED AND PUT INTO A COHESIVE ORDER THIS COLLECTION OF STORIES, LEGENDS, AND TRIBAL LINEAGES, SOMETIMES WEAVING TOGETHER TWO DIFFERENT VERSIONS OF THE SAME STORY, AND PROCLAIMED THE FINISHED PRODUCT A SACRED, HOLY DOCUMENT, THE SCROLLS THAT BE-CAME OBJECTS OF VENERATION, FOR PRIVILEGED EYES ONLY. THE STORIES OF THIS PEOPLE, THE HEBREWS, WERE THEN SOMETHING MORE THAN JUST STORIES, THEY WERE THE FOUNDATION, THE SOURCE, IN WRITING, OF RELIGIOUS AND POLITICAL POWER, HANDED DOWN BY GOD HIMSELF. THIS DOCUMENT WAS WRITTEN PROOF THAT YOU WERE ONE OF THE CHO-SEN PEOPLE, SPECIAL, AND DIFFERENT FROM ALL OTHER PEOPLES. MODERN SCHOLARS SAY THAT THE PRIESTS IN-TERJECTED WORDS AND DOCTORED THE ALREADY ANCIENT STORIES TO STRENGTHEN THEIR POLITICAL PURPOSES. MANY SCHOLARS, EXAMINING CLOSELY THE TERSELY WORDED CHAPTERS OF GENESIS, PERCEIVE IN THEM EARLIER, LOST MEANINGS AND INTENTIONS, THINGS THAT HAD BEEN ALTERED BY THE INCREASINGLY ENTRENCHED PRIESTS, AND THE TRIUMPH OF PATRIARCHY OVER AN ANCIENT AND EVER MORE DIMLY REMEMBERED MATRIARCHY. MUCH HAS BEEN LOST IN THE MISTS OF TIME. MUCH OF WHAT THE SCHOLARS SAY IS EDUCATED GUESSWORK, AS THEY PORE OVER THE CLUES AND HINTS AND TRY TO FILL IN THE MISSING FRAGMENTS, THE DETAILS THAT GOT LOST OR WERE SUPPRESSED TOO LONG AGO TO EVER BE RETRIEVED. WHILE WORKING ON THIS BOOK I READ SOME OF THESE SCHOLARLY EXAMINATIONS OF GENESIS AND FOUND THEM HELPFUL IN ENRICHING THE BACKGROUND MATERIAL FOR THE CONTENT OF THE DRAWINGS.

IF MY VISUAL, LITERAL INTERPRETATION OF THE BOOK OF GENESIS OFFENDS OR OUTRAGES SOME READERS, WHICH SEEMS INEVITABLE CONSIDERING THAT THE TEXT IS REVERED BY MANY PEOPLE, ALL I CAN SAY IN MY DE-FENSE IS THAT I APPROACHED THIS AS A STRAIGHT ILLUSTRATION JOB, WITH NO INTENTION TO RIDICULE OR MAKE VISUAL JOKES. THAT SAID, I KNOW THAT YOU CAN'T PLEASE EVERYBODY.

I WOULD LIKE TO PUBLICLY ACKNOWLEDGE MY GRATITUDE TO ROBERT ALTER FOR ALLOWING ME TO LIBERALLY USE, AND HOPEFULLY NOT ABUSE, HIS TRANSLATION, AND TO PETE POPLASKI FOR PROVIDING ME WITH AN ENORMOUS AMOUNT OF VISUAL SOURCE MATERIAL TO WORK FROM, INCLUDING HUNDREDS OF PHOTOS FROM HOLLYWOOD BIBLICAL EPICS WHICH HE TOOK BY FREEZE-FRAMING THEM ON A TELEVISION SCREEN, FROM D.V.D.S OR VIDEO TAPES. BEING AN ARTIST AND ILLUSTRATOR HIMSELF, PETE *KNEW* WHAT I WAS UP AGAINST WITH THIS PROJECT. ROGER KATAN, ANOTHER FRIEND, WAS ALSO VERY HELPFUL WITH VISUAL SOURCE MATERIAL. IT WAS HE WHO COM-PELLED ME TO GO BACK AND CORRECT SOME OF THE ARTWORK ON THE EARLIER PAGES AFTER HE *LAUGHED* AT HOW I'D DRAWN THE CLOTHING, WHICH HE SAID LOOKED LIKE MODERN BATHROBES, AND HOW THE TENTS LOOKED LIKE THEY CAME FROM A SPORTING GOODS STORE. I WAS IGNORANT. I HAD A LOT TO LEARN. KATAN GREW UP IN MOROCCO AND WAS VERY HELPFUL WITH THE DETAILS OF EVERYDAY LIFE IN THE PRE-MODERN WORLD OF HIS CHILDHOOD, AND, HAVING A PROFESSIONAL INTEREST IN INDIGENOUS ARCHITECTURE IN NORTH AFRICA, LENT ME BOOKS FULL OF PHOTOS OF STRANGE, "BIBLICAL"-LOOKING CITIES, PEOPLE WEARING ROBES AND USING IMPLEMENTS THAT HADN'T CHANGED OVER MILLENNIA. I ALSO WANT TO PUBLICLY THANK BETSY SANDLIN, AN OLD FRIEND, WHOSE KNOWLEDGE OF HEBREW HELPED CLARIFY CERTAIN AWKWARD PASSAGES. SOME OF IT IS QUITE DIFFICULT. EVEN THE MOST DEDI-CATED SCHOLARS WILL ADMIT THEY'RE NOT SURE WHAT, PRECISELY, IS MEANT BY SOME OF THE OLD WORDS, OR THE CONTEXT IN WHICH THEY ARE USED. THERE'S DISAGREEMENT AMONG THEM OVER SOME OF THESE WORDS. THE TEXT IS, AFTER ALL, SO VERY, VERY *OLD!*

—— R. CRUMB, JAN., 2009

The Book of
Genesis
ILLUSTRATED

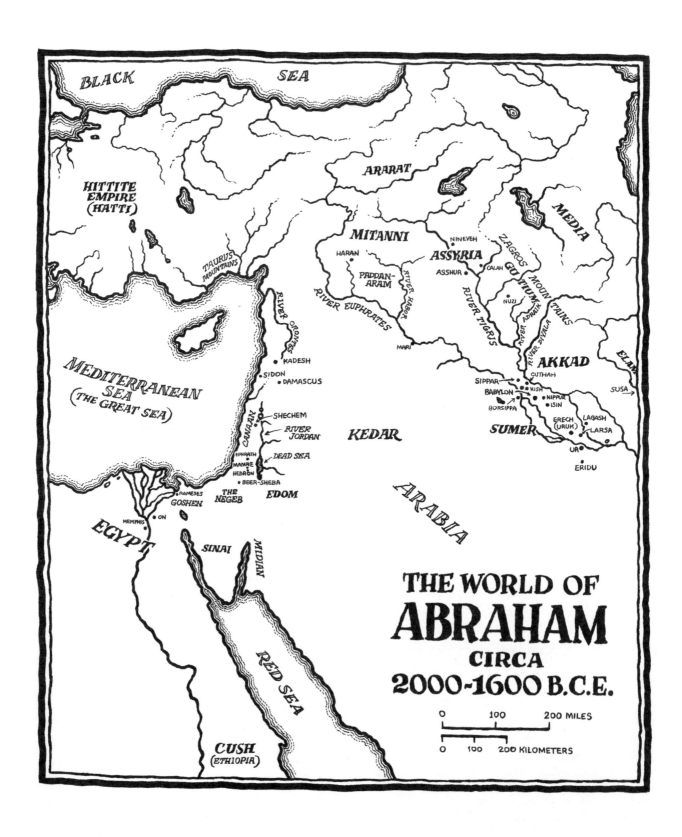

Chapter 1

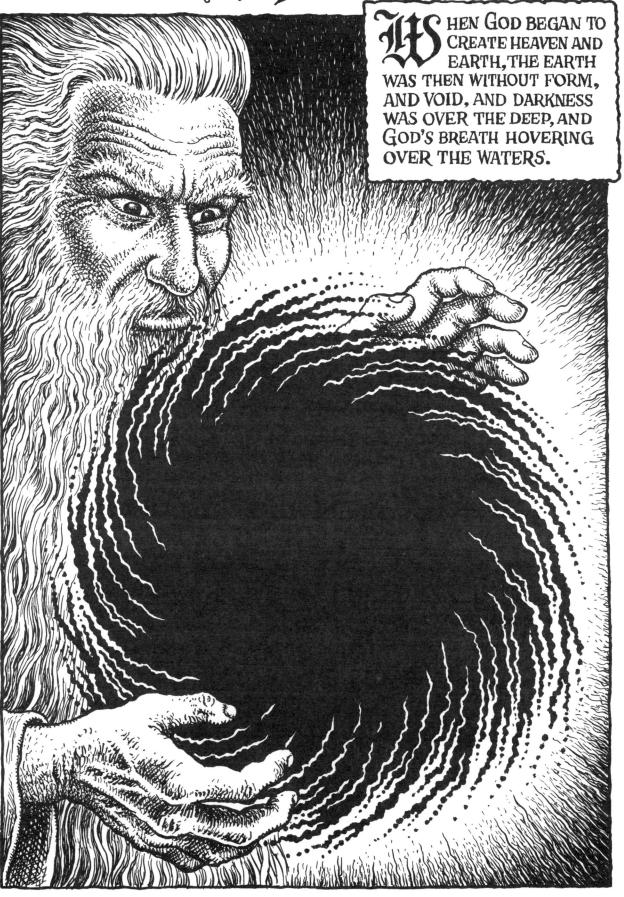

WHEN GOD BEGAN TO CREATE HEAVEN AND EARTH, THE EARTH WAS THEN WITHOUT FORM, AND VOID, AND DARKNESS WAS OVER THE DEEP, AND GOD'S BREATH HOVERING OVER THE WATERS.

AND GOD SAID, "LET THERE BE LIGHT." AND THERE WAS LIGHT.

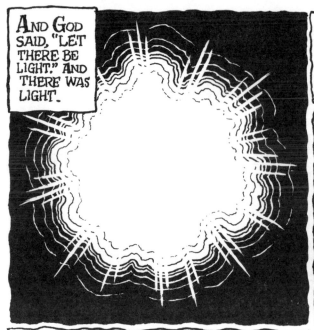

AND GOD SAW THE LIGHT, THAT IT WAS GOOD, AND GOD DIVIDED THE LIGHT FROM THE DARKNESS. AND GOD CALLED THE LIGHT DAY, AND THE DARKNESS HE CALLED NIGHT. AND IT WAS EVENING AND IT WAS MORNING, A *FIRST* DAY.

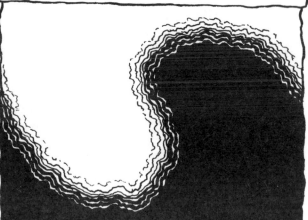

AND GOD SAID, "LET THERE BE A VAULT IN THE MIDST OF THE WATERS, AND LET IT DIVIDE WATER FROM WATER." AND GOD MADE THE VAULT AND IT DIVIDED THE WATER BENEATH THE VAULT FROM THE WATER ABOVE THE VAULT, AND SO IT WAS. AND GOD CALLED THE VAULT HEAVENS, AND IT WAS EVENING AND IT WAS MORNING, A *SECOND* DAY.

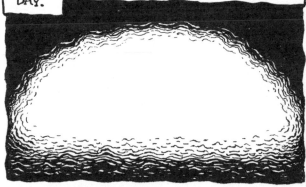

AND GOD SAID, "LET THE WATERS UNDER THE HEAVENS BE GATHERED IN ONE PLACE SO THAT THE DRY LAND WILL APPEAR." AND SO IT WAS. AND GOD CALLED THE DRY LAND EARTH, AND THE GATHERING OF WATERS HE CALLED SEAS, AND GOD SAW THAT IT WAS GOOD.

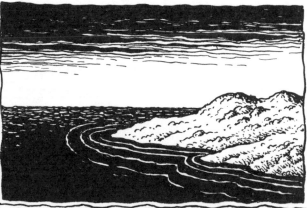

AND GOD SAID, "LET THE EARTH BRING FORTH GRASS, PLANTS YIELDING SEED OF EACH KIND, AND TREES BEARING FRUIT OF EACH KIND, THAT HAS ITS SEED WITHIN IT UPON THE EARTH." AND SO IT WAS.

AND THE EARTH PUT FORTH GRASS, PLANTS YIELDING SEED OF EACH KIND, AND TREES BEARING FRUIT THAT HAS ITS SEED WITHIN IT OF EACH KIND, AND GOD SAW THAT IT WAS GOOD, AND IT WAS EVENING AND IT WAS MORNING, A *THIRD* DAY.

AND GOD SAID, "LET THERE BE LIGHTS IN THE VAULT OF THE HEAVENS TO DIVIDE THE DAY FROM THE NIGHT, AND LET THEM BE FOR SIGNS FOR THE FIXED TIMES AND FOR DAYS AND YEARS, AND THEY SHALL BE LIGHTS IN THE VAULT OF THE HEAVENS TO GIVE LIGHT UPON THE EARTH." AND SO IT WAS.

AND GOD MADE THE TWO GREAT LIGHTS, THE GREATER LIGHT TO DOMINATE THE DAY AND THE LESSER LIGHT TO DOMINATE THE NIGHT AND THE STARS.

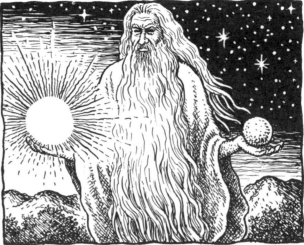

AND GOD PLACED THEM IN THE VAULT OF THE HEAVENS TO GIVE LIGHT UPON THE EARTH, AND TO RULE OVER THE DAY AND OVER THE NIGHT, AND TO DIVIDE THE LIGHT FROM THE DARKNESS. AND GOD SAW THAT IT WAS GOOD. AND IT WAS EVENING AND IT WAS MORNING, A *FOURTH* DAY.

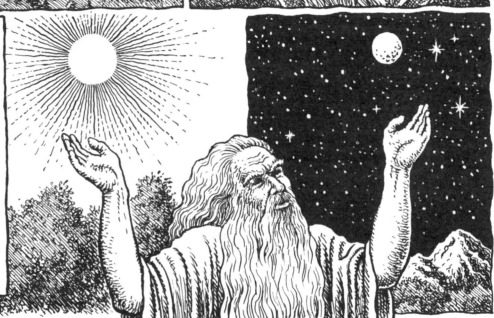

AND GOD SAID, "LET THE WATERS BRING FORTH SWARMS OF LIVING CREATURES AND BIRDS THAT FLY OVER THE EARTH ACROSS THE VAULT OF THE HEAVENS." AND GOD CREATED THE GREAT SEA MONSTERS, AND EVERY LIVING CREATURE THAT CRAWLS, WHICH THE WATER HAD BROUGHT FORTH IN SWARMS, AND ALL THE WINGED BIRDS OF EVERY KIND, AND GOD SAW THAT IT WAS GOOD.

AND GOD BLESSED THEM, SAYING, "BE FRUITFUL AND MULTIPLY AND FILL THE WATER IN THE SEAS AND LET THE BIRDS MULTIPLY IN THE EARTH." AND IT WAS EVENING AND IT WAS MORNING, A *FIFTH* DAY.

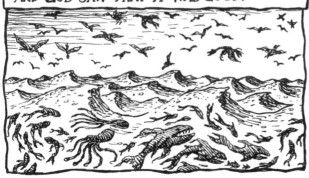

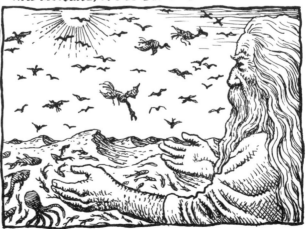

AND GOD SAID, "LET THE EARTH BRING FORTH LIVING CREATURES OF EACH KIND, CATTLE AND CRAWLING THINGS AND WILD BEASTS OF EACH KIND." AND SO IT WAS. AND GOD MADE WILD BEASTS OF EACH KIND AND CATTLE OF EVERY KIND, AND ALL CRAWLING THINGS ON THE GROUND OF EACH KIND, AND GOD SAW THAT IT WAS GOOD.

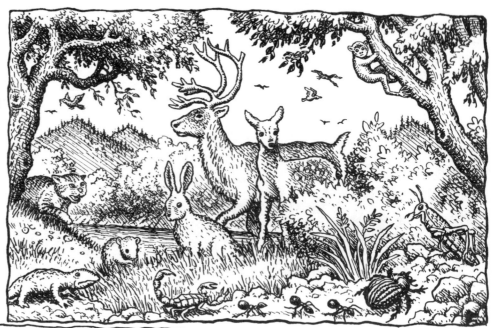

AND GOD SAID, "LET US MAKE MAN IN OUR OWN IMAGE, AFTER OUR LIKENESS; AND LET THEM HAVE DOMINION OVER THE FISH OF THE SEA AND OVER THE BIRDS OF THE HEAVENS, AND THE CATTLE, AND OVER THE EARTH, AND OVER EVERY CRAWLING THING THAT CRAWLS UPON THE EARTH."

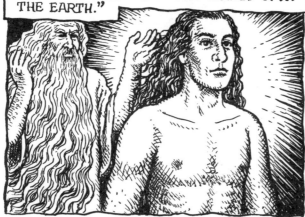

AND GOD CREATED MAN IN HIS OWN IMAGE, IN THE IMAGE OF GOD HE CREATED HIM, MALE AND FEMALE HE CREATED THEM.

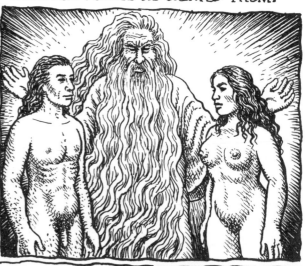

AND GOD BLESSED THEM, AND GOD SAID TO THEM...

BE FRUITFUL AND MULTIPLY AND FILL THE EARTH AND MASTER IT, AND HAVE DOMINION OVER THE FISH OF THE SEA, AND OVER THE BIRDS OF THE HEAVENS AND EVERY BEAST THAT CRAWLS UPON THE EARTH.

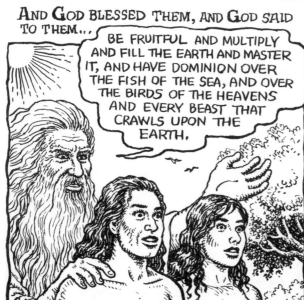

AND GOD SAID...

BEHOLD, I GIVE YOU EVERY SEED-BEARING PLANT ON THE FACE OF ALL THE EARTH AND EVERY TREE THAT HAS FRUIT-BEARING SEED, YOURS THEY SHALL BE FOR FOOD.

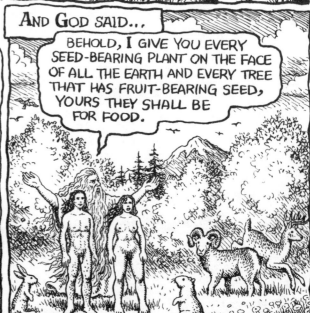

"AND TO EVERY BEAST OF THE EARTH, AND TO EVERY BIRD OF THE HEAVENS, AND TO EVERYTHING THAT CRAWLS ON THE EARTH, WHICH HAS THE BREATH OF LIFE WITHIN IT, I GIVE ALL THE GREEN PLANTS FOR FOOD." AND SO IT WAS.

AND GOD SAW ALL THAT HE HAD MADE, AND BEHOLD, IT WAS VERY GOOD. AND IT WAS EVENING AND IT WAS MORNING, THE *SIXTH* DAY.

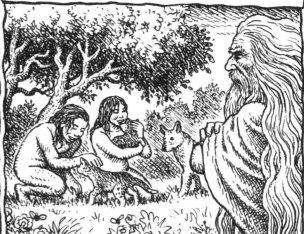

Chapter 2

THUS THE HEAVENS AND THE EARTH WERE COMPLETED, AND ALL THEIR ARRAY. AND ON THE *SEVENTH* DAY GOD FINISHED THE WORK WHICH HE HAD BEEN DOING, AND HE CEASED ON THE SEVENTH DAY FROM ALL THE WORK WHICH HE HAD DONE. AND GOD BLESSED THE SEVENTH DAY, AND MADE IT HOLY, FOR ON IT HE HAD CEASED FROM ALL HIS TASK THAT HE HAD CREATED TO DO.

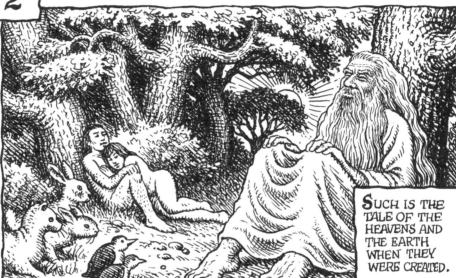

SUCH IS THE TALE OF THE HEAVENS AND THE EARTH WHEN THEY WERE CREATED.

ON THE DAY THE LORD GOD MADE EARTH AND HEAVEN, WHEN NO SHRUB OF THE FIELD WAS YET ON EARTH AND NO GRASSES OF THE FIELD HAD YET SPROUTED, BECAUSE THE LORD GOD HAD NOT SENT RAIN UPON THE EARTH AND THERE WAS NO MAN TO TILL THE SOIL, BUT WETNESS WOULD WELL UP FROM THE GROUND TO WATER ALL THE WHOLE SURFACE OF THE EARTH, THEN THE LORD GOD FORMED MAN FROM THE DIRT OF THE GROUND, AND BLEW INTO HIS NOSTRILS THE BREATH OF LIFE, AND MAN BECAME A LIVING CREATURE.

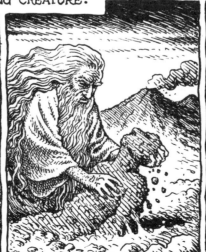

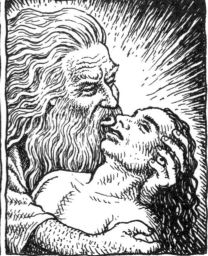

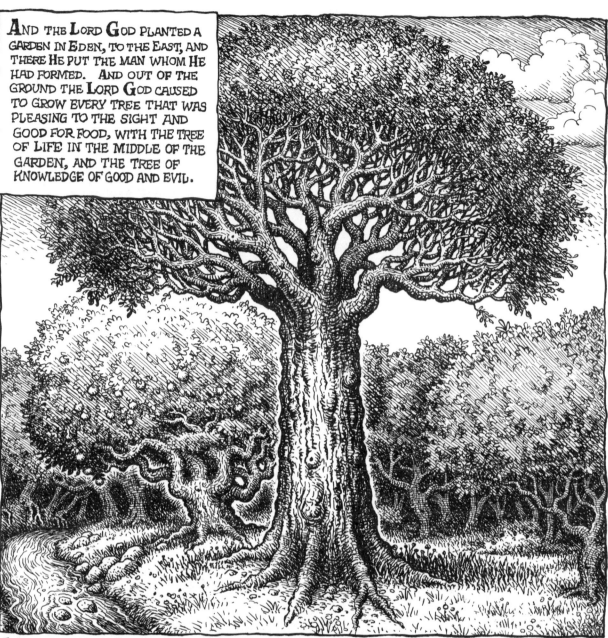

AND THE LORD GOD PLANTED A GARDEN IN EDEN, TO THE EAST, AND THERE HE PUT THE MAN WHOM HE HAD FORMED. AND OUT OF THE GROUND THE LORD GOD CAUSED TO GROW EVERY TREE THAT WAS PLEASING TO THE SIGHT AND GOOD FOR FOOD, WITH THE TREE OF LIFE IN THE MIDDLE OF THE GARDEN, AND THE TREE OF KNOWLEDGE OF GOOD AND EVIL.

A RIVER RUNS OUT OF EDEN TO WATER THE GARDEN, AND IT THEN DIVIDES AND BECOMES FOUR STREAMS. THE NAME OF THE FIRST IS PISHON, THE ONE THAT WINDS THROUGH THE WHOLE LAND OF HAVILAH, WHERE THERE IS GOLD. THE GOLD OF THAT LAND IS GOOD; BDELLIUM IS THERE, AND LAPIS LAZULI.

AND THE NAME OF THE SECOND RIVER IS GIHON, THE ONE THAT WINDS THROUGH THE WHOLE LAND OF CUSH.

AND THE NAME OF THE THIRD RIVER IS TIGRIS, THE ONE THAT GOES TO THE EAST OF ASHUR, AND THE FOURTH RIVER IS EUPHRATES.

AND THE LORD GOD TOOK THE MAN AND SET HIM DOWN IN THE GARDEN OF EDEN, TO TILL IT AND TO WATCH OVER IT. AND THE LORD GOD COMMANDED THE MAN, SAYING...

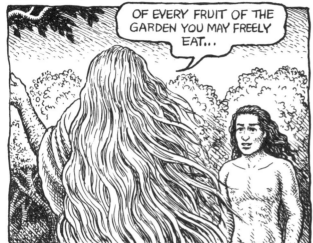

OF EVERY FRUIT OF THE GARDEN YOU MAY FREELY EAT...

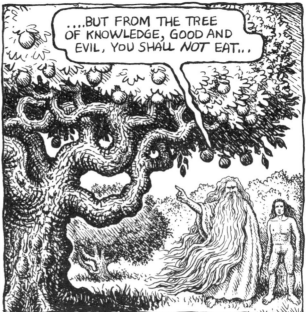

...BUT FROM THE TREE OF KNOWLEDGE, GOOD AND EVIL, YOU SHALL *NOT* EAT...

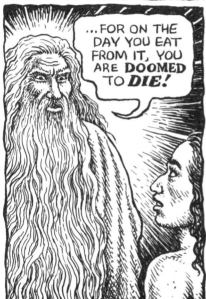

...FOR ON THE DAY YOU EAT FROM IT, YOU ARE **DOOMED** TO **DIE!**

AND THE LORD GOD SAID...

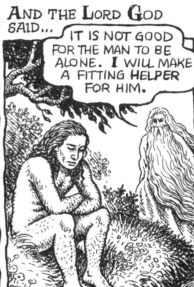

IT IS NOT GOOD FOR THE MAN TO BE ALONE. I WILL MAKE A FITTING HELPER FOR HIM.

AND THE LORD GOD FORMED OUT OF THE EARTH EVERY BEAST OF THE FIELD AND EVERY FOWL OF THE HEAVENS; AND HE BROUGHT EACH TO THE MAN TO SEE WHAT HE WOULD CALL IT, AND WHATEVER THE MAN CALLED A LIVING CREATURE, THAT WAS ITS NAME.

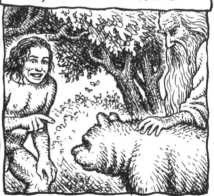

AND THE MAN GAVE NAMES TO ALL THE CATTLE AND TO THE FOWL OF THE HEAVENS AND TO ALL THE BEASTS OF THE FIELD, BUT FOR THE MAN NO FITTING HELPER WAS FOUND.

AND SO THE LORD GOD CAST A DEEP SLEEP UPON THE MAN, AND HE SLEPT, AND HE TOOK ONE OF HIS RIBS, AND CLOSED OVER THE FLESH WHERE IT HAD BEEN.

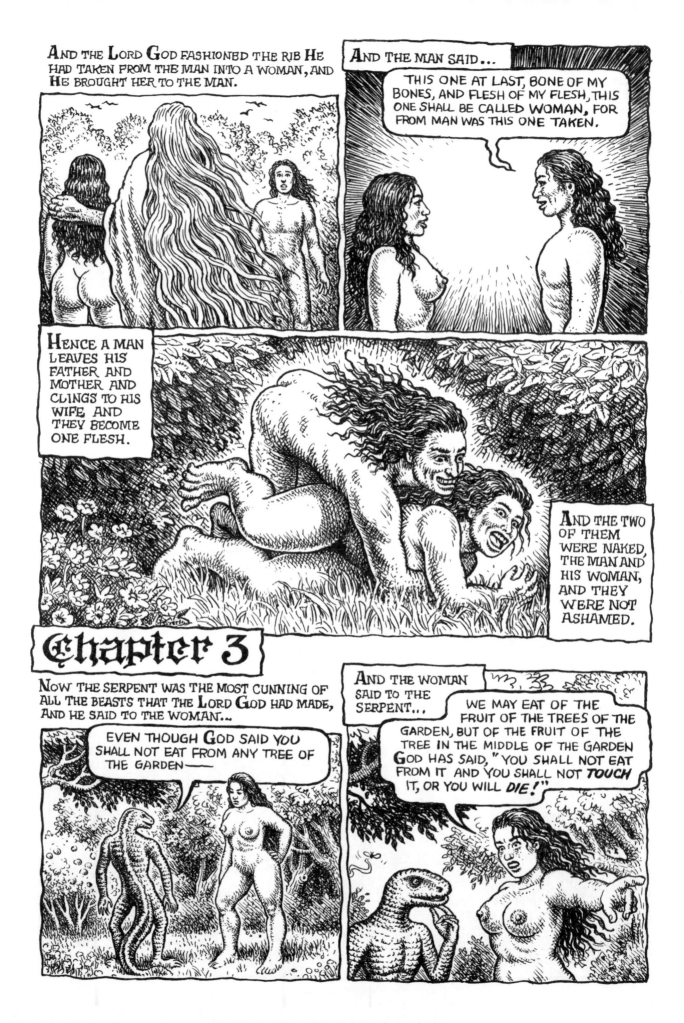

AND THE SERPENT SAID TO THE WOMAN: YOU SHALL NOT BE DOOMED TO DIE, FOR GOD KNOWS THAT ON THE DAY YOU EAT OF IT YOUR EYES WILL BE OPENED, AND YOU WILL BECOME AS DIVINE BEINGS, KNOWING GOOD AND EVIL.

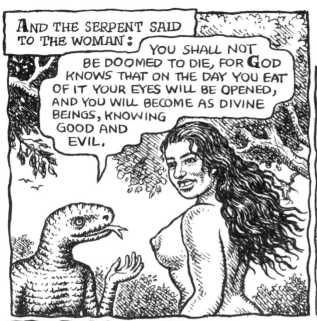

AND THE WOMAN SAW THAT THE TREE WAS GOOD FOR EATING AND THAT IT WAS LUST TO THE EYES AND LOVELY TO LOOK AT.

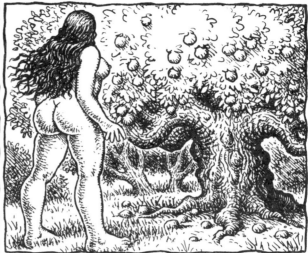

AND SHE TOOK OF ITS FRUIT AND ATE...,

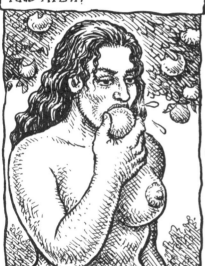

...AND SHE ALSO GAVE TO HER MAN, AND HE ATE.

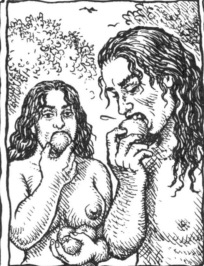

AND THE EYES OF THE TWO WERE OPENED, AND THEY KNEW THAT THEY WERE NAKED.

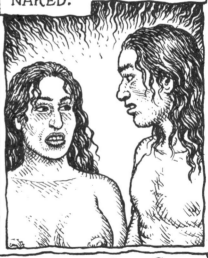

AND THEY SEWED FIG LEAVES AND MADE THEMSELVES LOINCLOTHS.

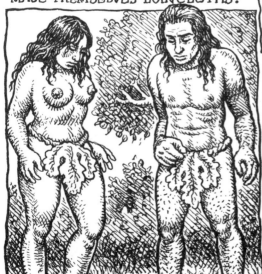

AND THEY HEARD THE SOUND OF THE LORD GOD WALKING ABOUT IN THE GARDEN IN THE EVENING BREEZE, AND THE MAN AND HIS WOMAN HID FROM THE LORD GOD IN THE MIDST OF THE TREES OF THE GARDEN.

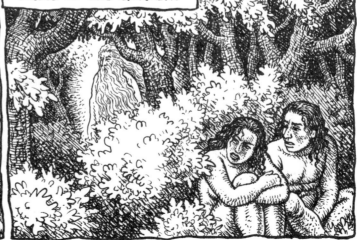

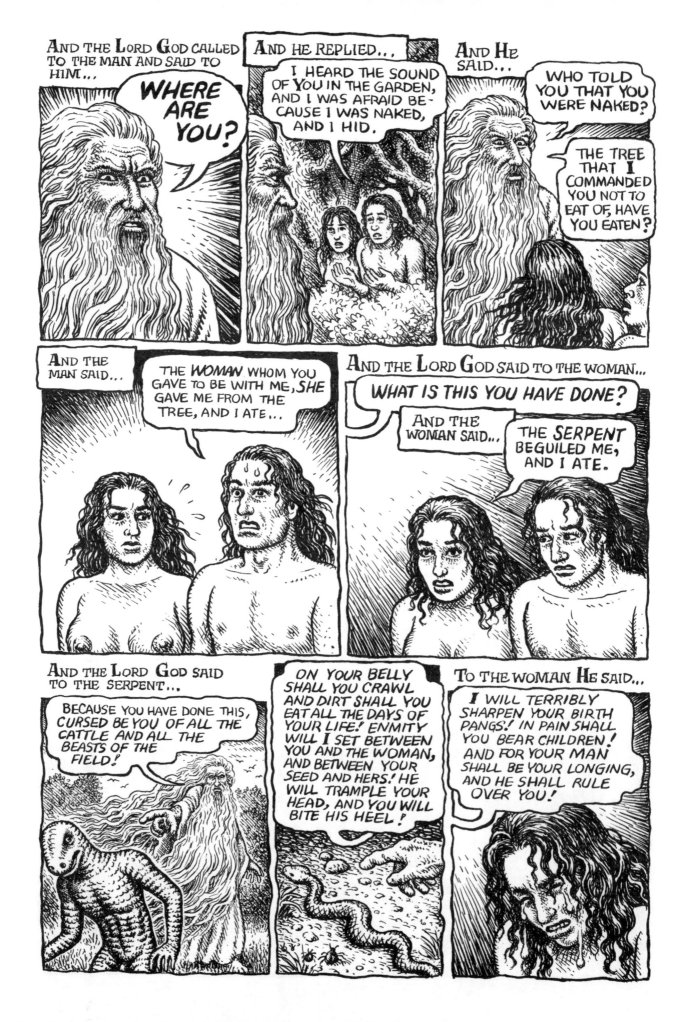

 AND TO ADAM HE SAID...

BECAUSE YOU LISTENED TO THE VOICE OF YOUR WIFE AND ATE FROM THE TREE OF WHICH I COMMANDED YOU, "YOU SHALL NOT EAT FROM IT," *CURSED BE THE GROUND BECAUSE OF YOU!*

IN SORROW YOU SHALL EAT FROM IT ALL THE DAYS OF YOUR LIFE! THORNS AND THISTLE SHALL IT SPROUT FOR YOU, AND YOU SHALL EAT THE GRASSES OF THE FIELD! BY THE SWEAT OF YOUR BROW SHALL YOU EAT BREAD, TILL YOU RETURN TO THE GROUND, FOR FROM THERE YOU WERE TAKEN!

FOR **DUST** YOU ARE, AND TO **DUST** YOU SHALL RETURN!

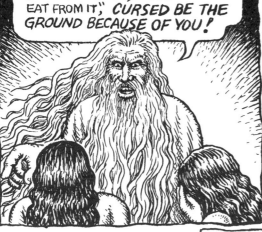

AND ADAM CALLED HIS WIFE'S NAME EVE, FOR SHE WAS THE MOTHER OF ALL THE LIVING.

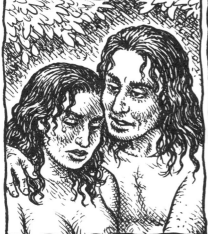

 AND THE LORD GOD MADE COATS OF SKINS FOR THE MAN AND HIS WOMAN, AND HE CLOTHED THEM.

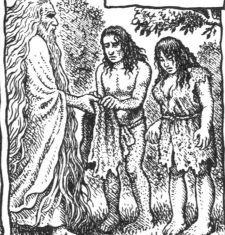

 AND THE LORD GOD SAID...

NOW THAT THE MAN HAS BECOME LIKE ONE OF **US**, KNOWING GOOD AND EVIL, HE MAY REACH OUT AND TAKE AS WELL FROM THE *TREE OF LIFE* AND *LIVE FOREVER!*

AND THE LORD GOD SENT HIM FORTH FROM THE GARDEN OF EDEN TO TILL THE GROUND FROM WHICH HE HAD BEEN TAKEN.

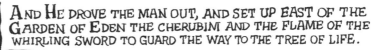 AND HE DROVE THE MAN OUT, AND SET UP EAST OF THE GARDEN OF EDEN THE CHERUBIM AND THE FLAME OF THE WHIRLING SWORD TO GUARD THE WAY TO THE TREE OF LIFE.

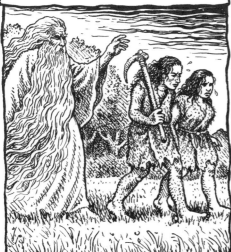

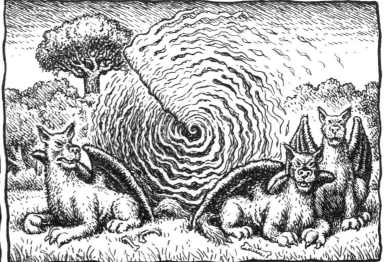

Chapter 4

AND THE MAN *KNEW* EVE, HIS WOMAN, AND SHE CONCEIVED, AND BORE CAIN, AND SHE SAID...

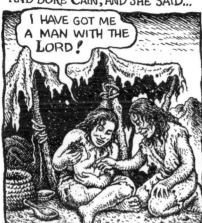

I HAVE GOT ME A MAN WITH THE LORD!

AND SHE BORE AS WELL HIS BROTHER ABEL, AND ABEL BECAME A HERDER OF SHEEP...

...WHILE CAIN WAS A TILLER OF THE SOIL.

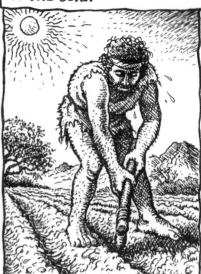

AND IT CAME TO PASS IN THE COURSE OF TIME THAT CAIN BROUGHT FROM THE FRUIT OF THE SOIL AN OFFERING TO THE LORD.

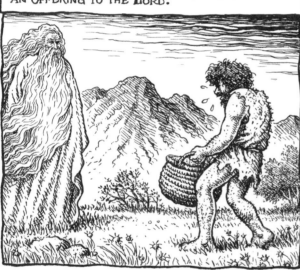

AND ABEL TOO BROUGHT FROM THE CHOICE FIRSTLINGS OF HIS FLOCK.

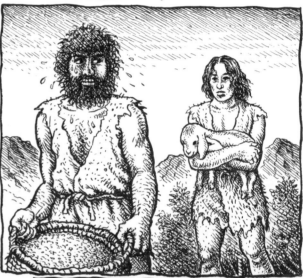

AND THE LORD PAID HEED TO ABEL AND HIS OFFERING, BUT TO CAIN AND HIS OFFERING HE PAID NO HEED. CAIN WAS MUCH DISTRESSED, AND HIS FACE FELL.

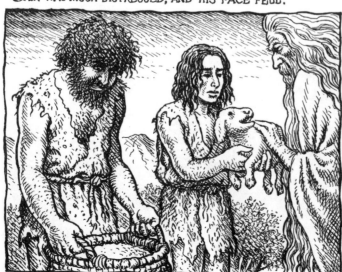

AND THE LORD SAID TO CAIN...

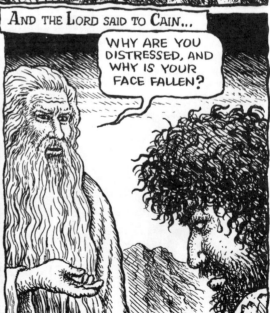

WHY ARE YOU DISTRESSED, AND WHY IS YOUR FACE FALLEN?

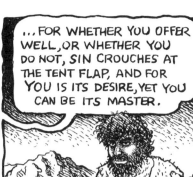

...FOR WHETHER YOU OFFER WELL, OR WHETHER YOU DO NOT, SIN CROUCHES AT THE TENT FLAP, AND FOR YOU IS ITS DESIRE, YET YOU CAN BE ITS MASTER.

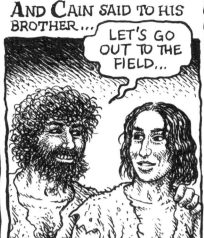

AND CAIN SAID TO HIS BROTHER...

LET'S GO OUT TO THE FIELD...

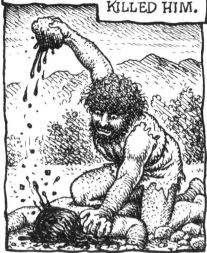

AND WHEN THEY WERE IN THE FIELD, CAIN ATTACKED HIS BROTHER ABEL AND KILLED HIM.

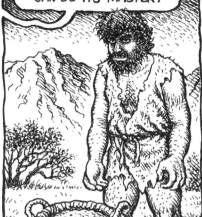

AND THE LORD SAID TO CAIN...

WHERE IS ABEL, YOUR BROTHER?

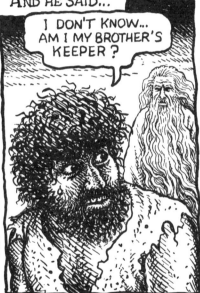

AND HE SAID...

I DON'T KNOW... AM I MY BROTHER'S KEEPER?

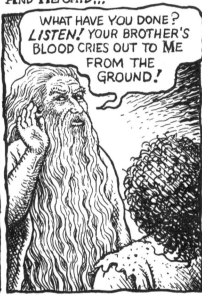

AND HE SAID...

WHAT HAVE YOU DONE? *LISTEN!* YOUR BROTHER'S BLOOD CRIES OUT TO ME FROM THE GROUND!

AND SO, *CURSED* SHALL YOU BE BY THE GROUND THAT OPENED WIDE ITS MOUTH TO TAKE YOUR BROTHER'S BLOOD FROM YOUR HAND! IF YOU TILL THE SOIL, IT WILL NO LONGER YIELD UNTO YOU ITS STRENGTH! A RESTLESS WANDERER YOU SHALL BE ON THE EARTH!

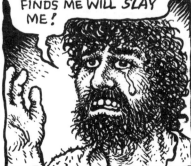

AND CAIN SAID TO THE LORD...

MY PUNISHMENT IS TOO GREAT TO BEAR! NOW THAT YOU HAVE BANISHED ME FROM THE FACE OF THE EARTH, AND FROM YOUR FACE I MUST HIDE, AND I MUST BE A FUGITIVE AND A VAGABOND, WHOEVER FINDS ME WILL *SLAY* ME!

AND THE LORD SAID TO HIM, "THEREFORE, WHOEVER KILLS CAIN SHALL SUFFER SEVEN-FOLD VENGEANCE." AND THE LORD SET A MARK UPON CAIN, SO THAT WHOEVER FOUND HIM WOULD NOT SLAY HIM.

AND CAIN WENT OUT FROM THE PRESENCE OF THE LORD AND DWELT IN THE LAND OF NOD EAST OF EDEN.

AND CAIN *KNEW* HIS WIFE, AND SHE CONCEIVED AND BORE ENOCH.

THEN HE BECAME FOUNDER OF A CITY, AND CALLED THE NAME OF THE CITY AFTER THE NAME OF HIS SON, ENOCH.

AND TO ENOCH WAS BORN IRAD, AND IRAD BEGOT MEHUJAEL, AND MEHUJAEL BEGOT METHUSAEL, AND METHUSAEL BEGOT LAMECH. AND LAMECH TOOK UNTO HIM TWO WIVES; THE NAME OF ONE WAS ADAH, AND THE NAME OF THE OTHER WAS ZILLAH.

AND ADAH BORE JABAL; HE WAS THE FATHER OF ALL TENT DWELLERS WHO HAVE CATTLE.

AND HIS BROTHER'S NAME WAS JUBAL; HE WAS THE FATHER OF ALL WHO PLAY ON THE LYRE AND THE PIPE.

AS FOR ZILLAH, SHE BORE TUBAL-CAIN, WHO FORGED EVERY IMPLEMENT OF COPPER AND IRON.

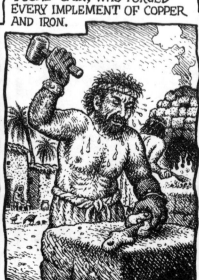

AND THE SISTER OF TUBAL-CAIN WAS NAAMAH.

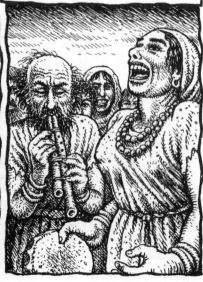

AND LAMECH SAID TO HIS WIVES...

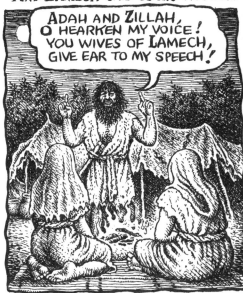

ADAH AND ZILLAH, O HEARKEN MY VOICE! YOU WIVES OF LAMECH, GIVE EAR TO MY SPEECH!

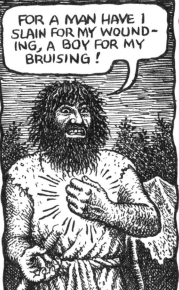

FOR A MAN HAVE I SLAIN FOR MY WOUNDING, A BOY FOR MY BRUISING!

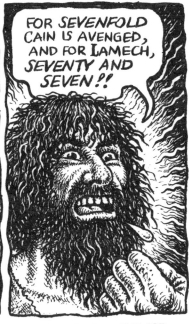

FOR SEVENFOLD CAIN IS AVENGED, AND FOR LAMECH, SEVENTY AND SEVEN?!

AND ADAM AGAIN *KNEW* HIS WIFE, AND SHE BORE A SON AND CALLED HIS NAME SETH, WHICH MEANS, "GOD HAS GRANTED ME ANOTHER SEED IN PLACE OF ABEL, FOR CAIN HAS KILLED HIM."

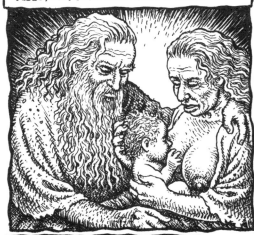

AND TO SETH, TO HIM ALSO A SON WAS BORN, AND HE CALLED HIS NAME ENOSH. IT WAS THEN THAT MEN BEGAN TO CALL UPON THE NAME OF THE LORD.

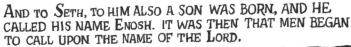

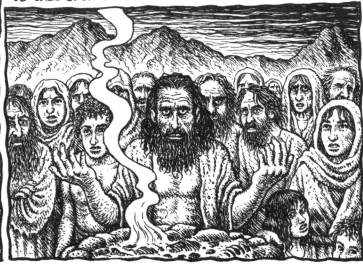

Chapter 5

THIS IS THE RECORD OF THE LINEAGE OF ADAM: ON THE DAY THAT GOD CREATED THE MAN, IN THE IMAGE OF GOD HE CREATED HIM. MALE AND FEMALE HE CREATED THEM. HE CREATED THEM, AND HE BLESSED THEM AND CALLED THEIR NAME MAN ON THE DAY THEY WERE CREATED.

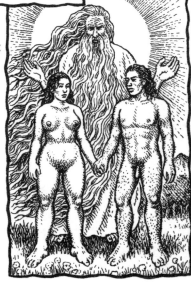

AND ADAM LIVED 130 YEARS AND HE BEGOT IN HIS LIKENESS BY HIS IMAGE AND CALLED HIS NAME SETH, AND THE DAYS OF ADAM AFTER HE BEGOT SETH WERE 800 YEARS, AND HE BEGOT SONS AND DAUGHTERS. AND ALL THE DAYS ADAM LIVED WERE 930 YEARS. AND HE DIED.

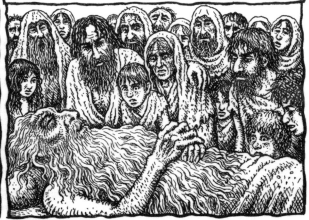

AND SETH LIVED 105 YEARS AND HE BEGOT ENOSH.

AND SETH LIVED AFTER HE BEGOT ENOSH 807 YEARS, AND HE BEGOT SONS AND DAUGHTERS. AND ALL THE DAYS OF SETH WERE 912 YEARS. THEN HE DIED.

AND ENOSH LIVED 90 YEARS AND HE BEGOT KENAN.

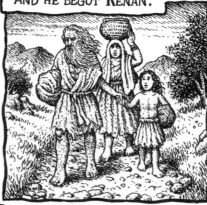

AND ENOSH LIVED AFTER HE BEGOT KENAN 815 YEARS, AND HE BEGOT SONS AND DAUGHTERS. AND ALL THE DAYS OF ENOSH WERE 905 YEARS. THEN HE DIED.

AND KENAN LIVED 70 YEARS AND HE BEGOT MAHALALEL.

AND KENAN LIVED AFTER HE BEGOT MAHALALEL 840 YEARS, AND HE BEGOT SONS AND DAUGHTERS. AND ALL THE DAYS OF KENAN WERE 910 YEARS. THEN HE DIED.

AND MAHALALEL LIVED 65 YEARS AND HE BEGOT JARED.

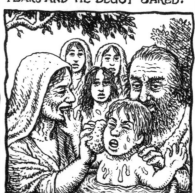

AND MAHALALEL LIVED AFTER HE BEGOT JARED 830 YEARS, AND HE BEGOT SONS AND DAUGHTERS. AND ALL THE DAYS OF MAHALALEL WERE 895 YEARS. THEN HE DIED.

AND JARED LIVED 162 YEARS AND HE BEGOT ENOCH.

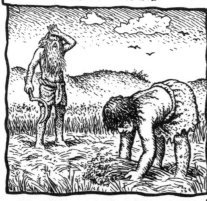

AND JARED LIVED AFTER HE BEGOT ENOCH 800 YEARS, AND HE BEGOT SONS AND DAUGHTERS. AND ALL THE DAYS OF JARED WERE 962 YEARS. THEN HE DIED.

AND ENOCH LIVED 65 YEARS AND HE BEGOT METHUSELAH.

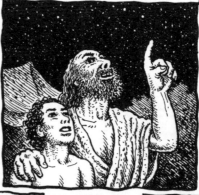

AND ENOCH WALKED WITH GOD AFTER HE BEGOT METHUSELAH 300 YEARS, AND HE BEGOT SONS AND DAUGHTERS. AND ALL THE DAYS OF ENOCH WERE 365 YEARS.

AND ENOCH WALKED WITH GOD AND HE WAS NO MORE, FOR GOD TOOK HIM.

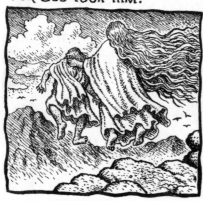

AND METHUSELAH LIVED 187 YEARS AND HE BEGOT LAMECH.

AND METHUSELAH LIVED AFTER HE BEGOT LAMECH 782 YEARS, AND HE BEGOT SONS AND DAUGHTERS. AND ALL THE DAYS OF METHUSELAH WERE 969 YEARS. THEN HE DIED.

AND LAMECH LIVED 182 YEARS AND HE BEGOT A SON, AND HE CALLED HIS NAME NOAH...

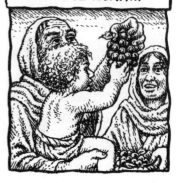

...AS IF TO SAY, "THIS ONE WILL CONSOLE US FOR THE PAIN OF OUR HANDS' WORK FROM THE SOIL WHICH THE LORD HAS CURSED." *

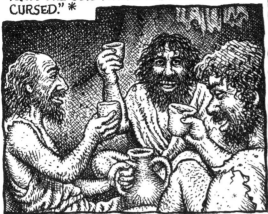

* THE NAME NOAH SOUNDS SIMILAR IN HEBREW TO THE WORD *NAHEM*, TO CONSOLE, SINCE NOAH WAS CREDITED WITH BEING THE FIRST MAN TO MAKE WINE! SEE CHAPTER 9.

AND LAMECH LIVED AFTER HE BEGOT NOAH 595 YEARS, AND HE BEGOT SONS AND DAUGHTERS. AND ALL THE DAYS OF LAMECH WERE 777 YEARS. THEN HE DIED.

AND NOAH WAS 500 YEARS OLD AND HE BEGOT SHEM, HAM, AND JAPHETH.

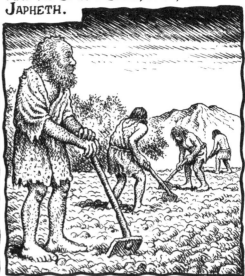

Chapter 6

AND IT CAME TO PASS, AS MEN BEGAN TO MULTIPLY OVER THE FACE OF THE EARTH AND DAUGHTERS WERE BORN TO THEM, THAT THE DIVINE BEINGS SAW THAT THE DAUGHTERS OF MAN WERE COMELY, AND THEY TOOK THEMSELVES WIVES HOWSOEVER THEY PLEASED.

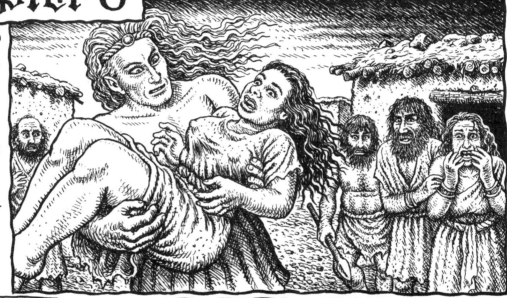

AND THE LORD SAID...

MY BREATH SHALL NOT ABIDE IN MAN FOREVER, BECAUSE HE IS ALSO BUT FLESH. LET HIS DAYS BE 120 YEARS.

THE NEPHILIM WERE THEN ON THE EARTH, AND AFTER THAT AS WELL, BECAUSE THE DIVINE BEINGS HAD ENTERED THE DAUGHTERS OF MEN, WHO BORE THEM CHILDREN.

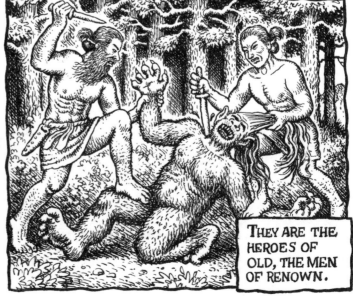

THEY ARE THE HEROES OF OLD, THE MEN OF RENOWN.

AND THE LORD SAW THAT THE WICKEDNESS OF THE HUMAN CREATURE WAS GREAT ON THE EARTH, AND THAT EVERY SCHEME OF HIS HEART'S DEVISING WAS ONLY PERPETUALLY EVIL.

AND THE LORD REGRETTED HAVING MADE MAN ON EARTH, AND IT GRIEVED HIM IN HIS HEART. AND THE LORD SAID...

I WILL *WIPE OUT* FROM THE FACE OF THE EARTH THE MEN WHOM I HAVE CREATED...

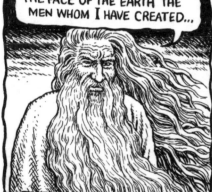

...FROM MAN TO CATTLE TO CRAWLING THINGS TO THE FOWL OF THE HEAVENS, FOR I REGRET THAT I HAVE MADE THEM!

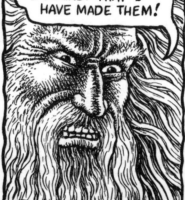

BUT NOAH FOUND FAVOR IN THE EYES OF THE LORD—NOAH WAS A RIGHTEOUS MAN, HE WAS BLAMELESS IN HIS TIME, NOAH WALKED WITH GOD.

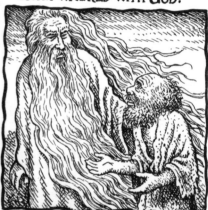

AND NOAH BEGOT THREE SONS, SHEM AND HAM AND JAPHETH.

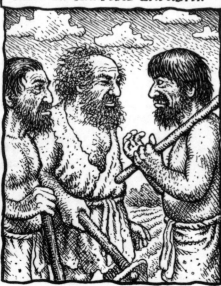

AND THE EARTH WAS CORRUPT BEFORE GOD, AND THE EARTH WAS FILLED WITH OUT-RAGE. AND GOD LOOKED UPON THE EARTH AND, BEHOLD, IT WAS CORRUPT, FOR ALL FLESH HAD CORRUPTED ITS WAYS UPON THE EARTH.

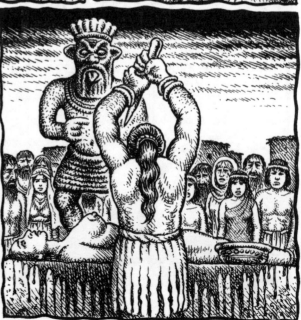

AND GOD SAID TO NOAH...

THE END OF ALL FLESH IS COME BEFORE ME, FOR THE EARTH IS FILLED WITH OUTRAGE BY THEM, AND I AM NOW ABOUT TO DESTROY THEM, WITH THE EARTH.

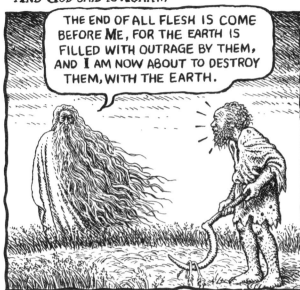

MAKE YOURSELF AN ARK OF CYPRESS WOOD, WITH ROOMS YOU SHALL MAKE THE ARK, AND CAULK IT INSIDE AND OUT WITH PITCH.

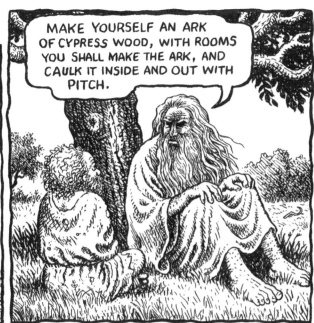

THIS IS HOW YOU SHALL MAKE IT: 300 CUBITS, THE ARK'S LENGTH; 50 CUBITS, ITS WIDTH; 30 CUBITS, ITS HEIGHT. MAKE AN OPENING FOR DAYLIGHT IN THE ARK, WITHIN A CUBIT OF THE TOP YOU SHALL FINISH IT, AND PUT AN ENTRANCE IN THE ARK ON ONE SIDE. WITH LOWER, MIDDLE, AND UPPER DECKS YOU SHALL MAKE IT.

FOR MY PART, I AM ABOUT TO BRING THE FLOOD, WATER UPON THE EARTH, TO DESTROY ALL FLESH WHEREIN IS THE BREATH OF LIFE FROM UNDER THE HEAVENS, EVERYTHING ON EARTH SHALL PERISH!

BUT I WILL ESTABLISH MY COVENANT WITH YOU, AND YOU SHALL ENTER THE ARK, YOU AND YOUR SONS AND YOUR WIFE AND THE WIVES OF YOUR SONS WITH YOU. AND FROM ALL THAT LIVES, FROM ALL FLESH, TWO OF EACH THING YOU SHALL BRING TO THE ARK TO KEEP ALIVE WITH YOU, MALE AND FEMALE THEY SHALL BE.

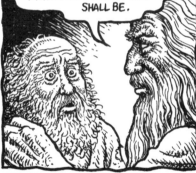

FROM THE FOWL OF EACH KIND AND FROM THE CATTLE OF EACH KIND AND FROM ALL THAT CRAWLS ON THE EARTH OF EACH KIND, TWO OF EACH THING SHALL COME TO YOU TO BE KEPT ALIVE. AS FOR YOU, TAKE YOU FROM EVERY FOOD THAT IS EATEN AND STORE IT BY YOU, TO SERVE FOR YOU AND THEM AS FOOD.

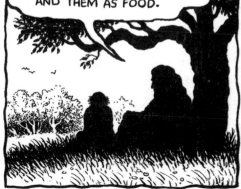

AND THIS NOAH DID; AS ALL THAT GOD COMMANDED HIM, SO HE DID.

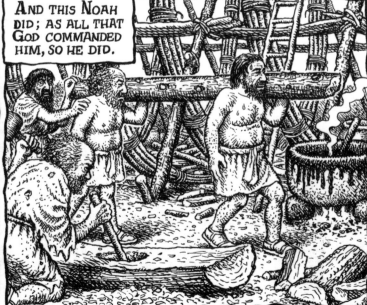

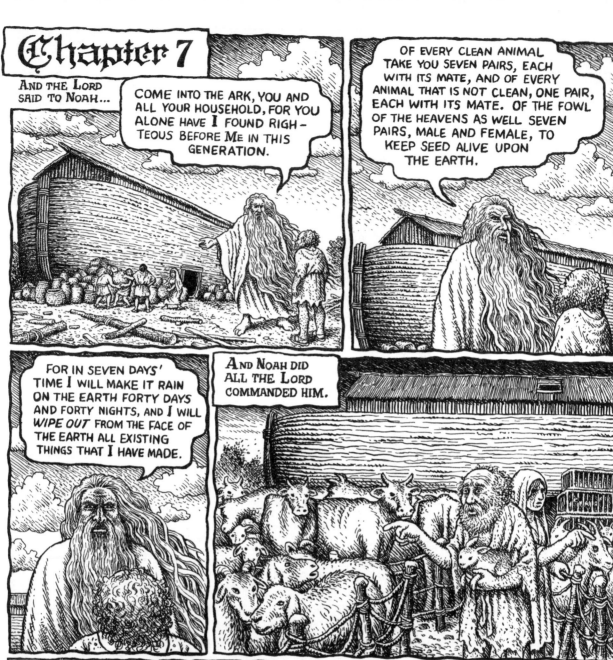

Chapter 7

AND THE LORD SAID TO NOAH...

COME INTO THE ARK, YOU AND ALL YOUR HOUSEHOLD, FOR YOU ALONE HAVE I FOUND RIGHTEOUS BEFORE ME IN THIS GENERATION.

OF EVERY CLEAN ANIMAL TAKE YOU SEVEN PAIRS, EACH WITH ITS MATE, AND OF EVERY ANIMAL THAT IS NOT CLEAN, ONE PAIR, EACH WITH ITS MATE. OF THE FOWL OF THE HEAVENS AS WELL SEVEN PAIRS, MALE AND FEMALE, TO KEEP SEED ALIVE UPON THE EARTH.

FOR IN SEVEN DAYS' TIME I WILL MAKE IT RAIN ON THE EARTH FORTY DAYS AND FORTY NIGHTS, AND I WILL *WIPE OUT* FROM THE FACE OF THE EARTH ALL EXISTING THINGS THAT I HAVE MADE.

AND NOAH DID ALL THE LORD COMMANDED HIM.

NOAH WAS 600 YEARS OLD WHEN THE FLOOD CAME, WATER OVER THE EARTH. AND NOAH AND HIS SONS AND HIS WIFE AND HIS SONS' WIVES CAME INTO THE ARK BECAUSE OF THE WATERS OF THE FLOOD.

OF THE CLEAN ANIMALS AND OF THE ANIMALS THAT WERE NOT CLEAN, AND OF THE FOWL AND OF ALL THAT CRAWLS UPON THE GROUND TWO EACH CAME TO NOAH INTO THE ARK, MALE AND FEMALE, AS GOD HAD COMMANDED NOAH.

AND IT CAME TO PASS AFTER SEVEN DAYS THAT THE WATERS OF THE FLOOD CAME UPON THE EARTH. IN THE SIX-HUNDREDTH YEAR OF NOAH'S LIFE, IN THE SECOND MONTH, ON THE SEVEN- TEENTH DAY, ALL THE WELL- SPRINGS OF THE GREAT DEEP BURST AND THE WINDOWS OF THE HEAVENS WERE OPENED. AND THE RAIN FELL ON THE EARTH FORTY DAYS AND FORTY NIGHTS.

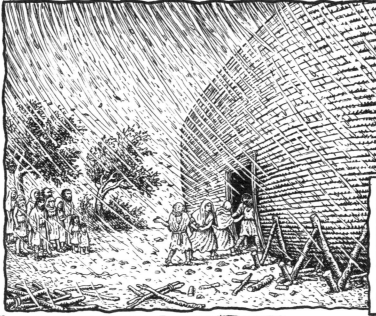

THAT VERY DAY, NOAH AND SHEM AND HAM AND JA- PHETH, THE SONS OF NOAH, AND NOAH'S WIFE, AND THE THREE WIVES OF HIS SONS TOGETHER WITH THEM, CAME INTO THE ARK...

...THEY AS WELL AS BEASTS OF EACH KIND AND CATTLE OF EACH KIND, AND EACH KIND OF CRAWLING THING THAT CRAWLS ON THE GROUND, AND EACH KIND OF BIRD, EACH WINGED THING. THEY CAME TO NOAH INTO THE ARK, TWO BY TWO OF ALL FLESH THAT HAS THE BREATH OF LIFE WITHIN IT.

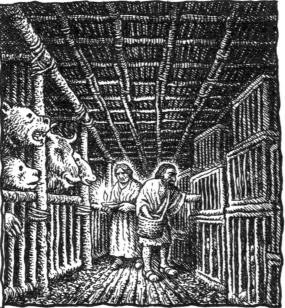

AND THOSE THAT CAME IN COMPRISED MALE AND FEMALE OF ALL FLESH, AS GOD HAD COMMANDED HIM, AND THE LORD SHUT HIM IN.

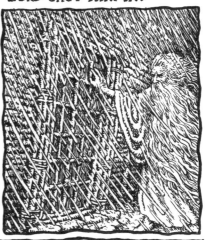

AND THE FLOOD WAS FORTY DAYS OVER THE EARTH, AND THE WATERS MULTIPLIED AND BORE THE ARK UPWARD, AND IT ROSE ABOVE THE EARTH. AND THE WATERS SURGED AND MULTIPLIED MIGHTILY OVER THE EARTH, AND THE ARK WENT ON THE SURFACE OF THE WATER.

AND THE WATERS SURGED MOST MIGHTILY OVER THE EARTH, AND ALL THE HIGH MOUN- TAINS UNDER THE HEAVENS WERE COVERED. FIFTEEN CUBITS ABOVE THEM THE WATERS SURGED AS THE MOUNTAINS WERE COVERED.

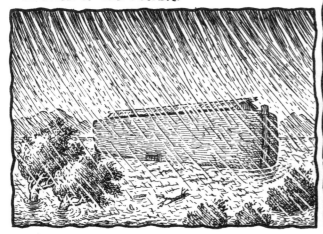

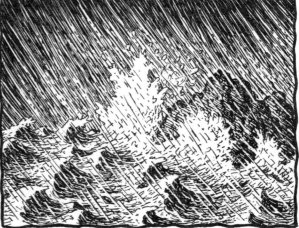

AND ALL FLESH THAT STIRS ON THE EARTH PERISHED, THE FOWL AND THE CATTLE AND THE BEASTS AND ALL THINGS THAT SWARMED UPON THE EARTH, AND ALL MANKIND. ALL THAT HAD THE QUICKENING BREATH OF LIFE IN ITS NOSTRILS, OF ALL THAT WAS ON DRY LAND, DIED. AND HE WIPED OUT ALL EXISTING THINGS FROM THE FACE OF THE EARTH, FROM HUMANS TO CATTLE TO CRAWLING THINGS TO THE FOWL OF THE HEAVENS, THEY WERE WIPED OUT FROM THE EARTH.

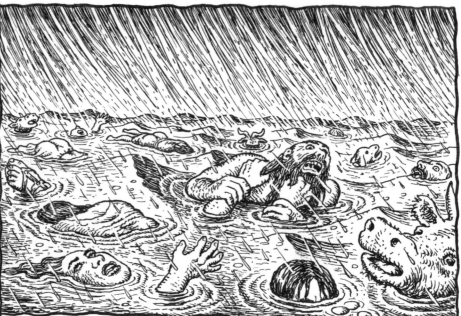

AND NOAH ALONE REMAINED, AND THOSE WITH HIM IN THE ARK.

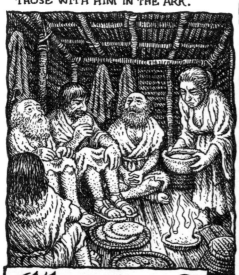

AND THE WATER SURGED OVER THE EARTH 150 DAYS.

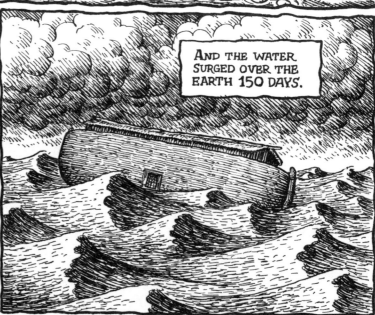

Chapter 8

AND GOD REMEMBERED NOAH AND ALL THE BEASTS AND ALL THE CATTLE THAT WERE WITH HIM IN THE ARK. AND GOD SENT A WIND OVER THE EARTH AND THE WATERS SUBSIDED. AND THE WELL SPRINGS OF THE DEEP WERE DAMMED UP, AND THE WINDOWS OF THE HEAVENS, THE RAIN FROM THE HEAVENS HELD BACK. AND THE WATERS RECEDED STEADILY FROM THE EARTH, AND THE WATERS EBBED.

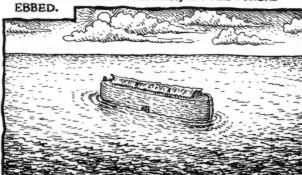

AT THE END OF 150 DAYS THE ARK CAME TO REST, ON THE SEVENTEENTH DAY OF THE SEVENTH MONTH, ON THE MOUNTAINS OF ARARAT. THE WATERS CONTINUED TO EBB, UNTIL THE TENTH MONTH, ON THE FIRST DAY OF THE TENTH MONTH, THE TOPS OF THE MOUNTAINS APPEARED.

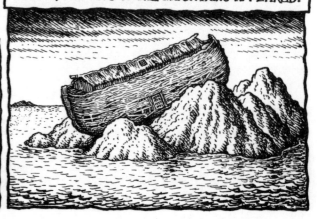

AND IT CAME TO PASS AT THE END OF FORTY DAYS THAT NOAH OPENED THE WINDOW OF THE ARK HE HAD MADE.

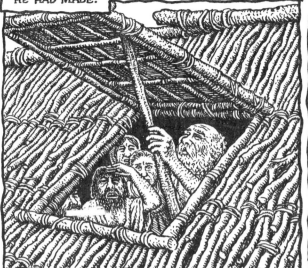

AND HE SENT OUT THE RAVEN, AND IT WENT FORTH TO AND FRO UNTIL THE WATERS SHOULD DRY UP FROM THE EARTH.

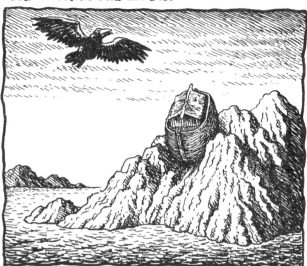

AND HE SENT OUT THE DOVE TO SEE WHETHER THE WATERS HAD ABATED FROM THE SURFACE OF THE GROUND.

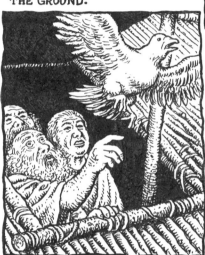

BUT THE DOVE FOUND NO REST FOR THE SOLE OF ITS FOOT, AND IT RETURNED TO HIM INTO THE ARK, FOR THE WATERS WERE ALL OVER THE EARTH.

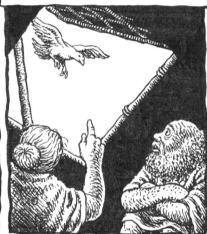

AND HE REACHED OUT AND TOOK IT AND BROUGHT IT BACK TO HIM INTO THE ARK.

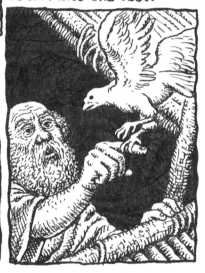

THEN HE WAITED ANOTHER SEVEN DAYS AND AGAIN SENT THE DOVE OUT FROM THE ARK. AND THE DOVE CAME BACK TO HIM AT EVENTIDE AND, LO, IN HER MOUTH WAS A PLUCKED OLIVE LEAF, AND NOAH KNEW THAT THE WATERS HAD ABATED FROM THE EARTH.

THEN HE WAITED STILL ANOTHER SEVEN DAYS AND SENT OUT THE DOVE, AND IT DID NOT RETURN TO HIM AGAIN.

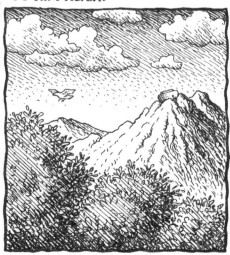

AND IT CAME TO PASS IN THE 601ST YEAR, IN THE FIRST MONTH, ON THE FIRST DAY OF THE MONTH, THE WATERS DRIED UP FROM THE EARTH, AND NOAH TOOK OFF THE COVERING OF THE ARK, AND HE LOOKED, AND BEHOLD, THE FACE OF THE GROUND WAS DRY.

AND IN THE SECOND MONTH, ON THE TWENTY-SEVENTH DAY OF THE MONTH, THE EARTH WAS COMPLETELY DRY. AND GOD SPOKE TO NOAH, SAYING...

GO OUT OF THE ARK, YOU AND YOUR WIFE AND YOUR SONS AND YOUR SONS' WIVES WITH YOU.

ALL THE ANIMALS THAT ARE WITH YOU OF ALL FLESH, FOWL AND CATTLE AND EVERY CRAWLING THING THAT CRAWLS ON THE EARTH, TAKE OUT WITH YOU, AND LET THEM SWARM OVER THE EARTH AND BE FRUITFUL AND MULTIPLY ON THE EARTH.

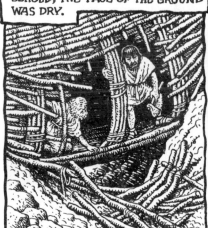

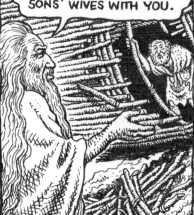

AND NOAH WENT OUT, HIS SONS AND HIS WIFE AND HIS SONS' WIVES WITH HIM. EVERY BEAST, EVERY CRAWLING THING, AND EVERY FOWL, EVERYTHING THAT STIRS ON THE EARTH, BY THEIR FAMILIES, CAME OUT OF THE ARK.

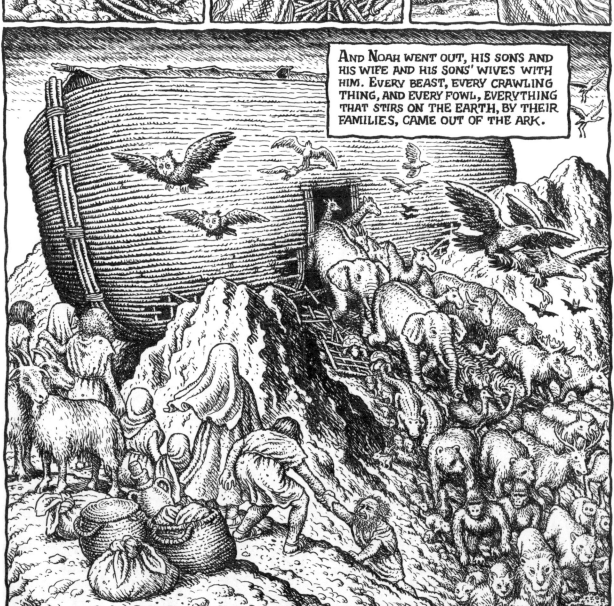

AND NOAH BUILT AN ALTAR TO THE LORD, AND HE TOOK FROM EVERY CLEAN CATTLE AND EVERY CLEAN FOWL AND OFFERED BURNT OFFERINGS ON THE ALTAR.

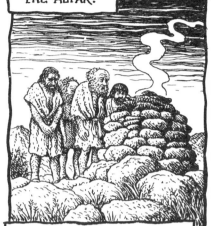

AND THE LORD SMELLED THE SWEET SAVOUR, AND THE LORD SAID IN HIS HEART...

I WILL NOT AGAIN CURSE THE GROUND ON MAN'S ACCOUNT, THOUGH THE DEVISINGS OF MAN'S HEART ARE EVIL FROM YOUTH.

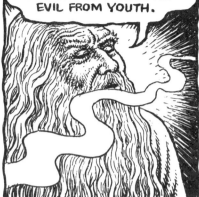

...AND I WILL NOT AGAIN STRIKE DOWN ALL LIVING THINGS AS I DID. AS LONG AS THE EARTH ENDURES, SEEDTIME AND HARVEST, AND COLD AND HEAT, AND SUMMER AND WINTER, AND DAY AND NIGHT SHALL NOT CEASE.

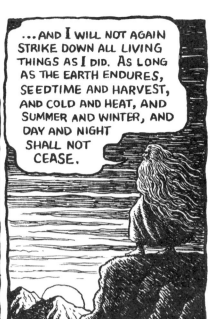

Chapter 9

AND GOD BLESSED NOAH AND HIS SONS AND HE SAID TO THEM...

BE FRUITFUL AND MULTIPLY AND FILL THE EARTH.

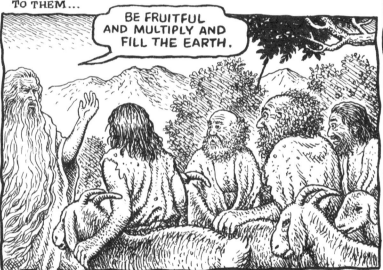

...AND THE FEAR AND THE DREAD OF YOU SHALL BE UPON ALL THE BEASTS OF THE FIELD AND ALL THE FOWL OF THE HEAVENS, IN ALL THAT CRAWLS ON THE GROUND AND IN ALL THE FISH OF THE SEA. INTO YOUR HANDS THEY ARE GIVEN.

EVERY MOVING THING THAT LIVES, YOURS SHALL BE FOR FOOD, AS WITH THE GREEN GRASSES, I HAVE GIVEN ALL TO YOU.

BUT FLESH WITH ITS LIFEBLOOD STILL IN IT YOU SHALL NOT EAT.

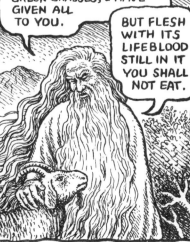

AND JUST SO, FOR YOUR *OWN* LIFEBLOOD I WILL REQUIRE A RECKONING, FROM EVERY BEAST I WILL REQUIRE IT, AND FROM *MAN*, FROM EVERY MAN FOR THAT OF HIS *FELLOW MAN!*

WHOEVER SPILLS THE BLOOD OF MAN, BY MAN SHALL HIS BLOOD BE SPILLED, FOR IN THE IMAGE OF GOD HE MADE MANKIND!

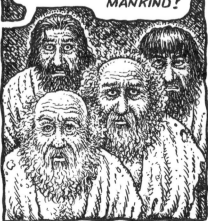

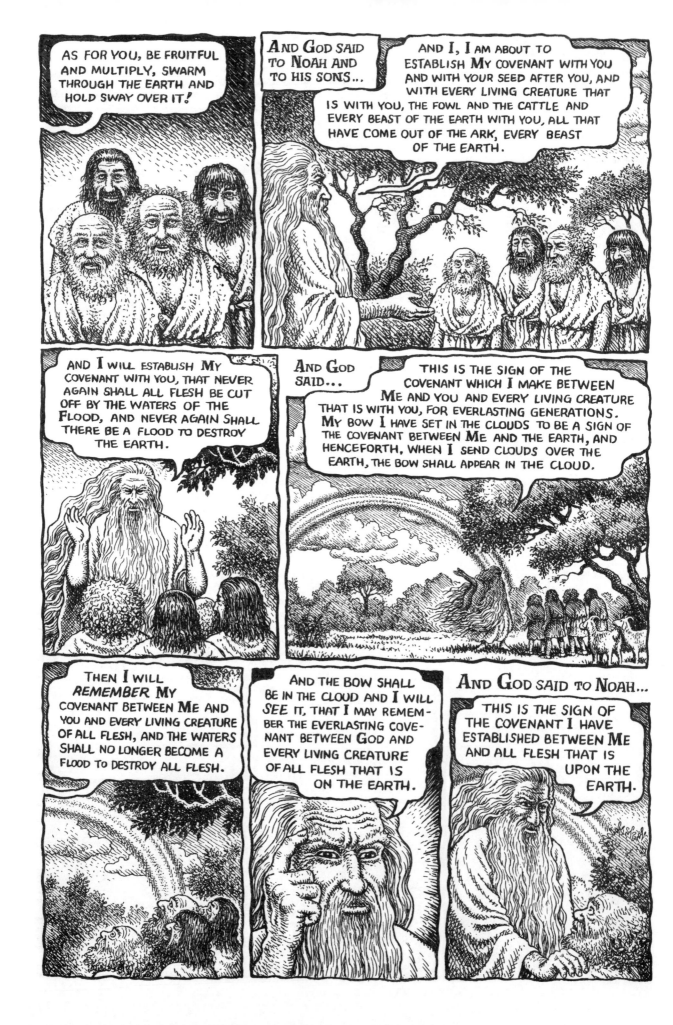

AND THE SONS OF NOAH WHO CAME OUT OF THE ARK WERE SHEM AND HAM AND JAPHETH, AND HAM WAS THE FATHER OF CANAAN. THESE THREE WERE THE SONS OF NOAH, AND FROM THESE THE WHOLE EARTH SPREAD OUT.

AND NOAH, A MAN OF THE SOIL, WAS THE FIRST TO PLANT A VINEYARD. AND HE DRANK OF THE WINE AND BECAME DRUNK AND EXPOSED HIMSELF WITHIN HIS TENT.

AND HAM, THE FATHER OF CANAAN, SAW HIS FATHER'S NAKEDNESS AND TOLD HIS TWO BROTHERS OUTSIDE.

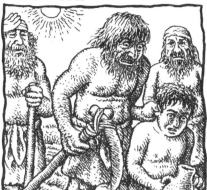

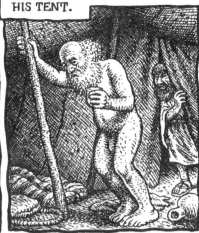

AND SHEM AND JAPHETH TOOK A CLOAK AND PUT IT OVER BOTH THEIR SHOULDERS AND WALKED BACKWARD AND COVERED THEIR FATHER'S NAKEDNESS, THEIR FACES TURNED AWAY SO THEY DID NOT SEE THEIR FATHER'S NAKEDNESS.

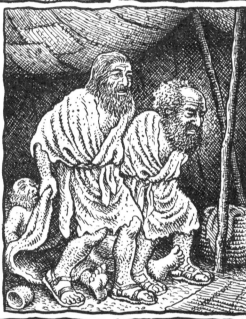

AND NOAH WOKE FROM HIS WINE AND HE KNEW WHAT HIS YOUNGEST SON HAD DONE TO HIM. AND HE SAID...

CURSED BE CANAAN! THE LOWLIEST OF SLAVES SHALL HE BE TO HIS BROTHERS!!

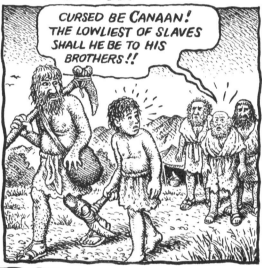

AND HE SAID...

BLESSED BE THE LORD, THE GOD OF SHEM, UNTO THEM SHALL CANAAN BE SLAVE!

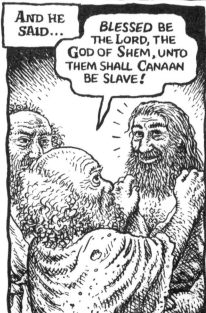

MAY GOD ENLARGE JAPHETH, MAY HE DWELL IN THE TENTS OF SHEM, UNTO THEM SHALL CANAAN BE SLAVE!

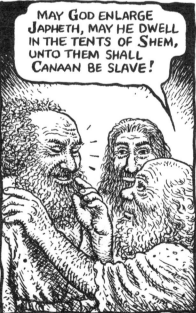

AND NOAH LIVED AFTER THE FLOOD 350 YEARS. AND ALL THE DAYS OF NOAH WERE 950 YEARS. THEN HE DIED.

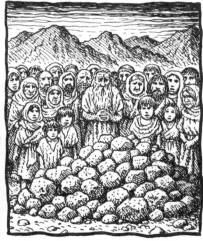

Chapter 10

AND THESE ARE THE GENERATIONS OF THE SONS OF NOAH, SHEM, HAM, AND JAPHETH. SONS WERE BORN TO THEM AFTER THE FLOOD. THE SONS OF JAPHETH: GOMER AND MAGOG AND MADAI AND JAVAN AND TUBAL AND MESHECH AND TIRAS. AND THE SONS OF GOMER: ASHKENAZ AND RIPHATH AND TOGARMAH. AND THE SONS OF JAVAN: ELISHAH AND TARSHISH, THE KITTITES AND THE DODANITES.

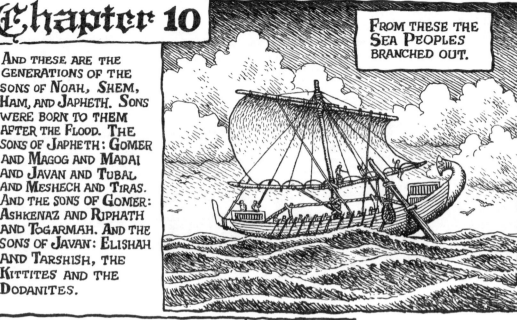

FROM THESE THE SEA PEOPLES BRANCHED OUT.

THESE ARE THE SONS OF JAPHETH, IN THEIR LANDS, EACH WITH HIS OWN TONGUE, ACCORDING TO THEIR CLANS IN THEIR NATIONS.

AND THE SONS OF HAM: CUSH AND MIZRAIM AND PUT AND CANAAN. AND THE SONS OF CUSH: SEBA AND HAVILAH AND RAAMAH AND SABTECA. AND THE SONS OF RAAMAH: SHEBA AND DEDAN. AND CUSH BEGOT NIMROD. HE WAS THE FIRST MIGHTY MAN ON EARTH. HE WAS A MIGHTY HUNTER BEFORE THE LORD. THEREFORE IT IS SAID, "LIKE NIMROD, A MIGHTY HUNTER BEFORE THE LORD."

THE BEGINNING OF HIS KINGDOM WAS BABYLON AND ERECH AND ACCAD, ALL OF THEM IN THE LAND OF SHINAR.

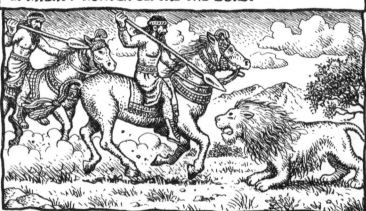

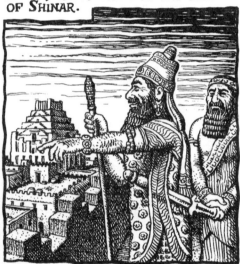

FROM THAT LAND ASSHUR CAME FORTH, AND HE BUILT NINEVEH AND REHOBOTH-IR AND CALAH, AND RESEN, BETWEEN NINEVEH AND CALAH, WHICH IS THE GREAT CITY.

AND MIZRAIM BEGOT THE LUDITES AND THE ANAMITES AND THE LEHABITES, AND THE NAPHTUHITES, AND THE PATHRUSITES, AND THE CASLUHITES, AND THE CAPHTORITES, FROM WHOM THE PHILISTINES CAME FORTH.

AND CANAAN BEGOT SIDON, HIS FIRSTBORN, AND HETH AND THE JEBUSITE AND THE AMORITE AND THE GIRGASHITE AND THE HIVITE AND THE ARCHITE AND THE SINITE AND THE ARVADITE AND THE ZEMARITE AND THE HAMATITE. AFTERWARD THE CLANS OF THE CANAANITE SPREAD OUT.

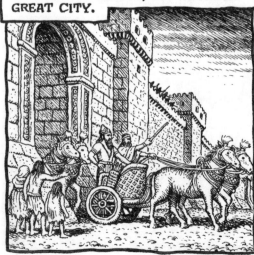

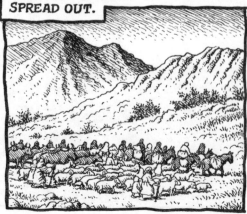

AND THE BORDER OF THE CANAANITE WAS FROM SIDON TILL YOU COME TO GERAR, AS FAR AS GAZA, TILL YOU COME TO SODOM AND GOMORRAH AND ADMAH AND ZEBOIIM, AS FAR AS LASHA. THESE ARE THE SONS OF HAM ACCORDING TO THEIR CLANS AND THEIR TONGUES, IN THEIR LANDS AND THEIR NATIONS.

SONS WERE BORN, TOO, TO SHEM, THE FATHER OF ALL THE DESCENDANTS OF EBER,* AND OLDER BROTHER OF JAPHETH. THE SONS OF SHEM: ELAM AND ASSHUR AND ARPACHSHAD AND LUD AND ARAM. AND THE SONS OF ARAM: UZ AND HUL AND GETHER AND MASH. AND ARPACHSHAD BEGOT SHELAH AND SHELAH BEGOT EBER.

*EBER: FROM WHOM THE HEBREW TRIBE TOOK THEIR NAME.

AND TO EBER TWO SONS WERE BORN. THE NAME OF ONE WAS PELEG,* FOR IN HIS DAYS THE EARTH WAS SPLIT APART;...

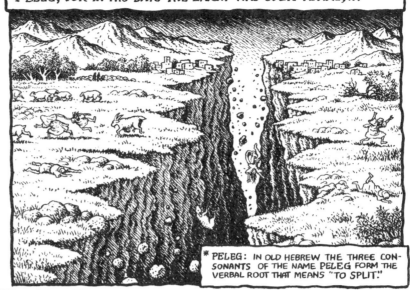

*PELEG: IN OLD HEBREW THE THREE CONSONANTS OF THE NAME PELEG FORM THE VERBAL ROOT THAT MEANS "TO SPLIT."

...AND HIS BROTHER'S NAME WAS JOKTAN. AND JOKTAN BEGOT ALMODAD AND SHELEPH AND HAZARMAVETH AND JERAH AND HADORAM AND UZAL AND DIKLAH AND OBAL AND ABIMAEL AND SHEBA AND OPHIR AND HAVILAH AND JOBAB. ALL THESE WERE THE SONS OF JOKTAN.

AND THEIR SETTLEMENTS WERE FROM MESHA TILL YOU COME TO SEPHAR, IN THE EASTERN HIGHLANDS. THESE ARE THE SONS OF SHEM ACCORDING TO THEIR CLANS AND TONGUES, IN THEIR LANDS AND THEIR NATIONS. THESE ARE THE CLANS OF THE SONS OF NOAH ACCORDING TO THEIR LINEAGE. AND FROM THESE THE NATIONS BRANCHED OUT OVER THE EARTH AFTER THE FLOOD.

Chapter 11

AND ALL THE EARTH WAS ONE LANGUAGE, ONE SET OF WORDS. AND IT CAME TO PASS, AS THEY JOURNEYED FROM THE EAST, THAT THEY FOUND A PLAIN IN THE LAND OF SHINAR, AND THEY SETTLED THERE.

AND THEY SAID TO ONE ANOTHER, "COME, LET US MAKE BRICKS AND BURN THEM HARD."

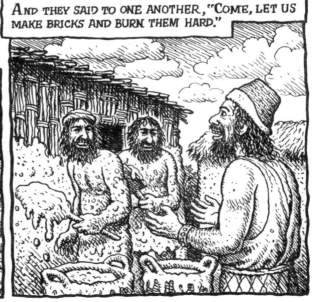

AND THE BRICK SERVED THEM AS STONE, AND THE BITUMEN SERVED THEM AS MORTAR.

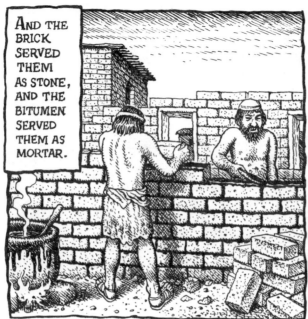

AND THEY SAID, "COME, LET US BUILD US A CITY AND A TOWER WITH ITS TOP IN THE HEAVENS, THAT WE MAY MAKE US A NAME, LEST WE BE SCATTERED OVER THE FACE OF ALL THE EARTH."

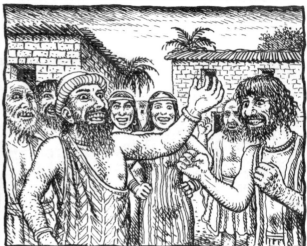

AND THE LORD CAME DOWN TO SEE THE CITY AND THE TOWER THAT THE HUMAN CREATURES HAD BUILT, AND THE LORD SAID...

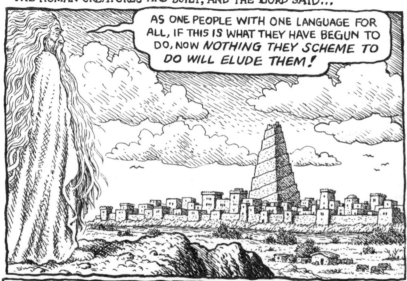

AS ONE PEOPLE WITH ONE LANGUAGE FOR ALL, IF THIS IS WHAT THEY HAVE BEGUN TO DO, NOW NOTHING THEY SCHEME TO DO WILL ELUDE THEM!

COME, LET US GO DOWN AND CONFOUND THEIR LANGUAGE THERE SO THAT THEY MAY NOT UNDERSTAND ONE ANOTHER'S SPEECH!

AND THE LORD SCATTERED THEM FROM THERE OVER THE FACE OF ALL THE EARTH, AND THEY LEFT OFF BUILDING THE CITY.

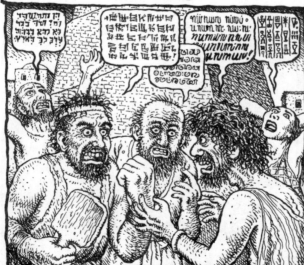

THEREFORE IS IT CALLED BABEL, BECAUSE THERE THE LORD CONFOUNDED THE LANGUAGE OF ALL THE EARTH AND FROM THERE THE LORD SCATTERED THEM OVER THE FACE OF ALL THE EARTH.

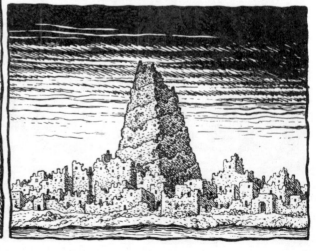

THIS IS THE LINEAGE OF SHEM. SHEM WAS A HUNDRED YEARS OLD WHEN HE BEGOT ARPACHSHAD, TWO YEARS AFTER THE FLOOD. AFTER THE BIRTH OF ARPACHSHAD, SHEM LIVED 500 YEARS AND HE BEGOT SONS AND DAUGHTERS.

AND ARPACHSHAD LIVED THIRTY-FIVE YEARS AND HE BEGOT SHELAH. AND ARPACHSHAD LIVED AFTER BEGETTING SHELAH 403 YEARS AND HE BEGOT SONS AND DAUGHTERS.

AND SHELAH LIVED THIRTY YEARS AND HE BEGOT EBER. AND SHELAH LIVED AFTER BEGETTING EBER 403 YEARS AND HE BEGOT SONS AND DAUGHTERS.

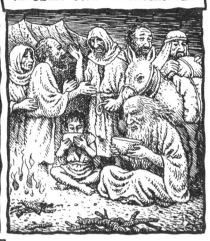

AND EBER LIVED THIRTY-FOUR YEARS AND HE BEGOT PELEG. AND EBER LIVED AFTER BEGETTING PELEG 430 YEARS AND HE BEGOT SONS AND DAUGHTERS.

AND PELEG LIVED THIRTY YEARS AND HE BEGOT REU. AND PELEG LIVED AFTER BEGETTING REU 209 YEARS AND HE BEGOT SONS AND DAUGHTERS.

AND REU LIVED THIRTY-TWO YEARS AND HE BEGOT SERUG. AND REU LIVED AFTER BEGETTING SERUG 207 YEARS AND HE BEGOT SONS AND DAUGHTERS.

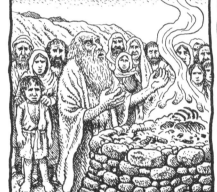

AND SERUG LIVED THIRTY YEARS AND HE BEGOT NAHOR. AND SERUG LIVED AFTER BEGETTING NAHOR 200 YEARS AND HE BEGOT SONS AND DAUGHTERS.

AND NAHOR LIVED TWENTY-NINE YEARS AND HE BEGOT TERAH. AND NAHOR LIVED AFTER BEGETTING TERAH 119 YEARS AND HE BEGOT SONS AND DAUGHTERS.

AND TERAH LIVED SEVENTY YEARS AND HE BEGOT ABRAM, NAHOR, AND HARAN.

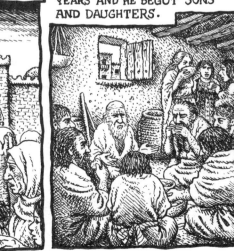

AND THIS IS THE LINEAGE OF TERAH: TERAH BEGOT ABRAM, NAHOR, AND HARAN, AND HARAN BEGOT LOT.

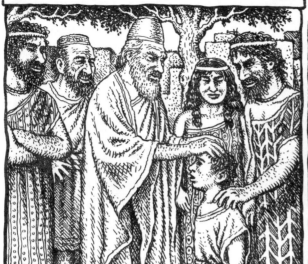

AND HARAN DIED IN THE LIFETIME OF TERAH HIS FATHER, IN THE LAND OF HIS BIRTH, UR OF THE CHALDEES.

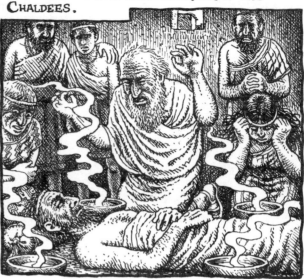

AND ABRAM AND NAHOR TOOK THEMSELVES WIVES. THE NAME OF ABRAM'S WIFE WAS SARAI AND THE NAME OF NAHOR'S WIFE WAS MILCAH, THE DAUGHTER OF HARAN, THE FATHER OF MILCAH AND THE FATHER OF ISCAH.

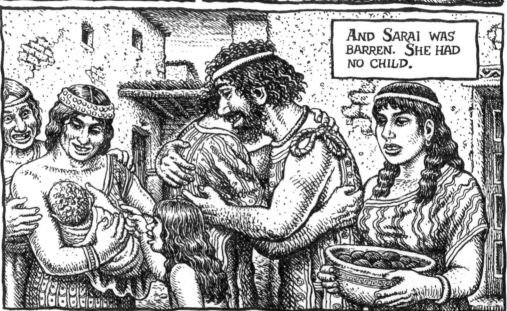

AND SARAI WAS BARREN. SHE HAD NO CHILD.

AND TERAH TOOK ABRAM HIS SON, HIS GRANDSON LOT THE SON OF HARAN, AND HIS DAUGHTER-IN-LAW SARAI, THE WIFE OF HIS SON ABRAM, AND HE SET OUT WITH THEM FROM UR OF THE CHALDEES TOWARD THE LAND OF CANAAN.

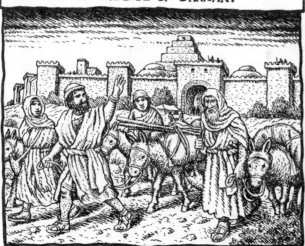

BUT WHEN THEY HAD COME AS FAR AS HARAN, THEY SETTLED THERE.

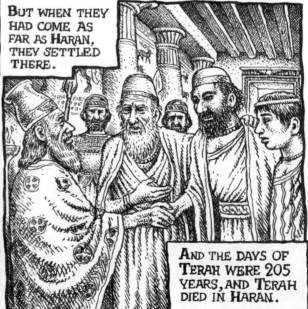

AND THE DAYS OF TERAH WERE 205 YEARS, AND TERAH DIED IN HARAN.

Chapter 12

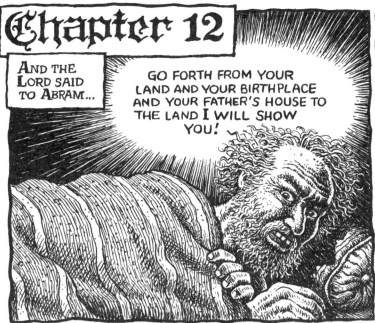

AND THE LORD SAID TO ABRAM...

GO FORTH FROM YOUR LAND AND YOUR BIRTHPLACE AND YOUR FATHER'S HOUSE TO THE LAND I WILL SHOW YOU!

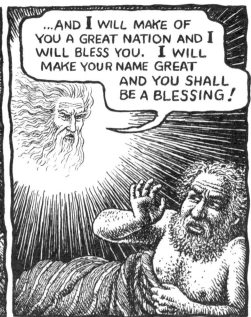

...AND I WILL MAKE OF YOU A GREAT NATION AND I WILL BLESS YOU. I WILL MAKE YOUR NAME GREAT AND YOU SHALL BE A BLESSING!

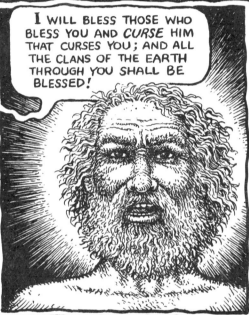

I WILL BLESS THOSE WHO BLESS YOU AND CURSE HIM THAT CURSES YOU; AND ALL THE CLANS OF THE EARTH THROUGH YOU SHALL BE BLESSED!

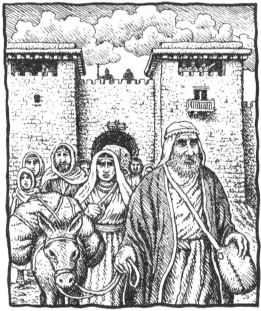

AND ABRAM WENT FORTH AS THE LORD HAD COMMANDED HIM, AND LOT WENT OUT WITH HIM. ABRAM WAS SEVENTY-FIVE YEARS OLD WHEN HE LEFT HARAN.

AND ABRAM TOOK SARAI HIS WIFE AND LOT HIS NEPHEW AND ALL THE GOODS THEY HAD GOTTEN AND THE PEOPLE THEY HAD BOUGHT IN HARAN, AND THEY SET OUT ON THE WAY TO THE LAND OF CANAAN, AND THEY CAME TO THE LAND OF CANAAN.

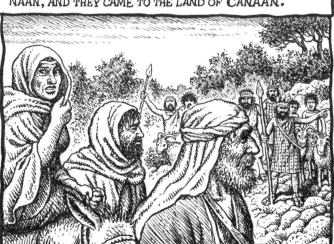

AND ABRAM PASSED THROUGH THE LAND TO THE SITE OF SHECHEM, TO THE TEREBINTH OF MOREH.* THE CANAANITE WAS THEN IN THE LAND.

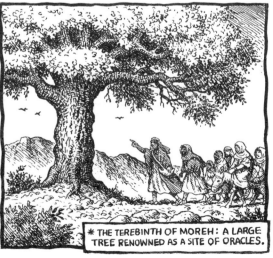

* THE TEREBINTH OF MOREH: A LARGE TREE RENOWNED AS A SITE OF ORACLES.

AND THE LORD APPEARED TO ABRAM AND SAID...

TO YOUR SEED I WILL GIVE THIS LAND!

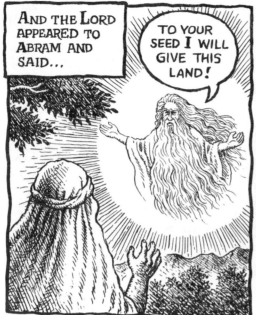

AND HE BUILT AN ALTAR THERE TO THE LORD WHO HAD APPEARED TO HIM.

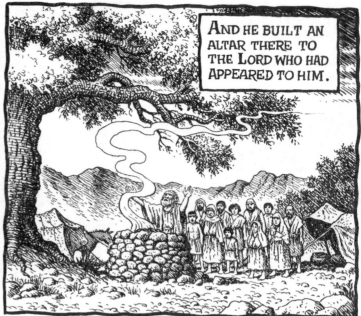

AND HE PULLED UP HIS STAKES FROM THERE FOR THE HIGH COUNTRY EAST OF BETHEL AND PITCHED HIS TENT WITH BETHEL TO THE WEST AND AI TO THE EAST, AND HE BUILT THERE AN ALTAR TO THE LORD, AND HE INVOKED THE NAME OF THE LORD.

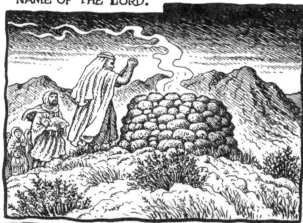

AND ABRAM JOURNEYED ONWARD BY STAGES TO THE NEGEB.

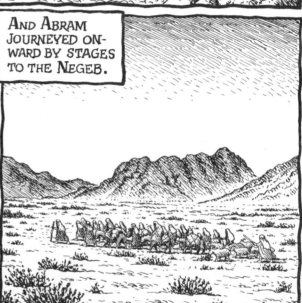

AND THERE WAS A FAMINE IN THE LAND, AND ABRAM WENT DOWN TO EGYPT TO SOJOURN THERE, FOR THE FAMINE WAS SEVERE IN THE LAND.

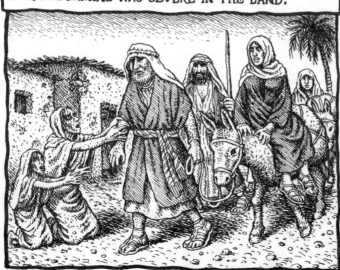

AND IT CAME TO PASS AS HE DREW NEAR TO THE BORDER OF EGYPT THAT HE SAID TO SARAI HIS WIFE...

LOOK HERE NOW, I KNOW THAT MY WIFE IS BEAUTIFUL TO BEHOLD!

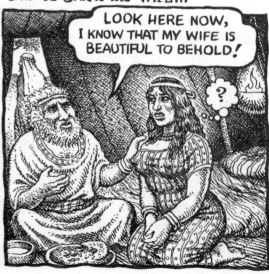

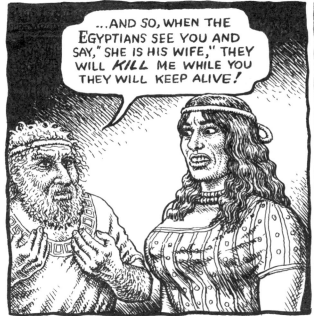

...AND SO, WHEN THE EGYPTIANS SEE YOU AND SAY, "SHE IS HIS WIFE," THEY WILL *KILL* ME WHILE YOU THEY WILL KEEP ALIVE!

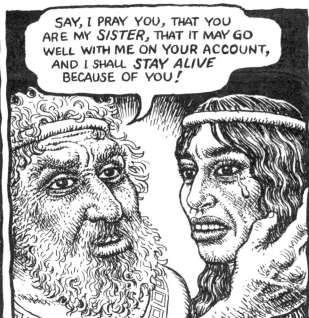

SAY, I PRAY YOU, THAT YOU ARE MY *SISTER*, THAT IT MAY GO WELL WITH ME ON YOUR ACCOUNT, AND I SHALL *STAY ALIVE* BECAUSE OF YOU!

AND IT CAME TO PASS THAT, WHEN ABRAM CAME INTO EGYPT, THE EGYPTIANS BEHELD THE WOMAN, THAT SHE WAS VERY BEAUTIFUL.

AND PHARAOH'S COURTIERS SAW HER AND COMMENDED HER TO PHARAOH, AND THE WOMAN WAS TAKEN INTO PHARAOH'S HOUSE.

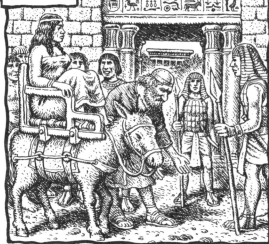

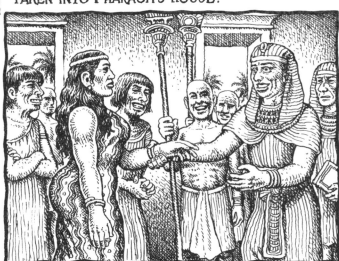

AND IT WENT WELL WITH ABRAM ON HER ACCOUNT, AND HE HAD SHEEP AND CATTLE AND DONKEYS AND MALE AND FEMALE SLAVES, AND SHE-ASSES AND CAMELS.

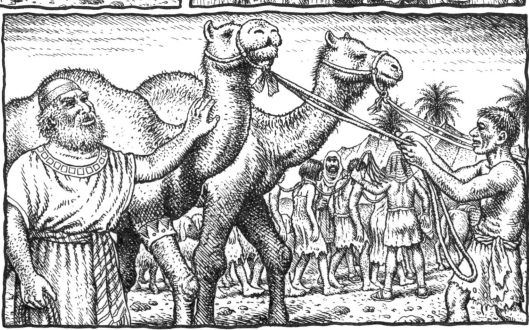

AND THE LORD AFFLICTED PHARAOH AND HIS HOUSE-HOLD WITH TERRIBLE PLAGUES BECAUSE OF SARAI THE WIFE OF ABRAM.

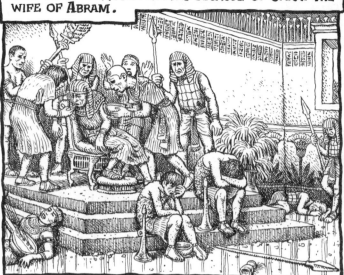

AND PHARAOH SUMMONED ABRAM AND SAID...

WHAT IS THIS YOU HAVE DONE TO ME??

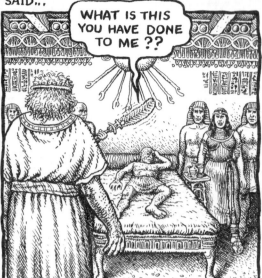

WHY DID YOU NOT TELL ME SHE WAS YOUR WIFE?! WHY DID YOU SAY, "SHE'S MY SISTER", SO THAT I TOOK HER TO ME AS WIFE?

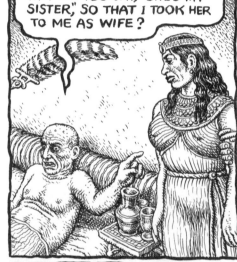

NOW HERE IS YOUR WIFE...

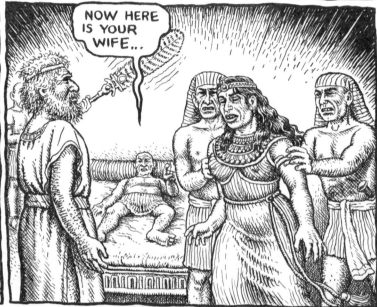

TAKE HER AND GET OUT!!

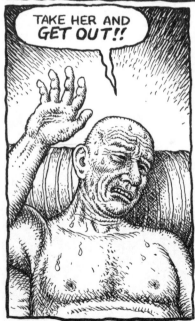

AND PHARAOH APPOINT-ED MEN OVER HIM AND THEY SENT HIM OUT, WITH HIS WIFE AND ALL THAT HE POS-SESSED.

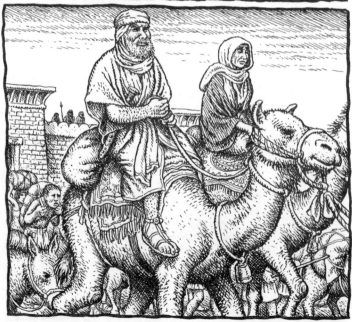

Chapter 13

AND ABRAM WENT UP OUT OF EGYPT, HE AND HIS WIFE AND ALL THAT HE HAD, AND LOT TOGETHER WITH HIM, TO THE NEGEB. AND ABRAM WAS HEAVILY LADEN WITH CATTLE, WITH SILVER AND GOLD. AND HE WENT BY STAGES FROM THE NEGEB UP TO BETHEL, TO THE PLACE WHERE HIS TENT HAD BEEN BEFORE, BETWEEN BETHEL AND AI...

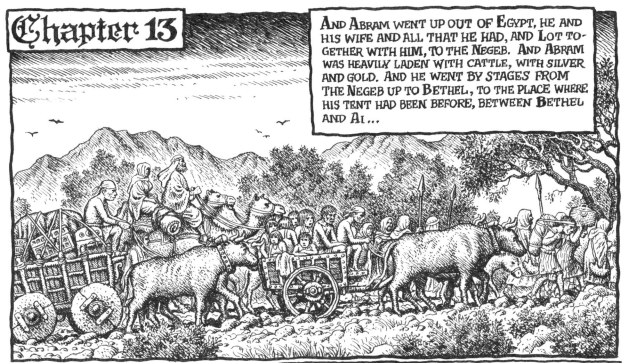

...TO THE PLACE OF THE ALTAR HE HAD MADE THE FIRST TIME, AND ABRAM INVOKED THERE THE NAME OF THE LORD.

AND LOT, TOO, WHO CAME ALONG WITH ABRAM, HAD FLOCKS AND HERDS AND TENTS. AND THE LAND COULD NOT SUPPORT THEIR DWELLING TOGETHER. AND THERE WAS STRIFE BETWEEN THE HERDSMEN OF ABRAM'S FLOCKS AND THE HERDSMEN OF LOT'S FLOCKS.

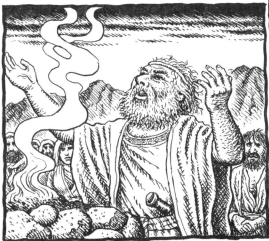

THE CANAANITE AND THE PERIZZITE WERE THEN DWELLING IN THE LAND.

AND ABRAM SAID TO LOT...

LET THERE BE NO CONTENTION, I PRAY YOU, BETWEEN YOU AND ME, BETWEEN YOUR HERDSMEN AND MINE, FOR WE ARE KINSMEN.

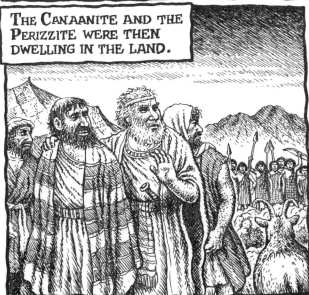

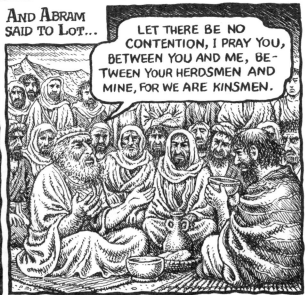

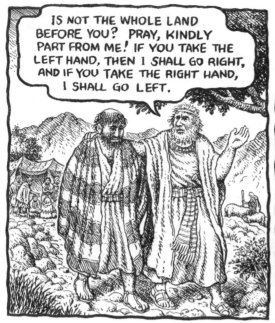

IS NOT THE WHOLE LAND BEFORE YOU? PRAY, KINDLY PART FROM ME! IF YOU TAKE THE LEFT HAND, THEN I SHALL GO RIGHT, AND IF YOU TAKE THE RIGHT HAND, I SHALL GO LEFT.

AND LOT LIFTED HIS EYES AND BEHELD ALL THE PLAIN OF JORDAN, SAW THAT ALL OF IT WAS WELL-WATERED— BEFORE THE LORD'S DESTRUCTION OF SODOM AND GOMOR- RAH—LIKE THE GARDEN OF THE LORD, LIKE THE LAND OF EGYPT, TILL YOU COME TO ZOAR.

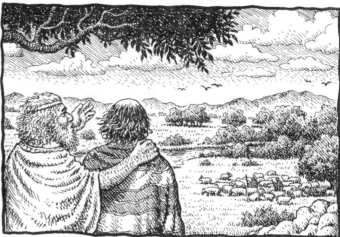

AND LOT CHOSE FOR HIMSELF THE WHOLE PLAIN OF JORDAN, AND LOT JOURNEYED EASTWARD, AND THUS THEY PARTED FROM ONE ANOTHER. ABRAM REMAINED IN THE LAND OF CANAAN, WHILE LOT DWELT AMONG THE CITIES OF THE PLAIN, AND HE PITCHED HIS TENT NEAR SODOM.

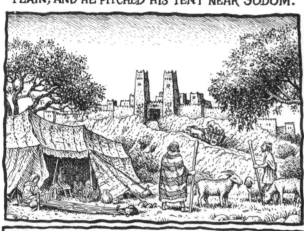

BUT THE PEOPLE OF SODOM WERE VERY EVIL OFFENDERS AGAINST THE LORD.

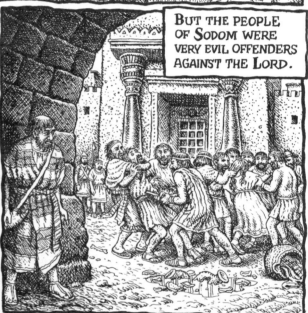

AND THE LORD SAID TO ABRAM, AFTER LOT HAD PARTED FROM HIM...

LIFT UP YOUR EYES AND LOOK OUT FROM THE PLACE WHERE YOU ARE, TO THE NORTH AND THE SOUTH, TO THE EAST AND THE WEST...

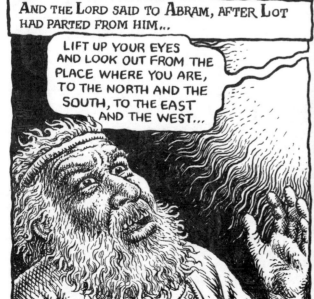

...FOR ALL THE LAND WHICH YOU SEE, TO YOU WILL I GIVE IT, AND TO YOUR SEED FOREVER!

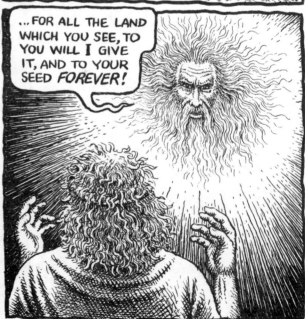

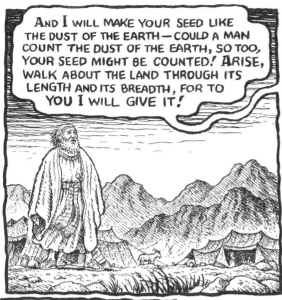

AND I WILL MAKE YOUR SEED LIKE THE DUST OF THE EARTH—COULD A MAN COUNT THE DUST OF THE EARTH, SO TOO, YOUR SEED MIGHT BE COUNTED! ARISE, WALK ABOUT THE LAND THROUGH ITS LENGTH AND ITS BREADTH, FOR TO YOU I WILL GIVE IT!

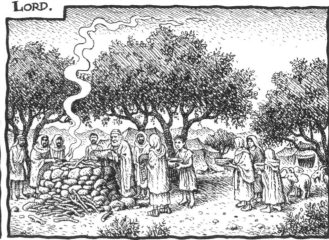

AND ABRAM TOOK UP HIS TENT AND CAME TO DWELL BY THE TEREBINTHS OF MAMRE, WHICH ARE IN HEBRON, AND HE BUILT THERE AN ALTAR TO THE LORD.

Chapter 14

AND IT CAME TO PASS IN THE DAYS OF AMRAPHEL, KING OF SHINAR, ARIOCH, KING OF ELLASAR, CHEDORLAOMER, KING OF ELAM, AND TIDAL, KING OF GOIIM, THAT THESE MADE WAR ON BERA, KING OF SODOM, AND BIRSHA, KING OF GOMORRAH, ON SHINAB, KING OF ADMAH, AND SHEMEBER, KING OF ZEBOIIM, AND THE KING OF BELA, THAT IS, ZOAR. THESE FIVE JOINED FORCES IN THE VALLEY OF SIDDIM, THAT IS, THE DEAD SEA.

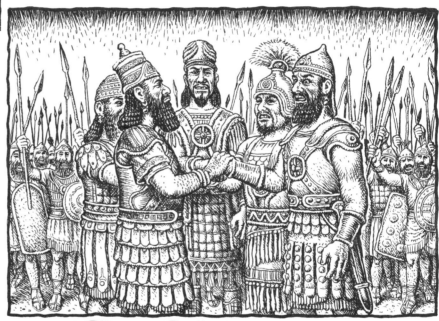

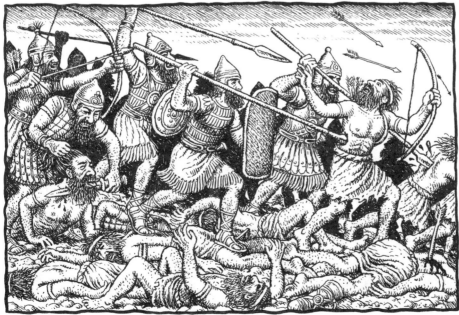

TWELVE YEARS THEY HAD BEEN SUBJECT TO CHEDORLAOMER, AND IN THE THIRTEENTH YEAR THEY REBELLED. AND IN THE FOURTEENTH YEAR CAME CHEDORLAOMER AND THE KINGS THAT WERE WITH HIM, AND STRUCK DOWN THE REPHAIM IN ASHTEROTH-KARNAIM, AND THE ZUZIM AT HAM AND THE EMIM AT SHAVEH-KIRIATHAIM, AND THE HORITE IN THE HIGH COUNTRY OF SEIR AS FAR AS EL-PARAN, WHICH IS BY THE WILDERNESS.

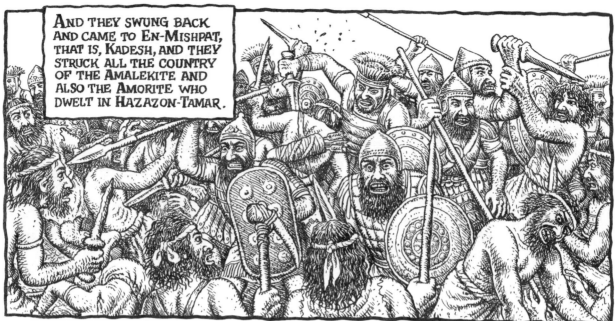

AND THEY SWUNG BACK AND CAME TO EN-MISHPAT, THAT IS, KADESH, AND THEY STRUCK ALL THE COUNTRY OF THE AMALEKITE AND ALSO THE AMORITE WHO DWELT IN HAZAZON-TAMAR.

AND THE KING OF SODOM AND THE KING OF GOMORRAH AND THE KING OF ADMAH AND THE KING OF ZEBOIIM AND THE KING OF BELA, THAT IS, ZOAR, WENT FORTH AND JOINED BATTLE WITH THEM IN THE VALLEY OF SIDDIM, WITH CHEDORLAOMER, KING OF ELAM, AND TIDAL, KING OF GOIIM, AND AMRAPHEL, KING OF SHINAR, AND ARIOCH, KING OF ELLASAR—FOUR KINGS AGAINST THE FIVE.

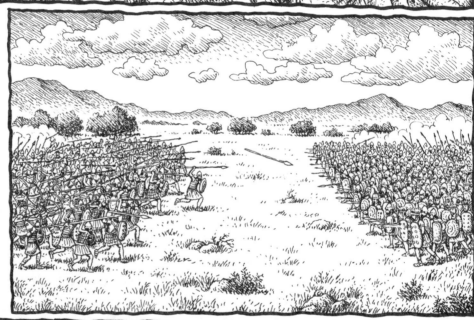

AND THE VALLEY OF SIDDIM WAS RIDDLED WITH BITUMEN PITS, AND THE KINGS OF SODOM AND GOMORRAH FLED THERE AND LEAPED INTO THEM, WHILE THE REST FLED TO THE HIGH COUNTRY.

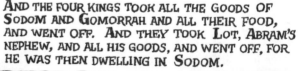

AND THE FOUR KINGS TOOK ALL THE GOODS OF SODOM AND GOMORRAH AND ALL THEIR FOOD, AND WENT OFF. AND THEY TOOK LOT, ABRAM'S NEPHEW, AND ALL HIS GOODS, AND WENT OFF, FOR HE WAS THEN DWELLING IN SODOM.

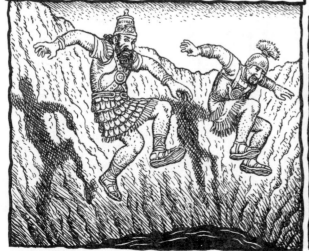

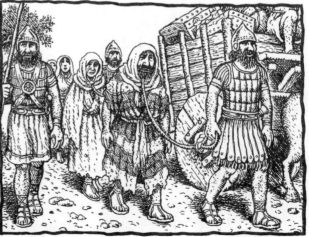

AND THERE CAME ONE THAT HAD ESCAPED, AND TOLD ABRAM THE HEBREW, FOR HE WAS THEN ENCAMPED AT THE TEREBINTHS OF MAMRE THE AMORITE, KINSMAN OF ESHKOL AND ANER, WHO WERE ABRAM'S CONFEDERATES.

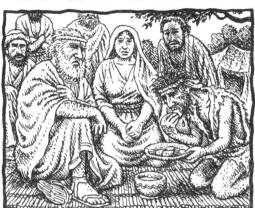

AND WHEN ABRAM HEARD THAT HIS KINSMAN WAS TAKEN CAPTIVE, HE MUSTERED HIS RETAINERS, BORN INTO HIS HOUSEHOLD, 318 OF THEM, AND WENT IN PURSUIT UP TO DAN.

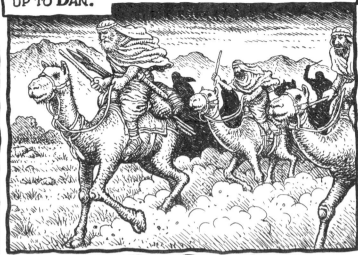

AND HE AND HIS SERVANTS WITH HIM FANNED OUT AGAINST THEM BY NIGHT AND STRUCK THEM AND PURSUED THEM UP TO HOBAH, WHICH IS NORTH OF DAMASCUS.

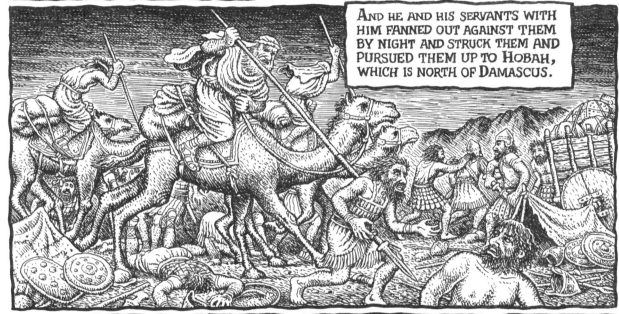

AND HE BROUGHT BACK ALL THE GOODS, AND ALSO LOT, HIS KINSMAN, AND HIS GOODS, AND THE WOMEN AND THE REST OF THE PEOPLE.

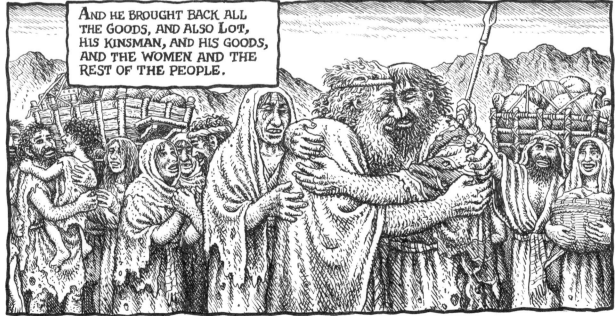

AND AFTER HE CAME BACK FROM STRIKING DOWN CHEDORLAOMER AND THE KINGS THAT WERE WITH HIM, THE KING OF SODOM CAME OUT TO MEET HIM IN THE VALLEY OF SHAVEH, THAT IS, THE VALLEY OF THE KING.

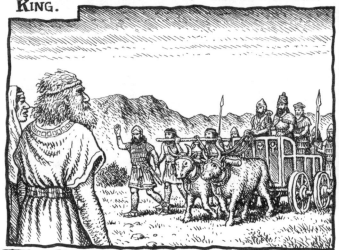

AND MELCHIZEDEK, KING OF SALEM, BROUGHT OUT BREAD AND WINE, FOR HE WAS A PRIEST TO EL ELYON.*

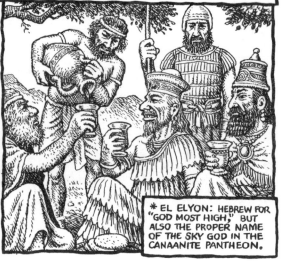

* EL ELYON: HEBREW FOR "GOD MOST HIGH," BUT ALSO THE PROPER NAME OF THE SKY GOD IN THE CANAANITE PANTHEON.

AND HE BLESSED HIM AND SAID...

BLESSED BE ABRAM TO EL ELYON, POSSESSOR OF HEAVEN AND EARTH, AND BLESSED BE EL ELYON, WHO DELIVERED YOUR FOES INTO YOUR HAND!

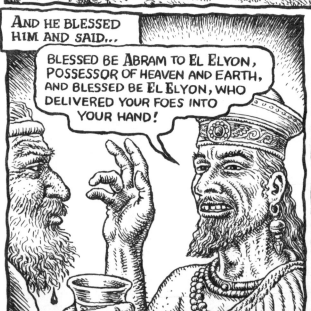

AND ABRAM GAVE HIM A TENTH OF EVERY-THING. AND THE KING OF SODOM SAID TO ABRAM...

GIVE ME THE PEOPLE, AND THE GOODS TAKE FOR YOURSELF!

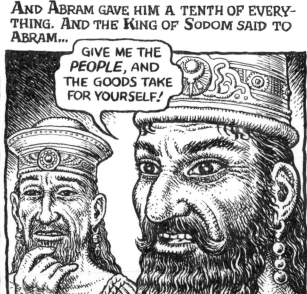

AND ABRAM SAID TO THE KING OF SODOM...

I LIFT UP MY HAND IN OATH TO THE LORD EL ELYON, "POSSESSOR OF HEAVEN AND EARTH," THAT I WILL NOT TAKE A SINGLE THREAD OR SANDAL STRAP OF ALL THAT IS YOURS, LEST YOU SAY, "IT IS I WHO HAVE MADE ABRAM RICH"!

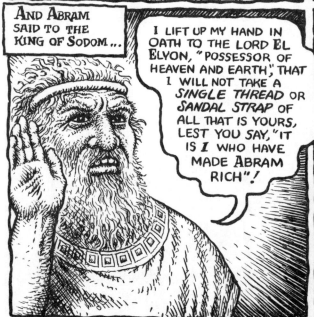

FOR ME, NOTHING BUT WHAT THE LADS HAVE CONSUMED. AND AS FOR THE SHARE OF THE MEN WHO WENT WITH ME, ANER, ESHKOL, AND MAMRE, LET THEM TAKE THEIR SHARE.

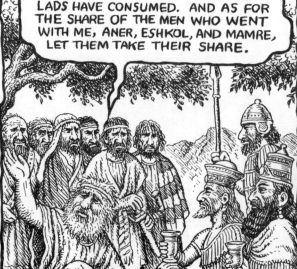

Chapter 15

SOME-TIME AFTER THESE THINGS THE WORD OF THE LORD CAME TO ABRAM IN A VISION, SAYING...

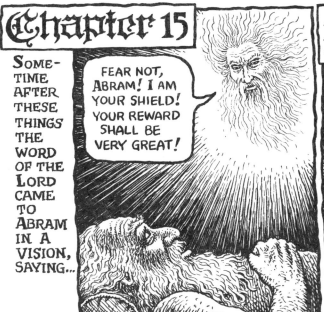

FEAR NOT, ABRAM! I AM YOUR SHIELD! YOUR REWARD SHALL BE VERY GREAT!

AND ABRAM SAID...

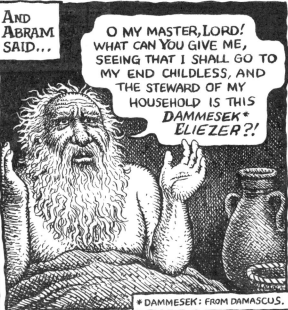

O MY MASTER, LORD! WHAT CAN YOU GIVE ME, SEEING THAT I SHALL GO TO MY END CHILDLESS, AND THE STEWARD OF MY HOUSEHOLD IS THIS DAMMESEK* ELIEZER?!

* DAMMESEK: FROM DAMASCUS.

AND ABRAM SAID...

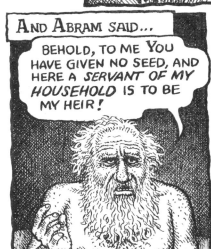

BEHOLD, TO ME YOU HAVE GIVEN NO SEED, AND HERE A SERVANT OF MY HOUSEHOLD IS TO BE MY HEIR!

AND BEHOLD, THE WORD OF THE LORD CAME TO HIM, SAYING...

THIS ONE WILL NOT BE YOUR HEIR, BUT HE WHO ISSUES FROM YOUR LOINS WILL BE YOUR HEIR!

AND HE TOOK HIM OUTSIDE AND HE SAID...

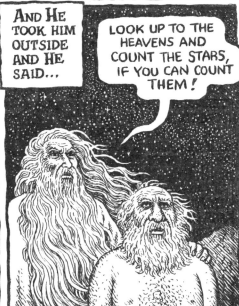

LOOK UP TO THE HEAVENS AND COUNT THE STARS, IF YOU CAN COUNT THEM!

AND HE SAID...

SO SHALL BE YOUR SEED.

AND HE PUT HIS TRUST IN THE LORD, AND HE RECK-ONED IT TO HIS MERIT.

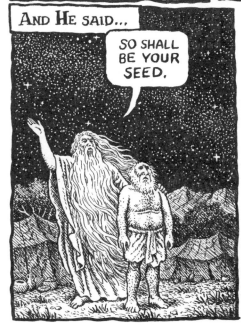

AND HE SAID TO HIM...

I AM THE LORD WHO BROUGHT YOU OUT OF UR OF THE CHALDEES TO GIVE YOU THIS LAND TO INHERIT.

AND HE SAID...

O MY MASTER, LORD, HOW SHALL I KNOW THAT I SHALL INHERIT IT?

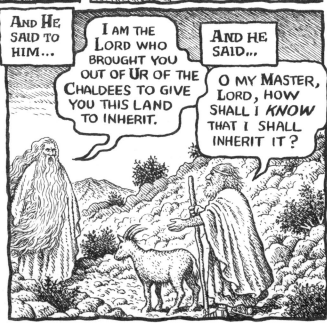

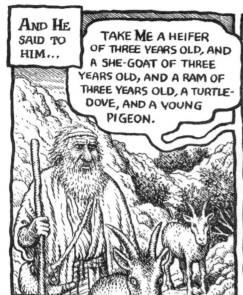

AND HE SAID TO HIM...

TAKE ME A HEIFER OF THREE YEARS OLD, AND A SHE-GOAT OF THREE YEARS OLD, AND A RAM OF THREE YEARS OLD, A TURTLE-DOVE, AND A YOUNG PIGEON.

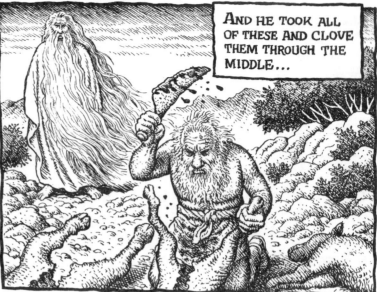

AND HE TOOK ALL OF THESE AND CLOVE THEM THROUGH THE MIDDLE...

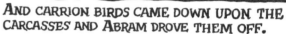

...AND EACH SET HIS PART OPPOSITE THE OTHER, BUT THE BIRDS HE DID NOT CUT UP.

AND CARRION BIRDS CAME DOWN UPON THE CARCASSES AND ABRAM DROVE THEM OFF.

AND AS THE SUN WAS GOING DOWN, A DEEP SLUMBER FELL UPON ABRAM, AND NOW A GREAT DARK DREAD DESCENDED UPON HIM.

AND HE SAID TO ABRAM...

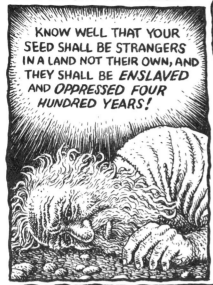

KNOW WELL THAT YOUR SEED SHALL BE STRANGERS IN A LAND NOT THEIR OWN, AND THEY SHALL BE *ENSLAVED* AND *OPPRESSED FOUR HUNDRED YEARS!*

BUT UPON THE NATION FOR WHOM THEY SLAVE *I* WILL BRING JUDGMENT, AND AFTERWARD THEY SHALL COME OUT WITH GREAT SUBSTANCE*!*

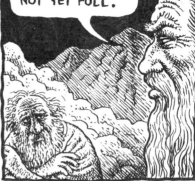

AS FOR YOU, YOU SHALL GO TO YOUR FATHERS IN PEACE; YOU SHALL BE BURIED IN RIPE OLD AGE. AND IN THE FOURTH GENERATION THEY SHALL COME HERE AGAIN, FOR THE INIQUITY OF THE AMORITES IS NOT YET FULL.

AND JUST AS THE SUN HAD SET, THERE WAS A THICK GLOOM AND, BEHOLD, A SMOKING BRAZIER WITH A FLAMING TORCH PASSED BETWEEN THOSE PARTS.

ON THAT DAY THE LORD MADE A COVE-NANT WITH ABRAM, SAYING...

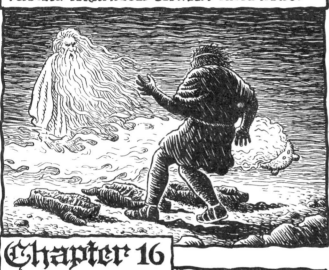

TO YOUR SEED *I* HAVE GIVEN THIS LAND, FROM THE RIVER OF EGYPT TO THE GREAT RIVER, THE RIVER EUPHRATES: THE KENITE AND THE KENIZITE AND THE KADMONITE AND THE HITTITE AND THE PERIZZITE AND THE REPHAIM AND THE AMORITE AND THE CANAANITE AND THE GIRGA-SHITE AND THE JEBUSITE.

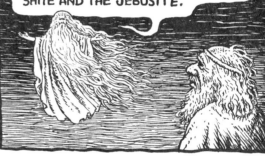

Chapter 16

NOW SARAI, ABRAM'S WIFE, HAD BORNE HIM NO CHILDREN, AND SHE HAD A HAND-MAID, AN EGYPTIAN, WHOSE NAME WAS HAGAR.

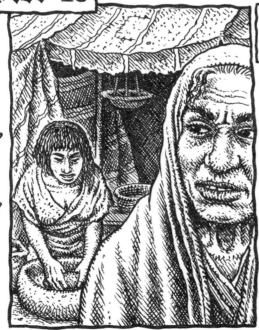

AND SARAI SAID TO ABRAM...

LOOK HERE, THE LORD HAS KEPT ME FROM BEARING CHILDREN. PRAY, COME TO BED WITH MY HANDMAID! PERHAPS MY HOUSE SHALL BE BUILT UP THROUGH *HER!*

AND ABRAM HEEDED THE WORDS OF SARAI. AND SARAI, ABRAM'S WIFE, TOOK HAGAR THE EGYPTIAN, HER HANDMAID, AFTER ABRAM HAD DWELT TEN YEARS IN THE LAND OF CANAAN, AND SHE GAVE HER TO ABRAM HER HUSBAND, AS A WIFE.

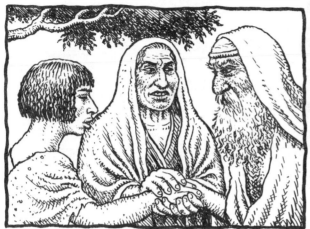

AND HE CAME TO BED WITH HAGAR AND SHE CONCEIVED...

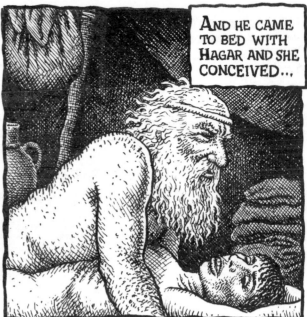

AND WHEN SHE SAW THAT SHE HAD CONCEIVED, HER MISTRESS SEEMED DIMINISHED IN HER EYES.

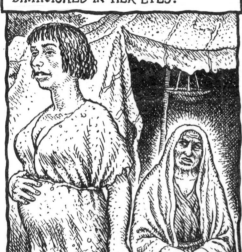

AND SARAI SAID TO ABRAM...

THIS OUTRAGE AGAINST ME IS BECAUSE OF YOU! I MYSELF PUT MY HANDMAID IN YOUR LAP, AND NOW THAT SHE SEES THAT SHE HAS CONCEIVED, I'VE BECOME DIMINISHED IN HER EYES!

LET THE LORD JUDGE BETWEEN YOU AND ME!

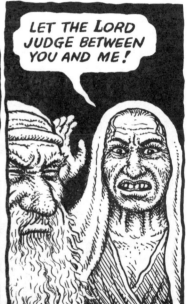

AND ABRAM SAID TO SARAI...

LOOK, YOUR HANDMAID IS IN YOUR HANDS! DO TO HER WHATEVER YOU THINK RIGHT!

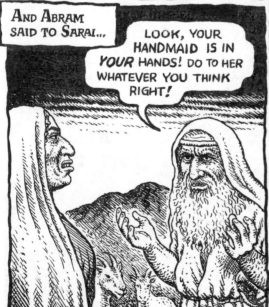

AND SARAI HARASSED HER AND SHE FLED FROM HER.

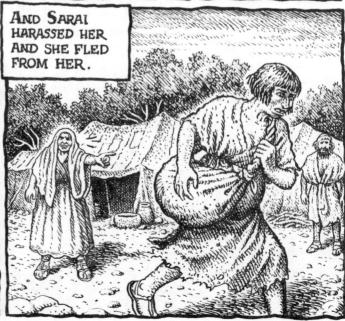

AND THE LORD'S MESSENGER FOUND HER BY A SPRING OF WATER IN THE WILDERNESS, BY THE SPRING ON THE WAY TO SHUR.

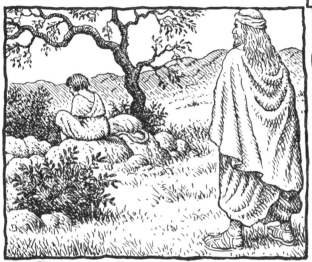

AND HE SAID TO HER...

HAGAR, HANDMAID OF SARAI, WHERE HAVE YOU COME FROM AND WHERE ARE YOU GOING?

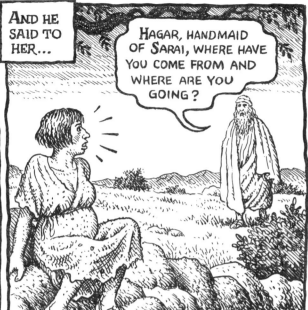

AND SHE SAID...

I AM FLEEING FROM THE FACE OF MY MISTRESS, SARAI!

AND THE LORD'S MESSENGER SAID TO HER...

RETURN TO YOUR MISTRESS AND SUBMIT YOURSELF TO HER HARSH TREATMENT...

AND THE LORD'S MESSENGER SAID TO HER...

I WILL SURELY MULTIPLY YOUR SEED AND IT WILL BE BEYOND ALL COUNTING!

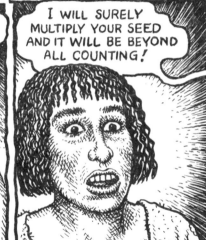

AND THE LORD'S MESSENGER SAID TO HER...

BEHOLD, YOU HAVE CONCEIVED AND WILL BEAR A SON AND YOU WILL CALL HIS NAME ISHMAEL,* FOR THE LORD HAS HEEDED YOUR SUFFERING!

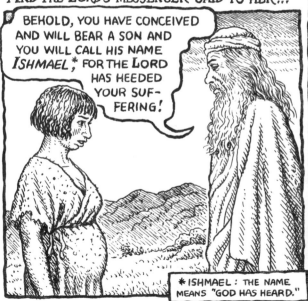

*ISHMAEL: THE NAME MEANS "GOD HAS HEARD."

... AND HE WILL BE A WILD ASS OF A MAN, HIS HAND AGAINST ALL, THE HAND OF ALL AGAINST HIM! EVEN SO, HE SHALL ENCAMP IN THE FACE OF ALL HIS KIN!

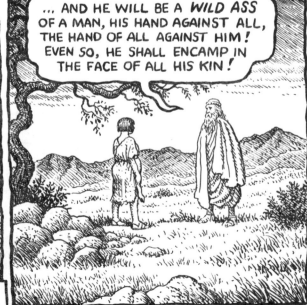

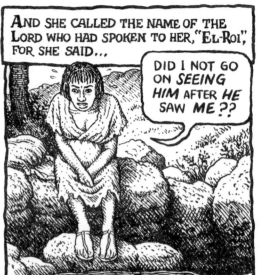

AND SHE CALLED THE NAME OF THE LORD WHO HAD SPOKEN TO HER, "EL-ROI", FOR SHE SAID...

DID I NOT GO ON *SEEING HIM* AFTER *HE* SAW *ME*??

THEREFORE IS THE WELL CALLED BEER-LAHAI-ROI,* WHICH IS BETWEEN KADESH AND BERED. AND HAGAR BORE A SON TO ABRAM, AND ABRAM CALLED HIS SON WHOM HAGAR HAD BORNE ISHMAEL.

*BEER-LAHAI-ROI : "WELL OF THE LIVING ONE WHO SEES ME."

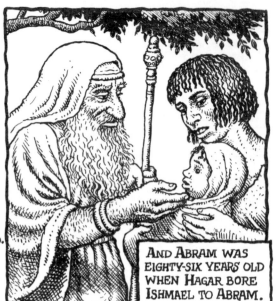

AND ABRAM WAS EIGHTY-SIX YEARS OLD WHEN HAGAR BORE ISHMAEL TO ABRAM.

Chapter 17

AND ABRAM WAS NINETY-NINE YEARS OLD, AND THE LORD APPEARED TO ABRAM AND SAID TO HIM...

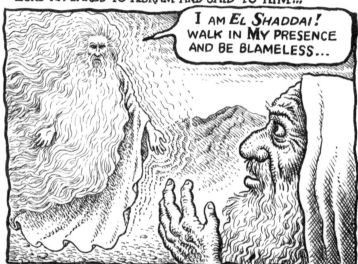

I AM *EL SHADDAI!* WALK IN *MY* PRESENCE AND BE BLAMELESS...

...AND I WILL GRANT *MY* COVENANT BETWEEN *ME* AND YOU, AND I WILL MULTIPLY YOU VERY GREATLY!

AND ABRAM FLUNG HIMSELF ON HIS FACE, AND GOD SPOKE TO HIM, SAYING...

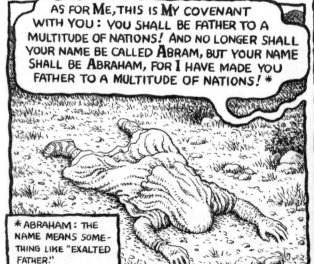

AS FOR *ME*, THIS IS *MY* COVENANT WITH YOU : YOU SHALL BE FATHER TO A MULTITUDE OF NATIONS! AND NO LONGER SHALL YOUR NAME BE CALLED ABRAM, BUT YOUR NAME SHALL BE ABRAHAM, FOR I HAVE MADE YOU FATHER TO A MULTITUDE OF NATIONS! *

*ABRAHAM : THE NAME MEANS SOMETHING LIKE "EXALTED FATHER."

AND I WILL MAKE YOU MOST ABUNDANTLY FRUITFUL AND MAKE NATIONS OF YOU, AND KINGS SHALL COME FORTH FROM YOU! AND I WILL MAINTAIN *MY* COVENANT BETWEEN *ME* AND YOU AND YOUR SEED AFTER YOU THROUGH THEIR GENERATIONS AS AN EVERLASTING COVENANT TO BE GOD TO YOU AND TO YOUR SEED AFTER YOU!

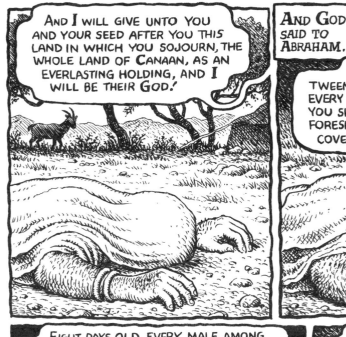

AND I WILL GIVE UNTO YOU AND YOUR SEED AFTER YOU THIS LAND IN WHICH YOU SOJOURN, THE WHOLE LAND OF CANAAN, AS AN EVERLASTING HOLDING, AND I WILL BE THEIR GOD!

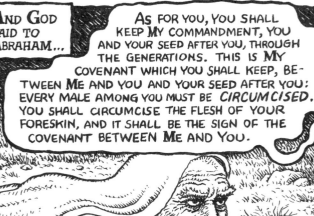

AND GOD SAID TO ABRAHAM...

AS FOR YOU, YOU SHALL KEEP MY COMMANDMENT, YOU AND YOUR SEED AFTER YOU, THROUGH THE GENERATIONS. THIS IS MY COVENANT WHICH YOU SHALL KEEP, BE-TWEEN ME AND YOU AND YOUR SEED AFTER YOU: EVERY MALE AMONG YOU MUST BE *CIRCUMCISED.* YOU SHALL CIRCUMCISE THE FLESH OF YOUR FORESKIN, AND IT SHALL BE THE SIGN OF THE COVENANT BETWEEN ME AND YOU.

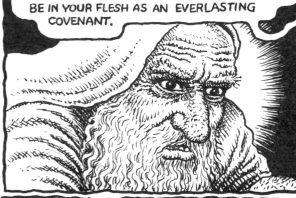

EIGHT DAYS OLD, EVERY MALE AMONG YOU SHALL BE CIRCUMCISED THROUGHOUT YOUR GENERATIONS, EVEN SLAVES BORN IN THE HOUSEHOLD AND THOSE PURCHASED WITH SILVER FROM ANY FOREIGNER, WHO ARE NOT OF YOUR SEED, THOSE BORN IN YOUR HOUSE-HOLD AND THOSE PURCHASED WITH SILVER MUST BE CIRCUMCISED. THUS SHALL MY COVENANT BE IN YOUR FLESH AS AN EVERLASTING COVENANT.

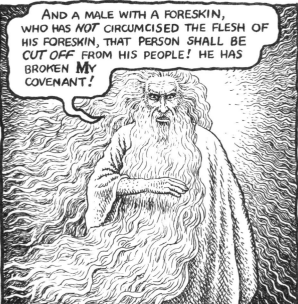

AND A MALE WITH A FORESKIN, WHO HAS *NOT* CIRCUMCISED THE FLESH OF HIS FORESKIN, THAT PERSON SHALL BE *CUT OFF* FROM HIS PEOPLE! HE HAS BROKEN MY COVENANT!

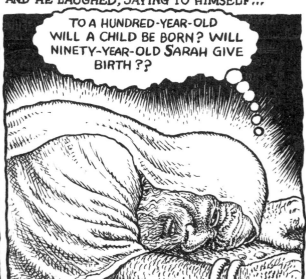

AND GOD SAID TO ABRAHAM...

SARAI, YOUR WIFE, SHALL NO LONGER CALL HERSELF SARAI, FOR *SARAH* IS HER NAME!

AND I WILL BLESS HER! INDEED, I WILL GIVE YOU A SON BY HER, AND I WILL BLESS *HIM,* AND SHE SHALL BECOME NA-TIONS! KINGS OF PEO-PLES *SHALL* ISSUE FROM HER!

AND ABRAHAM FLUNG HIMSELF ON HIS FACE AND HE LAUGHED, SAYING TO HIMSELF...

TO A HUNDRED-YEAR-OLD WILL A CHILD BE BORN? WILL NINETY-YEAR-OLD SARAH GIVE BIRTH??

AND ABRAHAM SAID TO GOD...

WOULD THAT ISHMAEL MIGHT LIVE IN YOUR FAVOR.

AND GOD SAID...

YET SARAH, YOUR WIFE, IS TO BEAR YOU A SON, AND YOU SHALL CALL HIS NAME ISAAC, AND I WILL ESTABLISH MY COVENANT WITH HIM AS AN EVERLASTING COVENANT, FOR HIS SEED AFTER HIM.

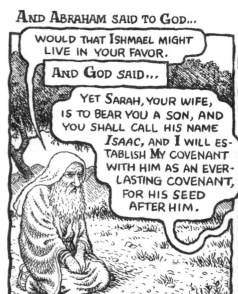

AS FOR ISHMAEL, I HAVE HEARD YOU. BEHOLD, I WILL BLESS HIM AND MAKE HIM FRUITFUL, AND WILL MULTIPLY HIM MOST ABUNDANTLY! TWELVE CHIEFTAINS SHALL HE BEGET, AND I WILL MAKE HIM A GREAT NATION!

BUT MY COVENANT I WILL ESTABLISH WITH ISAAC, WHOM SARAH WILL BEAR YOU BY THIS SEASON NEXT YEAR!

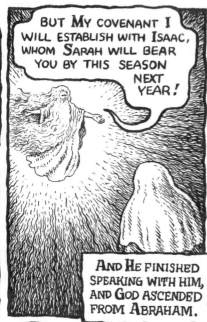

AND HE FINISHED SPEAKING WITH HIM, AND GOD ASCENDED FROM ABRAHAM.

AND ABRAHAM TOOK ISHMAEL, HIS SON, AND ALL THE SLAVES BORN IN HIS HOUSEHOLD AND THOSE PURCHASED WITH SILVER, EVERY MALE AMONG THE PEOPLE OF ABRAHAM'S HOUSEHOLD, AND HE CIRCUMCISED THE FLESH OF THEIR FORESKIN ON THE VERY DAY THAT GOD HAD SPOKEN TO HIM.

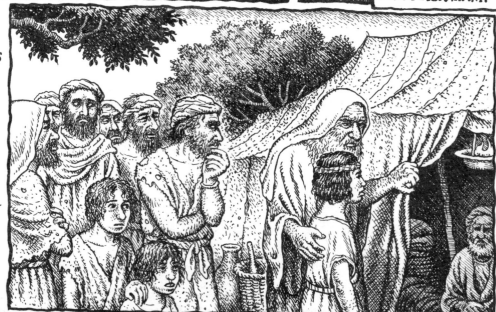

AND ABRAHAM WAS NINETY-NINE YEARS OLD WHEN THE FLESH OF HIS FORESKIN WAS CIRCUMCISED. AND ISHMAEL WAS THIRTEEN YEARS OLD WHEN THE FLESH OF HIS FORESKIN WAS CIRCUMCISED.

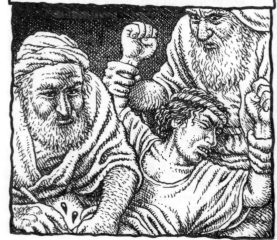

ON THAT VERY DAY ABRAHAM WAS CIRCUMCISED, AND ISHMAEL, HIS SON, AND ALL THE MEN OF HIS HOUSEHOLD, THOSE BORN IN THE HOUSEHOLD AND THOSE PURCHASED WITH SILVER FROM THE FOREIGNERS, WERE CIRCUMCISED WITH HIM.

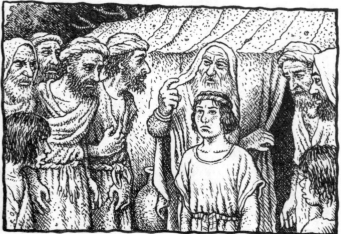

Chapter 18

AND THE LORD APPEARED TO HIM IN THE TEREBINTHS OF MAMRE WHEN HE WAS SITTING BY THE TENT FLAP IN THE HEAT OF THE DAY.

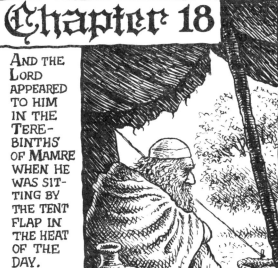

AND HE RAISED HIS EYES AND LOOKED. AND, BEHOLD, THREE MEN WERE STANDING BEFORE HIM!

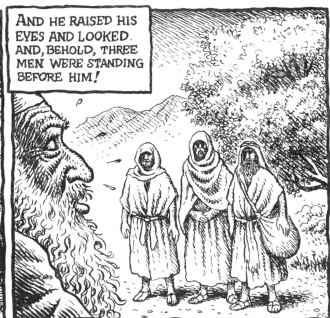

HE SAW, AND HE RAN TO MEET THEM FROM THE TENT FLAP, AND BOWED TO THE GROUND. AND HE SAID...

MY LORD, IF I HAVE FOUND FAVOR IN YOUR EYES, I PRAY YOU DO NOT GO ON PAST YOUR SERVANT!

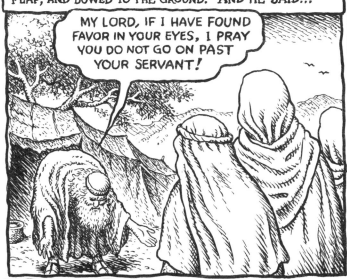

LET A LITTLE WATER BE FETCHED, AND BATHE YOUR FEET, AND STRETCH OUT UNDER THE TREE, AND LET ME FETCH A MORSEL OF BREAD, AND REFRESH YOURSELVES, THEN GO ON — FOR HAVE YOU NOT COME BY YOUR SERVANT?

AND THEY SAID...

DO AS YOU HAVE SPOKEN.

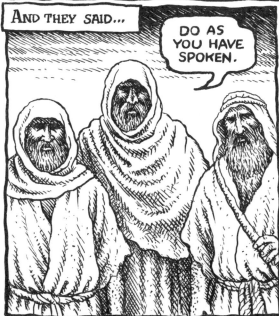

AND ABRAHAM HASTENED TO THE TENT TO SARAH, AND HE SAID...

HURRY! KNEAD THREE MEASURES OF CHOICE SEMOLINA FLOUR AND MAKE LOAVES!

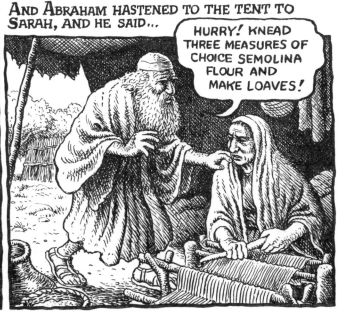

AND TO THE HERD ABRAHAM RAN AND FETCHED A TENDER AND GOODLY CALF AND GAVE IT TO THE LAD, WHO HASTENED TO PREPARE IT.

AND HE FETCHED CURDS AND MILK AND THE CALF THAT HAD BEEN PREPARED, AND HE SET THESE BEFORE THEM, AND HE STOOD BY THEM UNDER THE TREE, AND THEY ATE.

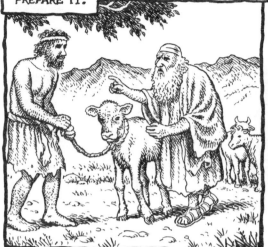
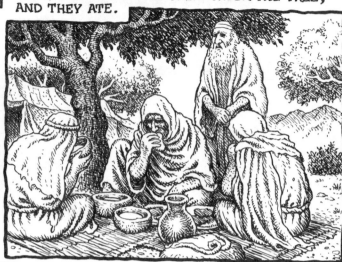

AND THEY SAID TO HIM...

WHERE IS SARAH, YOUR WIFE?

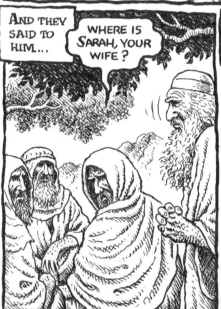

AND HE SAID...

THERE, IN THE TENT!

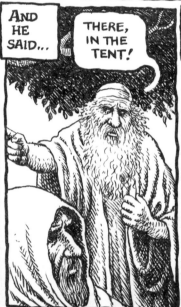

AND HE SAID...

I WILL SURELY RETURN TO YOU AT THIS VERY SEASON AND, BEHOLD, SARAH, YOUR WIFE, SHALL HAVE A SON!

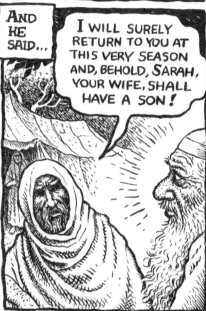

AND SARAH WAS LISTENING AT THE TENT FLAP, WHICH WAS BEHIND HIM...

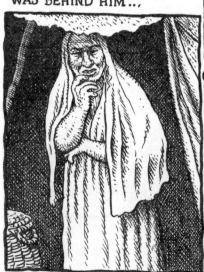

AND ABRAHAM AND SARAH WERE OLD, AND WELL ADVANCED IN YEARS. SARAH NO LONGER HAD HER WOMAN'S FLOW. AND SARAH LAUGHED TO HERSELF, SAYING...

NOW THAT I'M WITHERED, SHALL I HAVE PLEASURE, AND MY HUSBAND SO OLD?!

AND THE LORD SAID TO ABRAHAM...

WHY IS IT THAT SARAH LAUGHED, SAYING, "SHALL I REALLY GIVE BIRTH, OLD AS I AM??"

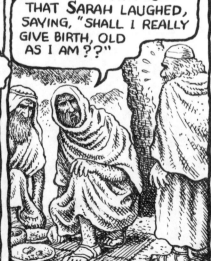

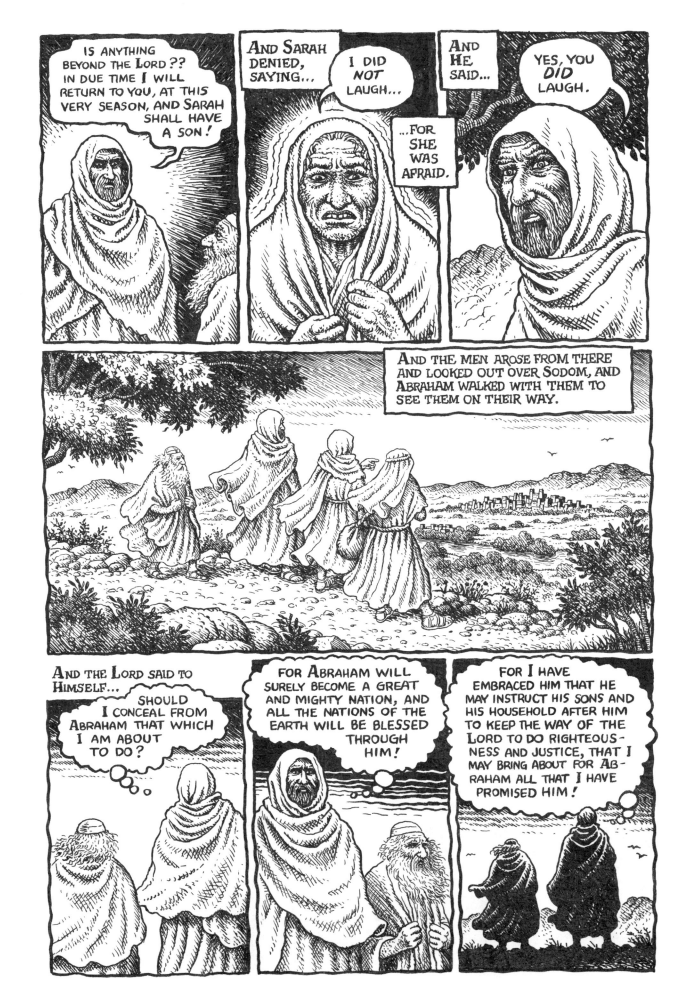

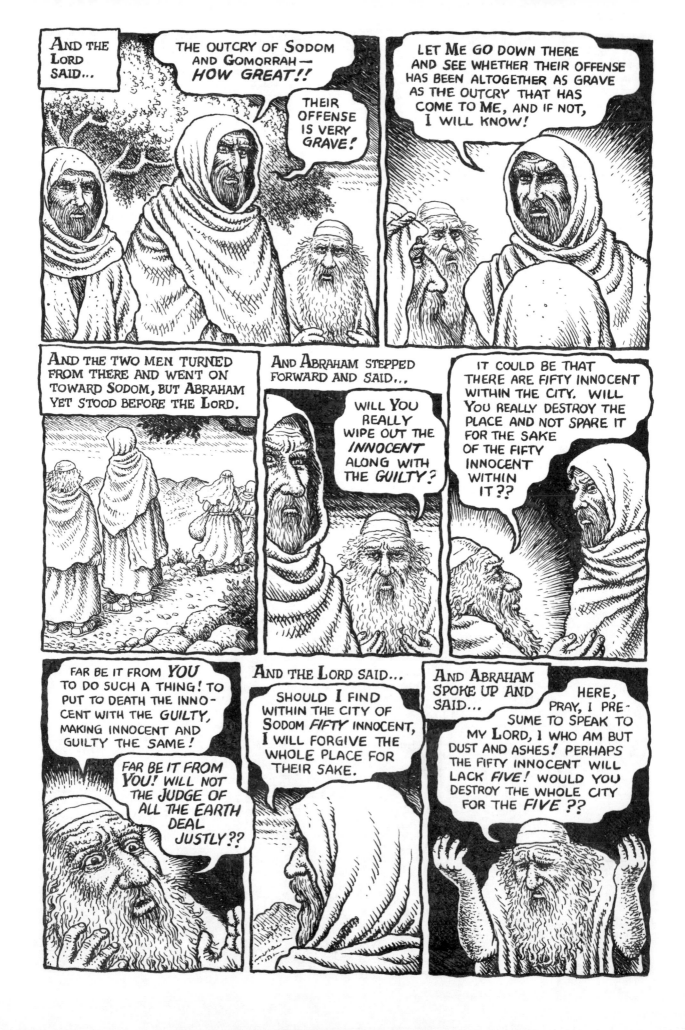

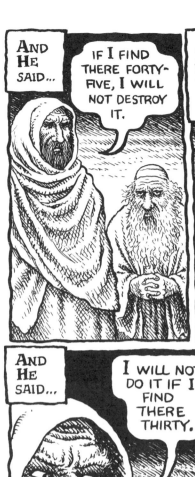

AND HE SAID...

IF I FIND THERE FORTY-FIVE, I WILL NOT DESTROY IT.

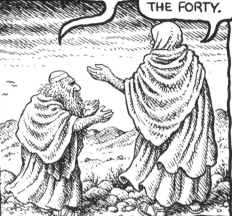

AND HE SPOKE TO HIM YET AGAIN, SAYING...

PERHAPS THERE WILL BE FOUND FORTY...

AND HE SAID...

I WILL NOT DO IT ON ACCOUNT OF THE FORTY.

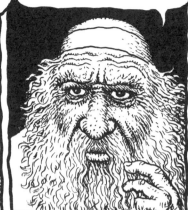

AND HE SAID...

PLEASE, LET NOT MY LORD BE INCENSED, AND ALLOW ME TO SPEAK...PERHAPS THERE WILL BE FOUND THIRTY...

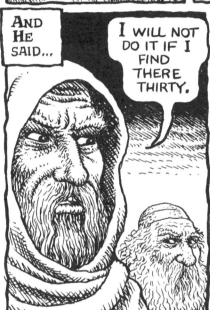

AND HE SAID...

I WILL NOT DO IT IF I FIND THERE THIRTY.

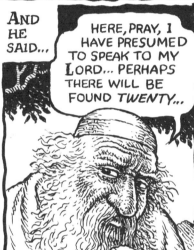

AND HE SAID...

HERE, PRAY, I HAVE PRESUMED TO SPEAK TO MY LORD... PERHAPS THERE WILL BE FOUND TWENTY...

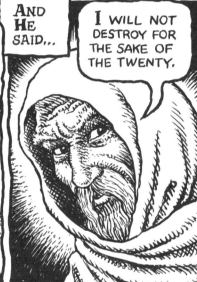

AND HE SAID...

I WILL NOT DESTROY FOR THE SAKE OF THE TWENTY.

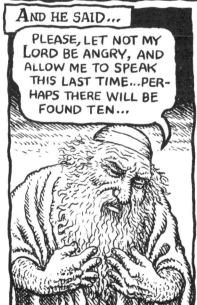

AND HE SAID...

PLEASE, LET NOT MY LORD BE ANGRY, AND ALLOW ME TO SPEAK THIS LAST TIME...PERHAPS THERE WILL BE FOUND TEN...

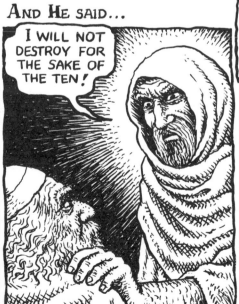

AND HE SAID...

I WILL NOT DESTROY FOR THE SAKE OF THE TEN!

AND THE LORD WENT OFF WHEN HE FINISHED SPEAKING WITH ABRAHAM, AND ABRAHAM RETURNED TO HIS PLACE.

Chapter 19

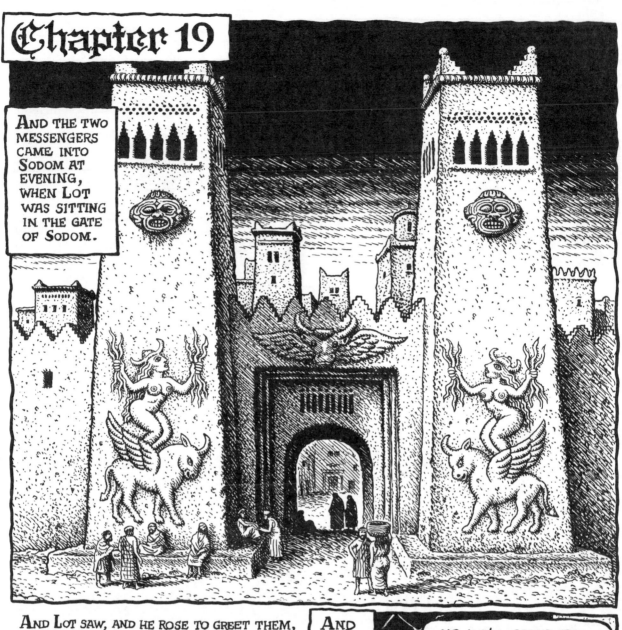

AND THE TWO MESSENGERS CAME INTO SODOM AT EVENING, WHEN LOT WAS SITTING IN THE GATE OF SODOM.

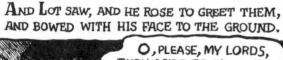

AND LOT SAW, AND HE ROSE TO GREET THEM, AND BOWED WITH HIS FACE TO THE GROUND.

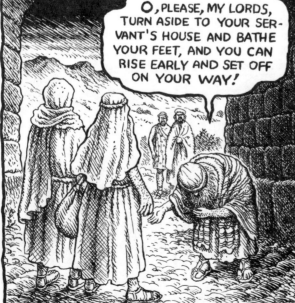

O, PLEASE, MY LORDS, TURN ASIDE TO YOUR SERVANT'S HOUSE AND BATHE YOUR FEET, AND YOU CAN RISE EARLY AND SET OFF ON YOUR WAY!

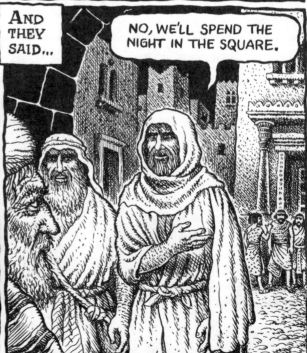

AND THEY SAID...

NO, WE'LL SPEND THE NIGHT IN THE SQUARE.

AND HE PRESSED THEM HARD, AND THEY TURNED HIS WAY AND CAME INTO HIS HOUSE.

AND HE PREPARED THEM A FEAST, AND BAKED UNLEAVENED BREAD, AND THEY DID EAT.

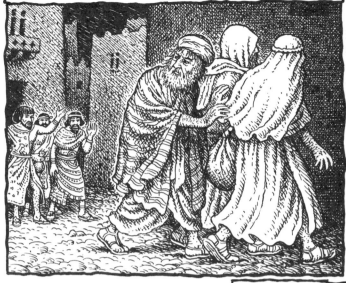

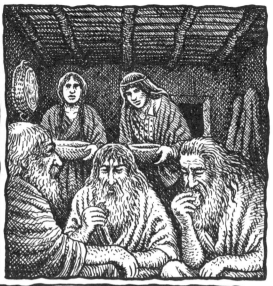

THEY HAD NOT YET LAIN DOWN WHEN THE TOWNSMEN, THE MEN OF SODOM, FROM LADS TO ELDERS, EVERY LAST MAN OF THEM, GATHERED ABOUT THE HOUSE.

AND THEY SHOUTED TO LOT AND SAID TO HIM...

WHERE ARE THE MEN WHO CAME TO YOU TONIGHT ?!?

BRING THEM OUT TO US SO THAT WE MAY KNOW THEM!!

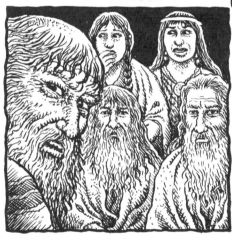

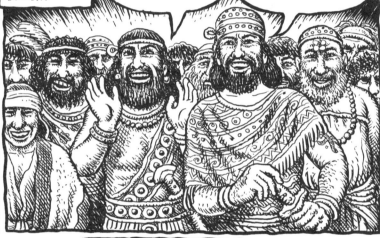

AND LOT WENT OUT TO THEM AT THE ENTRANCE, CLOSING THE DOOR BEHIND HIM, AND HE SAID...

PLEASE, MY BROTHERS, DO NO HARM! LOOK, I HAVE TWO DAUGHTERS WHO HAVE KNOWN NO MAN! LET ME BRING THEM OUT TO YOU, AND YOU CAN DO TO THEM HOWEVER YOU PLEASE!

ONLY TO THESE MEN DO NOTHING, FOR HAVE THEY NOT COME UNDER THE SHADOW OF MY ROOF-BEAM ?!?

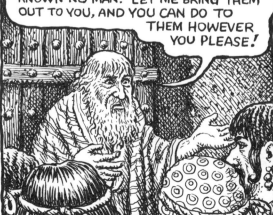

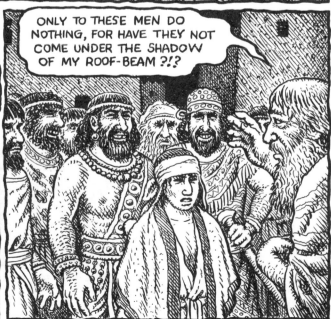

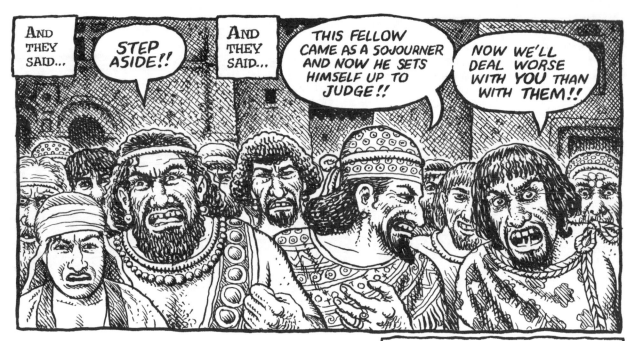

AND THEY SAID... STEP ASIDE!! AND THEY SAID... THIS FELLOW CAME AS A SOJOURNER AND NOW HE SETS HIMSELF UP TO JUDGE!! NOW WE'LL DEAL WORSE WITH YOU THAN WITH THEM!!

AND THEY PRESSED HARD AGAINST THE PERSON OF LOT, AND PUSHED FORWARD TO BREAK DOWN THE DOOR.

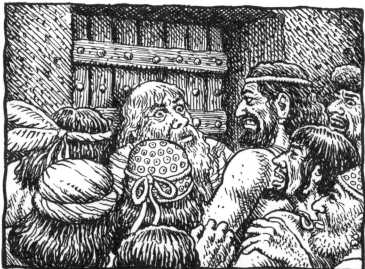

AND THE TWO MEN REACHED OUT THEIR HANDS AND PULLED LOT INTO THE HOUSE WITH THEM AND CLOSED THE DOOR.

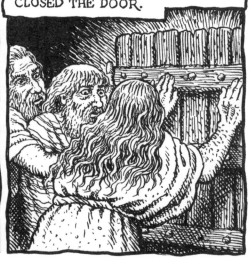

AND THE MEN AT THE ENTRANCE OF THE HOUSE THEY STRUCK WITH BLINDING LIGHT...

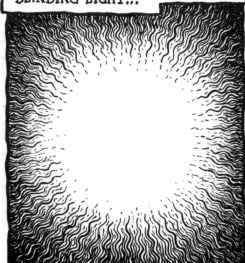

...FROM THE SMALLEST TO THE BIGGEST, AND THEY COULD NOT FIND THE ENTRANCE.

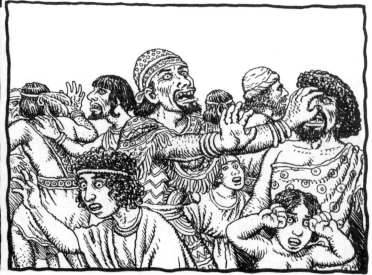

AND THE MEN SAID TO LOT...

WHO ELSE DO YOU HAVE HERE? YOUR SONS AND DAUGHTERS, SONS-IN-LAW, AND WHOMEVER ELSE YOU HAVE IN THE CITY, TAKE OUT OF THIS PLACE!

FOR WE ARE ABOUT TO DESTROY THIS PLACE, FOR THE OUTCRY AGAINST THEM HAS GROWN GREAT BEFORE THE LORD, AND THE LORD HAS SENT US TO DESTROY IT!

AND LOT WENT OUT...

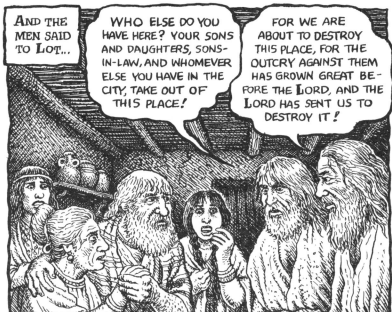

... AND SPOKE TO HIS SONS-IN-LAW WHO HAD MARRIED HIS DAUGHTERS, AND HE SAID...

RISE! GET OUT OF THIS PLACE, FOR THE LORD IS ABOUT TO DESTROY THIS CITY!!

BUT HE SEEMED TO HIS SONS-IN-LAW AS ONE THAT MOCKED.

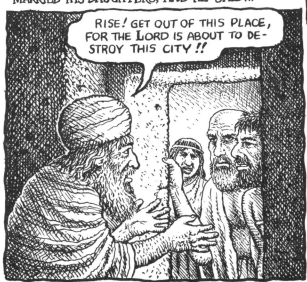

AND AS THE DAWN BROKE THE MESSENGERS URGED LOT, SAYING...

RISE UP!! TAKE YOUR WIFE AND YOUR TWO DAUGHTERS WHO REMAIN WITH YOU, LEST YOU BE WIPED OUT IN THE PUNISHMENT OF THE CITY!!

AND STILL HE LINGERED, AND THE MEN SEIZED HIS HAND AND HIS WIFE'S HAND AND THE HANDS OF HIS TWO DAUGHTERS, IN THE LORD'S MERCY UPON HIM, AND BROUGHT HIM OUT AND LEFT HIM OUTSIDE THE CITY.

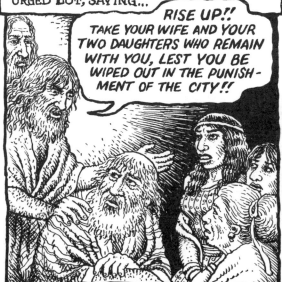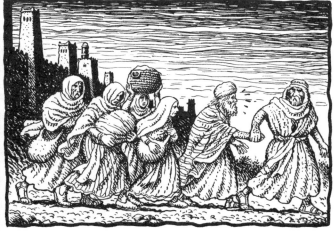

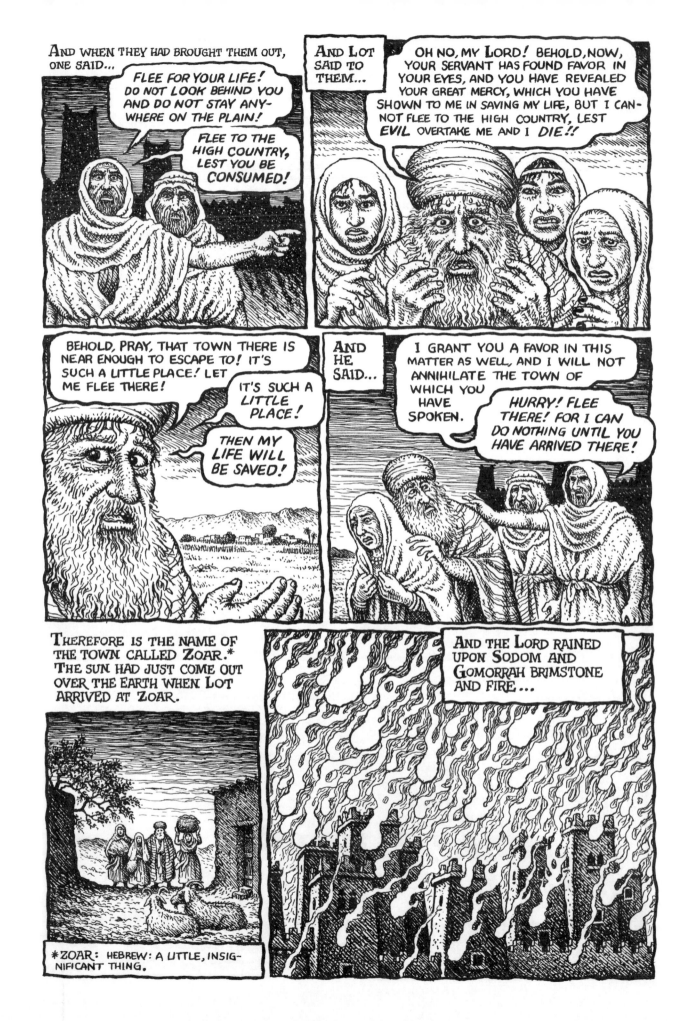

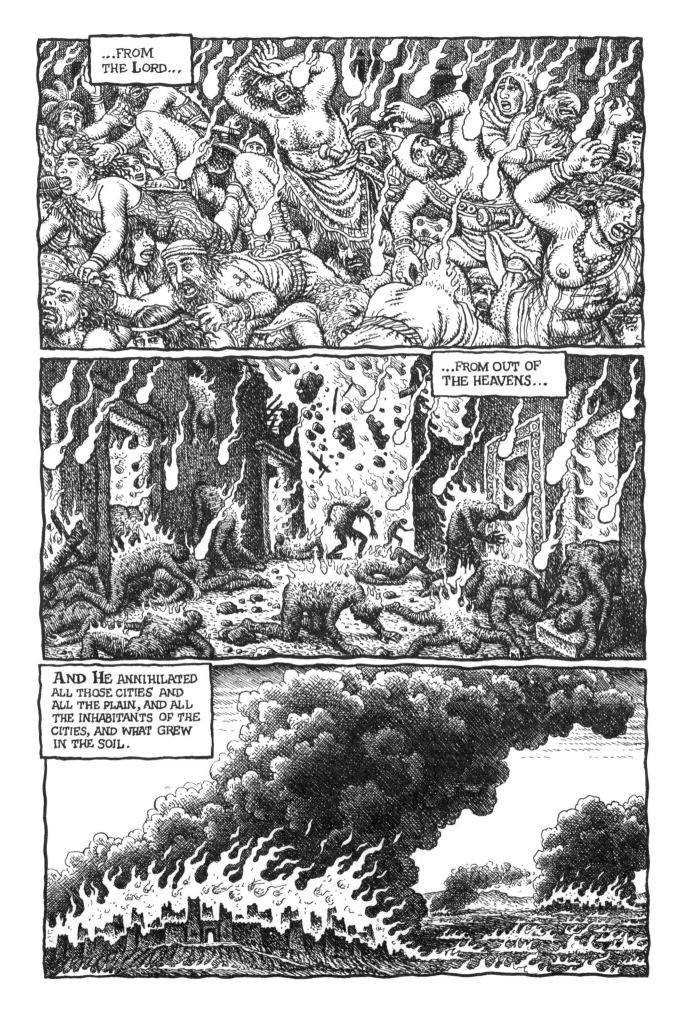

AND HIS WIFE LOOKED BACK...

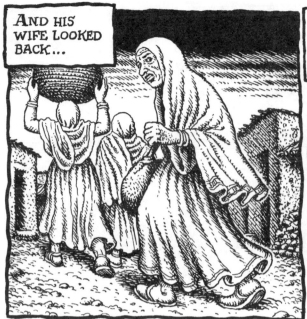

...AND SHE BECAME A PILLAR OF SALT.

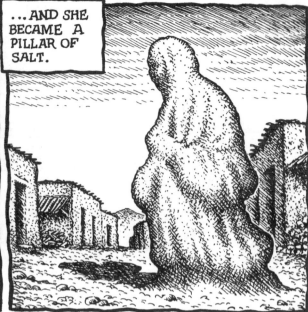

AND ABRAHAM HASTENED EARLY IN THE MORNING TO THE PLACE WHERE HE HAD STOOD IN THE PRESENCE OF THE LORD.

AND HE LOOKED OUT OVER SODOM AND GOMORRAH AND OVER ALL THE LAND OF THE PLAIN, AND HE SAW, AND BEHOLD, SMOKE WAS RISING LIKE THE SMOKE FROM A KILN!

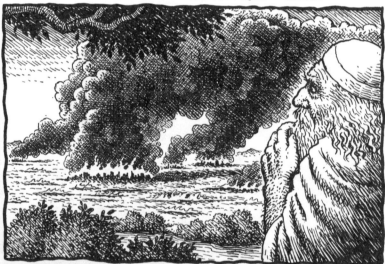

AND IT CAME TO PASS, WHEN GOD DESTROYED THE CITIES OF THE PLAIN, THAT GOD REMEMBERED ABRAHAM AND SENT LOT OUT FROM THE MIDST OF THE DESTRUCTION. AND LOT WENT UP OUT OF ZOAR AND SETTLED IN THE HIGH COUNTRY, AND HIS TWO DAUGHTERS WITH HIM, FOR HE WAS AFRAID TO DWELL IN ZOAR, AND HE DWELT IN A CERTAIN CAVE, HE AND HIS TWO DAUGHTERS.

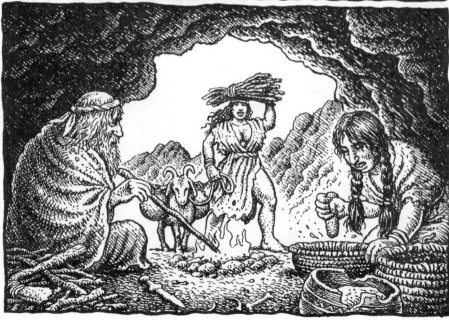

AND THE OLDER ONE SAID TO THE YOUNGER...

OUR FATHER IS OLD, AND THERE IS NO MAN ON EARTH TO COME TO BED WITH US LIKE THE WAY OF ALL THE WORLD!

COME, LET'S GIVE OUR FATHER WINE TO DRINK, AND LET'S LIE WITH HIM SO THAT WE MAY KEEP ALIVE SEED FROM OUR FATHER!

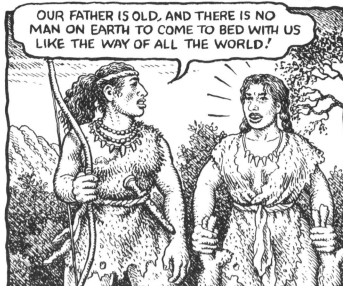
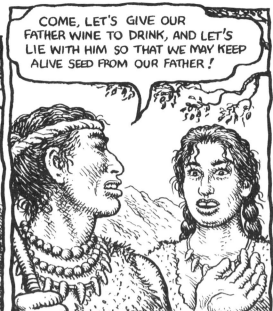

AND THAT NIGHT THEY GAVE THEIR FATHER WINE TO DRINK...

...AND THE OLDER ONE CAME AND LAY WITH HER FATHER, AND HE KNEW NOT WHEN SHE LAY DOWN OR WHEN SHE AROSE.

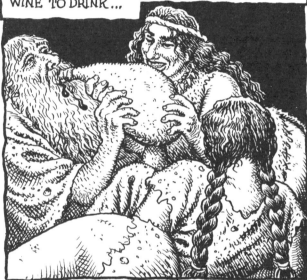
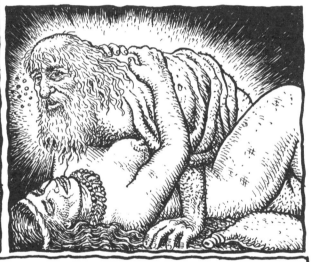

AND ON THE NEXT DAY THE OLDER ONE SAID TO THE YOUNGER...

BEHOLD, LAST NIGHT I LAY WITH MY FATHER. LET'S GIVE HIM WINE TO DRINK AGAIN TONIGHT, AND *YOU* GO AND LIE WITH HIM, SO THAT WE MAY KEEP ALIVE SEED FROM OUR FATHER!

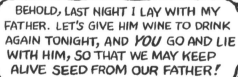
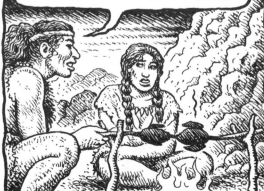

AND ON THAT NIGHT AGAIN THEY GAVE THEIR FATHER WINE TO DRINK, AND THE YOUNGER ONE AROSE AND LAY WITH HIM, AND HE KNEW NOT WHEN SHE LAY DOWN OR WHEN SHE AROSE.

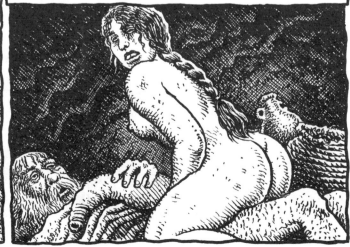

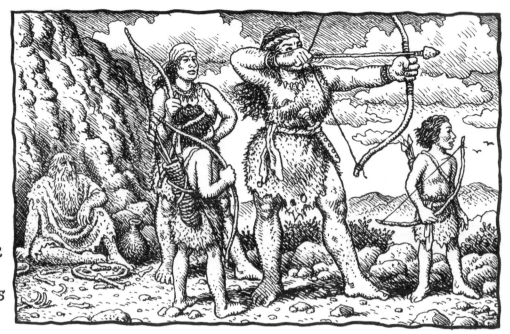

AND THE TWO DAUGHTERS OF **LOT** CONCEIVED BY THEIR FATHER. AND THE OLDER ONE BORE A SON AND CALLED HIS NAME MOAB; HE IS THE FATHER OF THE MOABITES OF OUR DAYS. AND THE YOUNGER ONE AS WELL BORE A SON AND CALLED HIS NAME BEN-AMMI; HE IS THE FATHER OF THE AMMONITES OF OUR DAYS.

Chapter 20

AND ABRAHAM JOURNEYED ONWARD FROM THERE TO THE NEGEB REGION AND DWELT BETWEEN KADESH AND SHUR, AND HE SOJOURNED IN GERAR. AND ABRAHAM SAID OF SARAH, HIS WIFE...

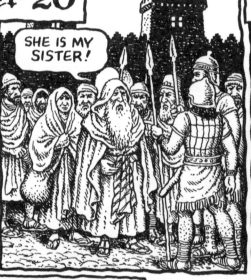

SHE IS MY SISTER!

AND ABIMELECH, THE KING OF GERAR, SENT AND TOOK SARAH.

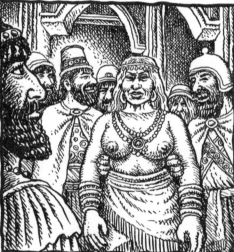

AND GOD CAME TO ABIMELECH IN A DREAM BY NIGHT AND SAID TO HIM...

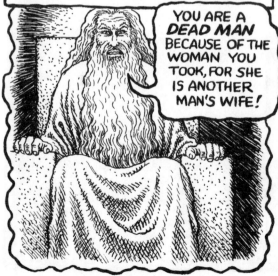

YOU ARE A **DEAD MAN** BECAUSE OF THE WOMAN YOU TOOK, FOR SHE IS ANOTHER MAN'S WIFE!

BUT ABIMELECH HAD NOT COME NEAR HER, AND HE SAID...

MY LORD, WILL YOU SLAY A NATION EVEN IF *INNOCENT*?? DID HE NOT SAY, "SHE IS MY SISTER"? AND SHE, SHE TOO SAID, "HE IS MY BROTHER"!!

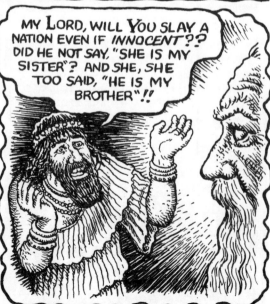

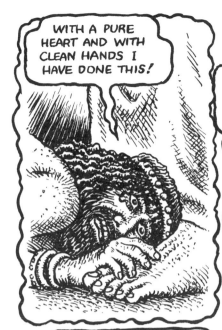

WITH A PURE HEART AND WITH CLEAN HANDS I HAVE DONE THIS!

AND GOD SAID TO HIM IN THE DREAM...

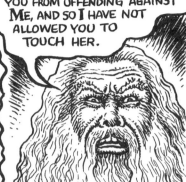

INDEED, I KNOW THAT WITH A PURE HEART YOU HAVE DONE THIS, AND I ON MY PART HAVE PREVENTED YOU FROM OFFENDING AGAINST ME, AND SO I HAVE NOT ALLOWED YOU TO TOUCH HER.

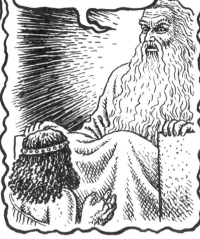

NOW SEND BACK THE MAN'S WIFE, FOR HE IS A *PROPHET*, AND HE WILL INTERCEDE FOR YOU, THAT YOU MAY *LIVE!*

AND IF YOU DO *NOT* SEND HER BACK, KNOW THAT YOU ARE DOOMED TO *DIE*, YOU AND ALL THAT BELONG TO YOU!

AND ABIMELECH ROSE EARLY IN THE MORNING AND CALLED TO ALL HIS SERVANTS.

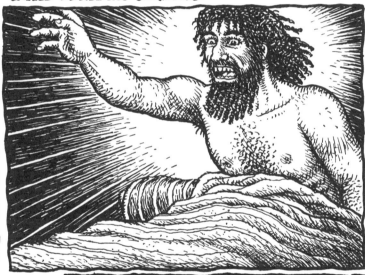

AND HE TOLD ALL THESE THINGS IN THEIR EARS, AND THE MEN WERE DEEPLY AFRAID.

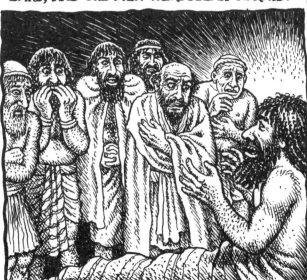

AND ABIMELECH SUMMONED ABRAHAM AND SAID TO HIM...

WHAT HAVE YOU DONE TO US?!

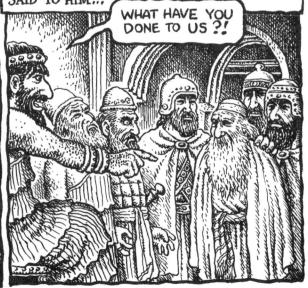

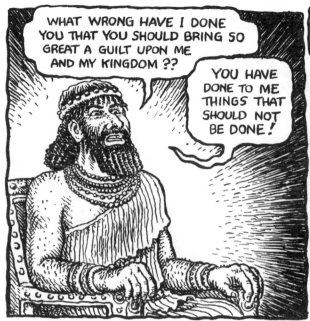

WHAT WRONG HAVE I DONE YOU THAT YOU SHOULD BRING SO GREAT A GUILT UPON ME AND MY KINGDOM??

YOU HAVE DONE TO ME THINGS THAT SHOULD NOT BE DONE!

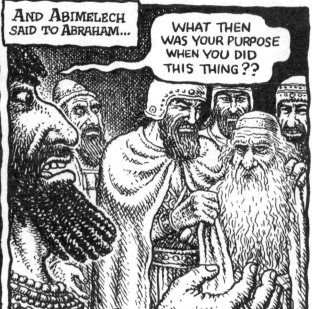

AND ABIMELECH SAID TO ABRAHAM...

WHAT THEN WAS YOUR PURPOSE WHEN YOU DID THIS THING??

AND ABRAHAM SAID...

WELL, I THOUGHT, SURELY THERE'S NO FEAR OF GOD IN THIS PLACE, AND THEY'LL KILL ME BECAUSE OF MY WIFE!

AND, IN POINT OF FACT, SHE IS MY SISTER, MY FATHER'S DAUGHTER, THOUGH NOT MY MOTHER'S DAUGHTER... AND SHE BECAME MY WIFE!

AND SO IT HAPPENED, WHEN THE GODS MADE ME A WANDERER FROM MY FATHER'S HOUSE, THAT I TOLD HER, "THIS IS THE KINDNESS WHICH YOU SHALL DO FOR ME: IN EVERY PLACE TO WHICH WE COME, SAY OF ME, HE IS MY BROTHER"!

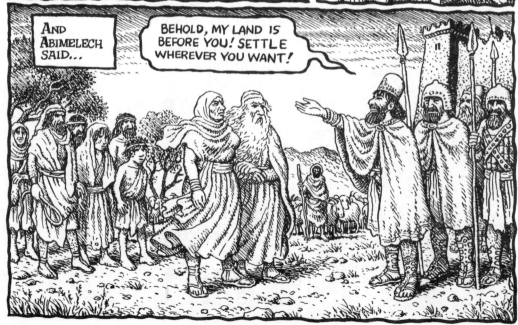

AND ABIMELECH SAID...

BEHOLD, MY LAND IS BEFORE YOU! SETTLE WHEREVER YOU WANT!

AND ABIMELECH TOOK SHEEP AND CATTLE AND MALE AND FEMALE SLAVES, AND GAVE THEM TO ABRAHAM, AND HE SENT BACK TO HIM SARAH, HIS WIFE.

AND TO SARAH HE SAID...

BEHOLD, I HAVE GIVEN A THOU-
SAND PIECES OF SILVER TO YOUR
BROTHER. LET IT HEREBY SERVE
YOU AS A SHIELD AGAINST AC-
CUSING EYES FOR EVERYONE
WHO IS WITH YOU, AND YOU ARE
NOW PUBLICLY VINDICATED.

SO ABRAHAM PRAYED TO GOD, AND GOD HEALED ABIMELECH AND HIS WIFE AND HIS SLAVE-WOMEN, AND THEY GAVE BIRTH. FOR THE LORD HAD SHUT FAST EVERY WOMB IN THE HOUSE OF ABIMELECH BECAUSE OF SARAH, THE WIFE OF ABRAHAM.

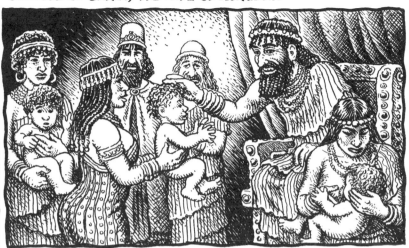

Chapter 21

AND THE LORD SINGLED OUT SARAH AS HE HAD SAID, AND THE LORD DID FOR SARAH AS HE HAD SPOKEN. AND SARAH CONCEIVED AND BORE A SON TO ABRAHAM IN HIS OLD AGE AT THE SET TIME OF WHICH GOD HAD SPOKEN TO HIM. AND ABRAHAM CALLED HIS NAME ISAAC.* AND ABRA-HAM CIRCUMCISED ISAAC HIS SON WHEN HE WAS EIGHT DAYS OLD, AS GOD HAD COMMANDED.

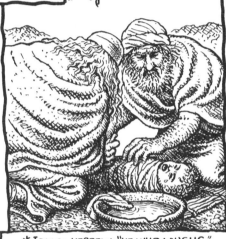

*ISAAC: HEBREW: "HE WHO LAUGHS."

AND ABRAHAH WAS A HUNDRED YEARS OLD WHEN ISAAC HIS SON WAS BORN TO HIM. AND SARAH SAID...

GOD MADE ME LAUGH, AND NOW ALL WHO HEAR WILL LAUGH AT ME!

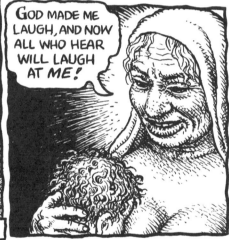

AND SHE SAID...

WHO WOULD HAVE UTTERED TO ABRAHAM, "SARAH IS SUCKLING SONS!" FOR I'VE BORNE HIM A SON IN HIS OLD AGE!

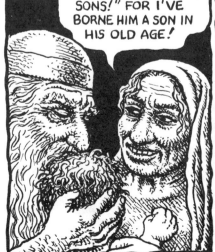

AND THE CHILD GREW AND WAS WEANED, AND ABRAHAM MADE A GREAT FEAST ON THE DAY ISAAC WAS WEANED.

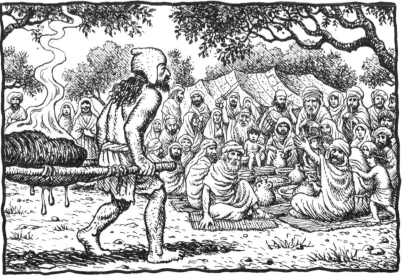

AND SARAH SAW THE SON OF HAGAR THE EGYPTIAN, WHOM SHE HAD BORNE TO ABRAHAM, MOCKING...

...AND SHE SAID TO ABRAHAM...

CAST OUT THIS SLAVEGIRL AND HER SON, FOR THE SLAVE-GIRL'S SON SHALL NOT INHERIT WITH MY SON, WITH ISAAC!!

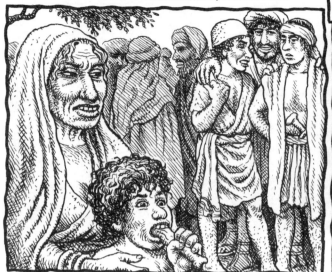

AND THE THING SEEMED EVIL IN ABRAHAM'S EYES BECAUSE IT CONCERNED A SON OF HIS. AND GOD SAID TO ABRAHAM...

LET IT NOT SEEM EVIL IN YOUR EYES ON ACCOUNT OF THE LAD, AND ON ACCOUNT OF YOUR SLAVEGIRL.

WHATEVER SARAH SAYS TO YOU, LISTEN TO HER VOICE, FOR THROUGH ISAAC SHALL YOUR SEED BE ACCLAIMED. BUT THE SLAVEGIRL'S SON, TOO, I WILL MAKE A NATION, FOR HE IS YOUR SEED.

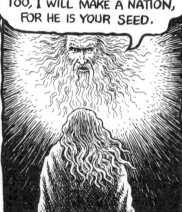

AND ABRAHAM ROSE EARLY IN THE MORNING AND TOOK BREAD AND A SKIN OF WATER AND GAVE THEM TO HAGAR, PLACING THEM ON HER SHOULDER.

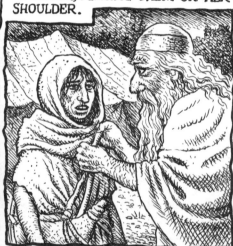

AND HE GAVE HER THE CHILD AND SENT HER AWAY.

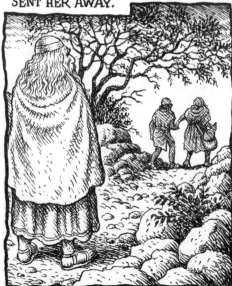

AND SHE WENT WANDERING THROUGH THE WILDERNESS OF BEERSHEBA.

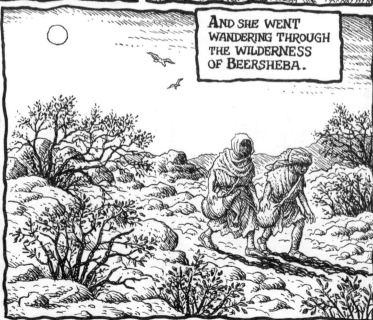

AND THE WATER IN THE SKIN WAS SPENT, AND SHE FLUNG THE CHILD UNDER ONE OF THE BUSHES.

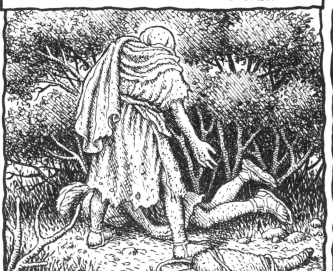

AND SHE WENT AND SAT DOWN A GOOD WAY OFF, A BOWSHOT AWAY, FOR SHE THOUGHT...

LET ME NOT *SEE* WHEN THE CHILD DIES...

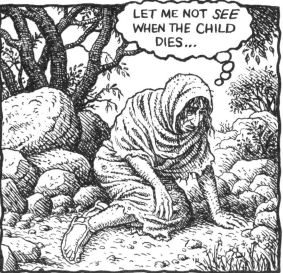

AND SHE SAT AT A DISTANCE AND RAISED HER VOICE AND WEPT.

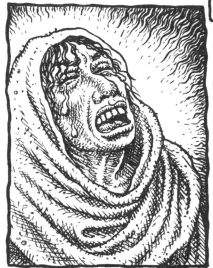

AND GOD HEARD THE VOICE OF THE LAD...

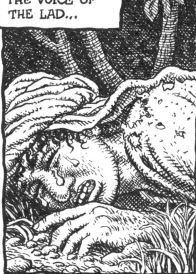

...AND GOD'S MESSENGER CALLED OUT FROM THE HEAVENS AND SAID TO HER...,

WHAT TROUBLES YOU, HAGAR??

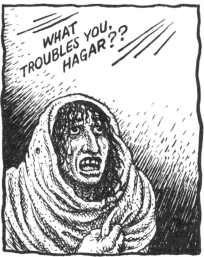

FEAR NOT, FOR GOD HAS HEARD THE LAD'S VOICE WHERE HE IS!

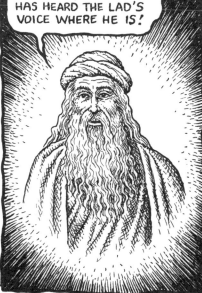

RISE, LIFT UP THE LAD AND HOLD HIM BY THE HAND, FOR I WILL MAKE OF HIM A GREAT NATION!

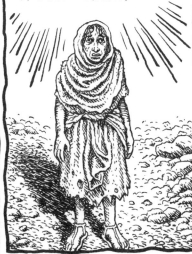

AND GOD OPENED HER EYES AND SHE SAW A WELL OF WATER.

AND SHE WENT AND FILLED THE SKIN WITH WATER AND GAVE IT TO THE LAD TO DRINK.

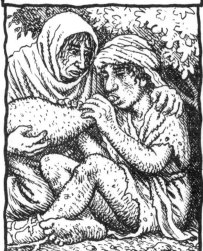

AND GOD WAS WITH THE LAD, AND HE GREW UP AND ABIDED IN THE WILDERNESS, AND HE BECAME A SEASONED ARCHER-BOWMAN.

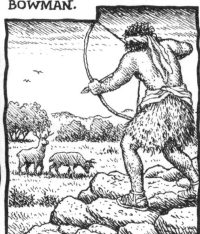

AND HE DWELT IN THE WILDERNESS OF PARAN, AND HIS MOTHER TOOK HIM A WIFE FROM THE LAND OF EGYPT.

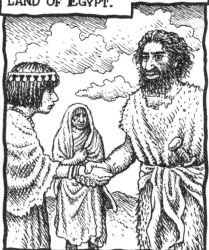

AND IT HAPPENED AT THAT TIME THAT ABIMELECH AND PHICOL, THE CHIEF CAPTAIN OF HIS TROOPS WITH HIM, SPOKE TO ABRAHAM, SAYING...

GOD IS WITH YOU IN ALL THAT YOU DO!

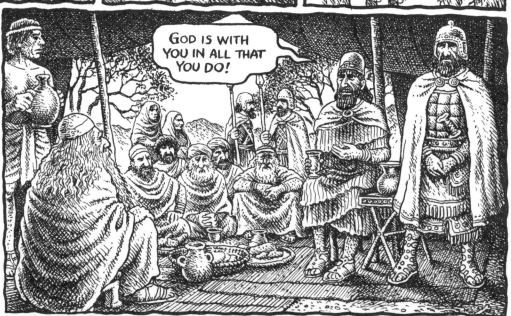

THEREFORE, SWEAR TO ME BY GOD THAT YOU WILL NOT DEAL FALSELY WITH ME, NOR WITH MY SON, NOR WITH MY SON'S SON.

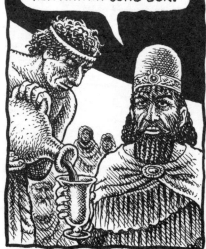

LIKE THE KINDNESS I HAVE DONE YOU, SO SHALL YOU DO FOR ME, AND FOR THE LAND IN WHICH YOU HAVE SOJOURNED.

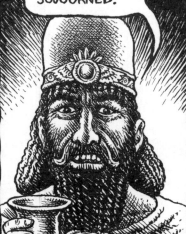

AND ABRAHAM SAID...

I INDEED WILL SWEAR!

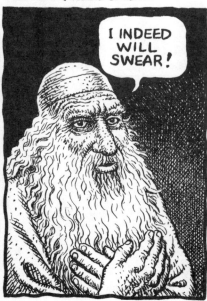

BUT THEN ABRAHAM REPROACHED ABIMELECH CONCERNING THE WELL OF WATER WHICH THE SERVANTS OF ABIMELECH HAD SEIZED.

AND ABIMELECH SAID...

I DO NOT KNOW WHO HAS DONE THIS THING, AND NEITHER DID YOU *TELL* ME, NOR HAVE I *HEARD* OF IT UNTIL *TODAY!*

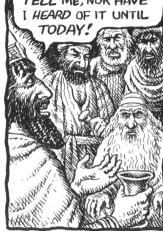

AND ABRAHAM TOOK SHEEP AND CATTLE AND GAVE THEM TO ABIMELECH, AND THE TWO OF THEM SEALED A PACT. AND ABRAHAM SET APART SEVEN EWES OF THE FLOCK, AND ABIMELECH SAID TO ABRAHAM...

WHAT ARE THESE SEVEN EWE LAMBS WHICH YOU HAVE SET APART?

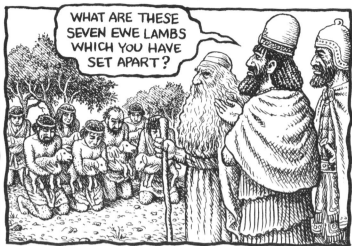

AND HE SAID...

FOR THESE SEVEN EWE LAMBS YOU SHALL TAKE FROM MY HAND, THAT THEY MAY BE A *WITNESS* UNTO ME, THAT *I DUG THIS WELL!*

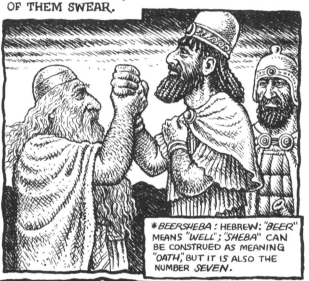

THEREFORE DID HE CALL THE NAME OF THE PLACE BEERSHEBA*, FOR THERE DID THE TWO OF THEM SWEAR.

*BEERSHEBA: HEBREW: "BEER" MEANS "WELL"; "SHEBA" CAN BE CONSTRUED AS MEANING "OATH," BUT IT IS ALSO THE NUMBER *SEVEN*.

AND THEY SEALED A PACT IN BEERSHEBA, AND ABIMELECH AROSE, AND PHICOL, CAPTAIN OF HIS TROOPS WITH HIM, AND THEY RETURNED TO THE LAND OF THE PHILISTINES.

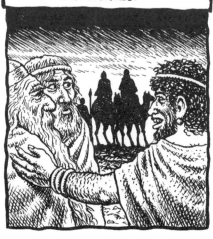

AND ABRAHAM PLANTED A TAMARISK AT BEERSHEBA, AND HE INVOKED THERE THE NAME OF THE LORD, EVERLASTING GOD. AND ABRAHAM SOJOURNED IN THE LAND OF THE PHILISTINES MANY DAYS.

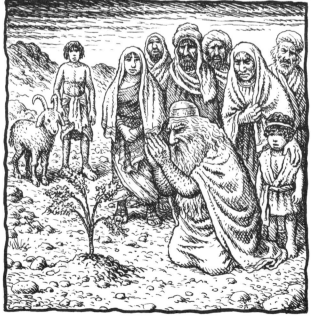

Chapter 22

AND IT CAME TO PASS AFTER THESE THINGS THAT GOD TESTED ABRAHAM. AND HE SAID TO HIM...

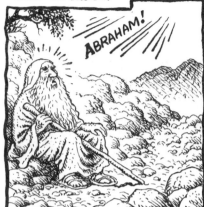

...AND HE SAID...

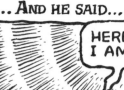

AND HE SAID...

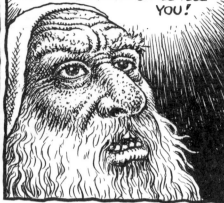

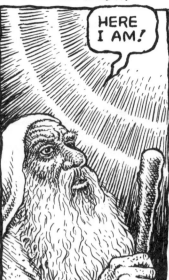

AND ABRAHAM ROSE EARLY IN THE MORNING AND SADDLED HIS DONKEY AND TOOK HIS TWO LADS WITH HIM, AND ISAAC, HIS SON, AND HE SPLIT WOOD FOR THE OFFERING AND ROSE AND JOURNEYED TO THE PLACE THAT GOD HAD TOLD HIM.

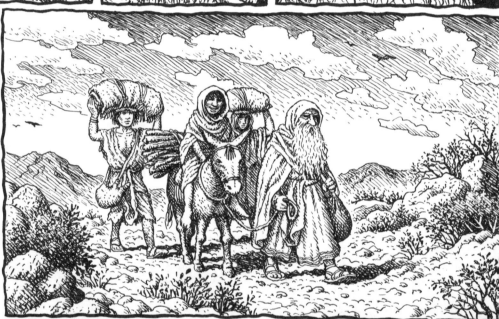

ON THE THIRD DAY ABRAHAM RAISED HIS EYES AND SAW THE PLACE FROM AFAR.

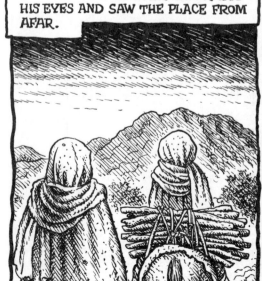

AND ABRAHAM SAID TO HIS LADS...

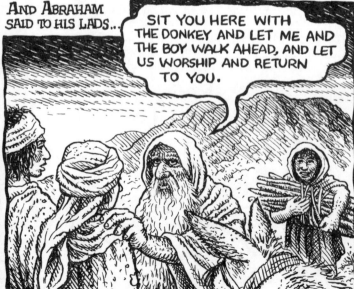

AND ABRAHAM TOOK THE WOOD FOR THE OF-
FERING AND PUT IT ON ISAAC HIS SON, AND
HE TOOK IN HIS HAND THE FIRE AND THE
CLEAVER, AND THE TWO OF THEM WENT UP
TOGETHER.

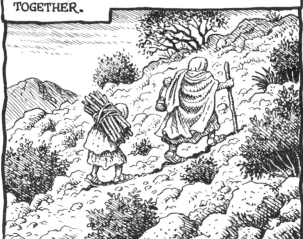

AND ISAAC SAID TO ABRAHAM, HIS FATHER...

FATHER...

AND HE SAID...

HERE I AM, MY SON...

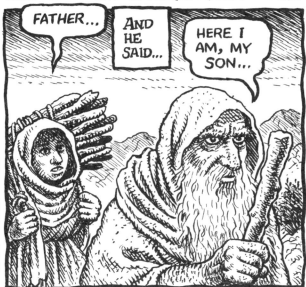

AND HE SAID...

HERE'S THE FIRE AND THE WOOD, BUT WHERE IS THE *SHEEP* FOR THE OFFERING??

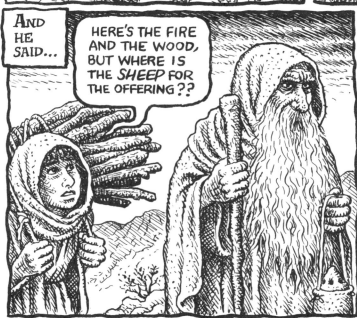

AND ABRAHAM SAID...

GOD WILL SEE TO THE SHEEP FOR THE OFFERING, MY SON...

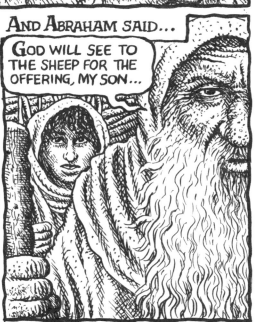

AND THE TWO OF THEM WENT TOGETHER.
AND THEY CAME TO THE PLACE THAT GOD HAD
TOLD TO HIM, AND ABRAHAM BUILT THERE AN
ALTAR, AND LAID OUT THE WOOD...

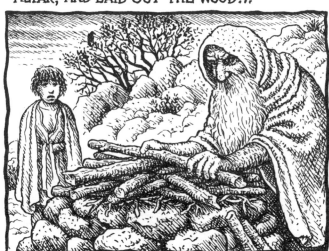

...AND BOUND ISAAC, HIS SON...

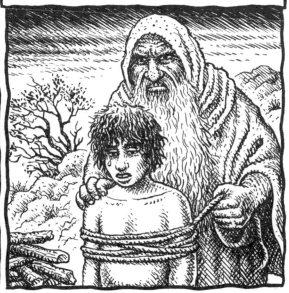

...AND PLACED HIM ON THE ALTAR ON TOP OF THE WOOD...

AND ABRAHAM REACHED OUT HIS HAND AND TOOK THE CLEAVER TO SLAUGHTER HIS SON.

AND THE LORD'S MESSENGER CALLED OUT TO HIM FROM THE HEAVENS AND SAID...

AND HE SAID...

HERE I AM!

AND HE SAID...

DO NOT REACH OUT YOUR HAND AGAINST THE LAD, AND DO NOTHING TO HIM!

FOR NOW I KNOW THAT YOU FEAR GOD, AND YOU HAVE NOT HELD BACK YOUR SON, YOUR ONLY ONE, FROM ME!

AND ABRAHAM RAISED HIS EYES AND LOOKED, AND, BEHOLD, A RAM WAS CAUGHT IN THE THICKET BY ITS HORNS.

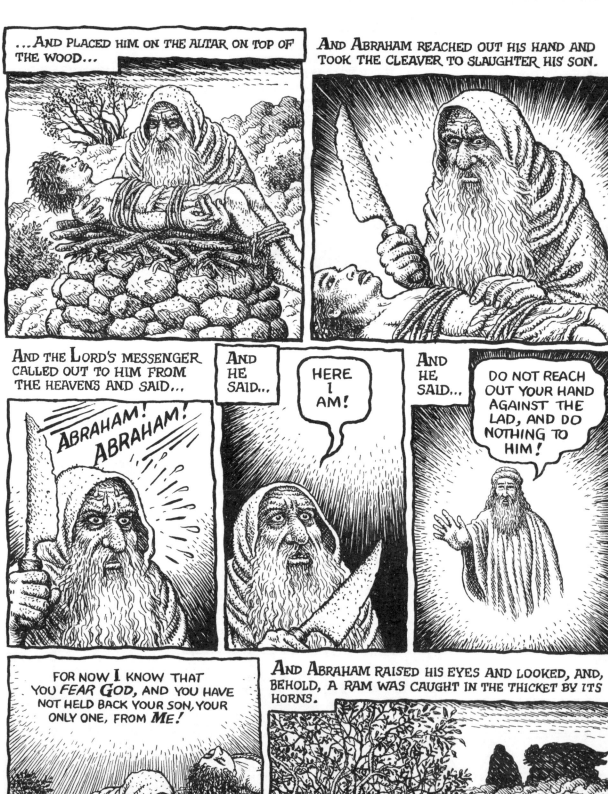
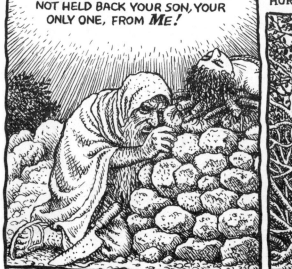
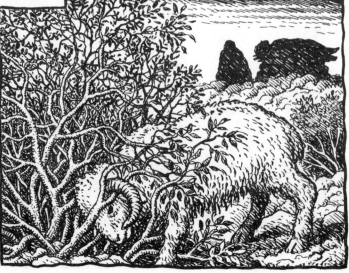

AND ABRAHAM WENT AND TOOK THE RAM AND OFFERED HIM UP AS A BURNT OFFERING INSTEAD OF HIS SON.

AND ABRAHAM CALLED THE NAME OF THE PLACE YHWH-YIREH,* AS IT IS SAID TO THIS DAY, "ON THE MOUNT OF THE LORD THERE IS SEEING!"

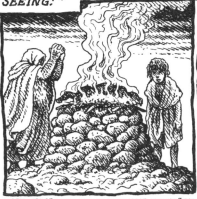

*YHWH-YIREH: THE PLACE-NAME MEANS "THE LORD SEES." THE PHRASE AT THE END CAN MEAN, "HE SEES", OR, "HE WILL BE SEEN", DEPENDING ON HOW THE VERB IS VOCALIZED.

AND THE LORD'S MESSENGER CALLED OUT TO ABRAHAM ONCE A-GAIN FROM THE HEAVENS, AND HE SAID...

BY MY OWN SELF I SWEAR, DECLARES THE LORD, THAT BECAUSE YOU HAVE DONE THIS THING AND HAVE NOT HELD BACK YOUR SON, YOUR ONLY ONE, I WILL GREATLY BLESS YOU AND WILL GREATLY MULTIPLY YOUR SEED, AS THE STARS IN THE HEAV-ENS, AND AS THE SAND ON THE SHORE OF THE SEA.

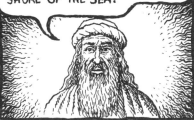

AND YOUR SEED SHALL TAKE HOLD OF THE GATE OF ITS ENEMIES, AND ALL THE NATIONS OF THE EARTH WILL BE BLESSED THROUGH YOUR SEED BECAUSE YOU HAVE LISTENED TO MY VOICE.

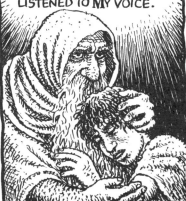

AND ABRAHAM RETURNED TO HIS LADS, AND THEY ROSE AND WENT TO-GETHER TO BEERSHEBA.

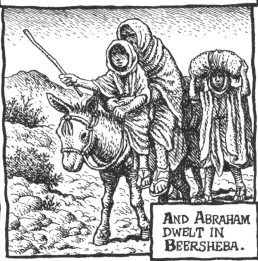

AND ABRAHAM DWELT IN BEERSHEBA.

AND IT CAME TO PASS AFTER THESE THINGS THAT IT WAS TOLD TO ABRAHAM, SAYING, "BEHOLD, MILCAH, TOO, HAS BORNE SONS TO NAHOR, YOUR BROTHER. UZ, HIS FIRST-BORN, AND BUZ, HIS BROTH-ER, AND KEMUEL, THE FATHER OF ARAM, AND CHES-ED AND HAZO AND PILDASH AND JIDLAPH, AND BETHUEL. AND BETHUEL BEGOT RE-BEKAH. THESE EIGHT MIL-CAH BORE TO NAHOR, ABRA-HAM'S BROTHER. AND HIS CONCUBINE, WHOSE NAME WAS REUMAH, SHE TOO GAVE BIRTH—TO TEBAH, AND TO GAHAM, AND TO TAHASH, AND TO MAACAH."

Chapter 23

AND SARAH'S LIFE WAS 127 YEARS, THE YEARS OF SARAH'S LIFE. AND SARAH DIED IN KARIATH-ARBA, WHICH IS NOW HEBRON, IN THE LAND OF CANAAN, AND ABRAHAM CAME TO MOURN SARAH AND TO KEEN FOR HER.

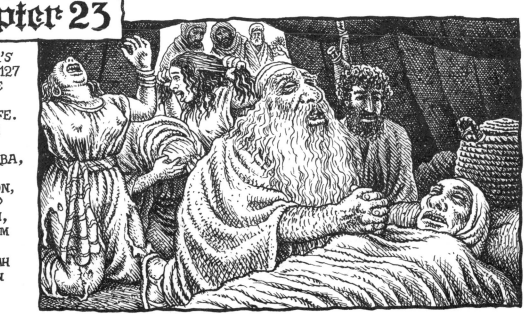

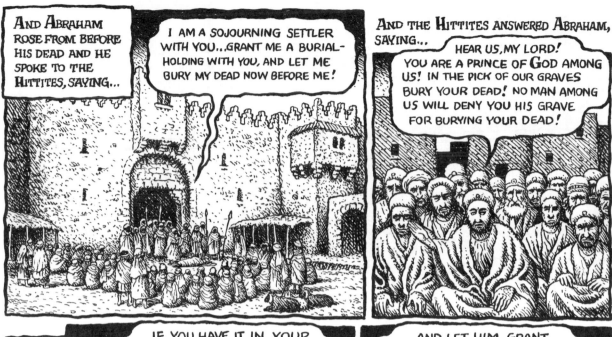

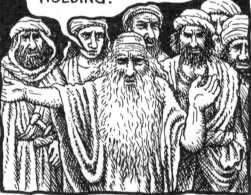

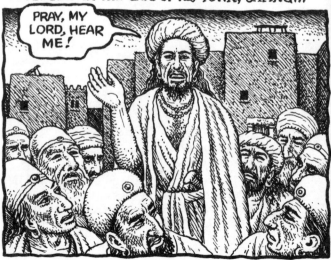

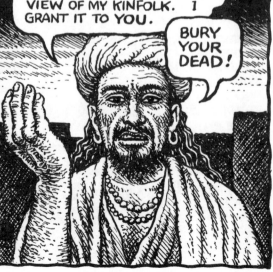

AND ABRAHAM BOWED BEFORE THE FOLK OF THE LAND, AND HE SPOKE TO EPHRON IN THE HEARING OF THE FOLK OF THE LAND, SAYING...

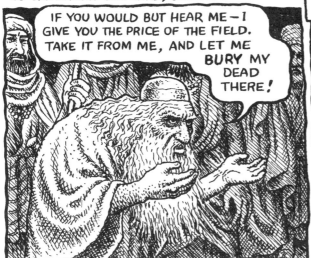

IF YOU WOULD BUT HEAR ME—I GIVE YOU THE PRICE OF THE FIELD. TAKE IT FROM ME, AND LET ME **BURY MY DEAD** THERE!

AND EPHRON ANSWERED ABRAHAM, SAYING...

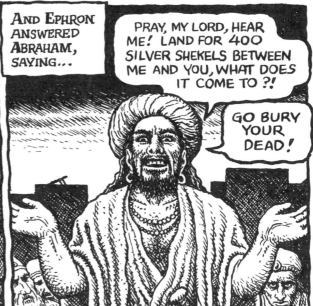

PRAY, MY LORD, HEAR ME! LAND FOR 400 SILVER SHEKELS BETWEEN ME AND YOU, WHAT DOES IT COME TO?!

GO BURY YOUR DEAD!

AND ABRAHAM HEEDED EPHRON, AND ABRAHAM WEIGHED OUT TO EPHRON THE SILVER THAT HE SPOKE OF IN THE HEARING OF THE HITTITES, 400 SILVER SHEKELS AT THE GOING MERCHANTS' RATE.

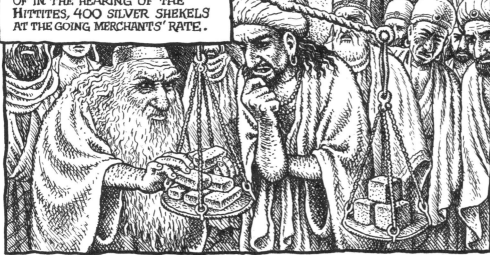

AND EPHRON'S FIELD AT MACHPELAH BY MAMRE, THE FIELD AND THE CAVE THAT WAS IN IT AND EVERY TREE IN THE FIELD, WITHIN ITS BOUNDARIES ALL AROUND, PASSED OVER TO ABRAHAM AS A POSSESSION, IN FULL VIEW OF THE HITTITES, ALL THE ASSEMBLED IN THE GATE OF HIS TOWN.

AND THEN ABRAHAM BURIED SARAH HIS WIFE IN THE CAVE OF THE MACHPELAH FIELD BY MAMRE, WHICH IS NOW HEBRON, IN THE LAND OF CANAAN.

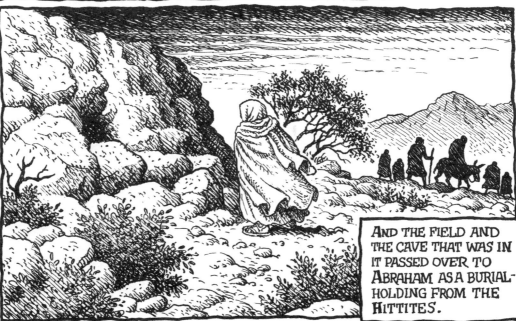

AND THE FIELD AND THE CAVE THAT WAS IN IT PASSED OVER TO ABRAHAM AS A BURIAL-HOLDING FROM THE HITTITES.

Chapter 24

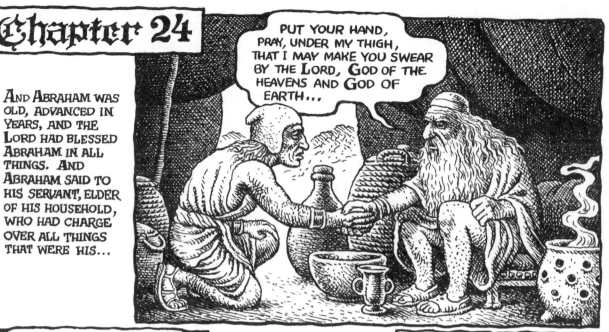

PUT YOUR HAND, PRAY, UNDER MY THIGH, THAT I MAY MAKE YOU SWEAR BY THE LORD, GOD OF THE HEAVENS AND GOD OF EARTH...

AND ABRAHAM WAS OLD, ADVANCED IN YEARS, AND THE LORD HAD BLESSED ABRAHAM IN ALL THINGS. AND ABRAHAM SAID TO HIS SERVANT, ELDER OF HIS HOUSEHOLD, WHO HAD CHARGE OVER ALL THINGS THAT WERE HIS...

...THAT YOU SHALL NOT TAKE A WIFE FOR MY SON FROM THE DAUGHTERS OF THE CANAANITE IN WHOSE MIDST I DWELL, BUT TO MY LAND AND TO MY BIRTHPLACE YOU SHALL GO, AND YOU SHALL TAKE A WIFE FOR MY SON, FOR ISAAC!

AND THE SERVANT SAID TO HIM...

PERHAPS THE WOMAN WILL NOT WANT TO COME AFTER ME TO THIS LAND! MUST I INDEED BRING YOUR SON BACK TO THE LAND YOU LEFT?

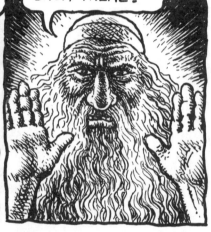

AND ABRAHAM SAID TO HIM...

WATCH YOURSELF! ON NO ACCOUNT MUST YOU BRING MY SON BACK THERE!

THE LORD GOD OF THE HEAVENS, WHO TOOK ME FROM MY FATHER'S HOUSE AND FROM THE LAND OF MY BIRTHPLACE, AND WHO SPOKE TO ME, AND WHO SWORE TO ME, SAYING, "TO YOUR SEED I WILL GIVE THIS LAND," HE SHALL SEND HIS MESSENGER BEFORE YOU AND YOU SHALL TAKE A WIFE FOR MY SON THERE.

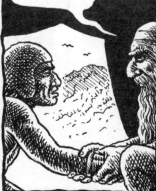

AND IF THE WOMAN SHOULD NOT WANT TO GO AFTER YOU, YOU SHALL BE CLEAR OF THIS VOW OF MINE, ONLY YOU MUST NOT BRING MY SON BACK THERE!

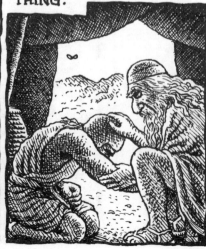

AND THE SERVANT PUT HIS HAND UNDER ABRAHAM'S THIGH, AND HE SWORE TO HIM CONCERNING THIS THING.

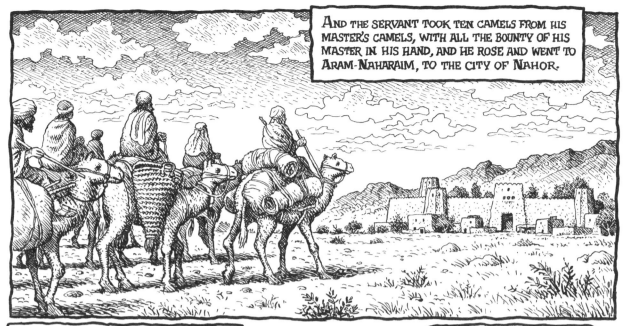

AND THE SERVANT TOOK TEN CAMELS FROM HIS MASTER'S CAMELS, WITH ALL THE BOUNTY OF HIS MASTER IN HIS HAND, AND HE ROSE AND WENT TO ARAM-NAHARAIM, TO THE CITY OF NAHOR.

AND HE MADE THE CAMELS KNEEL OUT-SIDE THE CITY BY THE WELL OF WATER AT EVENTIDE, THE HOUR WHEN THE WATER-DRAWING WOMEN COME OUT.

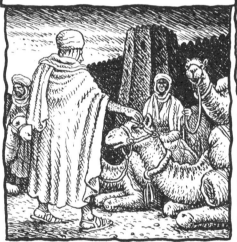

AND HE SAID...

LORD, GOD OF MY MASTER ABRAHAM, PRAY GRANT ME GOOD SPEED THIS DAY, AND DO KINDNESS TO MY MAS-TER, ABRAHAM! HERE, I AM POISED BY THE SPRING OF WATER, AND THE DAUGH-TERS OF THE MEN OF THE TOWN ARE COMING OUT TO DRAW WATER.

LET IT BE THAT THE YOUNG WOMAN TO WHOM I SAY, "PRAY, TIP DOWN YOUR JUG THAT I MAY DRINK," IF SHE SAYS, "DRINK, AND YOUR CAMELS, TOO, I SHALL WATER," SHE IT IS WHOM YOU HAVE MARKED FOR YOUR SERVANT, FOR ISAAC, AND BY THIS I SHALL KNOW THAT YOU HAVE SHOWN KIND-NESS UNTO MY MASTER!

HE HAD BARELY FINISHED SPEAKING WHEN, BEHOLD, REBEKAH WAS COM-ING OUT, WHO WAS BORN TO BETH-UEL, SON OF MILCAH, THE WIFE OF ABRAHAM'S BROTHER, NAHOR, WITH HER JUG ON HER SHOULDER.

AND THE YOUNG WOMAN WAS VERY COMELY TO LOOK AT, A VIRGIN, NO MAN HAD KNOWN HER. AND SHE CAME DOWN TO THE SPRING AND FILLED HER JUG.

AND SHE CAME BACK UP, AND THE SERVANT RAN TOWARD HER AND SAID...

PRAY, LET ME SIP A BIT OF WATER FROM YOUR JUG!

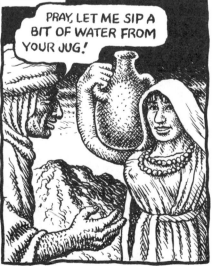

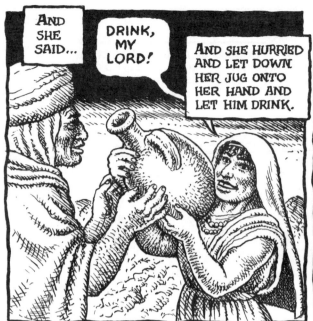

AND SHE SAID...

DRINK, MY LORD!

AND SHE HURRIED AND LET DOWN HER JUG ONTO HER HAND AND LET HIM DRINK.

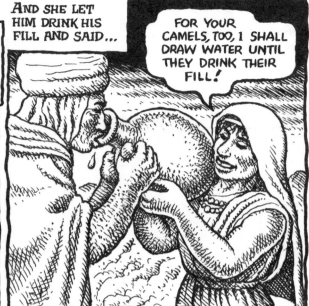

AND SHE LET HIM DRINK HIS FILL AND SAID...

FOR YOUR CAMELS, TOO, I SHALL DRAW WATER UNTIL THEY DRINK THEIR FILL!

AND SHE HURRIED AND EMPTIED HER JUG INTO THE TROUGH, AND SHE RAN AGAIN TO THE WELL TO DRAW WATER AND DREW WATER FOR ALL HIS CAMELS. AND THE MAN WAS GAZING AT HER, KEEPING SILENT, TO KNOW WHETHER THE LORD HAD GRANTED SUCCESS TO HIS JOURNEY.

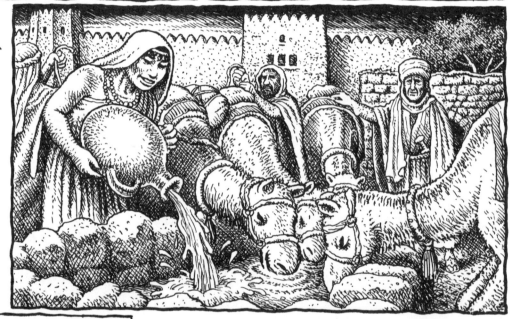

AND IT CAME TO PASS, WHEN THE CAMELS HAD DRUNK THEIR FILL, THAT THE MAN TOOK A GOLD NOSE RING, A HALF-SHEKEL IN WEIGHT, AND TWO BRACELETS FOR HER ARMS, TEN GOLD SHEKELS IN WEIGHT.

AND HE SAID...

WHOSE DAUGHTER ARE YOU? TELL ME, PRAY, IS THERE ROOM IN YOUR FATHER'S HOUSE FOR US TO SPEND THE NIGHT?

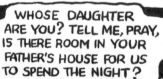

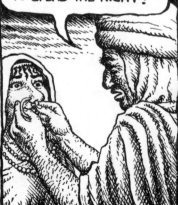

AND SHE SAID TO HIM...

I AM THE DAUGHTER OF BETHUEL, THE SON OF MILCAH, WHOM SHE BORE TO NAHOR.

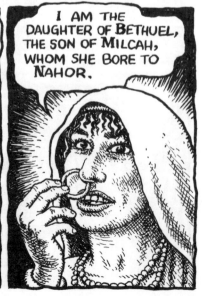

AND SHE SAID TO HIM...

WE HAVE PLENTY OF BRAN AND FEED AS WELL, AND ROOM TO SPEND THE NIGHT!

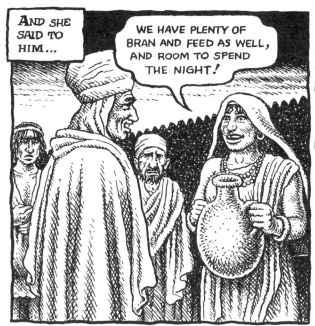

AND THE MAN BOWED DOWN HIS HEAD AND WORSHIPPED THE LORD, AND HE SAID...

BLESSED BE THE LORD, GOD OF MY MASTER ABRAHAM, WHO HAS NOT LEFT MY MASTER DESTITUTE OF HIS STEADFAST KINDNESS, FOR I HAVE BEEN GUIDED ON MY ERRAND BY THE LORD TO THE HOUSE OF MY MASTER'S KINSMEN!

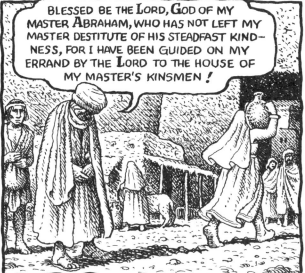

AND THE YOUNG WOMAN RAN AND TOLD HER MOTHER'S HOUSEHOLD ABOUT THESE THINGS. AND REBEKAH HAD A BROTHER WHOSE NAME WAS LABAN.

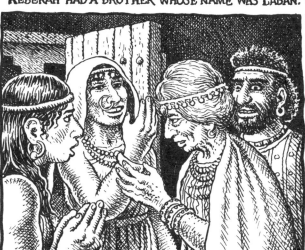

AND LABAN RAN OUT TO THE MAN BY THE SPRING. HAVING SEEN THE NOSE RING AND THE BRACELETS ON HIS SISTER'S ARMS, AND HAVING HEARD THE WORDS OF REBEKAH HIS SISTER, SAYING, "THUS THE MAN SPOKE TO ME," HE CAME UP TO THE MAN AND, BEHOLD, HE WAS STANDING OVER THE CAMELS BY THE SPRING.

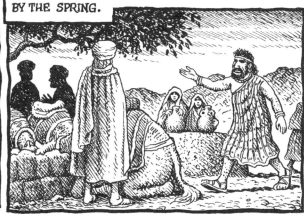

AND HE SAID...

COME IN, BLESSED OF THE LORD! WHY SHOULD YOU STAND OUTSIDE WHEN I HAVE READIED THE HOUSE AND A PLACE FOR THE CAMELS!?

AND THE MAN CAME INTO THE HOUSE AND UNHARNESSED THE CAMELS; AND HE GAVE BRAN AND FEED TO THE CAMELS, AND WATER TO BATHE HIS FEET AND THE FEET OF THE MEN WHO WERE WITH HIM.

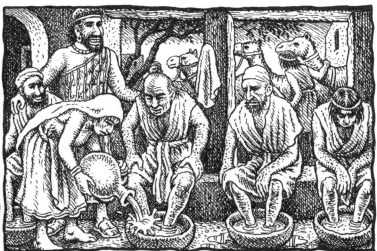

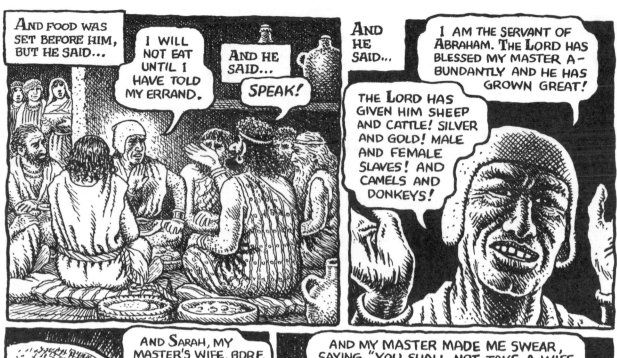

AND FOOD WAS SET BEFORE HIM, BUT HE SAID...

I WILL NOT EAT UNTIL I HAVE TOLD MY ERRAND.

AND HE SAID...

SPEAK!

AND HE SAID...

I AM THE SERVANT OF ABRAHAM. THE LORD HAS BLESSED MY MASTER ABUNDANTLY AND HE HAS GROWN GREAT!

THE LORD HAS GIVEN HIM SHEEP AND CATTLE! SILVER AND GOLD! MALE AND FEMALE SLAVES! AND CAMELS AND DONKEYS!

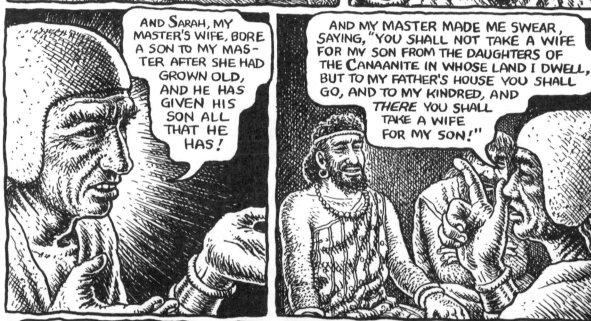

AND SARAH, MY MASTER'S WIFE, BORE A SON TO MY MASTER AFTER SHE HAD GROWN OLD, AND HE HAS GIVEN HIS SON ALL THAT HE HAS!

AND MY MASTER MADE ME SWEAR, SAYING, "YOU SHALL NOT TAKE A WIFE FOR MY SON FROM THE DAUGHTERS OF THE CANAANITE IN WHOSE LAND I DWELL, BUT TO MY FATHER'S HOUSE YOU SHALL GO, AND TO MY KINDRED, AND *THERE* YOU SHALL TAKE A WIFE FOR MY SON!"

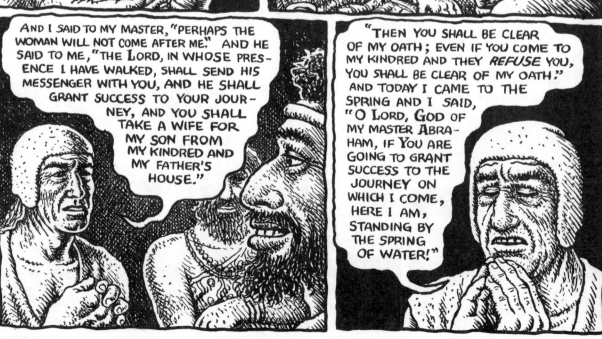

AND I SAID TO MY MASTER, "PERHAPS THE WOMAN WILL NOT COME AFTER ME." AND HE SAID TO ME, "THE LORD, IN WHOSE PRESENCE I HAVE WALKED, SHALL SEND HIS MESSENGER WITH YOU, AND HE SHALL GRANT SUCCESS TO YOUR JOURNEY, AND YOU SHALL TAKE A WIFE FOR MY SON FROM MY KINDRED AND MY FATHER'S HOUSE."

"THEN YOU SHALL BE CLEAR OF MY OATH; EVEN IF YOU COME TO MY KINDRED AND THEY *REFUSE* YOU, YOU SHALL BE CLEAR OF MY OATH." AND TODAY I CAME TO THE SPRING AND I SAID, "O LORD, GOD OF MY MASTER ABRAHAM, IF YOU ARE GOING TO GRANT SUCCESS TO THE JOURNEY ON WHICH I COME, HERE I AM, STANDING BY THE SPRING OF WATER!"

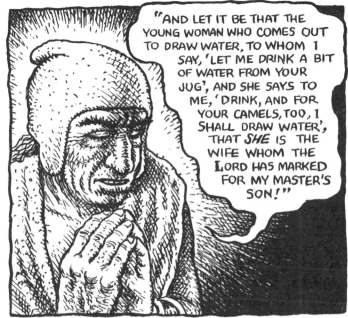

"AND LET IT BE THAT THE YOUNG WOMAN WHO COMES OUT TO DRAW WATER, TO WHOM I SAY, 'LET ME DRINK A BIT OF WATER FROM YOUR JUG', AND SHE SAYS TO ME, 'DRINK, AND FOR YOUR CAMELS, TOO, I SHALL DRAW WATER', THAT *SHE* IS THE WIFE WHOM THE LORD HAS MARKED FOR MY MASTER'S SON!"

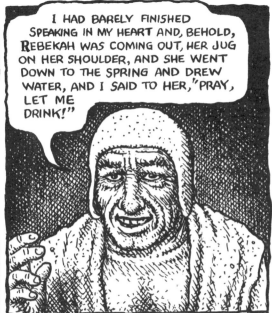

I HAD BARELY FINISHED SPEAKING IN MY HEART AND, BEHOLD, REBEKAH WAS COMING OUT, HER JUG ON HER SHOULDER, AND SHE WENT DOWN TO THE SPRING AND DREW WATER, AND I SAID TO HER, "PRAY, LET ME DRINK!"

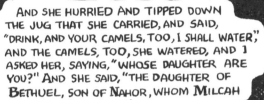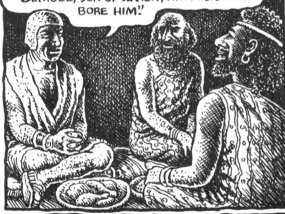

AND SHE HURRIED AND TIPPED DOWN THE JUG THAT SHE CARRIED, AND SAID, "DRINK, AND YOUR CAMELS, TOO, I SHALL WATER", AND THE CAMELS, TOO, SHE WATERED, AND I ASKED HER, SAYING, "WHOSE DAUGHTER ARE YOU?" AND SHE SAID, "THE DAUGHTER OF BETHUEL, SON OF NAHOR, WHOM MILCAH BORE HIM"

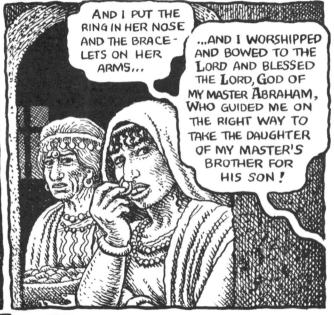

AND I PUT THE RING IN HER NOSE AND THE BRACE- LETS ON HER ARMS...

...AND I WORSHIPPED AND BOWED TO THE LORD AND BLESSED THE LORD, GOD OF MY MASTER ABRAHAM, WHO GUIDED ME ON THE RIGHT WAY TO TAKE THE DAUGHTER OF MY MASTER'S BROTHER FOR HIS SON!

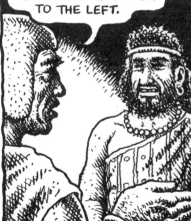

AND SO, IF YOU MEAN TO ACT WITH STEADFAST KINDNESS TOWARD MY MAS- TER, TELL ME, AND IF NOT, TELL ME, THAT I MAY TURN TO THE RIGHT HAND OR TO THE LEFT.

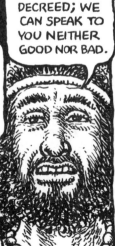

AND LABAN ANSWERED AND SAID...

HERE IS REBEKAH BEFORE YOU... TAKE HER AND GO, AND LET HER BE WIFE TO YOUR MASTER'S SON AS THE LORD HAS SPOKEN!

FROM THE LORD THIS MATTER WAS DECREED; WE CAN SPEAK TO YOU NEITHER GOOD NOR BAD.

AND IT CAME TO PASS THAT WHEN ABRAHAM'S SERVANT HEARD THESE WORDS HE BOWED TO THE GROUND TO THE LORD.

AND THE SERVANT TOOK OUT ORNAMENTS OF SILVER AND GOLD, AND GARMENTS, AND HE GAVE THEM TO REBEKAH, AND HE GAVE PRESENTS TO HER BROTHER AND TO HER MOTHER.

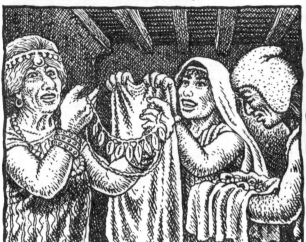

AND THEY ATE AND DRANK, HE AND THE MEN WHO WERE WITH HIM.

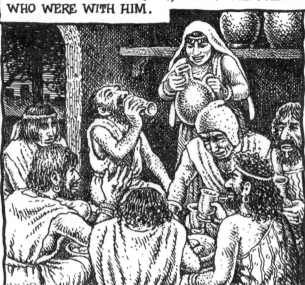

AND THEY SPENT THE NIGHT AND ROSE IN THE MORNING, AND HE SAID...

GIVE ME LEAVE, THAT I MAY GO TO MY MASTER!

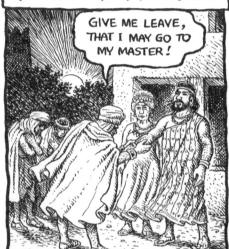

AND HER BROTHER AND HER MOTHER SAID...

LET THE YOUNG WOMAN STAY WITH US TEN DAYS OR SO, THEN SHE MAY GO!

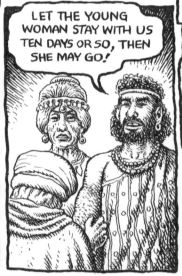

AND HE SAID TO THEM...

SEND ME OFF, THAT I MAY GO TO MY MASTER!

DO NOT HINDER ME, SEEING THAT THE LORD HAS MADE MY ERRAND SUCCESSFUL!

AND THEY SAID...

LET US CALL THE YOUNG WOMAN AND ASK FOR HER REPLY...

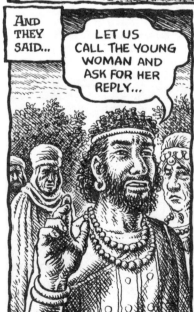

AND THEY CALLED REBEKAH AND SAID TO HER...

WILL YOU GO WITH THIS MAN?

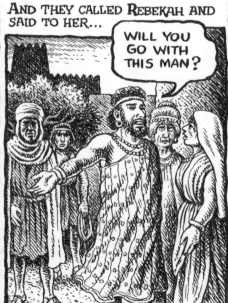

AND SHE SAID...

I WILL!

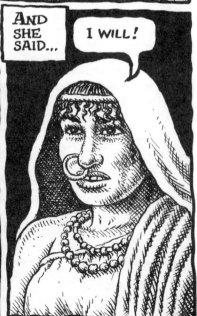

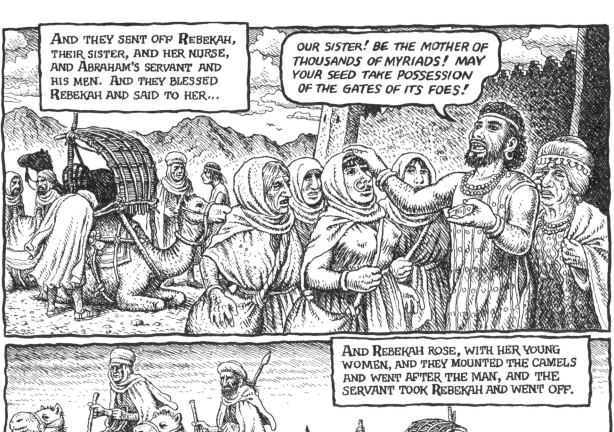

AND THEY SENT OFF REBEKAH, THEIR SISTER, AND HER NURSE, AND ABRAHAM'S SERVANT AND HIS MEN. AND THEY BLESSED REBEKAH AND SAID TO HER...

OUR SISTER! BE THE MOTHER OF THOUSANDS OF MYRIADS! MAY YOUR SEED TAKE POSSESSION OF THE GATES OF ITS FOES!

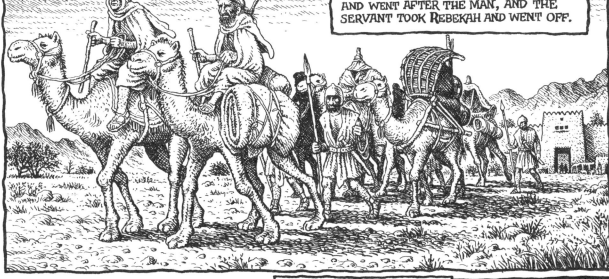

AND REBEKAH ROSE, WITH HER YOUNG WOMEN, AND THEY MOUNTED THE CAMELS AND WENT AFTER THE MAN, AND THE SERVANT TOOK REBEKAH AND WENT OFF.

AND ISAAC HAD COME BY WAY OF THE WELL OF BEER-LAHAI-ROI, AS HE WAS DWELLING IN THE NEGEB REGION. AND ISAAC WENT OUT TO MEDITATE IN THE FIELD TOWARD EVENING.

AND HE RAISED HIS EYES AND LOOKED, AND, BEHOLD, CAMELS WERE COMING.

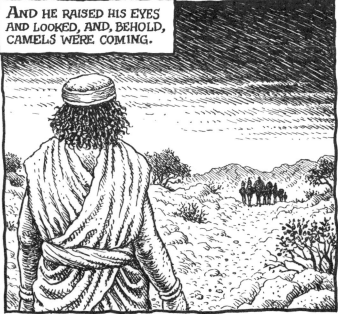

AND REBEKAH RAISED HER EYES AND SAW ISAAC.

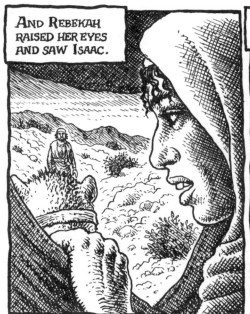

AND SHE ALIGHTED FROM THE CAMEL, AND SHE SAID TO THE SERVANT...

WHO IS THAT MAN WALKING THROUGH THE FIELD TOWARD US?

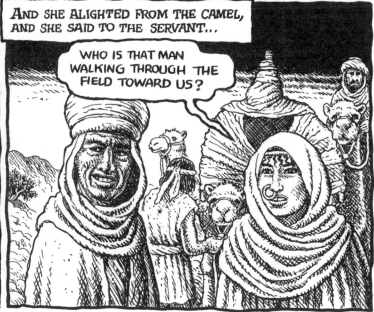

AND THE SERVANT SAID...

HE IS MY MASTER!

AND SHE TOOK HER VEIL AND COVERED HER FACE.

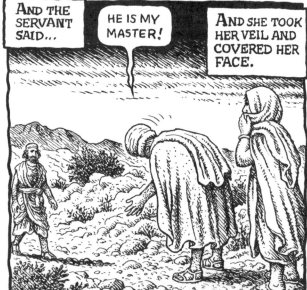

AND THE SERVANT RECOUNTED TO ISAAC ALL THE THINGS HE HAD DONE.

AND ISAAC BROUGHT HER INTO THE TENT OF SARAH, HIS MOTHER, AND TOOK REBEKAH AS WIFE. AND HE LOVED HER, AND ISAAC FOUND SOLACE AFTER THE DEATH OF HIS MOTHER.

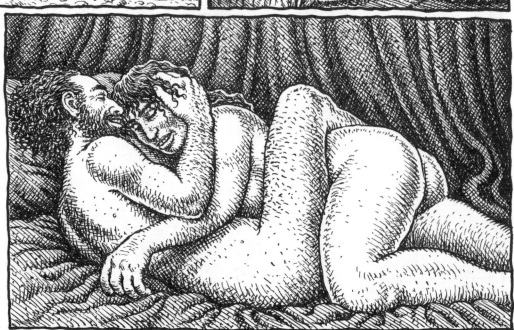

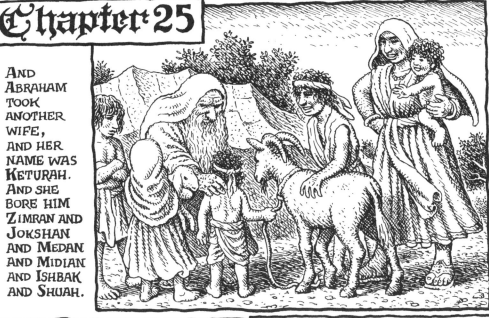

AND ABRAHAM TOOK ANOTHER WIFE, AND HER NAME WAS KETURAH. AND SHE BORE HIM ZIMRAN AND JOKSHAN AND MEDAN AND MIDIAN AND ISHBAK AND SHUAH.

AND JOKSHAN BEGOT SHEBA AND DEDAN. AND THE SONS OF DEDAN WERE THE ASHURIM AND THE LETUSHIM AND THE LEUMMIM. AND THE SONS OF MIDIAN WERE EPHAH AND EPHER AND ENOCH AND ABIDA AND ELDAAH. ALL THESE WERE THE DESCENDANTS OF KETURAH.

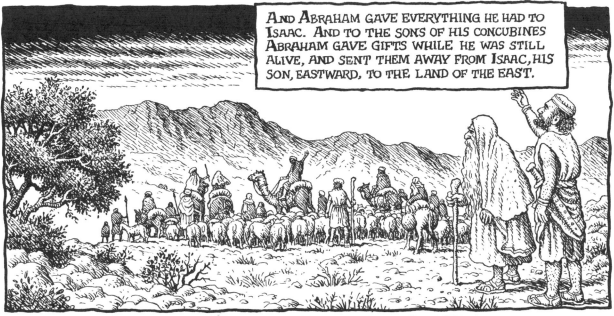

AND ABRAHAM GAVE EVERYTHING HE HAD TO ISAAC. AND TO THE SONS OF HIS CONCUBINES ABRAHAM GAVE GIFTS WHILE HE WAS STILL ALIVE, AND SENT THEM AWAY FROM ISAAC, HIS SON, EASTWARD, TO THE LAND OF THE EAST.

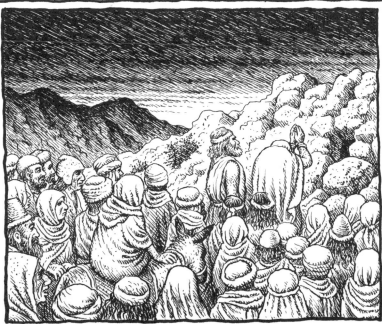

AND THESE ARE THE DAYS OF THE YEARS OF THE LIFE OF ABRAHAM, WHICH HE LIVED: 175 YEARS. AND ABRAHAM BREATHED HIS LAST AND DIED AT A RIPE OLD AGE, OLD AND SATED WITH YEARS, AND HE WAS GATHERED TO HIS KINFOLK.

AND ISAAC AND ISHMAEL, HIS SONS, BURIED HIM IN THE MACHPELAH CAVE IN THE FIELD OF EPHRON, SON OF ZOHAR THE HITTITE, WHICH FACES MAMRE, THE FIELD THAT ABRAHAM HAD BOUGHT FROM THE HITTITES. THERE ABRAHAM WAS BURIED, WITH SARAH, HIS WIFE.

AND IT CAME TO PASS AFTER THE DEATH OF ABRAHAM THAT GOD BLESSED HIS SON ISAAC, AND ISAAC SETTLED NEAR BEER-LAHAI-ROI.

AND THIS IS THE LINEAGE OF ISHMAEL, SON OF ABRAHAM WHOM HAGAR, THE EGYPTIAN, SARAH'S SLAVE-GIRL, BORE TO ABRAHAM. AND THESE ARE THE NAMES OF THE SONS OF ISHMAEL ACCORDING TO THEIR LINEAGE...

NEBAIOTH, THE FIRSTBORN OF ISHMAEL...

AND KEDAR...

AND ADBEEL...

AND MIBSAM...

AND MISHMA...

AND DUMA...

AND MASSA...

HADAD...

AND TEMA...

JETUR...

NAPHISH...

AND KEDMAH.

THESE ARE THE SONS OF ISHMAEL, AND THESE ARE THEIR NAMES, BY THEIR TOWNS AND BY THEIR STRONG-HOLDS, TWELVE CHIEFTAINS ACCORDING TO THEIR CLANS.

AND THESE ARE THE YEARS OF THE LIFE OF ISHMAEL: 137 YEARS. AND HE BREATHED HIS LAST AND DIED AND HE WAS GATHERED TO HIS KINFOLK. AND THEY RANGED FROM HAVILAH TO SHUR, WHICH FACES EGYPT, AND TILL YOU COME TO ASSHUR.

AND THIS IS THE LINEAGE OF ISAAC, SON OF ABRAHAM. ABRAHAM BEGOT ISAAC. AND ISAAC WAS FORTY YEARS OLD WHEN HE TOOK AS WIFE REBEKAH, DAUGHTER OF BETHUEL THE ARAMEAN FROM PADDAN-ARAM, SISTER OF LABAN THE ARAMEAN. AND ISAAC PLEADED WITH THE LORD ON BEHALF OF HIS WIFE, FOR SHE WAS BARREN.

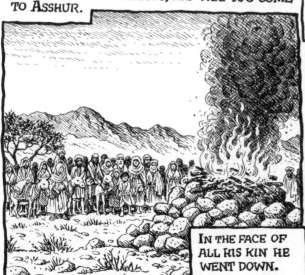

IN THE FACE OF ALL HIS KIN HE WENT DOWN.

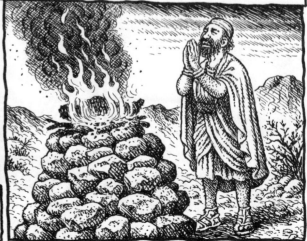

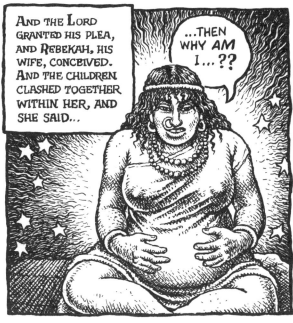

AND THE LORD GRANTED HIS PLEA, AND REBEKAH, HIS WIFE, CONCEIVED. AND THE CHILDREN CLASHED TOGETHER WITHIN HER, AND SHE SAID...

...THEN WHY AM I...??

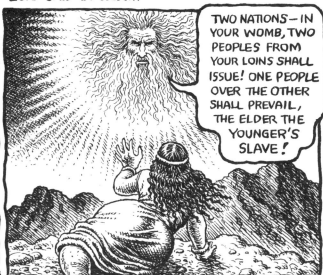

AND SHE WENT TO INQUIRE OF THE LORD. AND THE LORD SAID TO HER...

TWO NATIONS—IN YOUR WOMB, TWO PEOPLES FROM YOUR LOINS SHALL ISSUE! ONE PEOPLE OVER THE OTHER SHALL PREVAIL, THE ELDER THE YOUNGER'S SLAVE!

AND WHEN HER TIME WAS COME TO GIVE BIRTH, BEHOLD, THERE WERE TWINS IN HER WOMB. AND THE FIRST ONE CAME OUT RUDDY, LIKE A HAIRY MANTLE ALL OVER, AND THEY CALLED HIS NAME ESAU. THEN HIS BROTHER CAME OUT, HIS HAND GRASPING ESAU'S HEEL, AND THEY CALLED HIS NAME JACOB.

AND ISAAC WAS SIXTY YEARS OLD WHEN THEY WERE BORN.

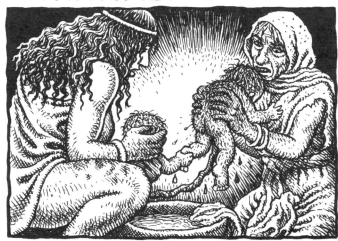

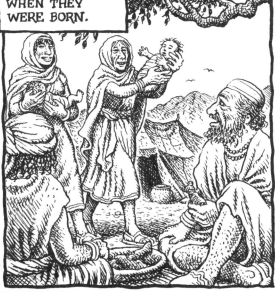

AND THE LADS GREW UP, AND ESAU WAS A MAN SKILLED IN HUNTING, A MAN OF THE FIELD.

AND JACOB WAS A MILD MAN, A DWELLER IN TENTS.

AND ISAAC LOVED ESAU BECAUSE HE HAD A TASTE FOR GAME.

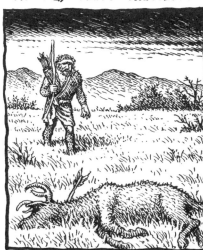

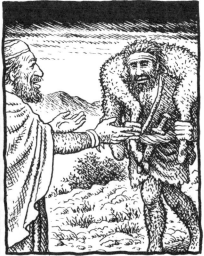

BUT REBEKAH LOVED JACOB.

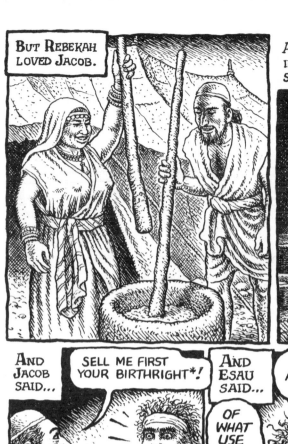

AND JACOB WAS PREPARING A STEW, AND ESAU CAME IN FROM THE FIELD, AND HE WAS FAMISHED, AND ESAU SAID TO JACOB...

LET ME GULP DOWN SOME OF THIS RED RED STUFF! I'M FAMISHED!

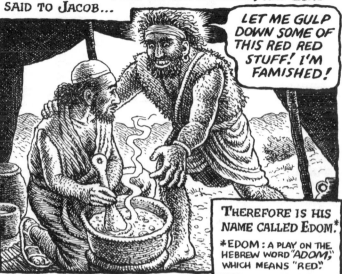

THEREFORE IS HIS NAME CALLED EDOM.*

*EDOM: A PLAY ON THE HEBREW WORD "ADOM," WHICH MEANS "RED."

AND JACOB SAID...

SELL ME FIRST YOUR BIRTHRIGHT*!

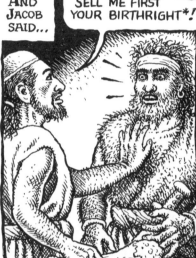

*BIRTHRIGHT: RIGHT OF THE FIRSTBORN SON TO INHERIT HIS FATHER'S ESTATE.

AND ESAU SAID...

BEHOLD, I'M AT THE POINT OF DEATH!!

OF WHAT USE IS MY BIRTH-RIGHT TO ME?!

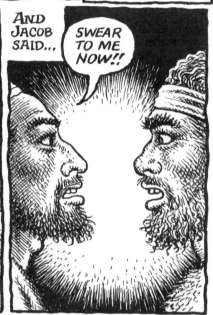

AND JACOB SAID...

SWEAR TO ME NOW!!

AND HE SWORE TO HIM, AND HE SOLD HIS BIRTHRIGHT TO JACOB.

THEN JACOB GAVE ESAU BREAD AND LENTIL STEW AND HE ATE AND DRANK.

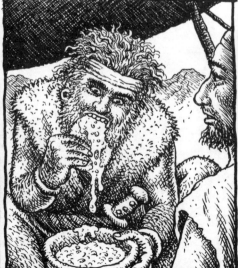

AND HE ROSE AND HE WENT OFF, AND THUS DID ESAU SPURN HIS BIRTHRIGHT.

AND THERE WAS A FAMINE IN THE LAND—ASIDE FROM THE FORMER FAMINE THAT WAS IN THE DAYS OF ABRAHAM—AND ISAAC WENT TO ABIMELECH, KING OF THE PHILISTINES IN GERAR.

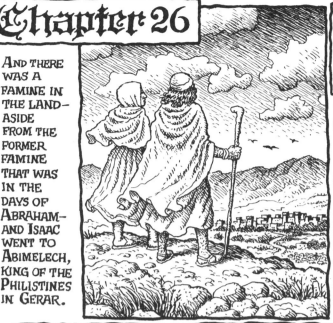

AND THE LORD APPEARED TO HIM AND SAID...

DO NOT GO DOWN TO EGYPT!

STAY IN THE LAND THAT I SHALL SAY TO YOU!

SOJOURN IN THIS LAND SO THAT I MAY BE WITH YOU AND BLESS YOU, FOR TO YOU AND YOUR SEED I WILL GIVE ALL THESE LANDS, AND I WILL FULFILL THE OATH THAT I SWORE TO ABRAHAM, YOUR FATHER, AND I WILL MULTIPLY YOUR SEED LIKE THE STARS IN THE HEAVENS!

AND I WILL GIVE TO YOUR SEED ALL THESE LANDS, AND ALL THE NATIONS OF THE EARTH SHALL BE BLESSED THROUGH YOUR SEED BECAUSE ABRAHAM LISTENED TO MY VOICE AND KEPT MY CHARGE, MY COMMANDMENTS, MY STATUTES, AND MY TEACHINGS.

AND ISAAC DWELT IN GERAR. AND THE MEN OF THE PLACE ASKED OF HIS WIFE, AND HE SAID, "SHE IS MY SISTER", FEARING TO SAY, "MY WIFE"—"LEST THE MEN OF THE PLACE KILL ME OVER REBEKAH, FOR SHE IS COMELY TO LOOK AT."

AND IT CAME TO PASS, WHEN HE HAD BEEN THERE FOR SOME TIME, THAT ABIMELECH, KING OF THE PHILISTINES, LOOKED OUT THE WINDOW AND SAW...

...AND THERE WAS ISAAC FROLICKING WITH REBEKAH, HIS WIFE!

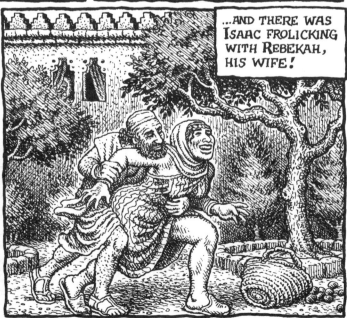

AND ABIMELECH SUMMONED ISAAC AND HE SAID...

WELL, BEHOLD! SHE IS YOUR *WIFE*! HOW THEN COULD YOU SAY, "SHE IS MY SISTER"!?

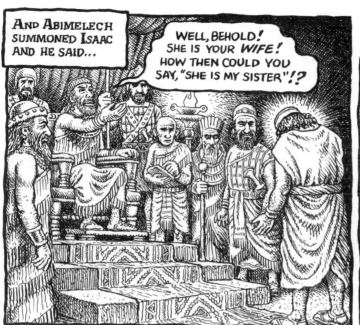

AND ISAAC SAID TO HIM...

BECAUSE I THOUGHT I MIGHT LOSE MY LIFE ON ACCOUNT OF HER!

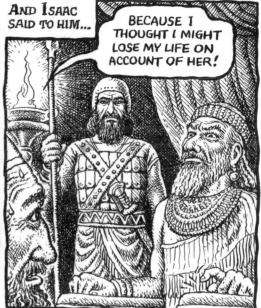

AND ABIMELECH SAID...

WHAT IS THIS YOU HAVE DONE TO US?? ONE OF MY PEOPLE MIGHT WELL HAVE LAIN WITH YOUR WIFE, AND YOU WOULD HAVE BROUGHT *GUILT* UPON US!

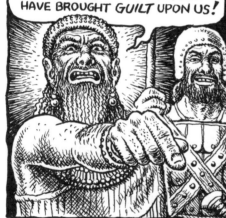

AND ABIMELECH COMMANDED ALL THE PEOPLE, SAYING...

WHOEVER MOLESTS THIS MAN OR HIS WIFE SHALL BE PUT TO DEATH!!

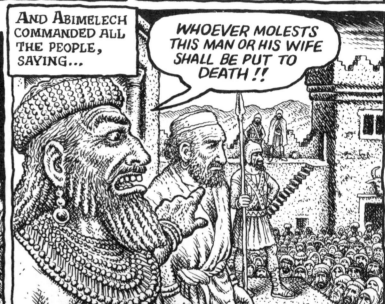

AND ISAAC SOWED IN THAT LAND, AND HE REAPED THAT YEAR A HUNDREDFOLD, AND THE LORD BLESSED HIM. AND THE MAN BECAME EVER GREATER UNTIL HE WAS VERY GREAT. AND HE HAD POSSESSIONS OF FLOCKS AND HERDS AND MANY SLAVES...

...AND THE PHILISTINES ENVIED HIM.

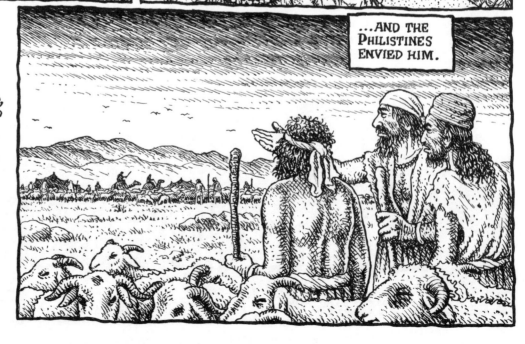

AND ALL THE WELLS THAT HIS FATHER'S SERVANTS HAD DUG IN THE DAYS OF ABRAHAM HIS FATHER, THE PHILISTINES STOPPED UP, FILLING THEM WITH EARTH.

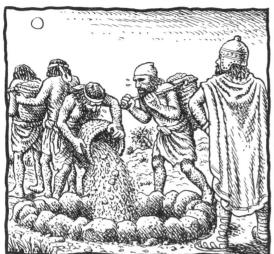

AND ABIMELECH SAID TO ISAAC...

GO AWAY FROM US! YOU'VE GROWN FAR TOO POWERFUL FOR US!

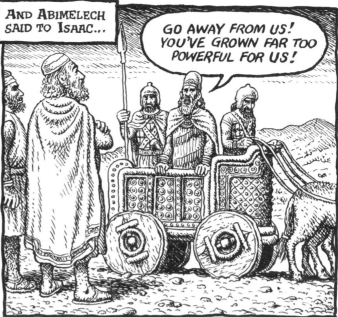

AND ISAAC WENT OFF FROM THERE AND PITCHED HIS CAMP IN THE WADI* OF GERAR, AND HE DWELT THERE.

*WADI: A DRY RIVERBED THAT RUNS WITH WATER ONLY DURING THE RAINY SEASON.

AND ISAAC DUG ANEW THE WELLS OF WATER THAT HAD BEEN DUG IN THE DAYS OF ABRAHAM, HIS FATHER, WHICH THE PHILISTINES HAD STOPPED UP AFTER ABRAHAM'S DEATH, AND HE GAVE THEM THE SAME NAMES HIS FATHER HAD GIVEN THEM.

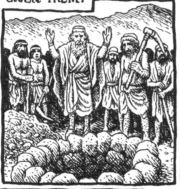

AND ISAAC'S SERVANTS DUG IN THE WADI, AND THEY FOUND THERE A WELL OF FRESH WATER. AND THE SHEPHERDS OF GERAR QUARRELED WITH ISAAC'S SHEPHERDS, SAYING...

THIS WATER IS OURS!!

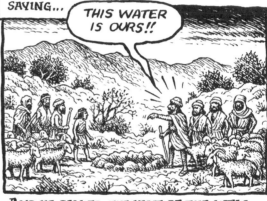

AND HE CALLED THE NAME OF THE WELL ESEK,* FOR THEY HAD CONTENDED WITH HIM.

*ESEK: IN HEBREW, ROUGHLY, "CONTENTION!"

AND THEY DUG ANOTHER WELL, AND THEY QUARRELED OVER IT, TOO, AND HE CALLED ITS NAME SITNAH.*

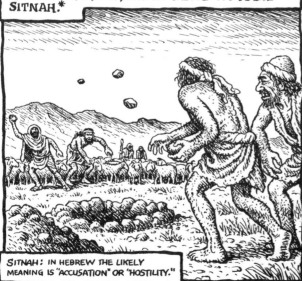

SITNAH: IN HEBREW THE LIKELY MEANING IS "ACCUSATION" OR "HOSTILITY."

AND HE PULLED UP STAKES FROM THERE AND DUG ANOTHER WELL, AND THEY DID NOT QUARREL OVER IT, AND HE CALLED ITS NAME REHOBOTH*, AND HE SAID...

FOR NOW THE LORD HAS MADE ROOM FOR US THAT WE MAY BE FRUITFUL IN THE LAND!

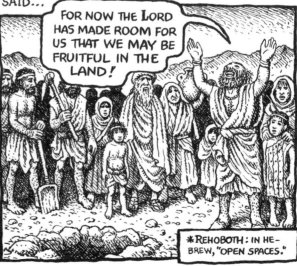

*REHOBOTH: IN HEBREW, "OPEN SPACES."

AND HE WENT UP FROM THERE TO BEERSHEBA. AND THE LORD APPEARED UNTO HIM ON THAT NIGHT AND SAID...

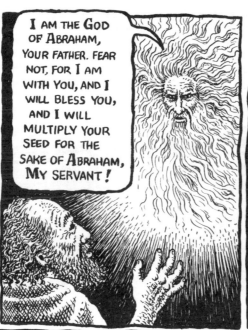

I AM THE GOD OF ABRAHAM, YOUR FATHER. FEAR NOT, FOR I AM WITH YOU, AND I WILL BLESS YOU, AND I WILL MULTIPLY YOUR SEED FOR THE SAKE OF ABRAHAM, MY SERVANT!

AND HE BUILT AN ALTAR THERE, AND HE INVOKED THE NAME OF THE LORD, AND HE PITCHED HIS TENT THERE. AND ISAAC'S SERVANTS BEGAN DIGGING A WELL THERE.

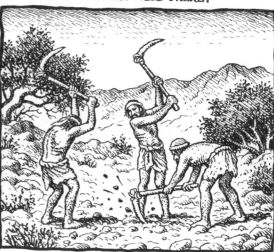

AND ABIMELECH CAME TO HIM FROM GERAR, WITH AHUZZATH, HIS COUNCILOR, AND PHICOL, CAPTAIN OF HIS TROOPS. AND ISAAC SAID TO THEM...

WHY HAVE YOU COME TO ME WHEN YOU'VE BEEN HOSTILE TOWARD ME, AND HAVE SENT ME AWAY FROM YOU?!

AND THEY SAID...

WE HAVE CLEARLY SEEN THAT THE LORD IS WITH YOU, AND WE THOUGHT, LET THERE BE AN OATH BETWEEN OUR TWO SIDES, BETWEEN YOU AND US!

AND LET US SEAL A PACT WITH YOU, THAT YOU WILL DO NO HARM TO US, JUST AS WE HAVE NOT TOUCHED YOU, AND JUST AS WE'VE DONE TOWARD YOU ONLY GOOD, SENDING YOU AWAY IN PEACE.

BE YOU HENCE BLESSED OF THE LORD!

AND HE MADE THEM A FEAST, AND THEY ATE AND DRANK.

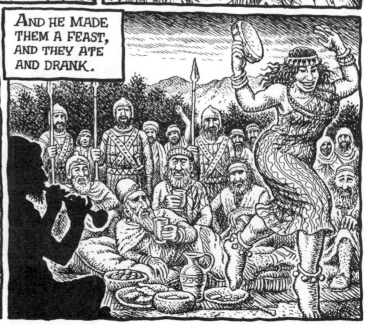

AND THEY ROSE EARLY IN THE MORNING AND SWORE TO EACH OTHER.

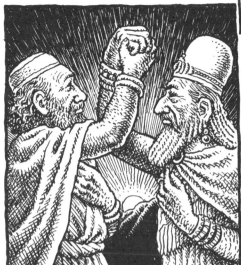

AND ISAAC SENT THEM AWAY, AND THEY WENT FROM HIM IN PEACE. AND IT CAME TO PASS ON THAT DAY THAT ISAAC'S SERVANTS CAME AND TOLD HIM OF THE WELL THEY HAD DUG, AND THEY SAID TO HIM...

WE'VE FOUND WATER!

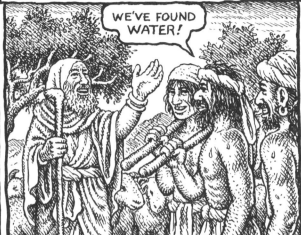

AND HE CALLED IT SHIBAH,* THEREFORE THE NAME OF THE TOWN IS BEERSHEBA TO THIS DAY.

*SHIBAH: IN THIS CONTEXT THE WORD IS RELATED TO THE HEBREW WORD SHEVU'AH, MEANING "OATH!"

AND ESAU WAS FORTY YEARS OLD AND HE TOOK AS WIVES JUDITH, THE DAUGHTER OF BEERI THE HITTITE, AND BASEMATH, THE DAUGHTER OF ELON THE HITTITE. AND THEY WERE A SOURCE OF PROVOCATION TO ISAAC AND TO REBEKAH.

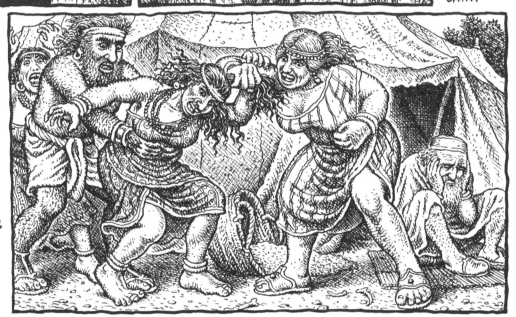

Chapter 27

AND IT CAME TO PASS WHEN ISAAC WAS OLD, THAT HIS EYES GREW TOO BLEARY TO SEE, AND HE CALLED TO ESAU, HIS ELDER SON, AND SAID TO HIM...

MY SON!

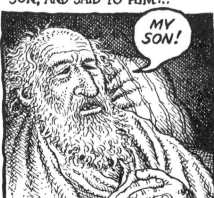

AND HE SAID...

HERE I AM!

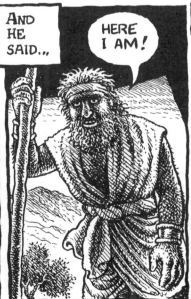

AND HE SAID...

BEHOLD, I'VE GROWN OLD!

I KNOW NOT HOW SOON I SHALL DIE!!

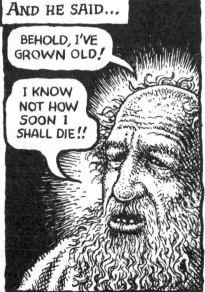

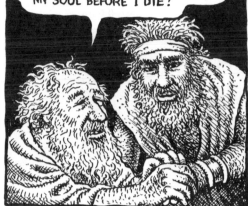
SO NOW, TAKE UP, I PRAY YOU, YOUR WEAPONS, YOUR QUIVER AND YOUR BOW, AND GO OUT TO THE FIELD, AND HUNT ME SOME GAME, AND MAKE ME A DISH OF THE KIND THAT I LOVE, AND BRING IT TO ME THAT I MAY EAT, SO THAT I MAY GIVE YOU A SOLEMN BLESSING FROM MY SOUL BEFORE I DIE!

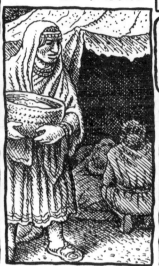
AND REBEKAH WAS LISTENING AS ISAAC SPOKE TO ESAU, HIS SON.

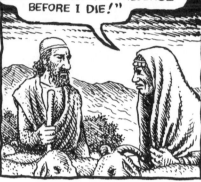
AND ESAU WENT OFF TO HUNT GAME TO BRING. AND REBEKAH SAID TO JACOB, HER SON...

BEHOLD, I HEARD YOUR FATHER SPEAKING TO ESAU, YOUR BROTHER, SAYING, "BRING ME SOME GAME AND MAKE ME A DISH THAT I MAY EAT, AND I SHALL BLESS YOU IN THE LORD'S PRESENCE BEFORE I DIE!"

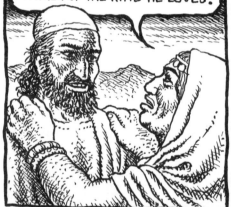
SO NOW, MY SON, LISTEN TO MY VOICE, TO WHAT I COMMAND YOU! GO NOW TO THE FLOCK AND FETCH ME FROM THERE TWO CHOICE KIDS, AND I WILL MAKE THEM INTO A DISH FOR YOUR FATHER OF THE KIND HE LOVES!

AND YOU SHALL BRING IT TO YOUR FATHER, AND HE SHALL EAT, SO THAT HE MAY BLESS YOU BEFORE HE DIES!

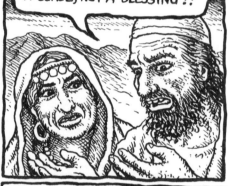
AND JACOB SAID TO REBEKAH, HIS MOTHER...

BEHOLD, ESAU, MY BROTHER, IS A HAIRY MAN, AND I'M A SMOOTH-SKINNED MAN. WHAT IF MY FATHER FEELS ME AND I SEEM TO HIM A DECEIVER, AND BRING ON MYSELF A CURSE, NOT A BLESSING?!

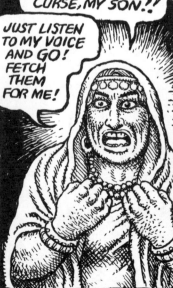
UPON ME YOUR CURSE, MY SON!!

JUST LISTEN TO MY VOICE AND GO! FETCH THEM FOR ME!

AND HE WENT AND HE FETCHED AND HE BROUGHT TO HIS MOTHER, AND HIS MOTHER MADE A DISH OF THE KIND HIS FATHER LOVED.

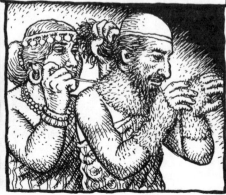
AND REBEKAH TOOK THE GARMENTS OF ESAU, HER ELDER SON, THE FINERY THAT WAS WITH HER IN THE HOUSE, AND PUT THEM ON JACOB, HER YOUNGER SON, AND THE SKINS OF THE KIDS SHE PUT ON HIS HANDS AND ON THE SMOOTH PART OF HIS NECK.

AND SHE PLACED THE DISH AND THE BREAD SHE HAD MADE IN THE HAND OF JACOB, HER SON, AND HE CAME TO HIS FATHER AND SAID...

FATHER!

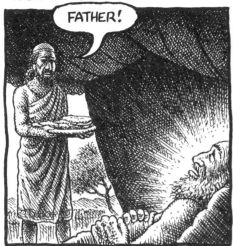

AND HE SAID...

HERE I AM! WHO ARE YOU, MY SON??

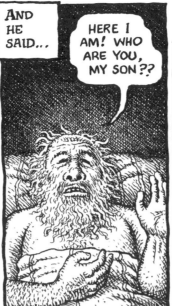

AND JACOB SAID TO HIS FATHER...

I AM ESAU, YOUR FIRST-BORN! I'VE DONE AS YOU TOLD ME. RISE, PRAY, SIT UP AND EAT OF MY GAME, SO THAT YOU MAY GIVE ME YOUR MOST SOLEMN BLESSING!

?!

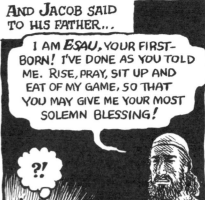

AND ISAAC SAID TO HIS SON...

HOW IS IT THAT YOU FOUND IT SO SOON, MY SON??

AND HE SAID...

BECAUSE THE LORD, YOUR GOD, GAVE ME GOOD LUCK!

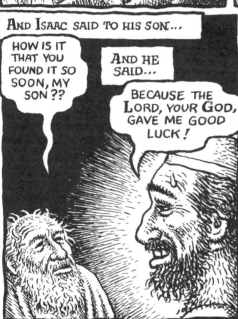

AND ISAAC SAID TO JACOB...

COME CLOSE, PRAY, THAT I MAY FEEL YOU, MY SON, WHETHER YOU ARE MY SON ESAU OR NOT!

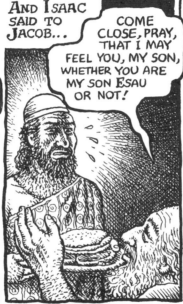

AND JACOB CAME CLOSE TO ISAAC HIS FATHER AND HE FELT HIM, AND HE SAID...

THE VOICE IS THE VOICE OF JACOB, BUT THE HANDS ARE ESAU'S HANDS...

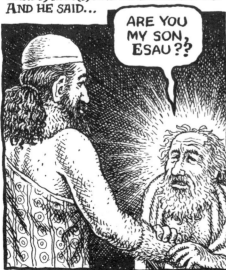

BUT HE DID NOT RECOGNIZE HIM, FOR HIS HANDS WERE LIKE ESAU'S HANDS, HAIRY, AND HE BLESSED HIM. AND HE SAID...

ARE YOU MY SON, ESAU??

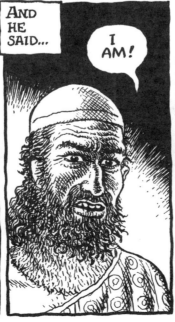

AND HE SAID...

I AM!

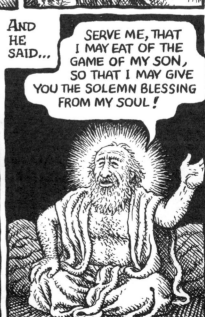

AND HE SAID...

SERVE ME, THAT I MAY EAT OF THE GAME OF MY SON, SO THAT I MAY GIVE YOU THE SOLEMN BLESSING FROM MY SOUL!

AND HE SERVED HIM, AND HE ATE, AND HE BROUGHT HIM WINE, AND HE DRANK.

AND ISAAC HIS FATHER SAID TO HIM...

COME CLOSE, PRAY, AND KISS ME, MY SON!

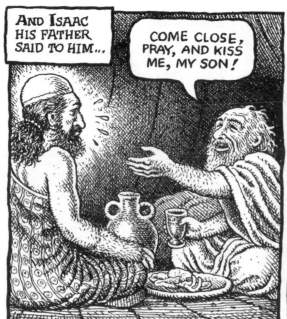

AND HE CAME CLOSE AND KISSED HIM, AND HE SMELLED HIS GARMENTS, AND HE BLESSED HIM, AND HE SAID...

SEE, THE SMELL OF MY SON IS LIKE THE SMELL OF THE FIELD THAT THE LORD HAS BLESSED!

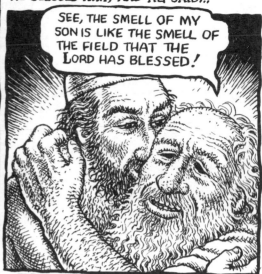

MAY GOD GRANT YOU FROM THE DEW OF THE HEAVENS AND THE FAT OF THE EARTH AND ABUNDANCE OF GRAIN AND DRINK! MAY PEOPLES SERVE YOU, AND NATIONS BOW DOWN TO YOU!

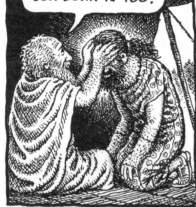

BE OVERLORD TO YOUR BROTHERS, AND MAY YOUR MOTHER'S SONS BOW DOWN TO YOU! THOSE WHO CURSE YOU BE CURSED, AND THOSE WHO BLESS YOU, BLESSED!

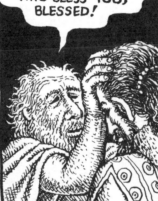

AND IT CAME TO PASS AS SOON AS ISAAC FINISHED BLESSING JACOB, AND JACOB HAD BARELY LEFT THE PRESENCE OF ISAAC HIS FATHER, THAT ESAU HIS BROTHER CAME BACK FROM THE HUNT. AND HE, TOO, MADE A DISH AND BROUGHT IT TO HIS FATHER.

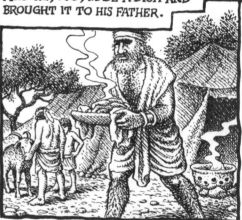

AND HE SAID TO HIS FATHER...

LET MY FATHER RISE AND EAT OF THE GAME OF HIS SON, SO THAT YOU MAY SOLEMNLY BLESS ME!

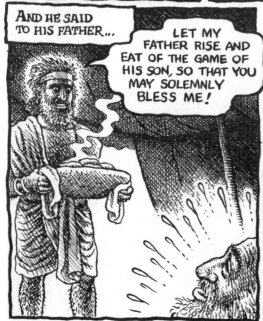

AND HIS FATHER ISAAC SAID...

WHO *ARE* YOU??

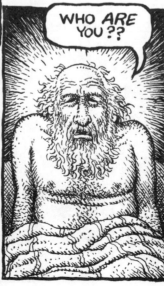

AND HE SAID...

I AM YOUR SON, YOUR FIRSTBORN, *ESAU!!*

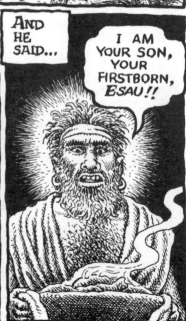

AND ISAAC WAS SEIZED WITH A GREAT TREMBLING, AND HE SAID...

WHO IS IT THEN WHO CAUGHT GAME AND BROUGHT IT TO ME, AND I ATE EVERYTHING BEFORE YOU CAME, AND BLESSED HIM ??

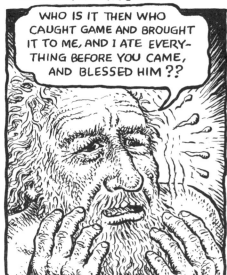

AND NOW BLESSED HE STAYS!

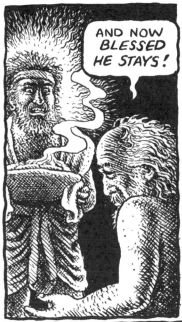

WHEN ESAU HEARD HIS FATHER'S WORDS HE CRIED OUT WITH A GREAT AND EXCEEDINGLY BITTER OUTCRY, AND HE SAID TO HIS FATHER...

BLESS ME, TOO, FATHER!

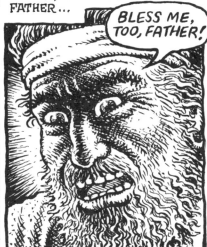

AND HE SAID...

YOUR BROTHER HAS COME IN DECEIT AND HAS TAKEN YOUR BLESSING!

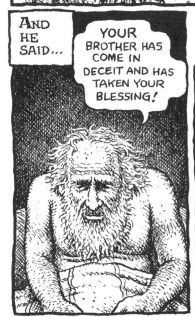

AND HE SAID...

WAS HE RIGHTLY NAMED JACOB*, THAT HE SHOULD TRIP ME NOW TWICE BY THE HEELS ??

MY BIRTHRIGHT HE TOOK, AND, BEHOLD, NOW HE'S TAKEN MY BLESSING!

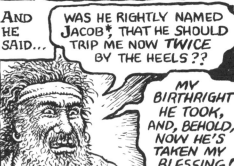
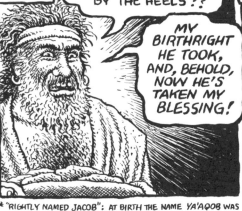

* "RIGHTLY NAMED JACOB": AT BIRTH THE NAME YA'AQOB WAS A PLAY ON HEBREW WORDS MEANING "HEEL GRABBER." HERE ANOTHER PLAY ON HEBREW MAKES THE NAME INTO A VERB MEANING "CROOKED," WITH THE OBVIOUS SENSE OF DEVIOUS OR DECEITFUL DEALING.

AND HE SAID...

HAVE YOU NOT RESERVED A BLESSING FOR ME ??

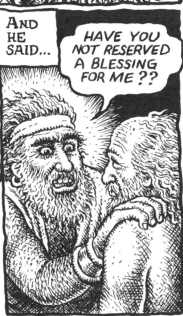

AND ISAAC ANSWERED AND SAID TO ESAU...

WHAT CAN I DO FOR YOU, THEN, MY SON ??

BEHOLD, I MADE HIM OVERLORD TO YOU, AND I GAVE HIM ALL HIS BROTHERS AS SLAVES, AND I ENDOWED HIM WITH GRAIN AND WINE!

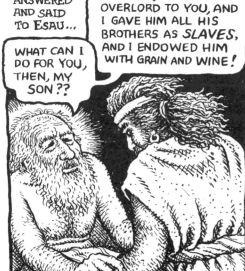

AND ESAU SAID TO HIS FATHER...

DO YOU HAVE ONLY ONE BLESSING, FATHER? BLESS ME, TOO, FATHER!

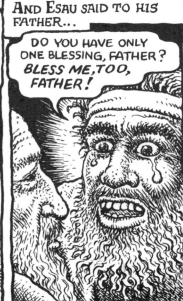

AND ESAU RAISED HIS VOICE AND HE WEPT.

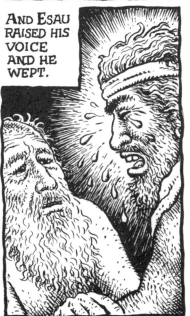

AND ISAAC HIS FATHER ANSWERED AND SAID TO HIM...

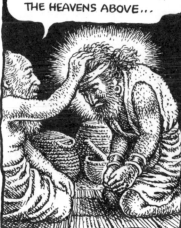

BEHOLD, FROM THE FAT OF THE EARTH BE YOUR DWELLING, AND FROM THE DEW OF THE HEAVENS ABOVE...

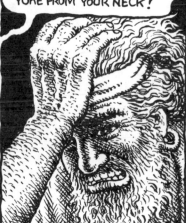

BY YOUR SWORD YOU SHALL LIVE, AND YOUR BROTHER SHALL YOU SERVE. AND WHEN YOU REBEL YOU SHALL BREAK OFF HIS YOKE FROM YOUR NECK!

AND ESAU SEETHED WITH RESENTMENT AGAINST JACOB OVER THE BLESSING HIS FATHER HAD BLESSED HIM, AND ESAU SAID IN HIS HEART...

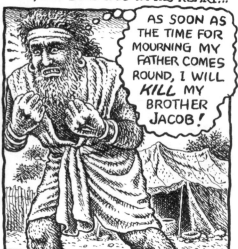

AS SOON AS THE TIME FOR MOURNING MY FATHER COMES ROUND, I WILL KILL MY BROTHER JACOB!

AND REBEKAH WAS TOLD THE WORDS OF ESAU HER ELDER SON, AND SHE SENT AND SUMMONED JACOB HER YOUNGER SON, AND SAID TO HIM...

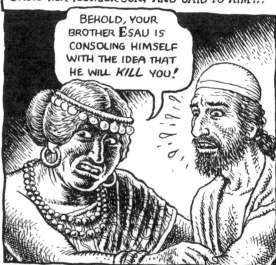

BEHOLD, YOUR BROTHER ESAU IS CONSOLING HIMSELF WITH THE IDEA THAT HE WILL KILL YOU!

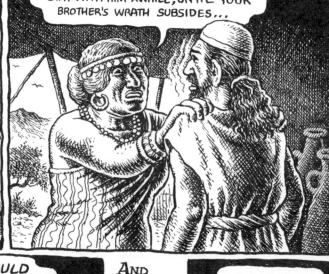

SO NOW, MY SON, LISTEN TO MY VOICE AND RISE, FLEE TO MY BROTHER LABAN IN HARAN, AND YOU MAY STAY WITH HIM AWHILE, UNTIL YOUR BROTHER'S WRATH SUBSIDES...

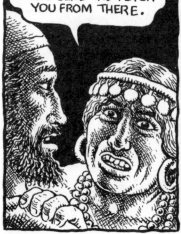

...UNTIL YOUR BROTHER'S RAGE AGAINST YOU SUBSIDES, AND HE FORGETS WHAT YOU DID TO HIM, AND I SHALL SEND AND FETCH YOU FROM THERE.

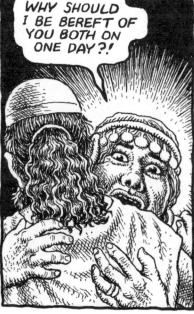

WHY SHOULD I BE BEREFT OF YOU BOTH ON ONE DAY?!

AND REBEKAH SAID TO ISAAC...

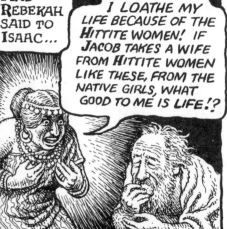

I LOATHE MY LIFE BECAUSE OF THE HITTITE WOMEN! IF JACOB TAKES A WIFE FROM HITTITE WOMEN LIKE THESE, FROM THE NATIVE GIRLS, WHAT GOOD TO ME IS LIFE!?

Chapter 28

AND ISAAC SUMMONED JACOB AND BLESSED HIM, AND COMMANDED HIM, SAYING...

YOU SHALL *NOT* TAKE A WIFE FROM THE DAUGHTERS OF CANAAN! RISE, GO TO PADDAN-ARAM, TO THE HOUSE OF BETHUEL, YOUR *MOTHER'S* FATHER, AND TAKE YOU FROM THERE A WIFE FROM THE DAUGHTERS OF LABAN, YOUR MOTHER'S BROTHER.

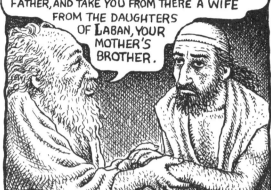

AND MAY EL SHADDAI BLESS YOU AND MAKE YOU FRUITFUL AND MULTIPLY, SO YOU BECOME AN *ASSEMBLY* OF PEOPLES!

AND MAY HE GRANT YOU THE BLESSING OF ABRAHAM, TO YOU AND YOUR SEED AS WELL, THAT YOU MAY TAKE HOLD OF THE LAND OF YOUR SOJOURNINGS, WHICH GOD GRANTED TO ABRAHAM!

AND ISAAC SENT JACOB OFF, AND HE WENT TO PADDAN-ARAM, TO LABAN, SON OF BETHUEL THE ARAMEAN, BROTHER OF REBEKAH, MOTHER OF JACOB AND ESAU.

AND ESAU SAW THAT ISAAC HAD BLESSED JACOB AND HAD SENT HIM OFF TO PADDAN-ARAM TO TAKE HIM A WIFE FROM THERE WHEN HE BLESSED HIM, AND CHARGED HIM, SAYING...

YOU SHALL *NOT* TAKE A WIFE FROM THE DAUGHTERS OF CANAAN!

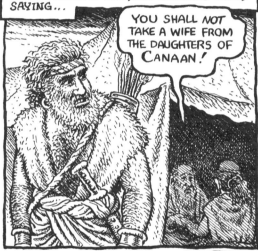

AND JACOB LISTENED TO HIS FATHER AND TO HIS MOTHER AND HE WENT TO PADDAN-ARAM. AND ESAU SAW THAT THE DAUGHTERS OF CANAAN WERE EVIL IN THE EYES OF ISAAC, HIS FATHER.

AND ESAU WENT TO ISHMAEL AND HE TOOK MAHALATH, DAUGHTER OF ISHMAEL, SON OF ABRAHAM, SISTER OF NEBAIOTH, AS WIFE, IN ADDITION TO THE WIVES HE HAD.

AND JACOB LEFT BEERSHEBA AND SET OUT FOR HARAN.

AND HE CAME UPON A CERTAIN PLACE AND STOPPED THERE FOR THE NIGHT, FOR THE SUN HAD SET.

AND HE TOOK ONE OF THE STONES OF THE PLACE AND PUT IT AT HIS HEAD, AND HE LAY DOWN IN THAT PLACE AND HE DREAMED.

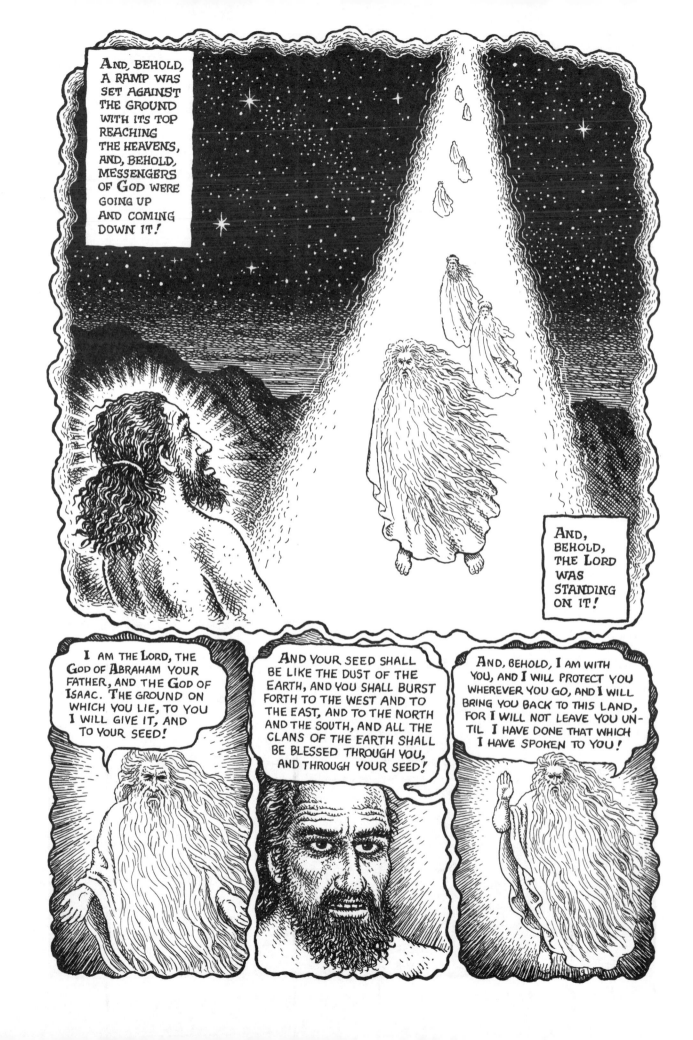

AND JACOB AWOKE FROM HIS SLEEP, AND HE SAID...

INDEED, THE LORD IS IN THIS PLACE, AND I DID NOT KNOW!

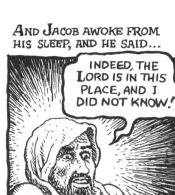

AND HE WAS AFRAID, AND HE SAID...

HOW FEARSOME IS THIS PLACE!!

THIS CAN BE BUT THE HOUSE OF GOD, AND THIS IS THE GATE OF THE HEAVENS!

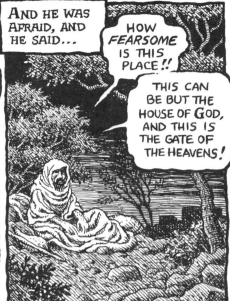

AND JACOB ROSE EARLY IN THE MORNING AND TOOK THE STONE HE HAD PUT AT HIS HEAD, AND SET IT UP AS A PILLAR.

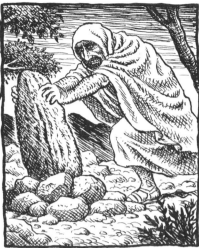

AND HE POURED OIL OVER ITS TOP AND HE CALLED THE NAME OF THAT PLACE BETHEL, THOUGH THE NAME OF THE TOWN BEFORE HAD BEEN LUZ.

AND JACOB MADE A VOW, SAYING...

IF THE LORD GOD BE WITH ME AND PROTECT ME ON THIS WAY THAT I AM GOING, AND GIVES ME BREAD TO EAT AND CLOTHING TO PUT ON, AND IF I RETURN SAFELY TO MY FATHER'S HOUSE, THEN THE LORD WILL BE MY GOD!

AND THIS STONE THAT I SET UP AS A PILLAR WILL BE A HOUSE OF GOD, AND OF ALL THAT YOU GIVE ME I WILL SURELY GIVE THE TENTH UNTO YOU!

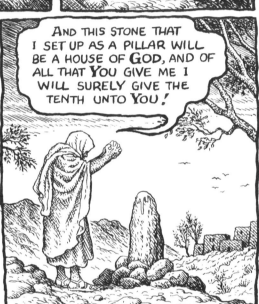

Chapter 29

AND JACOB LIFTED HIS FEET AND JOURNEYED ON TO THE LAND OF THE EASTERNERS. AND HE LOOKED AND, BEHOLD, THERE WAS A WELL IN THE FIELD, AND THREE FLOCKS OF SHEEP WERE LYING BESIDE IT...

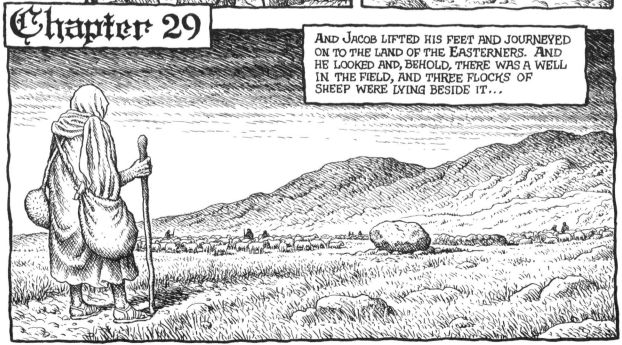

...FOR OUT OF THAT WELL THEY WATERED THE FLOCKS, AND A GREAT STONE WAS ON THE MOUTH OF THE WELL. AND WHEN ALL THE FLOCKS WERE GATHERED THERE, THE STONE WOULD BE ROLLED FROM THE MOUTH OF THE WELL AND THE SHEEP WOULD BE WATERED AND THE STONE AGAIN PUT UPON THE WELL'S MOUTH.

AND JACOB SAID TO THEM...

MY BROTHERS! WHERE ARE YOU FROM?

AND THEY SAID...

WE ARE FROM HARAN!

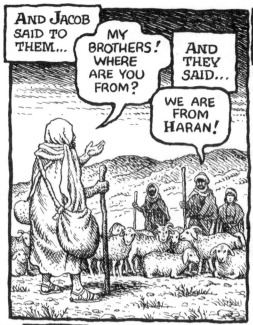

AND HE SAID TO THEM...

DO YOU KNOW LABAN, SON OF NAHOR?

AND THEY SAID...

WE KNOW HIM!

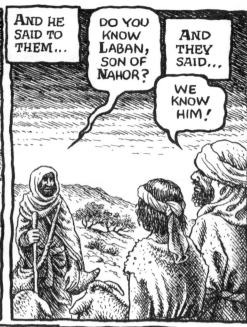

AND HE SAID...

IS HE WELL?

AND THEY SAID...

HE IS WELL, AND, BEHOLD, RACHEL, HIS DAUGHTER, IS COMING WITH THE SHEEP!

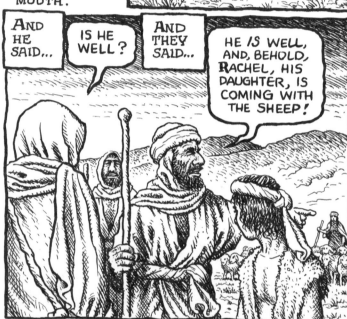

AND HE SAID...

BEHOLD, THE DAY IS STILL LONG! IT'S NOT YET TIME TO GATHER IN THE HERD!

WATER THE SHEEP AND TAKE THEM TO GRAZE!

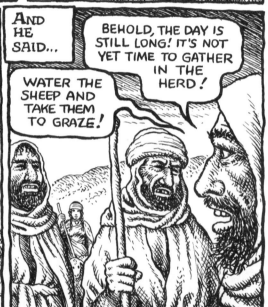

AND THEY SAID...

WE CANNOT UNTIL ALL THE FLOCKS HAVE GATHERED, AND THEN THE STONE IS ROLLED FROM THE MOUTH OF THE WELL, AND THEN WE WATER THE SHEEP.

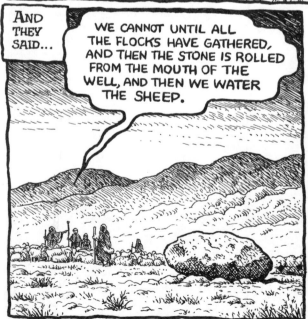

HE WAS STILL SPEAKING WITH THEM WHEN RACHEL CAME WITH HER FATHER'S SHEEP, FOR SHE WAS A SHEPHERDESS.

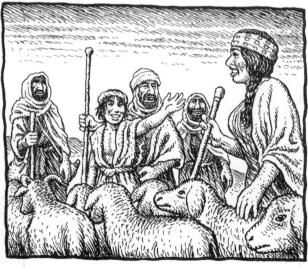

AND IT CAME TO PASS, WHEN JACOB SAW RACHEL, DAUGHTER OF LABAN, HIS MOTHER'S BROTHER, AND THE SHEEP OF LABAN, HIS MOTHER'S BROTHER, THAT HE STEPPED FORWARD AND ROLLED THE STONE FROM THE MOUTH OF THE WELL...

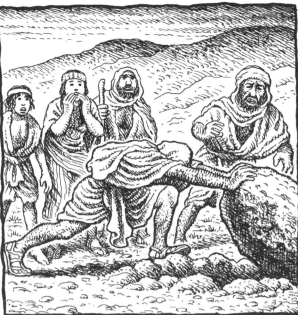

...AND WATERED THE SHEEP OF LABAN, HIS MOTHER'S BROTHER.

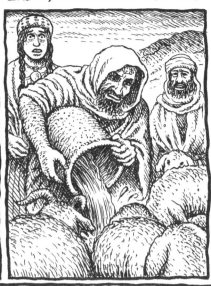

AND JACOB KISSED RACHEL...

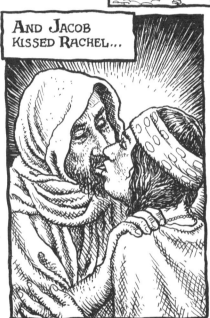

...AND LIFTED UP HIS VOICE AND WEPT.

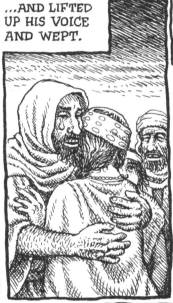

AND JACOB TOLD RACHEL THAT HE WAS HER FATHER'S KIN, AND THAT HE WAS REBEKAH'S SON. AND SHE RAN AND TOLD HER FATHER.

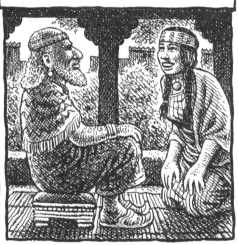

AND IT CAME TO PASS, WHEN LABAN HEARD THE REPORT OF JACOB, HIS SISTER'S SON, HE RAN TO HIM AND EMBRACED HIM AND KISSED HIM, AND BROUGHT HIM TO HIS HOUSE.

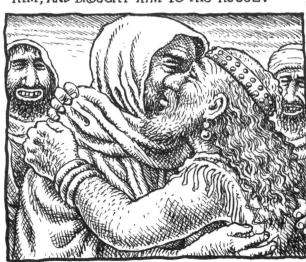

AND HE RECOUNTED TO LABAN ALL THESE THINGS, AND LABAN SAID TO HIM...

INDEED, YOU ARE MY BONE AND MY FLESH!

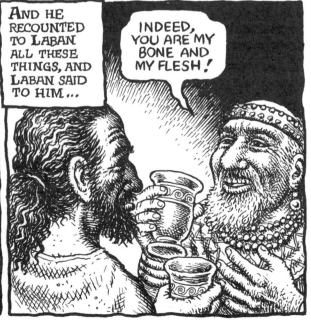

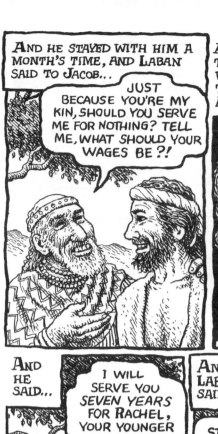

AND HE STAYED WITH HIM A MONTH'S TIME, AND LABAN SAID TO JACOB...

JUST BECAUSE YOU'RE MY KIN, SHOULD YOU SERVE ME FOR NOTHING? TELL ME, WHAT SHOULD YOUR WAGES BE?!

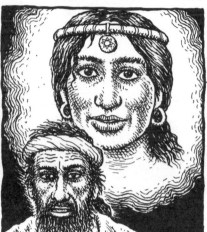

AND LABAN HAD TWO DAUGHTERS. THE NAME OF THE ELDER WAS LEAH AND THE NAME OF THE YOUNGER WAS RACHEL. AND LEAH'S EYES WERE TENDER...

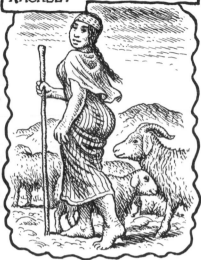

...BUT RACHEL WAS COMELY IN FEATURES AND WELL-FORMED. AND JACOB LOVED RACHEL.

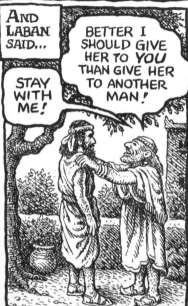

AND HE SAID...

I WILL SERVE YOU SEVEN YEARS FOR RACHEL, YOUR YOUNGER DAUGHTER!

AND LABAN SAID...

BETTER I SHOULD GIVE HER TO YOU THAN GIVE HER TO ANOTHER MAN!

STAY WITH ME!

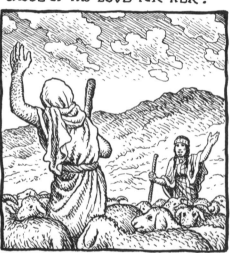

SO JACOB SERVED SEVEN YEARS FOR RACHEL, AND THEY SEEMED IN HIS EYES BUT A FEW DAYS BECAUSE OF HIS LOVE FOR HER!

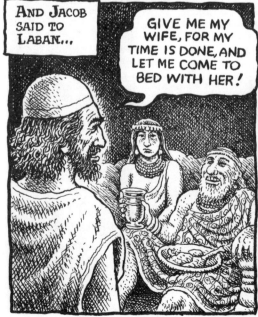

AND JACOB SAID TO LABAN...

GIVE ME MY WIFE, FOR MY TIME IS DONE, AND LET ME COME TO BED WITH HER!

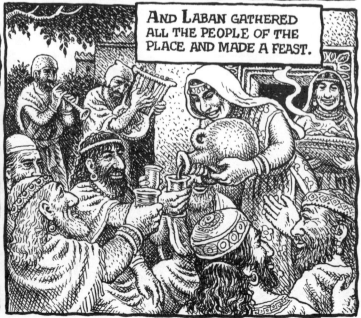

AND LABAN GATHERED ALL THE PEOPLE OF THE PLACE AND MADE A FEAST.

AND WHEN NIGHT CAME HE TOOK HIS DAUGHTER LEAH AND BROUGHT HER TO JACOB. AND LABAN GAVE HIS SLAVEGIRL ZILPAH TO LEAH TO BE HER HANDMAID.

AND WHEN MORNING CAME, BEHOLD, IT WAS LEAH!

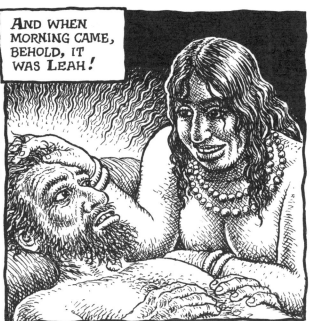

AND HE SAID TO LABAN...

WHAT IS THIS YOU'VE DONE TO ME?! WASN'T IT FOR RACHEL THAT I SERVED YOU??

WHY HAVE YOU DECEIVED ME??

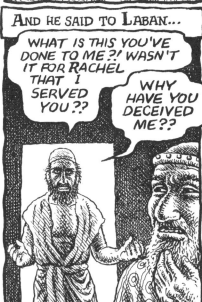

AND LABAN SAID...

IT'S NOT THE PRACTICE IN OUR PLACE TO GIVE THE YOUNGER GIRL BEFORE THE FIRSTBORN.

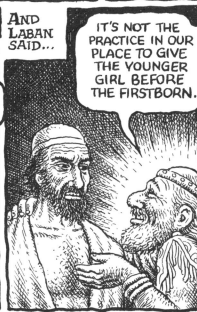

FINISH OUT THE BRIDAL WEEK WITH THIS ONE AND WE SHALL GIVE YOU THE OTHER ONE AS WELL, FOR THE SERVICE YOU RENDER ME FOR STILL ANOTHER SEVEN YEARS.

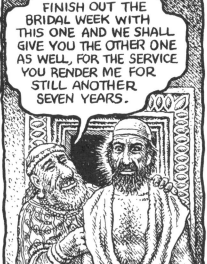

AND SO JACOB DID. AND WHEN HE HAD FINISHED OUT THE BRIDAL WEEK WITH THE ONE HE GAVE HIM RACHEL, HIS OTHER DAUGHTER, AS WIFE.

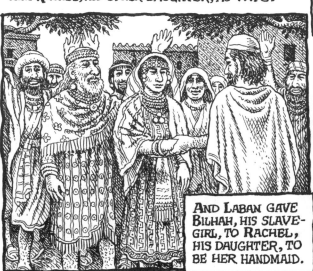

AND LABAN GAVE BILHAH, HIS SLAVE-GIRL, TO RACHEL, HIS DAUGHTER, TO BE HER HANDMAID.

AND JACOB CAME TO BED WITH RACHEL AS WELL, AND, INDEED, LOVED RACHEL MORE THAN LEAH.

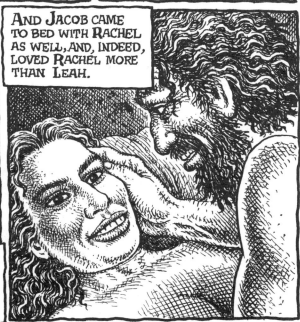

AND HE SERVED HIM STILL ANOTHER SEVEN YEARS.

AND THE LORD SAW THAT LEAH WAS DESPISED, AND HE OPENED HER WOMB, BUT RACHEL WAS BARREN. AND LEAH CONCEIVED AND BORE A SON AND CALLED HIS NAME REUBEN...*

* REUBEN: IN HEBREW, A PLAY ON THE WORDS RE'U BEN: "SEE, A SON!"

...FOR SHE SAID...

YES, THE LORD HAS SEEN MY SUFFERING, FOR NOW MY HUSBAND WILL LOVE ME!

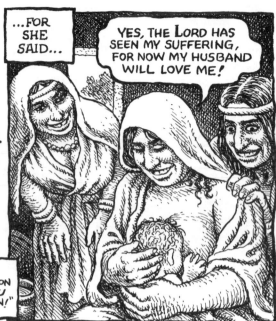

AND SHE CONCEIVED AGAIN AND BORE A SON, AND SHE SAID...

YES, THE LORD HAS HEARD I WAS DESPISED, AND HE HAS GIVEN ME THIS ONE, TOO!

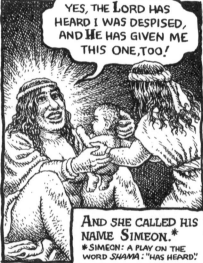

AND SHE CALLED HIS NAME SIMEON.*
* SIMEON: A PLAY ON THE WORD SHAMA: "HAS HEARD."

AND SHE CONCEIVED AGAIN AND BORE A SON, AND SHE SAID...

THIS TIME AT LAST MY HUSBAND WILL JOIN ME, FOR I HAVE BORNE HIM THREE SONS!

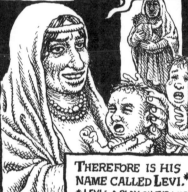

THEREFORE IS HIS NAME CALLED LEVI.*
* LEVI: A PLAY ON THE WORD YILAVEH: "WILL JOIN."

AND SHE CONCEIVED AGAIN, AND BORE A SON, AND SHE SAID...

THIS TIME I SING PRAISE TO THE LORD!

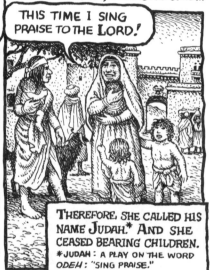

THEREFORE, SHE CALLED HIS NAME JUDAH.* AND SHE CEASED BEARING CHILDREN.
* JUDAH: A PLAY ON THE WORD ODEH: "SING PRAISE."

Chapter 30

AND RACHEL SAW THAT SHE HAD BORNE NO CHILDREN TO JACOB, AND RACHEL WAS JEALOUS OF HER SISTER.

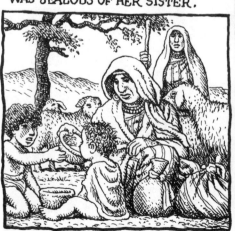

AND SHE SAID TO JACOB...

GIVE ME SONS, FOR IF YOU DON'T, I'M A DEAD WOMAN!!

AND JACOB WAS INCENSED WITH RACHEL, AND HE SAID...

SO, THEN, IT'S ME, NOT GOD, WHO HAS DENIED YOU FRUIT OF THE WOMB!?

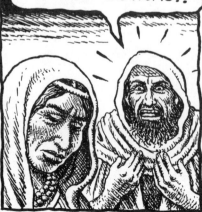

AND SHE SAID...

HERE'S MY HANDMAID, BILHAH! COME IN BED WITH HER, THAT SHE SHALL BEAR UPON *MY* KNEES, AND THROUGH HER MY HOUSE, TOO, WILL BE BUILT UP!

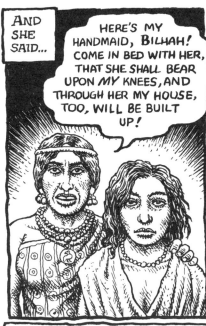

AND SHE GAVE HIM BILHAH, HER HANDMAID, AS A WIFE, AND JACOB CAME TO BED WITH HER, AND BILHAH CONCEIVED AND BORE JACOB A SON. AND RACHEL SAID...

GOD GRANTED MY CAUSE! YES, HE HEARD MY VOICE AND GAVE ME A SON!

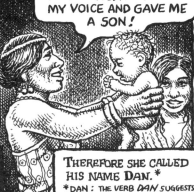

THEREFORE SHE CALLED HIS NAME DAN.*
*DAN : THE VERB *DAN* SUGGESTS VINDICATION OF A LEGAL PLEA.

AND BILHAH, RACHEL'S HANDMAID, CONCEIVED AGAIN AND BORE A SECOND SON TO JACOB. AND RACHEL SAID..

WITH FIERCE GRAPPLINGS I HAVE WRESTLED WITH MY SISTER, AND, YES, I HAVE WON OUT!

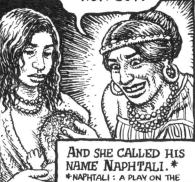

AND SHE CALLED HIS NAME NAPHTALI.*
*NAPHTALI : A PLAY ON THE WORD *NAFTULIM* : "GRAPPLINGS."

AND LEAH SAW THAT SHE HAD CEASED BEARING CHILDREN, AND SHE TOOK ZILPAH, HER HANDMAID, AND GAVE HER TO JACOB AS A WIFE.

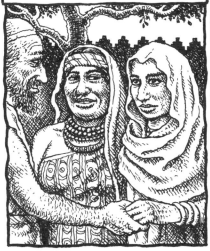

AND ZILPAH, LEAH'S HANDMAID, BORE JACOB A SON. AND LEAH SAID...

GOOD LUCK HAS COME!

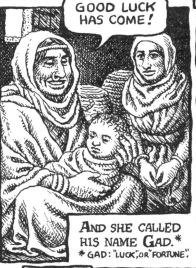

AND SHE CALLED HIS NAME GAD.*
* GAD: "LUCK", OR "FORTUNE."

AND ZILPAH, LEAH'S HANDMAID, BORE A SECOND SON TO JACOB. AND LEAH SAID...

WHAT GOOD FORTUNE! FOR THE WOMEN HAVE ACCLAIMED ME FORTUNATE!

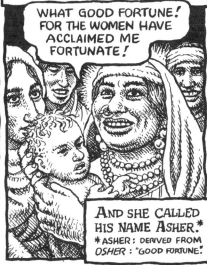

AND SHE CALLED HIS NAME ASHER.*
*ASHER: DERIVED FROM *OSHER* : "GOOD FORTUNE."

AND REUBEN WENT OUT IN THE DAYS OF THE WHEAT HARVEST AND FOUND MANDRAKES IN THE FIELD AND BROUGHT THEM TO LEAH, HIS MOTHER.

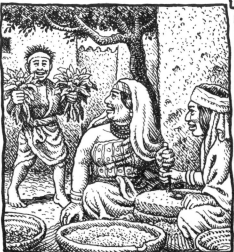

AND RACHEL SAID TO LEAH...

GIVE ME, I PRAY YOU, SOME OF OF THE MANDRAKES* OF YOUR SON!

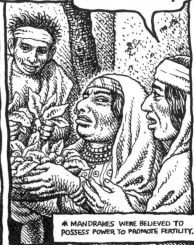

* MANDRAKES WERE BELIEVED TO POSSESS POWER TO PROMOTE FERTILITY.

AND SHE SAID...

IS IT A SMALL MATTER THAT YOU'VE TAKEN MY HUSBAND, AND NOW YOU'D TAKE AWAY MY SON'S MANDRAKES ALSO?!?

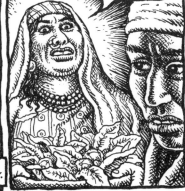

AND RACHEL SAID...

THEN LET HIM LIE WITH *YOU* TONIGHT IN RETURN FOR THE MANDRAKES OF YOUR SON!

AND JACOB CAME FROM THE FIELD IN THE EVENING, AND LEAH WENT OUT TO MEET HIM AND SAID...

YOU MUST COME IN UNTO ME, FOR INDEED I'VE *HIRED* YOU WITH THE MANDRAKES OF MY SON!

AND HE LAY WITH HER THAT NIGHT.

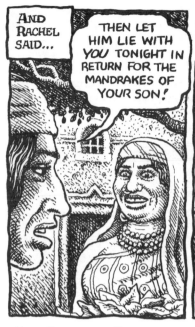
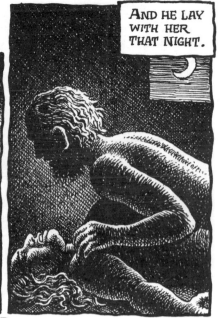

AND GOD HEARD LEAH AND SHE CONCEIVED AND BORE JACOB A FIFTH SON. AND LEAH SAID...

GOD HAS GIVEN MY WAGES BECAUSE I GAVE MY HANDMAID TO MY HUSBAND!

AND LEAH CONCEIVED AGAIN AND BORE A SIXTH SON TO JACOB. AND LEAH SAID...

GOD HAS GRANTED ME A GOODLY GIFT. THIS TIME MY HUSBAND WILL EXALT ME, FOR I HAVE BORNE HIM *SIX SONS!*

AND AFTERWARD SHE BORE A DAUGHTER AND SHE CALLED HER NAME DINAH.

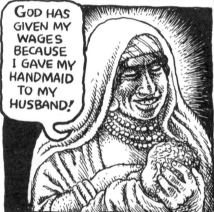
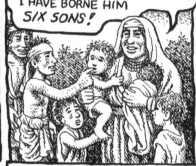

AND SHE CALLED HIS NAME ISSACHAR.*

*ISSACHAR: A PLAY ON THE WORD *SAKHAR*: "WAGES" OR "REWARD," ALSO A FEE PAID FOR HIRING.

AND SHE CALLED HIS NAME ZEBULUN.*

*ZEBULUN: A PLAY ON TWO WORDS: ZEBED: "GIFT," AND ZABAL: "EXALT."

AND GOD REMEMBERED RACHEL. GOD HEEDED HER AND OPENED HER WOMB, AND SHE CONCEIVED AND BORE A SON, AND SHE SAID...

GOD HAS TAKEN AWAY MY SHAME!

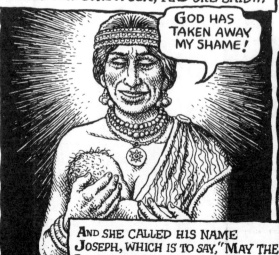

AND SHE CALLED HIS NAME JOSEPH, WHICH IS TO SAY, "MAY THE LORD ADD ME ANOTHER SON!"

AND IT CAME TO PASS, WHEN RACHEL BORE JOSEPH, THAT JACOB SAID TO LABAN...

SEND ME OFF, THAT I MAY GO TO MY OWN PLACE AND TO MY COUNTRY! GIVE ME MY WIVES AND CHILDREN, FOR WHOM I HAVE SERVED YOU, AND LET ME GO!

FOR *WELL YOU KNOW* THE SERVICES THAT I'VE DONE YOU!

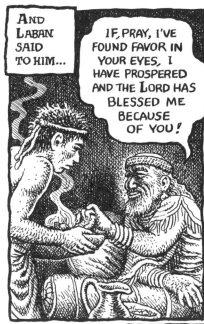

AND LABAN SAID TO HIM... IF, PRAY, I'VE FOUND FAVOR IN YOUR EYES, I HAVE PROSPERED AND THE LORD HAS BLESSED ME BECAUSE OF YOU!

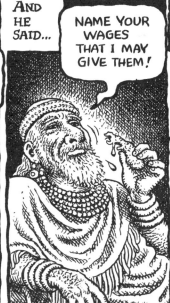

AND HE SAID... NAME YOUR WAGES THAT I MAY GIVE THEM!

AND HE SAID TO HIM... YOU KNOW WELL HOW I'VE SERVED YOU, AND HOW YOUR LIVE-STOCK HAS FARED WITH ME! FOR THE LITTLE YOU HAD BEFORE I CAME HAS SWOLLEN TO A MULTITUDE, AND THE LORD HAS BLESSED YOU ON MY ACCOUNT!

AND NOW, WHEN SHALL I PROVIDE FOR MY OWN HOUSEHOLD?!

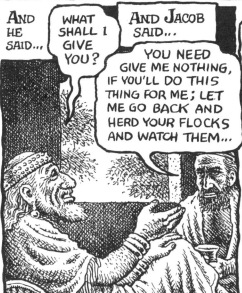

AND HE SAID... WHAT SHALL I GIVE YOU?

AND JACOB SAID... YOU NEED GIVE ME NOTHING, IF YOU'LL DO THIS THING FOR ME; LET ME GO BACK AND HERD YOUR FLOCKS AND WATCH THEM...

I'LL PASS THROUGH YOUR FLOCKS TODAY AND REMOVE FROM THEM EVERY SPOTTED AND SPECKLED ANI-MAL, AND EVERY DARK-COL-ORED SHEEP AND THE SPECK-LED AND SPOTTED AMONG THE GOATS, AND THAT WILL BE MY WAGES!

SO SHALL MY HONESTY TESTIFY FOR ME IN DAYS TO COME THAT WHEN YOU INSPECT MY WAGES, EVERY ONE AMONG MY GOATS THAT IS NOT SPECKLED OR SPOTTED, OR DARK-COLORED AMONG MY SHEEP, SHALL BE AC-COUNTED STOLEN BY ME!

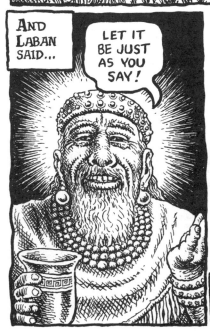

AND LABAN SAID... LET IT BE JUST AS YOU SAY!

AND ON THAT SAME DAY HE REMOVED THE SPOTTED AND SPECKLED HE-GOATS AND ALL THE STREAKED AND SPECKLED SHE-GOATS, EVERY ONE THAT HAD WHITE*ON IT, AND EVERY DARK-COLORED ONE AMONG THE SHEEP, AND PUT THEM IN THE CHARGE OF HIS SONS.

* WHITE: THE HEBREW WORD FOR "WHITE", LAVAN, IS IDENTICAL WITH THE NAME LABAN.

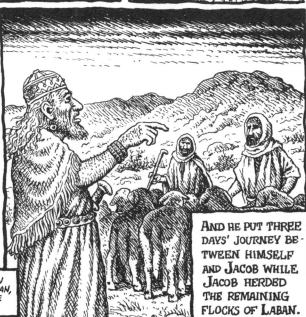

AND HE PUT THREE DAYS' JOURNEY BE-TWEEN HIMSELF AND JACOB WHILE JACOB HERDED THE REMAINING FLOCKS OF LABAN.

AND JACOB TOOK HIMSELF FRESH SHOOTS OF POPLAR, AND OF THE ALMOND AND PLANE-TREE, AND PEELED WHITE STRIPS IN THEM, LAYING BARE THE WHITE OF THE SHOOTS.

AND HE STOOD THE SHOOTS HE HAD PEELED IN THE TROUGHS, IN THE WATER CHANNELS FROM WHICH THE FLOCKS CAME TO DRINK — OPPOSITE THE FLOCKS, WHICH WENT INTO HEAT WHEN THEY CAME TO DRINK.

AND THE FLOCKS WENT INTO HEAT AT THE SHOOTS AND THEY BORE STREAKED, SPOTTED, AND SPECKLED YOUNG.

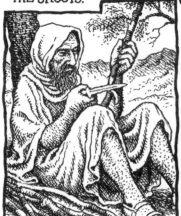
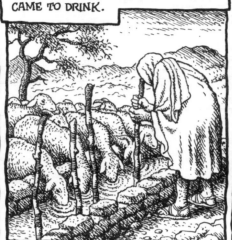

AND THE SHEEP JACOB KEPT APART. HE PLACED THEM FACING THE SPOTTED AND ALL THE DARK-COLORED IN LABAN'S FLOCKS, AND SO HE PRODUCED SPECIAL FLOCKS FOR HIMSELF WHICH HE DID NOT PUT WITH LABAN'S FLOCKS.

AND SO, WHENEVER THE VIGOROUS OF THE FLOCKS WENT INTO HEAT, JACOB PUT THE SHOOTS IN THE TROUGHS IN FULL SIGHT OF THE FLOCKS, FOR THEM TO GO IN HEAT BY THE SHOOTS.

AND FOR THE WEAKLINGS OF THE FLOCKS HE DID NOT PUT THE SHOOTS. AND SO THE FEEBLE ONES WENT TO LABAN AND THE VIGOROUS ONES TO JACOB.

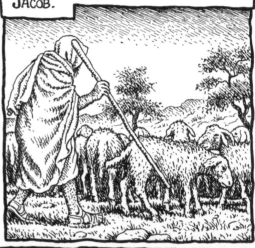

AND THE MAN SWELLED UP MIGHTILY, AND HE HAD MANY FLOCKS, AND FEMALE AND MALE SLAVES, AND CAMELS AND DONKEYS.

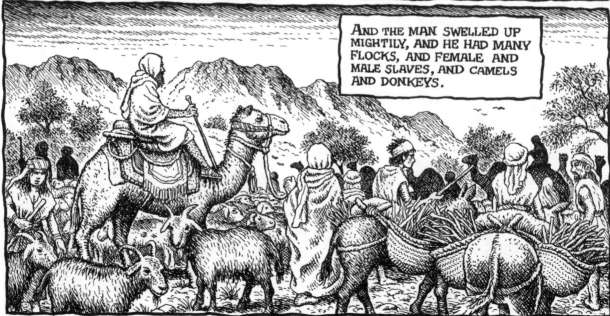

Chapter 31

AND JACOB SAW LABAN'S FACE AND, BEHOLD, IT WAS NOT AS IT HAD BEEN TOWARD HIM BEFORE.

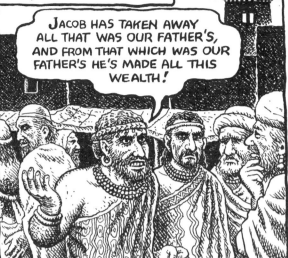

AND HE HEARD THE WORDS OF LABAN'S SONS, SAYING...

JACOB HAS TAKEN AWAY ALL THAT WAS OUR FATHER'S, AND FROM THAT WHICH WAS OUR FATHER'S HE'S MADE ALL THIS WEALTH!

AND THE LORD SAID TO JACOB...

RETURN TO THE LAND OF YOUR FATHERS, WHERE YOU WERE BORN, AND I WILL BE WITH YOU!

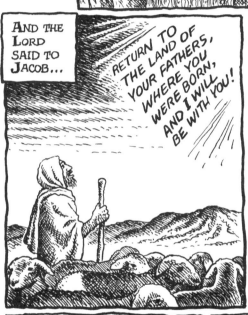

AND JACOB SENT AND HAD RACHEL AND LEAH CALLED OUT TO THE FIELD, TO HIS FLOCKS, AND HE SAID TO THEM...

I OBSERVE IN YOUR FATHER'S FACE THAT HE IS NO LONGER DISPOSED TOWARD ME AS HE USED TO BE...

BUT THE GOD OF MY FATHER HAS BEEN WITH ME!

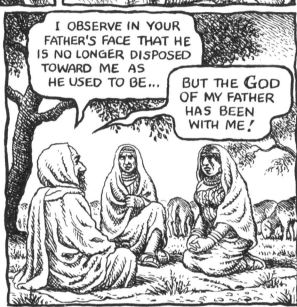

AND YOU KNOW THAT WITH ALL MY STRENGTH I'VE SERVED YOUR FATHER! BUT YOUR FATHER HAS CHEATED ME, AND HAS SWITCHED MY WAGES TEN TIMES OVER!

YET GOD WOULD NOT LET HIM DO ME HARM!

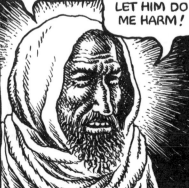

IF THUS HE SAID, "THE SPOTTED ONES WILL BE YOUR WAGES," ALL THE FLOCKS BORE SPOTTED ONES! AND IF HE SAID, "THE STREAKED ONES WILL BE YOUR WAGES," ALL THE FLOCKS BORE STREAKED ONES!

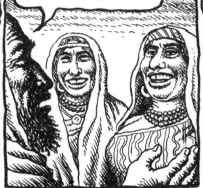

AND THUS GOD HAS TAKEN AWAY YOUR FATHER'S LIVESTOCK AND GIVEN THEM TO ME! AND SO, AT THE TIME WHEN THE FLOCKS WERE IN HEAT, IN A DREAM I RAISED MY EYES AND SAW, AND, BE-HOLD, THE RAMS MOUNTING THE FLOCK WERE STREAKED, SPOTTED, AND SPECKLED!

AND GOD'S MESSENGER SAID TO ME IN THE DREAM, "JACOB!" AND I SAID, "HERE I AM." AND HE SAID, "RAISE YOUR EYES, PRAY, AND SEE! ALL THE RAMS MOUNTING THE FLOCKS ARE SPOTTED, STREAKED, AND SPECKLED, FOR I SAW ALL THAT LABAN HAS BEEN DOING TO YOU!"

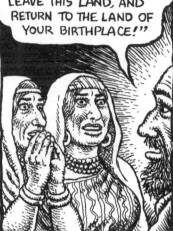

"I AM THE GOD WHO APPEARED TO YOU AT BETHEL, WHERE YOU RAISED A PILLAR AND MADE ME A VOW. NOW RISE, LEAVE THIS LAND, AND RETURN TO THE LAND OF YOUR BIRTHPLACE!"

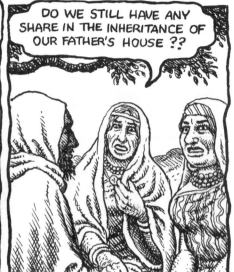

AND RACHEL AND LEAH ANSWERED AND THEY SAID TO HIM...

DO WE STILL HAVE ANY SHARE IN THE INHERITANCE OF OUR FATHER'S HOUSE??

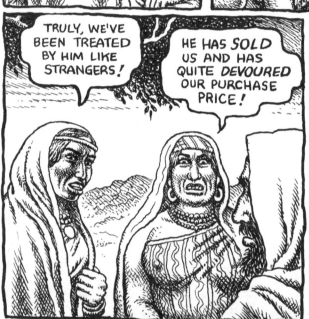

TRULY, WE'VE BEEN TREATED BY HIM LIKE STRANGERS!

HE HAS SOLD US AND HAS QUITE DEVOURED OUR PURCHASE PRICE!

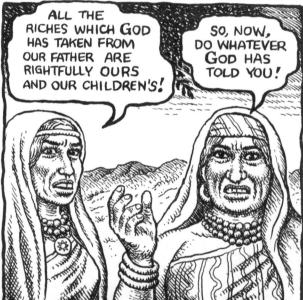

ALL THE RICHES WHICH GOD HAS TAKEN FROM OUR FATHER ARE RIGHTFULLY OURS AND OUR CHILDREN'S!

SO, NOW, DO WHATEVER GOD HAS TOLD YOU!

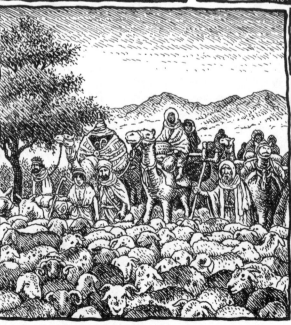

AND JACOB ROSE UP, AND SET HIS SONS AND WIVES UPON CAMELS. AND HE DROVE ALL HIS LIVESTOCK AND ALL HIS GOODS THAT HE HAD AMASSED, HIS PROPERTY IN LIVESTOCK THAT HE HAD ACQUIRED IN PADDAN-ARAM, TO GO TO ISAAC, HIS FATHER, IN THE LAND OF CANAAN.

AND LABAN HAD GONE TO SHEAR HIS FLOCKS, AND RACHEL STOLE THE HOUSEHOLD GODS THAT WERE HER FATHER'S.

AND JACOB DECEIVED LABAN THE ARAMEAN IN THAT HE DID NOT TELL HIM THAT HE WAS FLEEING. AND HE FLED, AND ALL THAT WAS HIS, AND SOON HE CROSSED THE EUPHRATES, AND SET HIS FACE TOWARD THE HIGH COUNTRY OF GILEAD.

AND ON THE THIRD DAY IT WAS TOLD TO LABAN THAT JACOB HAD FLED. AND HE TOOK HIS KINSMEN WITH HIM AND PURSUED HIM A SEVEN DAYS' JOURNEY, AND OVERTOOK HIM IN THE HIGH COUNTRY OF GILEAD.

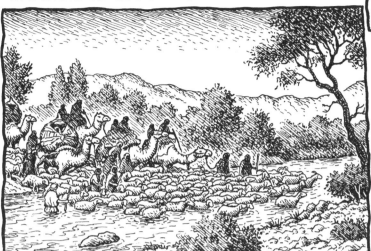

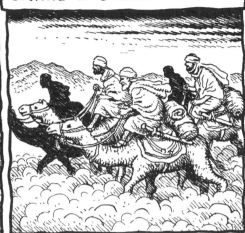

AND GOD CAME TO LABAN THE ARAMEAN IN A DREAM BY NIGHT, AND SAID TO HIM...

AND LABAN CAUGHT UP WITH JACOB, AND JACOB HAD PITCHED HIS TENT ON THE HEIGHT, AND LABAN PITCHED WITH HIS KINSMEN IN THE HIGH COUNTRY OF GILEAD.

TAKE CARE WHEN ATTEMPTING ANYTHING WITH JACOB, EITHER GOOD OR EVIL!

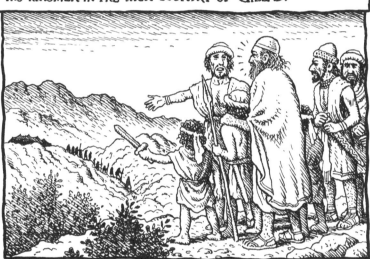

AND LABAN SAID TO JACOB...

WHAT HAVE YOU DONE, DECEIVING ME AND DRIVING AWAY MY DAUGHTERS LIKE CAPTIVES OF THE SWORD?!

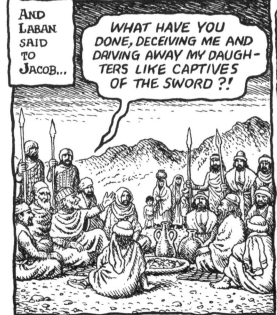

WHY DID YOU FLEE SECRETLY AND STEAL AWAY AND NOT TELL ME?? I WOULD'VE SENT YOU OFF WITH FESTIVE SONGS, WITH TIMBREL AND LYRE!!

AND YOU DIDN'T LET ME KISS MY SONS AND DAUGHTERS! O, YOU'VE ACTED FOOLISHLY IN DOING THIS!

MY HAND HAS THE MIGHT TO DO YOU HARM!!

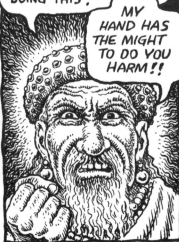

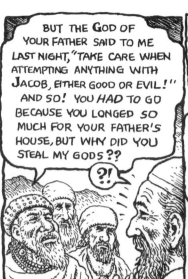

BUT THE GOD OF YOUR FATHER SAID TO ME LAST NIGHT, "TAKE CARE WHEN ATTEMPTING ANYTHING WITH JACOB, EITHER GOOD OR EVIL!" AND SO! YOU HAD TO GO BECAUSE YOU LONGED SO MUCH FOR YOUR FATHER'S HOUSE, BUT WHY DID YOU STEAL MY GODS??

?!

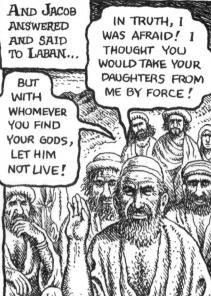

AND JACOB ANSWERED AND SAID TO LABAN...

BUT WITH WHOMEVER YOU FIND YOUR GODS, LET HIM NOT LIVE!

IN TRUTH, I WAS AFRAID! I THOUGHT YOU WOULD TAKE YOUR DAUGHTERS FROM ME BY FORCE!

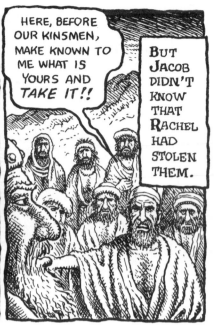

HERE, BEFORE OUR KINSMEN, MAKE KNOWN TO ME WHAT IS YOURS AND TAKE IT!!

BUT JACOB DIDN'T KNOW THAT RACHEL HAD STOLEN THEM.

AND LABAN WENT INTO JACOB'S TENT, AND INTO LEAH'S TENT, AND INTO THE TENT OF THE TWO SLAVE-GIRLS, AND HE FOUND NOTHING.

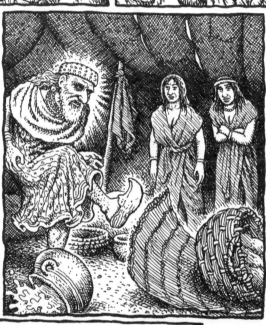

AND HE CAME OUT OF LEAH'S TENT AND WENT INTO RACHEL'S TENT. AND RACHEL HAD TAKEN THE HOUSEHOLD GODS AND PUT THEM IN THE CAMEL CUSHION AND SAT ON THEM.

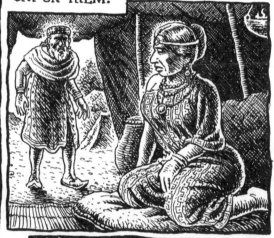

AND LABAN RUMMAGED THROUGH THE ENTIRE TENT AND FOUND NOTHING.

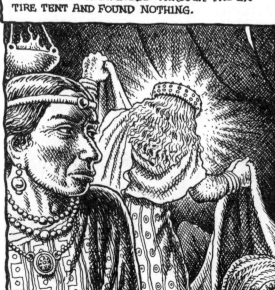

AND SHE SAID TO HER FATHER...

LET NOT MY LORD BE OUTRAGED THAT I AM UNABLE TO RISE BEFORE YOU, FOR THE WAY OF WOMEN IS UPON ME.

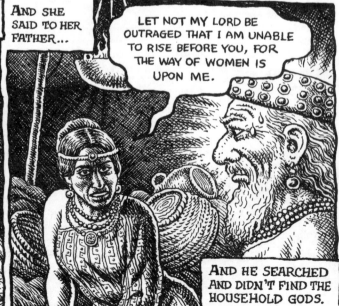

AND HE SEARCHED AND DIDN'T FIND THE HOUSEHOLD GODS.

AND JACOB BECAME INCENSED AND TOOK UP HIS GRIEVANCE WITH LABAN. AND JACOB SPOKE OUT AND SAID TO LABAN...

WHAT IS MY CRIME?! WHAT IS MY GUILT, THAT YOU SHOULD SO HOTLY PURSUE ME??

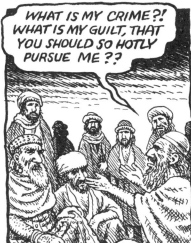

THOUGH YOU RUMMAGED THROUGH ALL MY STUFF, WHAT HAVE YOU FOUND OF YOUR HOUSEHOLD THINGS??

SET IT HERE BEFORE MY KIN AND YOURS, AND LET THEM JUDGE BETWEEN US TWO!

THESE TWENTY YEARS I'VE BEEN WITH YOU, YOUR EWES AND YOUR SHE-GOATS DID NOT LOSE THEIR YOUNG! THE RAMS OF YOUR FLOCK I HAVE NOT EATEN! WHAT WAS DESTROYED BY WILD BEASTS WAS BROUGHT NOT TO YOU! I BORE THE LOSS! FROM MY HAND YOU REQUIRED IT, WHETHER STOLEN BY DAY, OR STOLEN BY NIGHT!

OFTEN BY DAY THE PARCHING HEAT ATE ME UP, AND FROST IN THE NIGHT, AND SLEEP WAS A STRANGER TO MY EYES!

THESE TWENTY YEARS IN YOUR HOUSEHOLD I SERVED YOU, FOURTEEN YEARS FOR YOUR TWO DAUGHTERS AND SIX YEARS FOR YOUR FLOCKS, AND YOU SWITCHED MY WAGES TEN TIMES OVER!

WERE IT NOT THAT THE GOD OF MY FATHER, THE GOD OF ABRAHAM AND THE TERROR OF ISAAC, WAS WITH ME, YOU WOULD HAVE SENT ME OFF EMPTY-HANDED!

MY SUFFERING AND THE TOIL OF MY HANDS GOD HAS SEEN, AND LAST NIGHT HE JUDGED IN MY FAVOR!

AND LABAN ANSWERED AND SAID TO JACOB...

THE DAUGHTERS ARE MY DAUGHTERS, AND THE SONS ARE MY SONS, AND THE FLOCKS ARE MY FLOCKS, AND ALL THAT YOU SEE IS MINE!!

YET FOR MY DAUGHTERS WHAT CAN I DO NOW, OR FOR THEIR SONS WHOM THEY BORE??

AND SO, COME, LET US MAKE A PACT, YOU AND I, AND LET IT BE A WITNESS BETWEEN YOU AND ME!

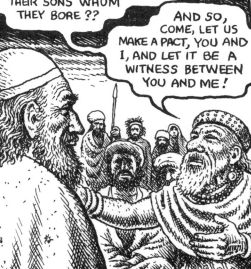

AND JACOB TOOK A STONE AND SET IT UP AS A PILLAR.

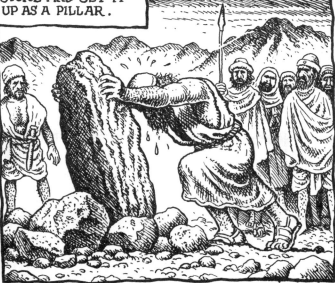

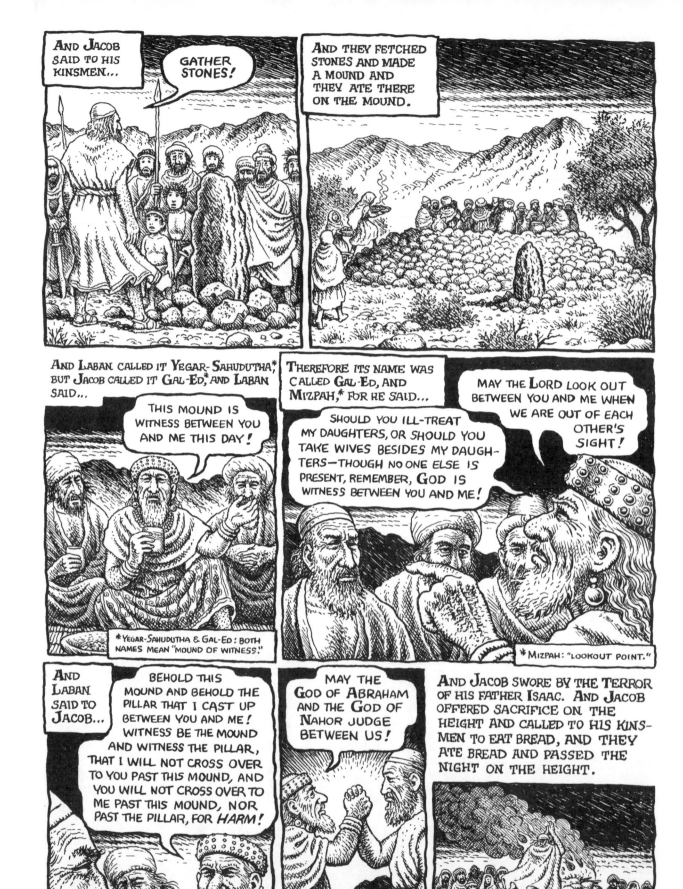

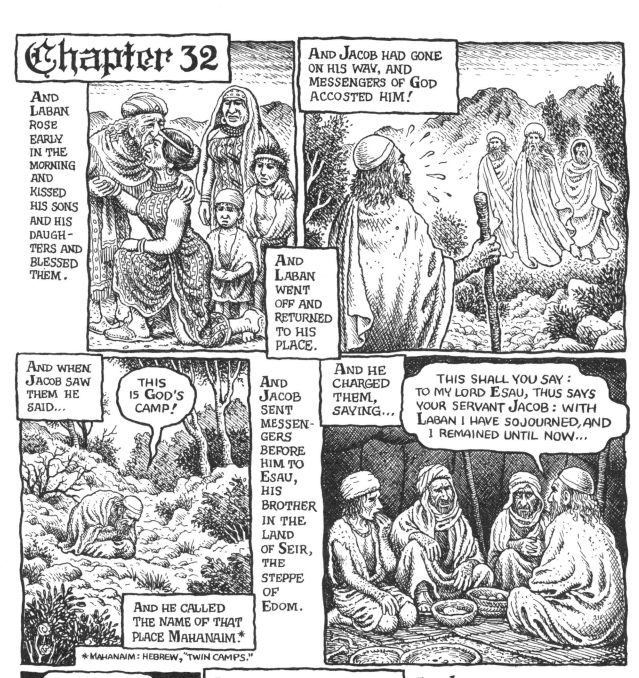

Chapter 32

AND LABAN ROSE EARLY IN THE MORNING AND KISSED HIS SONS AND HIS DAUGHTERS AND BLESSED THEM.

AND JACOB HAD GONE ON HIS WAY, AND MESSENGERS OF GOD ACCOSTED HIM!

AND LABAN WENT OFF AND RETURNED TO HIS PLACE.

AND WHEN JACOB SAW THEM HE SAID...

THIS IS GOD'S CAMP!

AND HE CALLED THE NAME OF THAT PLACE MAHANAIM.*

*MAHANAIM: HEBREW, "TWIN CAMPS."

AND JACOB SENT MESSENGERS BEFORE HIM TO ESAU, HIS BROTHER IN THE LAND OF SEIR, THE STEPPE OF EDOM.

AND HE CHARGED THEM, SAYING...

THIS SHALL YOU SAY: TO MY LORD ESAU, THUS SAYS YOUR SERVANT JACOB: WITH LABAN I HAVE SOJOURNED, AND I REMAINED UNTIL NOW...

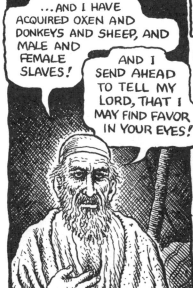

...AND I HAVE ACQUIRED OXEN AND DONKEYS AND SHEEP, AND MALE AND FEMALE SLAVES!

AND I SEND AHEAD TO TELL MY LORD, THAT I MAY FIND FAVOR IN YOUR EYES!

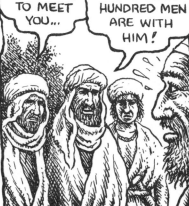

AND THE MESSENGERS RETURNED TO JACOB, SAYING...

WE CAME TO YOUR BROTHER, TO ESAU, AND HE HIMSELF IS COMING TO MEET YOU...

...AND FOUR-HUNDRED MEN ARE WITH HIM!

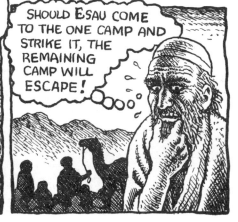

AND JACOB WAS GREATLY AFRAID, AND WAS DISTRESSED, AND HE DIVIDED THE PEOPLE THAT WERE WITH HIM, AND THE SHEEP AND THE CATTLE AND THE CAMELS, INTO TWO CAMPS, FOR HE THOUGHT...

SHOULD ESAU COME TO THE ONE CAMP AND STRIKE IT, THE REMAINING CAMP WILL ESCAPE!

AND JACOB SAID...

GOD OF MY FATHER ABRAHAM AND GOD OF MY FATHER ISAAC! LORD WHO HAS SAID TO ME, "RETURN TO YOUR LAND AND YOUR BIRTHPLACE, AND I WILL DEAL WELL WITH YOU," I AM UNWORTHY OF ALL THE KINDNESS YOU HAVE STEADFASTLY SHOWN YOUR SERVANT!

FOR WITH MY STAFF I CROSSED THIS JORDAN, AND NOW I'VE BECOME TWO CAMPS!

O, SAVE ME FROM THE HAND OF MY BROTHER, FROM THE HAND OF ESAU, FOR I FEAR HIM, LEST HE COME AND STRIKE ME, MOTHERS AND SONS ALIKE!

AND YOU YOURSELF SAID, "I WILL SURELY DEAL WELL WITH YOU, AND I WILL SET YOUR SEED LIKE THE SAND OF THE SEA, MULTITUDINOUS BEYOND ALL COUNT!"

AND HE PASSED THAT SAME NIGHT THERE, AND HE TOOK FROM WHAT HE HAD IN HAND A TRIBUTE TO ESAU HIS BROTHER: 200 SHE-GOATS AND TWENTY HE-GOATS; 200 EWES AND TWENTY RAMS; THIRTY MILCH CAMELS WITH THEIR YOUNG; FORTY COWS AND TEN BULLS; TWENTY SHE-ASSES AND TEN HE-ASSES. AND HE PUT THEM IN THE HANDS OF HIS SERVANTS, EACH HERD BY ITSELF.

AND HE SAID TO HIS SERVANTS...

GO ON AHEAD OF ME, AND KEEP A DISTANCE BETWEEN ONE HERD AND THE NEXT!

AND HE CHARGED THE ONE IN FRONT, SAYING...

WHEN ESAU, MY BROTHER, MEETS YOU AND ASKS YOU, "WHOSE MAN ARE YOU, AND WHERE ARE YOU GOING, AND WHOSE ARE THESE HERDS IN FRONT OF YOU?" YOU SHALL ANSWER, "THEY'RE YOUR SERVANT JACOB'S, A TRIBUTE SENT TO MY LORD ESAU, AND, BEHOLD, HE HIMSELF IS BEHIND US!"

AND HE CHARGED THE SECOND ONE AS WELL, AND THE THIRD, INDEED, ALL THOSE WHO WENT AFTER THE HERDS, SAYING...

IN THIS MANNER YOU SHALL SPEAK TO ESAU WHEN YOU FIND HIM. AND YOU SHALL SAY, "BEHOLD, YOUR SERVANT JACOB HIMSELF IS BEHIND YOU!"

FOR HE THOUGHT...

LET ME PLACATE HIM WITH THE TRIBUTE THAT GOES BEFORE ME, AND AFTER, WHEN I SHALL SEE HIS FACE, PERHAPS HE'LL SHOW ME A KINDLY FACE!

AND THE TRIBUTE PASSED ON BEFORE HIM, AND HE SPENT THE NIGHT IN THE CAMP.

AND HE ROSE THAT SAME NIGHT AND TOOK HIS TWO WIVES AND HIS TWO SLAVEGIRLS AND HIS ELEVEN BOYS AND HE CROSSED OVER THE JABBOK FORD. AND HE TOOK THEM AND BROUGHT THEM ACROSS THE STREAM, AND HE BROUGHT ACROSS ALL THAT HE HAD.

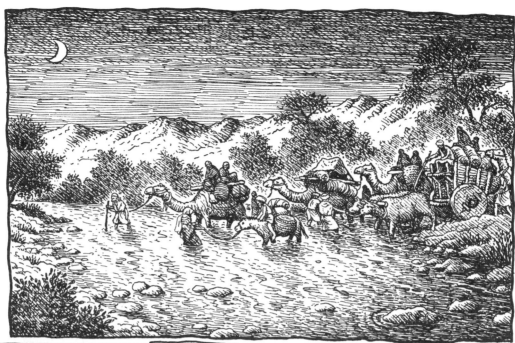

AND JACOB WAS LEFT ALONE, AND A MAN WRESTLED WITH HIM UNTIL THE BREAK OF DAWN.

AND HE SAW THAT HE HAD NOT WON OUT AGAINST HIM AND HE TOUCHED HIS HIP-SOCKET AND JACOB'S HIP-SOCKET WAS WRENCHED AS HE WRESTLED WITH HIM.

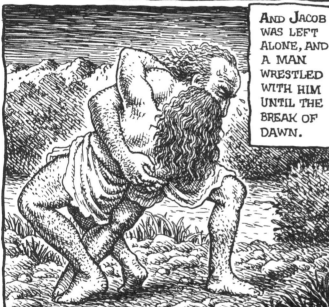

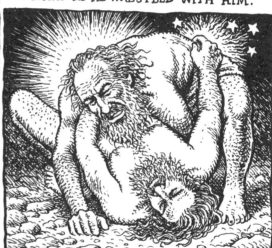

AND THE MAN SAID...

LET ME GO, FOR DAWN IS BREAKING!

AND JACOB SAID...

I WON'T LET YOU GO UNLESS YOU BLESS ME!

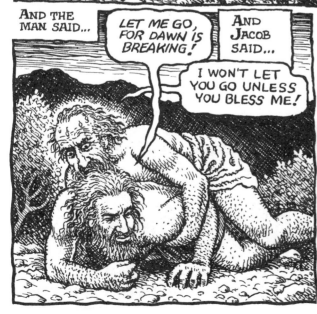

AND THE MAN SAID TO HIM...

WHAT'S YOUR NAME?

AND HE SAID...

JACOB...

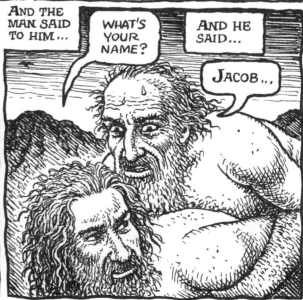

AND
HE
SAID...

YOUR NAME SHALL NO LONGER BE JACOB, BUT *ISRAEL*,* FOR YOU HAVE STRUGGLED WITH DIVINE BEINGS AND WON OUT!

WHY SHOULD YOU ASK *MY* NAME?

TELL ME *YOUR* NAME, PRAY!

AND JACOB CALLED THE NAME OF THE PLACE PENIEL, MEANING, "I HAVE SEEN A DIVINE BEING FACE TO FACE AND I CAME OUT ALIVE."

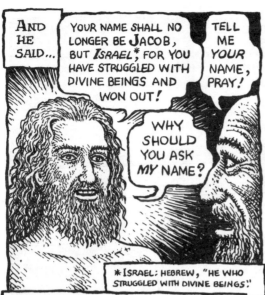

*ISRAEL: HEBREW, "HE WHO STRUGGLED WITH DIVINE BEINGS."

AND THE SUN ROSE UPON HIM AS HE PASSED PENIEL, AND HE WAS LIMPING ON HIS HIP.

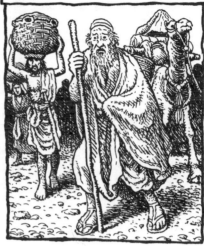

THERE-FORE THE CHILDREN OF ISRAEL DO NOT EAT THE SINEW OF THE THIGH WHICH IS BY THE HIP-SOCKET TO THIS DAY, FOR HE HAD TOUCHED JACOB'S HIP-SOCKET AT THE SINEW OF THE THIGH.

Chapter 33

AND JACOB RAISED HIS EYES AND LOOKED AND, BEHOLD, ESAU WAS COMING, AND WITH HIM WERE FOUR-HUNDRED MEN.

AND HE DIVIDED THE CHILDREN BETWEEN LEAH AND RACHEL, AND BETWEEN THE TWO SLAVE-GIRLS. AND HE PLACED THE SLAVEGIRLS AND THEIR CHILDREN FIRST, AND LEAH AND HER CHILDREN AFTER THEM, AND RACHEL AND JOSEPH LAST.

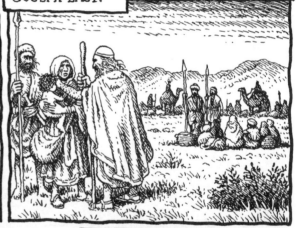

AND HE HIMSELF WENT ON AHEAD AND BOWED LOW TO THE GROUND SEVEN TIMES UNTIL HE DREW NEAR TO HIS BROTHER.

AND ESAU RAN TO MEET HIM.

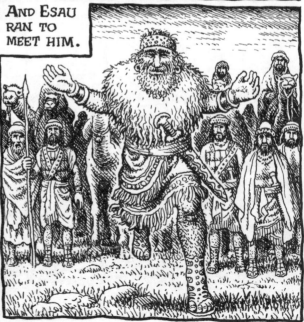

HE EMBRACED HIM AND FELL UPON HIS NECK AND KISSED HIM, AND THEY WEPT.

AND HE RAISED HIS EYES AND SAW THE WOMEN AND CHILDREN, AND HE SAID...

WHO ARE THESE WITH YOU?

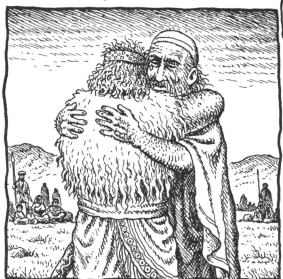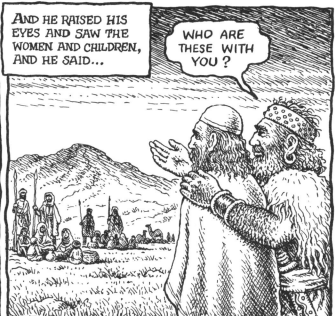

AND HE SAID...

THE CHILDREN WITH WHOM GOD HAS FAVORED YOUR SERVANT!

AND THE SLAVEGIRLS DREW NEAR, THEY AND THEIR CHILDREN, AND THEY BOWED DOWN. AND LEAH, TOO, AND HER CHILDREN DREW NEAR, AND THEY BOWED DOWN, AND THEN JOSEPH AND RACHEL DREW NEAR AND BOWED DOWN.

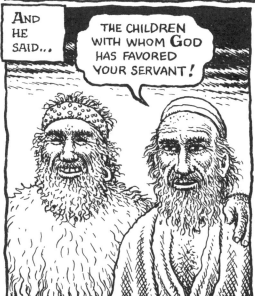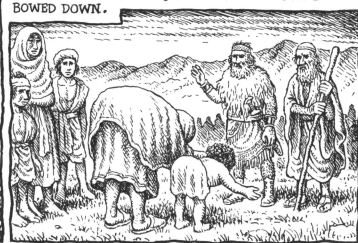

AND ESAU SAID...

WHAT DO YOU MEAN BY ALL THESE DROVES I MET ON MY WAY HERE?

AND JACOB SAID...

TO FIND FAVOR IN THE EYES OF MY LORD!

AND ESAU SAID...

I HAVE MUCH, MY BROTHER!

KEEP WHAT YOU HAVE!

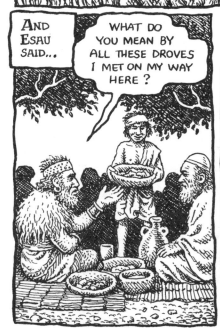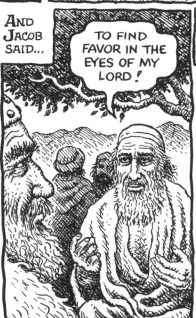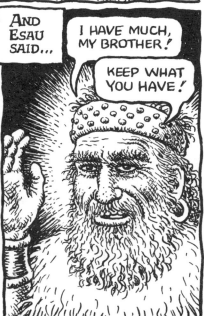

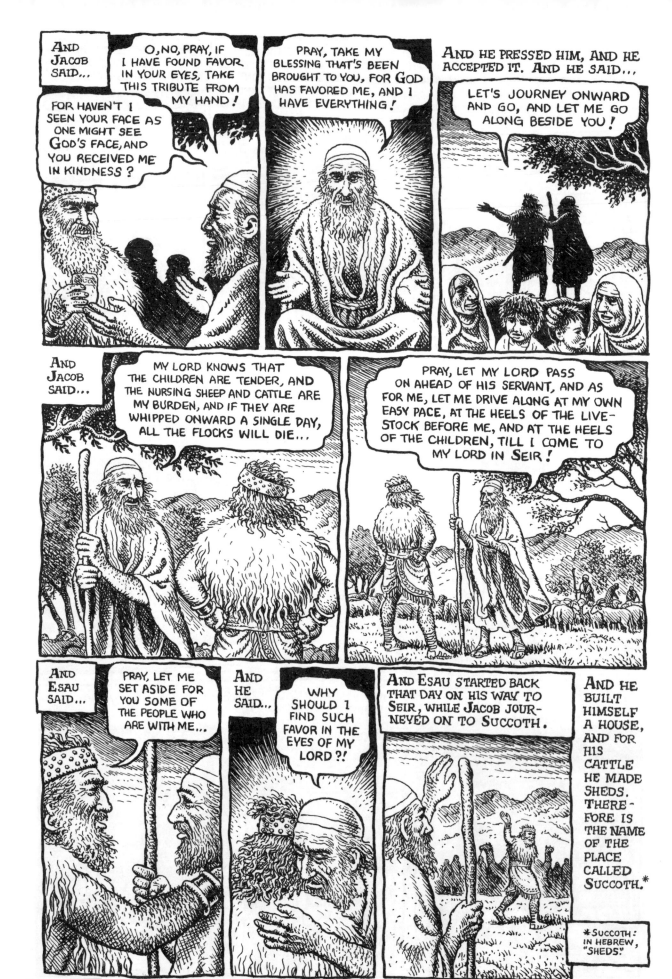

AND JACOB CAME IN PEACE TO THE TOWN OF SHECHEM, WHICH IS IN THE LAND OF CANAAN, WHEN HE CAME FROM PADDAN-ARAM, AND HE CAMPED BEFORE THE TOWN.

AND HE BOUGHT THE PARCEL OF LAND WHERE HE HAD PITCHED HIS TENT FROM THE SONS OF HAMOR, FATHER OF SHECHEM, FOR A HUNDRED KESITAHS.

AND HE SET UP AN ALTAR THERE AND CALLED IT EL-ELOHEI-ISRAEL.*

*EL-ELOHEI-ISRAEL: THE NAME MEANS, "GOD, GOD OF ISRAEL."

Chapter 34

AND DINAH, LEAH'S DAUGHTER, WHOM SHE HAD BORNE TO JACOB, WENT OUT TO SEE SOME OF THE DAUGHTERS OF THE LAND. AND SHECHEM, THE SON OF HAMOR THE HIVITE, PRINCE OF THE LAND, SAW HER...

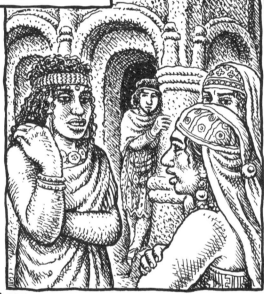

...AND TOOK HER...

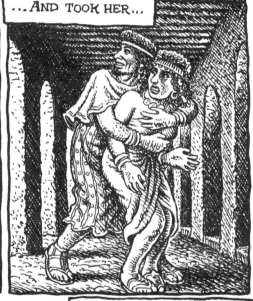

...AND LAID HER AND DEFILED HER.

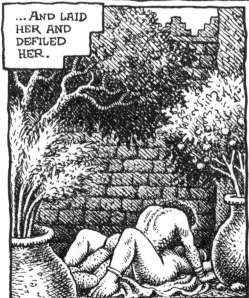

AND HIS VERY SOUL CLUNG TO DINAH, DAUGHTER OF JACOB, AND HE LOVED THE YOUNG WOMAN, AND HE SPOKE TO THE YOUNG WOMAN'S HEART.

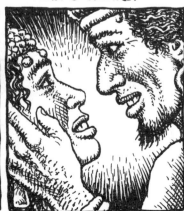

AND SHECHEM SPOKE TO HAMOR, HIS FATHER, SAYING...

GET ME THIS GIRL AS WIFE!

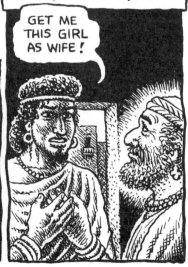

AND JACOB HAD HEARD THAT HE HAD DEFILED DINAH, HIS DAUGHTER, AND HIS SONS WERE WITH HIS LIVESTOCK IN THE FIELD, AND JACOB HELD HIS PEACE TILL THEY WOULD COME HOME.

AND HAMOR, SHECHEM'S FATHER, CAME OUT TO JACOB TO SPEAK WITH HIM.

AND JACOB'S SONS CAME IN FROM THE FIELD AS SOON AS THEY HEARD, AND THE MEN WERE PAINED, AND THEY WERE HIGHLY INCENSED, FOR HE HAD DONE A DESPICABLE THING IN ISRAEL BY LYING WITH JACOB'S DAUGHTER, A THING WHICH OUGHT NOT TO BE DONE.

AND HAMOR SPOKE WITH THEM, SAYING...

PRAY, GIVE HER TO HIM AS WIFE, AND ALLY WITH US BY MARRIAGE!

SHECHEM, MY SON, HIS VERY SOUL LONGS FOR YOUR DAUGHTER!

YOUR DAUGHTERS YOU WILL GIVE US, AND OUR DAUGHTERS TAKE FOR YOURSELVES, AND AMONG US YOU'LL SETTLE, AND THE LAND IS BEFORE YOU!

SETTLE AND GO ABOUT IT AND TAKE HOLDINGS IN IT!

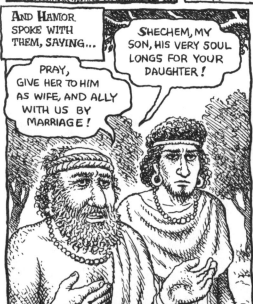
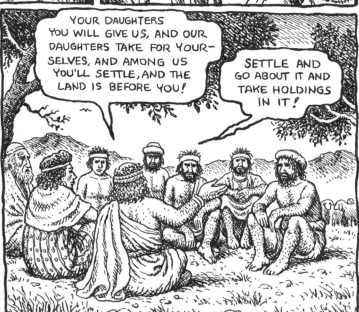

AND SHECHEM SAID TO DINAH'S FATHER AND TO HER BROTHERS...

LET ME FIND FAVOR IN YOUR EYES, AND WHATEVER YOU SAY TO ME, I WILL GIVE! NAME ME HOWEVER MUCH BRIDE-PRICE AND CLAN-GIFT, I'LL GIVE YOU WHAT YOU SAY, AND GIVE ME THE YOUNG WOMAN AS WIFE!

AND THE SONS OF JACOB ANSWERED SHECHEM AND HAMOR HIS FATHER DECEITFULLY, AND THEY SPOKE AS THEY DID BECAUSE HE HAD DEFILED DINAH THEIR SISTER, AND THEY SAID TO THEM...

WE CANNOT DO THIS THING...

...TO GIVE OUR SISTER TO A MAN WHO HAS A FORESKIN!

THAT'S A DISGRACE FOR US!

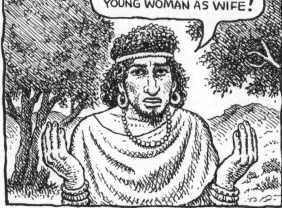
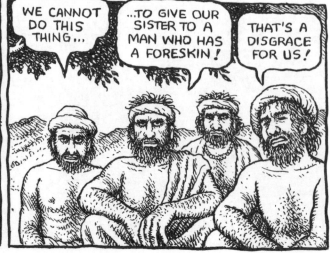

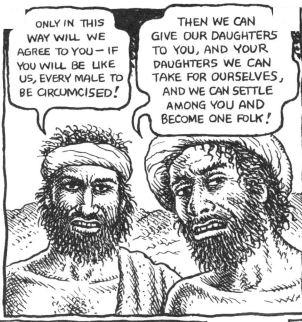

ONLY IN THIS WAY WILL WE AGREE TO YOU — IF YOU WILL BE LIKE US, EVERY MALE TO BE CIRCUMCISED!

THEN WE CAN GIVE OUR DAUGHTERS TO YOU, AND YOUR DAUGHTERS WE CAN TAKE FOR OURSELVES, AND WE CAN SETTLE AMONG YOU AND BECOME ONE FOLK!

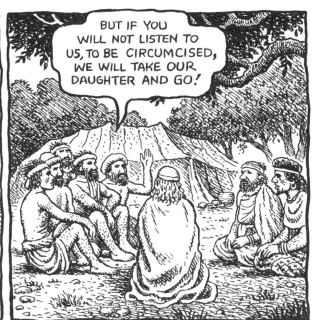

BUT IF YOU WILL NOT LISTEN TO US, TO BE CIRCUMCISED, WE WILL TAKE OUR DAUGHTER AND GO!

AND THEIR WORDS SEEMED GOOD IN THE EYES OF HAMOR AND IN THE EYES OF SHECHEM, SON OF HAMOR.

AND THE LAD LOST NO TIME IN DOING THE THING, FOR HE WANTED JACOB'S DAUGHTER, AND HE WAS THE MOST HIGHLY REGARDED OF ALL HIS FATHER'S HOUSE.

AND HAMOR, WITH SHECHEM HIS SON, CAME TO THE GATE OF THEIR TOWN, AND THEY SPOKE TO THEIR TOWNSMEN, SAYING...

THESE MEN COME IN PEACE TO US! LET THEM SETTLE IN THE LAND AND GO ABOUT IT, FOR THE LAND, BEHOLD, IS AMPLE BEFORE THEM!

WE SHALL TAKE THEIR DAUGHTERS AS WIVES AND OUR DAUGHTERS WE SHALL GIVE TO THEM. BUT ONLY ON ONE CONDITION WILL THE MEN AGREE TO US, TO DWELL AMONG US AND BE ONE FOLK; THAT EVERY MALE OF US BE CIRCUMCISED AS THEY ARE CIRCUMCISED.

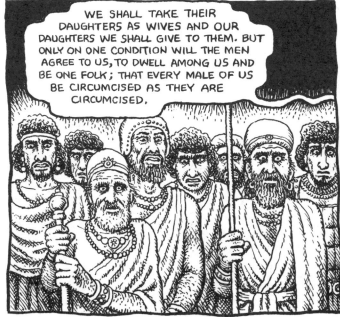

THEIR POSSESSIONS IN LIVESTOCK AND ALL THEIR CATTLE, WILL THEY NOT BE OURS IF ONLY WE AGREE TO THEM AND THEY SETTLE AMONG US??

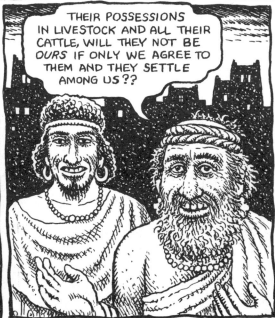

AND ALL WHO CAME FROM THE GATE OF HIS TOWN LISTENED TO HAMOR, AND TO SHECHEM HIS SON, AND EVERY MALE WAS CIRCUMCISED, ALL WHO CAME OUT OF THE GATE OF HIS TOWN.

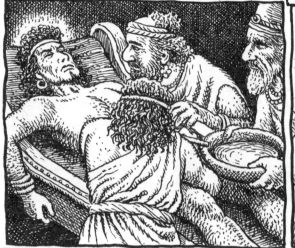

AND IT CAME TO PASS ON THE THIRD DAY, WHILE THEY WERE STILL HURTING, THAT JACOB'S TWO SONS, SIMEON AND LEVI, DINAH'S BROTHERS, TOOK EACH HIS SWORD, AND CAME UPON THE CITY UNOPPOSED...

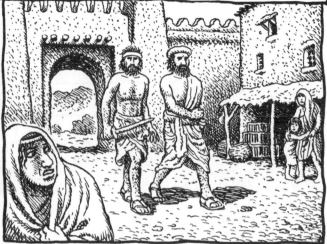

...AND THEY KILLED EVERY MALE.

AND HAMOR AND SHECHEM HIS SON THEY KILLED BY THE EDGE OF THE SWORD.

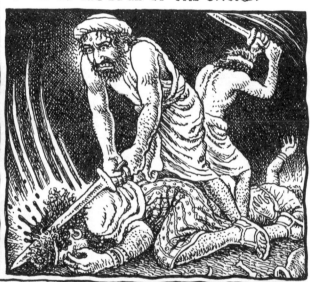

AND THEY TOOK DINAH FROM THE HOUSE OF SHECHEM AND WENT OUT.

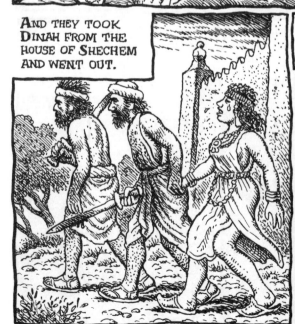

THE OTHER SONS OF JACOB CAME UPON THE SLAIN AND LOOTED THE TOWN BECAUSE THEIR SISTER HAD BEEN DEFILED.

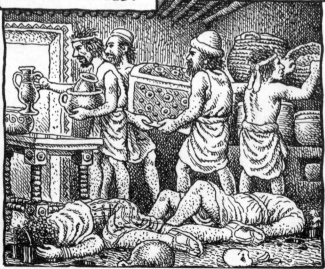

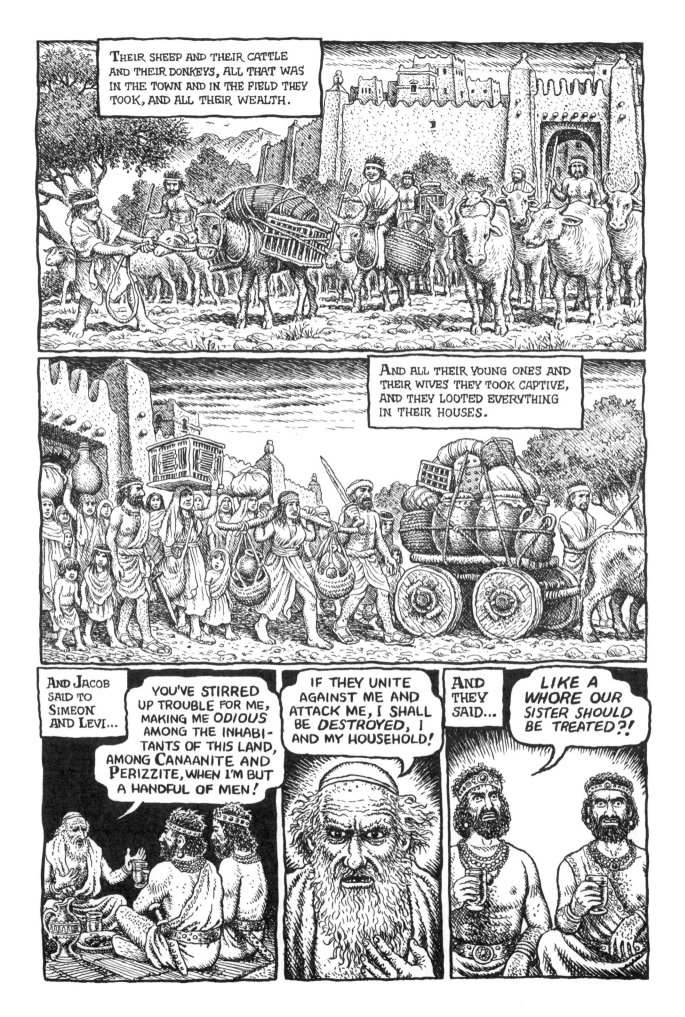

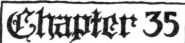

Chapter 35

AND GOD SAID TO JACOB...

RISE, GO TO BETHEL AND DWELL THERE AND MAKE AN ALTAR THERE TO THE GOD WHO APPEARED TO YOU WHEN YOU FLED FROM ESAU, YOUR BROTHER!

AND JACOB SAID TO HIS HOUSEHOLD AND TO ALL WHO WERE WITH HIM...

PUT AWAY THE ALIEN GODS THAT ARE IN YOUR MIDST AND CLEANSE YOURSELVES AND CHANGE YOUR GARMENTS!

AND LET US RISE AND GO UP TO BETHEL, AND I SHALL MAKE AN ALTAR THERE TO THE GOD WHO ANSWERED ME ON THE DAY OF MY DISTRESS, AND HAS BEEN WITH ME WHEREVER I WENT!

AND THEY GAVE JACOB ALL THE ALIEN GODS THAT WERE IN THEIR HANDS, AND THE RINGS THAT WERE IN THEIR EARS.

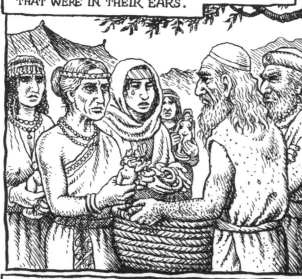

AND JACOB BURIED THEM UNDER THE TEREBINTH THAT IS BY SHECHEM.

AND THEY JOURNEYED ONWARD, AND THE TERROR OF GOD WAS UPON THE TOWNS AROUND THEM, AND THEY DID NOT PURSUE THE SONS OF JACOB.

AND JACOB CAME TO LUZ IN THE LAND OF CANAAN, THAT IS, BETHEL, HE AND ALL THE PEOPLE WHO WERE WITH HIM. AND HE BUILT THERE AN ALTAR, AND HE CALLED THE PLACE EL-BETHEL, FOR THERE GOD WAS REVEALED TO HIM WHEN HE FLED FROM HIS BROTHER.

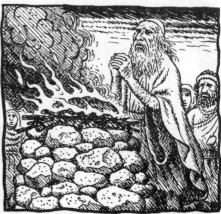

AND DEBORAH, REBEKAH'S NURSE, DIED, AND SHE WAS BURIED BELOW BETHEL, UNDER THE OAK, AND ITS NAME WAS CALLED ALLON-BACUTH.*

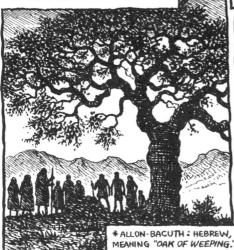

*ALLON-BACUTH: HEBREW, MEANING "OAK OF WEEPING."

AND GOD APPEARED TO JACOB AGAIN WHEN HE CAME OUT OF PADDAN-ARAM, AND HE BLESSED HIM, AND GOD SAID TO HIM...

YOU WHOSE NAME IS JACOB—NO LONGER SHALL YOUR NAME BE CALLED JACOB, BUT *ISRAEL* SHALL BE YOUR NAME!

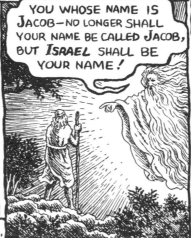

AND HE CALLED HIS NAME ISRAEL. AND GOD SAID TO HIM...

I AM EL SHADDAI! BE FRUITFUL AND MULTIPLY! A NATION, AN ASSEMBLY OF NATIONS SHALL STEM FROM YOU, AND KINGS SHALL COME FORTH FROM YOUR LOINS!

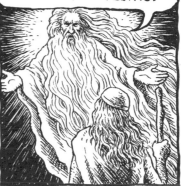

AND THE LAND THAT I GAVE TO ABRAHAM AND TO ISAAC, TO *YOU* I WILL GIVE IT, AND TO YOUR SEED AFTER YOU WILL I GIVE IT!

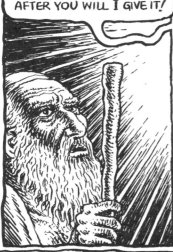

AND GOD ASCENDED FROM HIM IN THE PLACE WHERE HE HAD SPOKEN WITH HIM.

AND JACOB SET UP A PILLAR IN THE PLACE WHERE HE HAD SPOKEN WITH HIM, A PILLAR OF STONE.

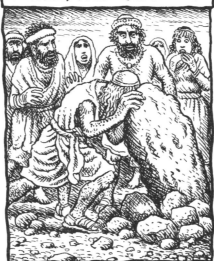

AND HE OFFERED LIBATION UPON IT AND POURED OIL UPON IT. AND JACOB CALLED THE NAME OF THE PLACE WHERE GOD HAD SPOKEN TO HIM BETHEL.

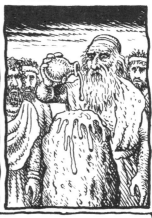

AND THEY JOURNEYED ONWARD FROM BETHEL, AND WHEN THEY WERE STILL SOME DISTANCE FROM EPHRATH, RACHEL GAVE BIRTH, AND SHE LABORED HARD IN THE BIRTH.

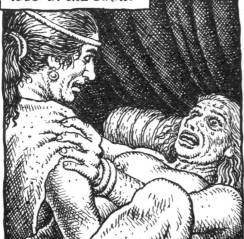

AND IT CAME TO PASS, WHEN SHE WAS LABORING HARDEST IN THE BIRTH, THAT THE MIDWIFE SAID TO HER...

FEAR NOT, FOR THIS ONE, TOO, IS A SON FOR YOU!!

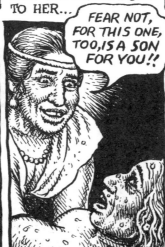

AND IT CAME TO PASS AS HER LIFE RAN OUT, FOR SHE WAS DYING, THAT SHE CALLED HIS NAME BEN-ONI.*

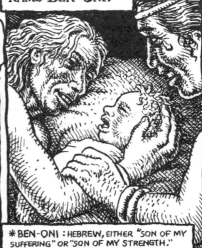

*BEN-ONI: HEBREW, EITHER "SON OF MY SUFFERING" OR "SON OF MY STRENGTH."

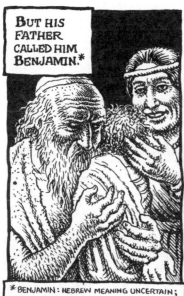

BUT HIS FATHER CALLED HIM BENJAMIN.*

*BENJAMIN: HEBREW MEANING UNCERTAIN; "SON OF THE RIGHT HAND"(THE FAVORED SIDE), OR "SON OF THE SOUTH", OR "SON OF OLD AGE".

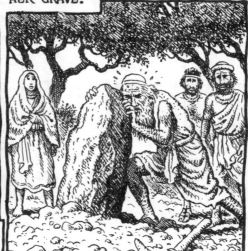

AND RACHEL DIED AND SHE WAS BURIED ON THE ROAD TO EPHRATH, THAT IS, BETHLEHEM. AND JACOB SET UP A PILLAR ON HER GRAVE.

IT IS THE PILLAR OF RACHEL'S GRAVE TO THIS DAY.

AND ISRAEL JOURNEYED ONWARD AND PITCHED HIS TENT ON THE FAR SIDE OF MIGDAL-EDER. AND IT CAME TO PASS, WHEN ISRAEL WAS ENCAMPED IN THAT LAND, THAT REUBEN WENT AND LAY WITH BILHAH, HIS FATHER'S CONCUBINE.

AND ISRAEL HEARD OF IT.

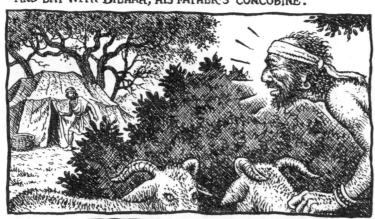

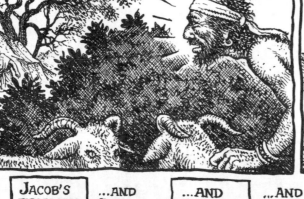

AND THE SONS OF JACOB WERE TWELVE. THE SONS OF LEAH...

JACOB'S FIRSTBORN, REUBEN...

...AND SIMEON...

...AND LEVI...

...AND JUDAH...

...AND ISSACHAR...

...AND ZEBULUN.

THE SONS OF RACHEL...

...JOSEPH...

...AND BENJAMIN...

...AND THE SONS OF BILHAH, RACHEL'S SLAVEGIRL...

...DAN...

...AND NAPHTALI.

AND THE SONS OF ZILPAH, LEAH'S SLAVEGIRL...

...GAD...

...AND ASHER.

THESE ARE THE SONS OF JACOB WHO WERE BORN TO HIM IN PADDAN-ARAM.

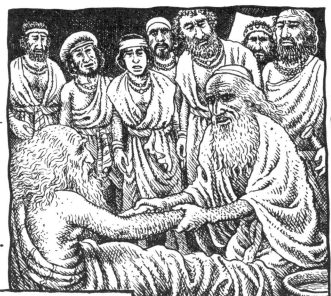

AND JACOB CAME TO ISAAC, HIS FATHER, IN MAMRE, AT KIRIATH-ARBA, THAT IS, HEBRON, WHERE ABRAHAM AND ISAAC HAD SOJOURNED.

AND ISAAC'S DAYS WERE 180 YEARS, AND ISAAC BREATHED HIS LAST AND DIED, AND WAS GATHERED TO HIS KIN, OLD AND SATED WITH YEARS, AND ESAU AND JACOB, HIS SONS, BURIED HIM.

Chapter 36

AND THIS IS THE LINEAGE OF ESAU, THAT IS, EDOM. ESAU TOOK HIS WIVES FROM THE DAUGHTERS OF CANAAN...

...ADAH, DAUGHTER OF ELON THE HITTITE...

...AND OHOLIBAMAH, DAUGHTER OF ANAH, SON OF ZIBEON THE HIVITE...

...AND BASEMATH, DAUGHTER OF ISHMAEL, SISTER OF NEBAIOTH.

AND ADAH BORE TO ESAU ELIPHAZ.

...WHILE BASE-MATH BORE REUEL...

...AND OHOLI-BAMAH BORE JEUSH...

...AND JALAM...

...AND KORAH.

THESE ARE THE SONS OF ESAU WHO WERE BORN TO HIM IN THE LAND OF CANAAN.

AND ESAU TOOK HIS WIVES AND HIS SONS AND HIS DAUGHTERS AND ALL THE PEOPLE OF HIS HOUSEHOLD, AND HIS LIVESTOCK AND ALL HIS CATTLE, AND ALL THE GOODS HE HAD GOTTEN IN THE LAND OF CANAAN, AND HE WENT TO ANOTHER LAND AWAY FROM JACOB, HIS BROTHER.

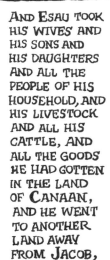

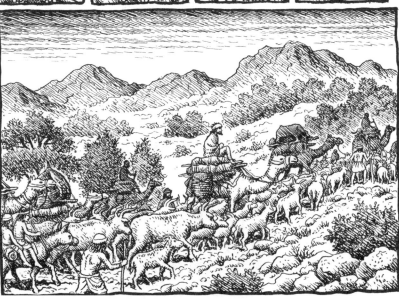

FOR THEIR SUBSTANCE WAS TOO GREAT FOR DWELLING TOGETHER, AND THE LAND OF THEIR SOJOURNINGS COULD NOT SUPPORT THEM BECAUSE OF THEIR LIVESTOCK. AND ESAU SETTLED IN THE HIGH COUNTRY OF SEIR-ESAU, THAT IS, EDOM.

AND THIS IS THE LINEAGE OF ESAU, FATHER OF EDOM, IN THE HIGH COUNTRY OF SEIR. THESE ARE THE NAMES OF THE SONS OF ESAU: ELIPHAZ, SON OF ADAH, ESAU'S WIFE, AND REUEL, SON OF BASEMATH, ESAU'S WIFE.

AND THE SONS OF ELIPHAZ WERE TEMAN, OMAR, ZEPHO, AND GATAM AND KENAZ.

AND TIMNA WAS A CONCUBINE OF ELIPHAZ, SON OF ESAU, AND SHE BORE TO ELIPHAZ AMALEK.

THESE WERE THE SONS OF ADAH, ESAU'S WIFE.

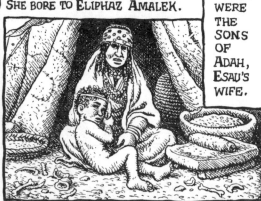

AND THESE ARE THE SONS OF REUEL: NAHATH AND ZERAH, SHAMMAH AND MIZZAH.

THESE WERE THE SONS OF BASEMATH, ESAU'S WIFE.

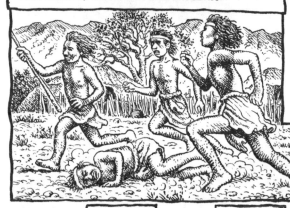

AND THESE ARE THE SONS OF ESAU'S WIFE, OHOLIBAMAH, DAUGHTER OF ANAH, SON OF ZIBEON. SHE BORE ESAU JEUSH AND JALAM AND KORAH.

THESE ARE THE CHIEFTAINS OF THE SONS OF ESAU. THE SONS OF ELIPHAZ, FIRSTBORN OF ESAU...

...THE CHIEFTAIN TEMAN... ...THE CHIEFTAIN OMAR... ...THE CHIEFTAIN ZEPHO... ...THE CHIEFTAIN KENAZ... ...THE CHIEFTAIN KORAH... ...THE CHIEFTAIN GATAM... ...THE CHIEFTAIN AMALEK.

THESE ARE THE CHIEFTAINS OF ELIPHAZ IN THE LAND OF EDOM. THESE ARE THE SONS OF ADAH.

AND THESE ARE THE SONS OF REUEL, SON OF ESAU...

...THE CHIEFTAIN NAHATH... ...THE CHIEFTAIN ZERAH... ...THE CHIEFTAIN SHAMMAH... ...THE CHIEFTAIN MIZZAH.

THESE ARE THE CHIEFTAINS OF REUEL IN THE LAND OF EDOM, THESE ARE THE SONS OF BASEMATH, ESAU'S WIFE.

AND THESE ARE THE SONS OF OHOLIBAMAH, ESAU'S WIFE...

...THE CHIEFTAIN JEUSH... ...THE CHIEFTAIN JALAM... ...THE CHIEFTAIN KORAH.

THESE ARE THE CHIEFTAINS OF OHOLIBAMAH, DAUGHTER OF ANAH, ESAU'S WIFE. THESE ARE THE SONS OF ESAU, THAT IS, EDOM, AND THESE ARE THEIR CHIEFTAINS.

THESE ARE THE SONS OF SEIR THE HORITE WHO HAD SETTLED IN THE LAND: LOTAN AND SHOBAL AND ZIBEON AND ANAH, AND DISHON AND EZER AND DISHAN. THESE ARE THE HORITE CHIEFTAINS, SONS OF SEIR, IN THE LAND OF EDOM. AND THE SONS OF LOTAN WERE HORI AND HEMAM, AND LOTAN'S SISTER WAS TIMNA. AND THESE ARE THE SONS OF SHOBAL: ALVAN AND MANAHOTH AND EBAL, SHEPHO AND ONAM.

AND THESE ARE THE SONS OF ZIBEON: AIAH AND ANAH, HE IS ANAH WHO FOUND THE WATER IN THE WILDERNESS WHEN HE TOOK THE DONKEYS OF HIS FATHER ZIBEON TO GRAZE.

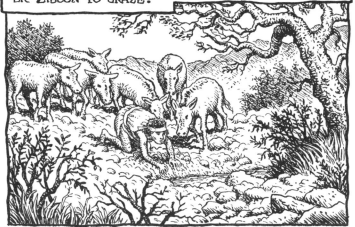

AND THESE ARE THE CHILDREN OF ANAH: DISHON AND OHOLIBAMAH, DAUGHTER OF ANAH. AND THESE ARE THE SONS OF DISHON: HEMDAN AND ESHBAN AND ITHRAN AND CHERAN. THESE ARE THE SONS OF EZER: BILHAN AND ZAAVAN AND AKAN. THESE ARE THE SONS OF DISHAN: UZ AND ARAN.

THESE ARE THE HORITE CHIEFTAINS...

...THE CHIEFTAIN LOTAN...

...THE CHIEFTAIN SHOBAL...

...THE CHIEFTAIN ZIBEON...

...THE CHIEFTAIN ANAH...

...THE CHIEFTAIN DISHON...

...THE CHIEFTAIN EZER...

...THE CHIEFTAIN DISHAN.

THESE ARE THE HORITE CHIEFTAINS BY THEIR CLANS IN THE LAND OF SEIR.

THESE ARE THE KINGS THAT REIGNED IN THE LAND OF EDOM BEFORE ANY KING REIGNED OVER THE ISRAELITES.

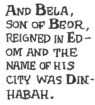

AND BELA, SON OF BEOR, REIGNED IN EDOM AND THE NAME OF HIS CITY WAS DINHABAH.

AND BELA DIED AND JOBAB, SON OF ZERAH FROM BOZRAH, REIGNED IN HIS STEAD.

AND JOBAB DIED, AND HUSHAM FROM THE LAND OF THE TEMANITE REIGNED IN HIS STEAD.

AND HUSHAM DIED AND HADAD, SON OF BEDAD, REIGNED IN HIS STEAD, HE WHO STRUCK DOWN MIDIAN ON THE STEPPE OF MOAB, AND THE NAME OF HIS CITY WAS AVITH.

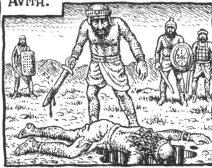

AND HADAD DIED AND SAMLAH OF MASREKAH REIGNED IN HIS STEAD.

AND SAMLAH DIED AND SAUL FROM REHOBOTH-ON-THE-RIVER REIGNED IN HIS STEAD.

AND SAUL DIED AND BAAL-HANAN, SON OF ACHBOR, REIGNED IN HIS STEAD.

AND BAAL-HANAN, SON OF ACHBOR, DIED AND HADAD REIGNED IN HIS STEAD, AND THE NAME OF HIS CITY WAS PAU...

...AND THE NAME OF HIS WIFE WAS MEHETABEL, DAUGHTER OF MATRED, DAUGHTER OF ME-ZAHAB.

AND THESE ARE THE CHIEFTAINS OF ESAU BY THEIR CLANS AND PLACES NAME BY NAME...

...THE CHIEFTAIN OF TIMNA...

...THE CHIEFTAIN ALVAH...

...THE CHIEFTAIN JETHETH...

...THE CHIEFTAIN OF O-HOLIBAMAH...

...THE CHIEFTAIN ELAH...

...THE CHIEFTAIN PINON...

...THE CHIEFTAIN KENAZ...

...THE CHIEFTAIN TEMAN...

...THE CHIEFTAIN MIBZAR...

...THE CHIEFTAIN MAGDIEL...

...THE CHIEFTAIN IRAM.

THESE ARE THE CHIEFTAINS OF EDOM BY THEIR SETTLEMENTS IN THE LAND OF THEIR STRONGHOLDS— THAT IS, ESAU, FATHER OF EDOM.

Chapter 37

AND JACOB DWELLED IN THE LAND OF HIS FATHER'S SO-JOURNINGS, IN THE LAND OF CANAAN. THIS IS THE LINEAGE OF JACOB— JOSEPH, SEVEN-TEEN YEARS OLD, WAS TENDING THE FLOCK WITH HIS BROTHERS, AS-SISTING THE SONS OF BILHAH AND THE SONS OF ZILPAH, THE WIVES OF HIS FATHER.

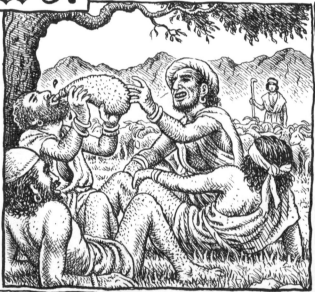

AND JOSEPH BROUGHT ILL RE-PORT OF THEM TO THEIR FATHER.

AND ISRAEL LOVED JOSEPH MORE THAN ALL HIS SONS, FOR HE WAS THE CHILD OF HIS OLD AGE, AND HE MADE HIM AN ORNAMENTAL TUNIC.

AND HIS BROTHERS SAW IT WAS HE THEIR FATHER LOVED MORE THAN ALL HIS BROTHERS.

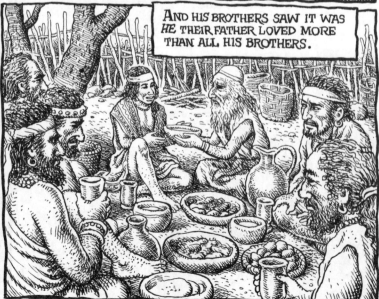

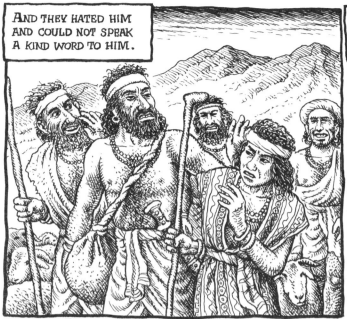

AND THEY HATED HIM AND COULD NOT SPEAK A KIND WORD TO HIM.

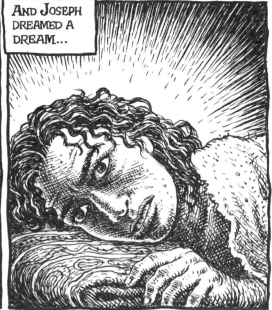

AND JOSEPH DREAMED A DREAM...

...AND TOLD IT TO HIS BROTHERS, AND THEY HATED HIM ALL THE MORE.

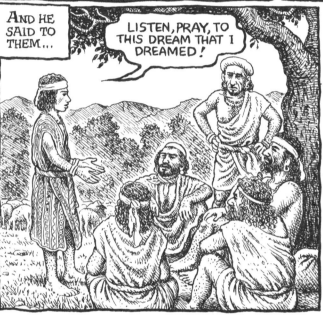

AND HE SAID TO THEM...

LISTEN, PRAY, TO THIS DREAM THAT I DREAMED!

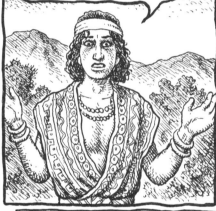

AND, BEHOLD, WE WERE BINDING SHEAVES IN THE FIELD, AND, BEHOLD, MY SHEAF AROSE AND ACTUALLY *STOOD UP*, AND, BEHOLD, YOUR SHEAVES DREW ROUND AND *BOWED TO MY SHEAF!*

AND HIS BROTHERS SAID TO HIM...

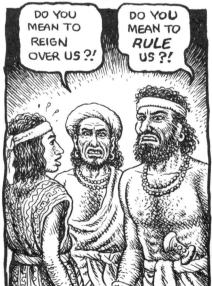

DO YOU MEAN TO REIGN OVER US ?!

DO YOU MEAN TO *RULE* US ?!

AND THEY HATED HIM ALL THE MORE, FOR HIS DREAMS AND FOR HIS WORDS.

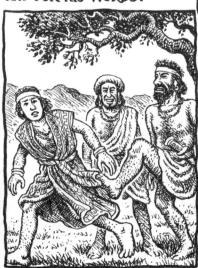

AND HE DREAMED YET AN-OTHER DREAM AND RECOUNTED IT TO HIS BROTHERS...

BEHOLD, I DREAMED A DREAM AGAIN!

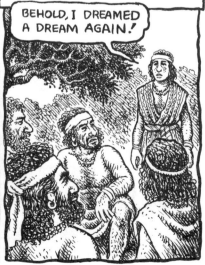

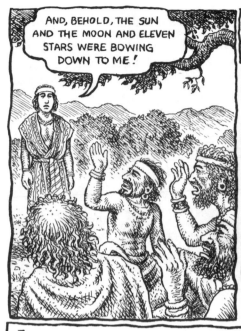

AND, BEHOLD, THE SUN AND THE MOON AND ELEVEN STARS WERE BOWING DOWN TO ME!

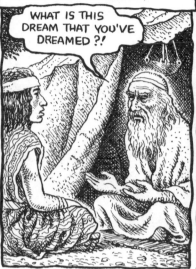

AND HE RECOUNTED IT TO HIS FATHER, AND HIS FATHER REBUKED HIM AND SAID TO HIM...

WHAT IS THIS DREAM THAT YOU'VE DREAMED?!

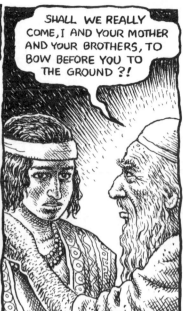

SHALL WE REALLY COME, I AND YOUR MOTHER AND YOUR BROTHERS, TO BOW BEFORE YOU TO THE GROUND?!

AND HIS BROTHERS WERE JEALOUS OF HIM, WHILE HIS FATHER KEPT THE THING IN MIND.

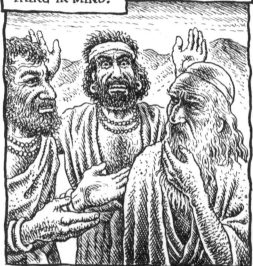

AND HIS BROTHERS WENT TO GRAZE THEIR FATHER'S FLOCK AT SHECHEM. AND ISRAEL SAID TO JOSEPH...

YOU KNOW, YOUR BROTHERS ARE PASTURING AT SHECHEM. COME, LET ME SEND YOU TO THEM!

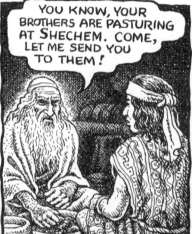

AND HE SAID TO HIM...

I'M READY!

AND HE SAID TO HIM...

GO, PRAY, TO SEE HOW YOUR BROTHERS FARE, AND HOW THE FLOCK FARES, AND BRING ME BACK WORD.

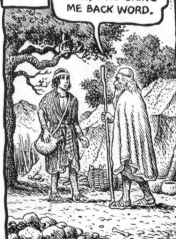

AND HE SENT HIM FROM THE VALLEY OF HEBRON AND HE CAME TO SHECHEM. AND A MAN FOUND HIM AND, BEHOLD, HE WAS WANDERING IN THE FIELD.

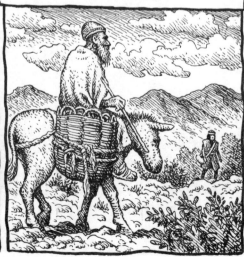

AND THE MAN ASKED HIM, SAYING...

WHAT IS IT YOU SEEK?

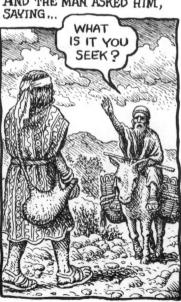

AND HE SAID...

MY BROTHERS I SEEK...TELL ME, PRAY, WHERE ARE THEY PASTURING?

AND THE MAN SAID...

THEY'VE JOURNEYED ON FROM HERE, FOR I HEARD THEM SAY, "LET'S GO TO DOTHAN!"

AND JOSEPH WENT AFTER HIS BROTHERS AND FOUND THEM AT DOTHAN. AND THEY SAW HIM FROM AFAR BEFORE HE DREW NEAR THEM.

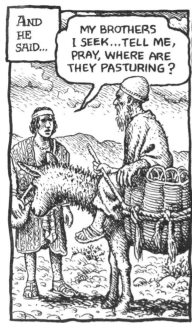
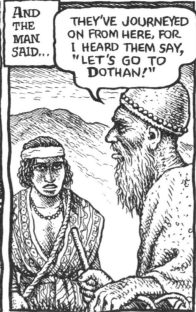
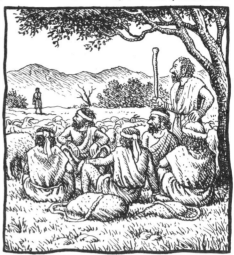

AND THEY PLOTTED AGAINST HIM TO PUT HIM TO DEATH. AND THEY SAID TO ONE ANOTHER...

HERE COMES THAT DREAM-MASTER!

AND SO NOW LET'S KILL HIM AND FLING HIM INTO ONE OF THE PITS!!

AND WE CAN SAY A VICIOUS BEAST HAS DEVOURED HIM!

AND WE'LL SEE WHAT COMES OF HIS DREAMS!

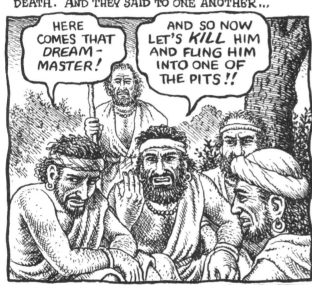
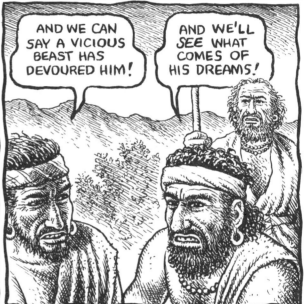

AND REUBEN HEARD AND CAME TO HIS RESCUE AND SAID...

WE MUST NOT TAKE HIS LIFE!

AND REUBEN SAID TO THEM...

SHED NO BLOOD!

FLING HIM INTO THIS PIT IN THE WILDERNESS, BUT DO NOT RAISE A HAND AGAINST HIM!

...THAT HE MIGHT RESCUE HIM FROM THEIR HANDS TO BRING HIM BACK TO HIS FATHER.

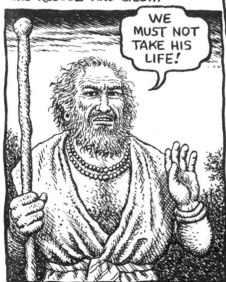
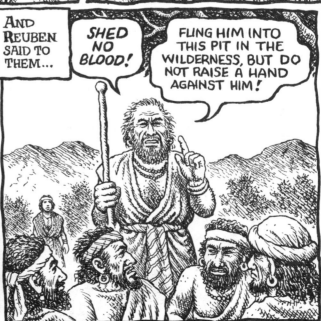

AND IT CAME TO PASS, WHEN JOSEPH CAME TO HIS BROTHERS, THAT THEY STRIPPED HIM OF HIS ORNAMENTAL TUNIC THAT HE HAD ON HIM.

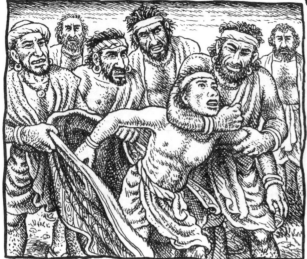

AND THEY TOOK HIM AND FLUNG HIM INTO THE PIT.

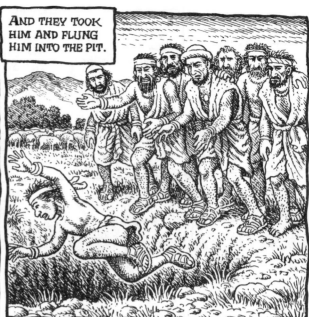

AND THE PIT WAS EMPTY, THERE WAS NO WATER IN IT.

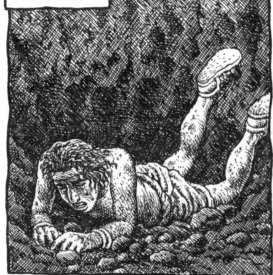

AND THEY SAT DOWN TO EAT BREAD...

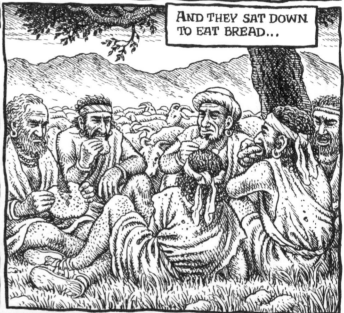

AND THEY RAISED THEIR EYES AND LOOKED, AND, BEHOLD, A CARAVAN OF ISHMAELITES WAS COMING FROM GILEAD, THEIR CAMELS BEARING GUM AND BALM AND LADANUM ON THEIR WAY TO TAKE DOWN TO EGYPT.

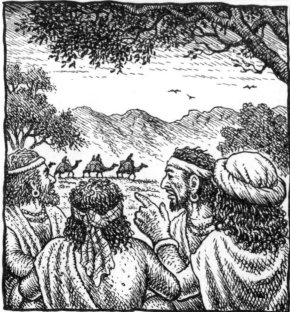

AND JUDAH SAID TO HIS BROTHERS...

WHAT GAIN IS THERE IF WE KILL OUR BROTHER AND COVER UP HIS BLOOD?!

COME, LET'S SELL HIM TO THE ISHMAELITES, AND OUR HAND WILL NOT BE AGAINST HIM, FOR HE IS OUR BROTHER, OUR OWN FLESH!

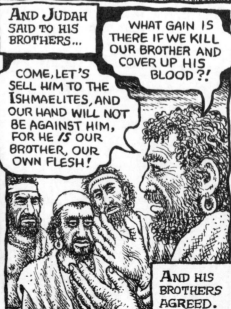

AND HIS BROTHERS AGREED.

AND MIDIANITE MERCHANTS PASSED BY AND PULLED JOSEPH OUT OF THE PIT...

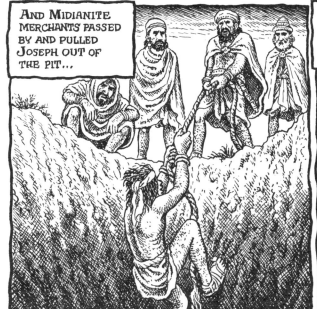

...AND SOLD JOSEPH TO THE ISHMAELITES FOR TWENTY PIECES OF SILVER.

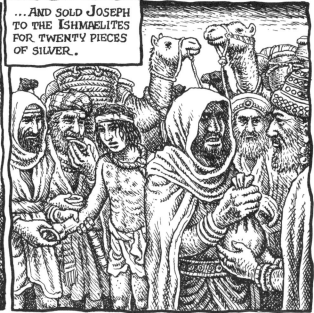

AND THEY BROUGHT JOSEPH TO EGYPT.

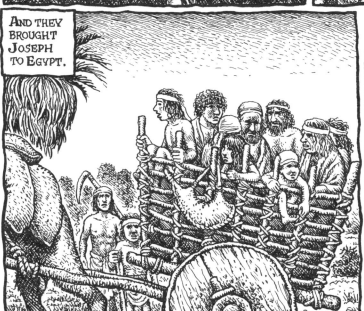

AND REUBEN CAME BACK TO THE PIT, AND, BEHOLD, JOSEPH WAS NOT IN THE PIT.

AND HE RENT HIS GARMENTS...

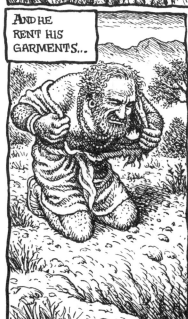

...AND HE CAME BACK TO HIS BROTHERS, AND HE SAID...

THE BOY IS GONE, AND NOW, WHAT AM I TO DO?!?

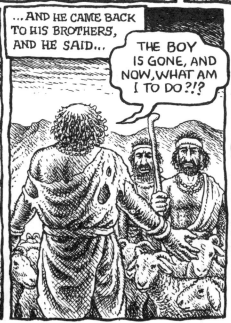

AND THEY TOOK JOSEPH'S TUNIC AND SLAUGHTERED A KID AND DIPPED THE TUNIC IN THE BLOOD.

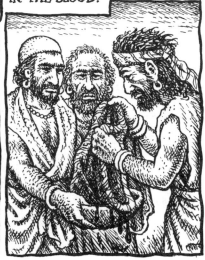

AND THEY SENT THE ORNAMENTAL TUNIC AND HAD IT BROUGHT TO THEIR FATHER, AND THEY SAID...

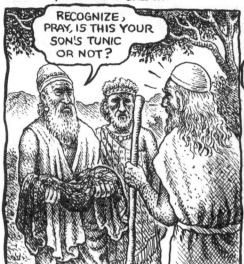

RECOGNIZE, PRAY, IS THIS YOUR SON'S TUNIC OR NOT?

AND HE RECOGNIZED IT AND HE SAID...

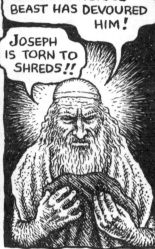

IT *IS* MY SON'S TUNIC! A VICIOUS BEAST HAS DEVOURED HIM!

JOSEPH IS TORN TO SHREDS!!

AND JACOB RENT HIS CLOTHES AND PUT SACKCLOTH ROUND HIS LOINS AND MOURNED HIS SON MANY DAYS.

AND ALL HIS SONS AND ALL HIS DAUGHTERS SOUGHT TO COMFORT HIM, BUT HE REFUSED TO BE COMFORTED, SAYING...

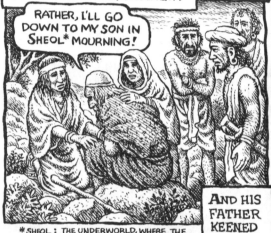

RATHER, I'LL GO DOWN TO MY SON IN SHEOL* MOURNING!

* SHEOL : THE UNDERWORLD, WHERE THE SPIRITS OF THE DEAD WERE BELIEVED TO RESIDE.

AND HIS FATHER KEENED FOR HIM.

BUT THE MIDIANITES' HAD SOLD HIM INTO EGYPT TO POTIPHAR, PHARAOH'S COURTIER, THE HIGH CHAMBERLAIN.

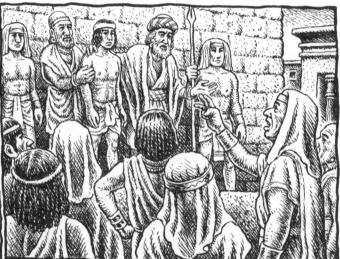

Chapter 38

AND IT CAME TO PASS AT THIS TIME THAT JUDAH WENT DOWN FROM HIS BROTHERS AND PITCHED HIS TENT BY AN ADULLAMITE NAMED HIRAH. AND JUDAH SAW THERE THE DAUGHTER OF A CANAANITE NAMED SHUA.

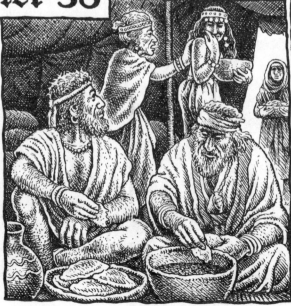

AND HE TOOK HER AND CAME TO BED WITH HER, AND SHE CONCEIVED AND BORE A SON AND CALLED HIS NAME ER.

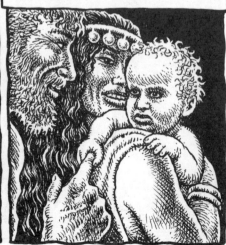

AND SHE CONCEIVED AGAIN AND BORE A SON AND CALLED HIS NAME ONAN.

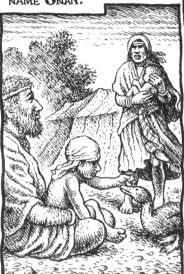

AND SHE BORE STILL ANOTHER SON AND CALLED HIS NAME SHELAH, AND HE WAS AT CHEZIB WHEN SHE BORE HIM.

AND JUDAH TOOK A WIFE FOR ER HIS FIRSTBORN, AND HER NAME WAS TAMAR.

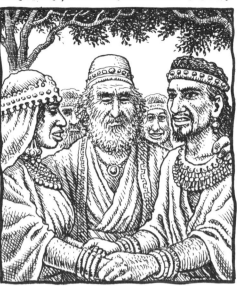

AND ER, JUDAH'S FIRSTBORN, WAS EVIL IN THE EYES OF THE LORD.

AND THE LORD PUT HIM TO DEATH.

AND JUDAH SAID TO ONAN...

COME TO BED WITH YOUR BROTHER'S WIFE AND DO YOUR DUTY AS BROTHER-IN-LAW FOR HER, AND RAISE UP SEED FOR YOUR BROTHER!

AND ONAN KNEW THAT THE SEED WOULD NOT COUNT AS HIS, AND SO WHEN HE WOULD COME TO BED WITH HIS BROTHER'S WIFE HE WOULD WASTE IT ON THE GROUND SO AS NOT TO PROVIDE SEED FOR HIS BROTHER.

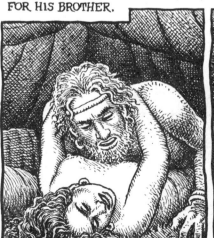

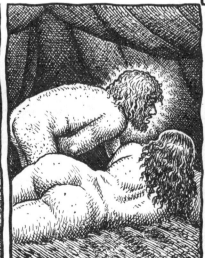

AND WHAT HE DID WAS EVIL IN THE EYES OF THE LORD, AND HE PUT HIM TO DEATH AS WELL.

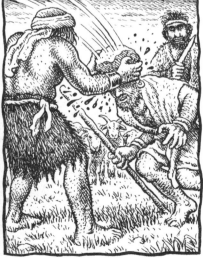

AND JUDAH SAID TO TAMAR, HIS DAUGHTER-IN-LAW...

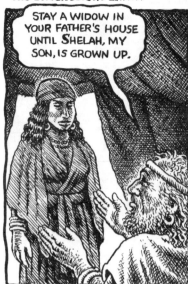

STAY A WIDOW IN YOUR FATHER'S HOUSE UNTIL SHELAH, MY SON, IS GROWN UP.

FOR HE THOUGHT...

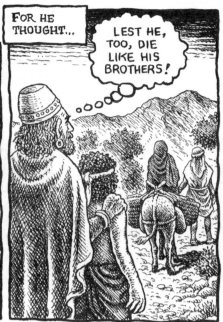

LEST HE, TOO, DIE LIKE HIS BROTHERS!

AND TAMAR WENT AND STAYED AT HER FATHER'S HOUSE.

AND A LONG TIME PASSED AND THE DAUGHTER OF SHUA, JUDAH'S WIFE, DIED, AND AFTER THE MOURNING PERIOD, JUDAH WENT UP TO HIS SHEEPSHEARERS, ALONG WITH HIS FRIEND, HIRAH THE ADULLAMITE, TO TIMNAH.

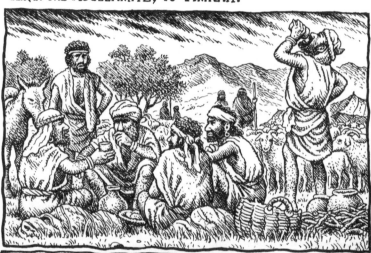

AND TAMAR WAS TOLD, SAYING...

BEHOLD, YOUR FATHER-IN-LAW IS GOING UP TO TIMNAH TO SHEAR HIS SHEEP.

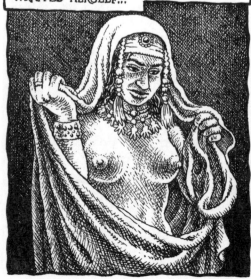

AND SHE TOOK OFF HER WIDOW'S GARB AND COVERED HERSELF WITH A VEIL AND WRAPPED HERSELF...

...AND SAT BY THE ENTRANCE TO ENAIM, WHICH IS ON THE ROAD TO TIMNAH, FOR SHE SAW THAT SHELAH HAD GROWN UP AND SHE HAD NOT BEEN GIVEN TO HIM AS WIFE.

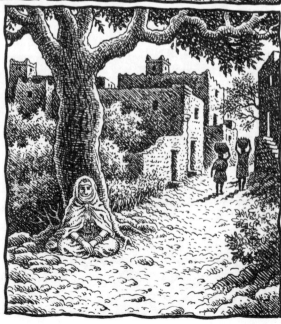

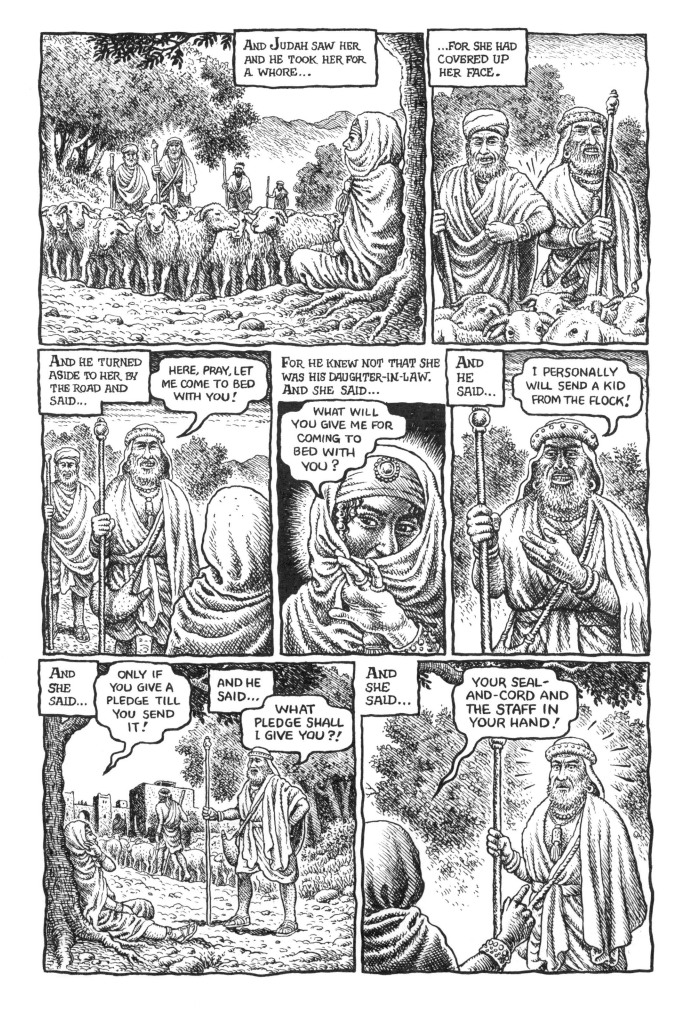

AND HE GAVE THEM TO HER, AND HE CAME TO BED WITH HER.

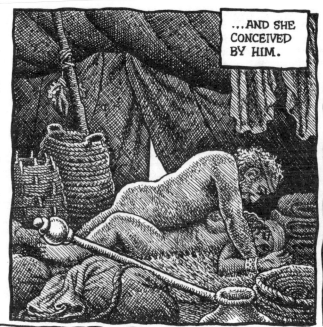

...AND SHE CONCEIVED BY HIM.

AND SHE ROSE AND WENT HER WAY, AND TOOK OFF THE VEIL SHE WAS WEARING AND PUT ON HER WIDOW'S GARB.

AND JUDAH SENT THE KID BY THE HAND OF HIS FRIEND THE ADULLAMITE TO TAKE BACK THE PLEDGE FROM THE WOMAN'S HAND, AND HE DID NOT FIND HER.

AND HE ASKED THE MEN OF THE PLACE, SAYING...

WHERE'S THE CULT-HARLOT, THE ONE AT ENAIM, BY THE ROAD?

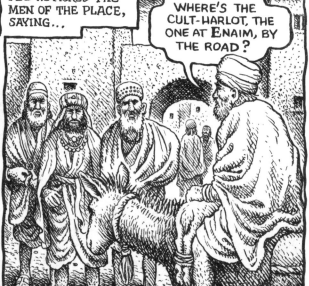

AND THEY SAID...

THERE'S BEEN NO CULT-HARLOT HERE!

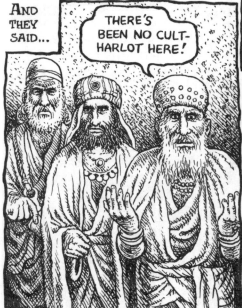

AND HE RETURNED TO JUDAH AND SAID...

I COULDN'T FIND HER!

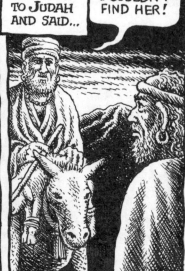

AND THE MEN OF THE PLACE SAID AS WELL, "THERE'S BEEN NO CULT-HARLOT HERE"!

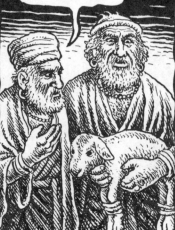

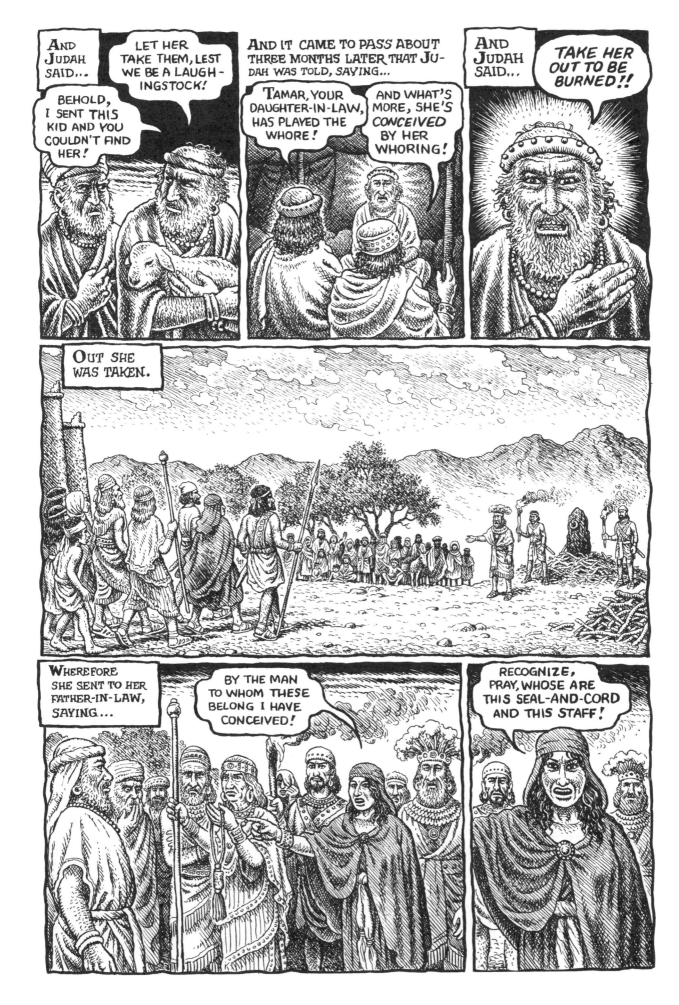

AND JUDAH RECOGNIZED THEM AND HE SAID...

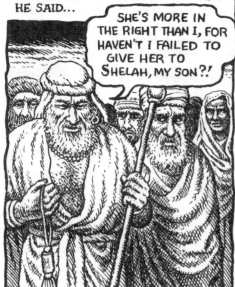

SHE'S MORE IN THE RIGHT THAN I, FOR HAVEN'T I FAILED TO GIVE HER TO SHELAH, MY SON?!

AND HE KNEW HER AGAIN NO MORE.

AND IT CAME TO PASS AT THE TIME, SHE GAVE BIRTH THAT, BEHOLD, THERE WERE TWINS IN HER WOMB.

AND IT HAPPENED AS SHE GAVE BIRTH THAT ONE PUT OUT HIS HAND AND THE MIDWIFE TOOK IT AND BOUND A SCARLET THREAD ON HIS HAND, TO SAY, THIS ONE CAME OUT FIRST.

AND HE DREW BACK HIS HAND AND, BEHOLD, OUT CAME HIS BROTHER, AND SHE SAID...

WHAT A BREACH YOU'VE MADE FOR YOURSELF!

AND SHE CALLED HIS NAME PEREZ.*

* PEREZ: FROM THE HEBREW, *PERETS*, MEANING "BURSTS FORTH."

AND AFTERWARD OUT CAME HIS BROTHER, ON WHOSE HAND WAS THE SCARLET THREAD, AND SHE CALLED HIS NAME ZERAH.*

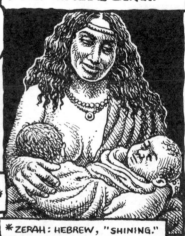

* ZERAH: HEBREW, "SHINING."

Chapter 39

AND JOSEPH WAS BROUGHT DOWN TO EGYPT, AND POTIPHAR, COURTIER OF PHARAOH, THE HIGH CHAMBERLAIN, AN EGYPTIAN MAN, BOUGHT HIM FROM THE HANDS OF THE ISHMAELITES WHO HAD BROUGHT HIM DOWN THERE.

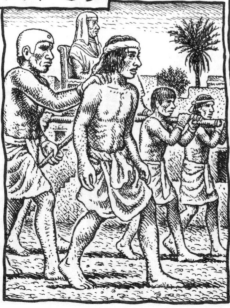

AND THE LORD WAS WITH JOSEPH AND HE WAS A SUCCESSFUL MAN, AND HE WAS IN THE HOUSE OF HIS EGYPTIAN MASTER. AND HIS MASTER SAW THAT THE LORD WAS WITH HIM, AND ALL THAT HE DID THE LORD MADE SUCCEED IN HIS HAND.

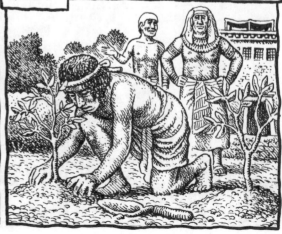

AND JOSEPH FOUND FAVOR IN HIS EYES AND HE MINISTERED TO HIM, AND HE PUT HIM IN CHARGE OF HIS HOUSE, AND ALL THAT HE HAD HE PLACED IN HIS HANDS.

AND IT CAME TO PASS FROM THE TIME HE PUT HIM IN CHARGE OF HIS HOUSE AND OF ALL HE HAD THAT THE LORD HAD BLESSED IN THE EGYPTIAN'S HOUSE FOR JOSEPH'S SAKE, THAT THE LORD'S BLESSING WAS ON ALL THAT HE HAD IN HOUSE AND FIELD.

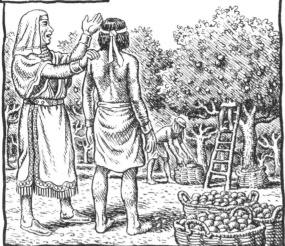
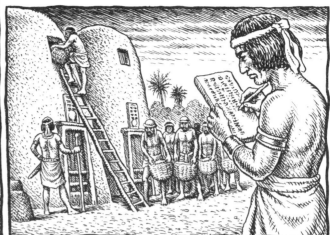

AND HE LEFT ALL THAT HE HAD IN JOSEPH'S HANDS AND, WITH HIM THERE, GAVE NO THOUGHT TO ANYTHING SAVE THE FOOD THAT HE ATE.

AND JOSEPH WAS HANDSOME IN FEATURES AND COMELY TO LOOK AT.

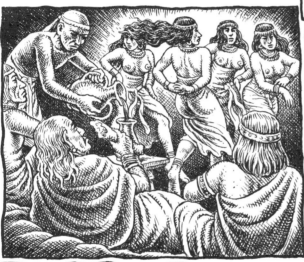

AND IT CAME TO PASS AFTER THESE THINGS THAT HIS MASTER'S WIFE RAISED HER EYES TO JOSEPH AND SAID...

LIE WITH ME!

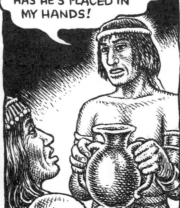

AND HE REFUSED. AND HE SAID TO HIS MASTER'S WIFE...

BEHOLD, MY MASTER HAS GIVEN NO THOUGHT WITH ME HERE TO WHAT'S IN HIS HOUSE, AND ALL THAT HE HAS HE'S PLACED IN MY HANDS!

HE WIELDS NO MORE AUTHORITY IN THIS HOUSE THAN I, AND HE'S HELD BACK NOTHING FROM ME EXCEPT YOU, SINCE YOU'RE HIS WIFE!

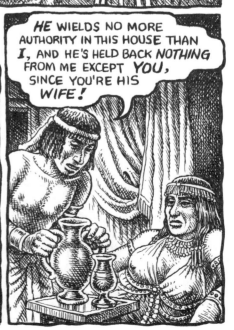

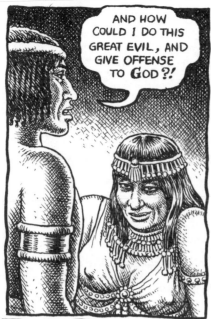

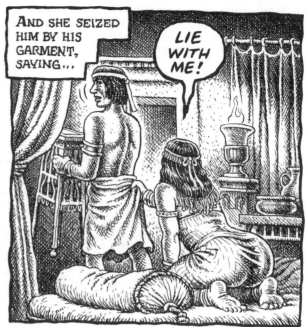

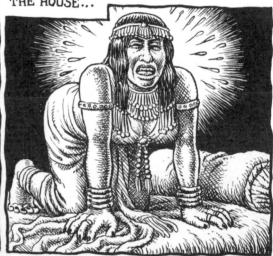

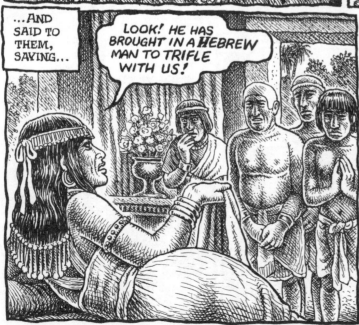

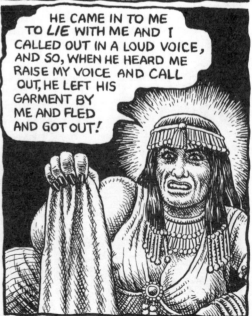

AND SHE LAID OUT HIS GARMENT BY HER UNTIL HIS MASTER CAME HOME. AND SHE SPOKE TO HIM THINGS OF THIS SORT, SAYING...

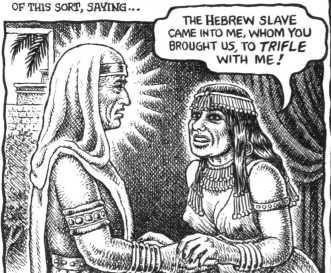

THE HEBREW SLAVE CAME INTO ME, WHOM YOU BROUGHT US, TO *TRIFLE* WITH ME!

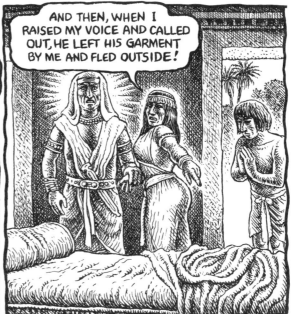

AND THEN, WHEN I RAISED MY VOICE AND CALLED OUT, HE LEFT HIS GARMENT BY ME AND FLED OUTSIDE!

AND IT CAME TO PASS, WHEN HIS MASTER HEARD HIS WIFE'S WORDS WHICH SHE SPOKE TO HIM, SAYING, "THUS AND SO YOUR SLAVE DID TO ME," HE BECAME INCENSED.

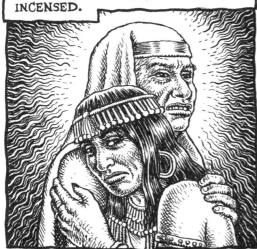

AND JOSEPH'S MASTER TOOK HIM AND PLACED HIM IN THE PRISON-HOUSE, THE PLACE WHERE THE KING'S PRISONERS WERE HELD.

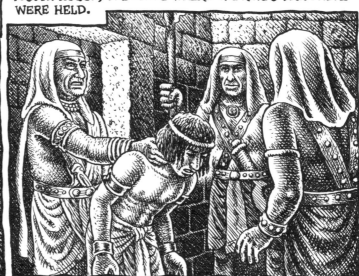

AND HE WAS THERE IN THE PRISON-HOUSE...

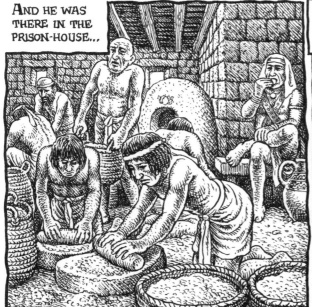

...AND GOD WAS WITH JOSEPH AND EXTENDED KINDNESS TO HIM, AND GRANTED HIM FAVOR IN THE EYES OF THE PRISON-HOUSE WARDEN.

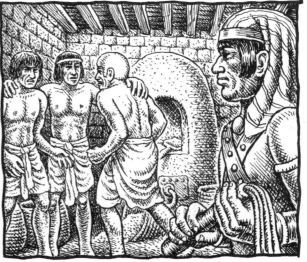

AND THE PRISON-HOUSE WARDEN PLACED IN JOSEPH'S HANDS ALL THE PRISONERS WHO WERE IN THE PRISON-HOUSE, AND ALL THAT THEY WERE TO DO THERE, IT WAS HE WHO SAW THAT IT WAS DONE.

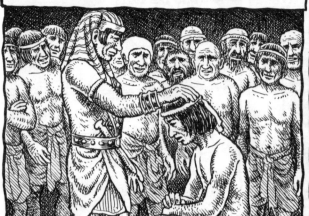

THE PRISON-HOUSE WARDEN HAD TO SEE TO NOTHING THAT WAS IN JOSEPH'S HANDS, AS THE LORD WAS WITH HIM, AND WHATEVER HE DID, THE LORD MADE SUCCEED.

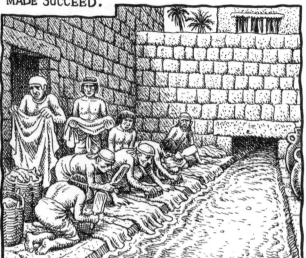

Chapter 40

AND IT CAME TO PASS AFTER THESE THINGS THAT THE CUPBEARER OF THE KING OF EGYPT AND HIS BAKER GAVE OFFENSE TO THEIR LORD, THE KING OF EGYPT.

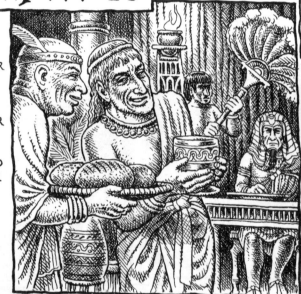

AND PHARAOH WAS FURIOUS WITH HIS TWO COURTIERS, THE CHIEF CUPBEARER AND THE CHIEF BAKER.

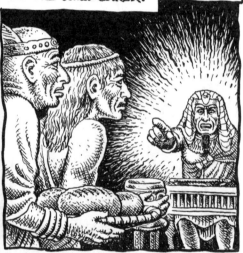

AND HE PUT THEM UNDER GUARD IN THE HOUSE OF THE HIGH CHAMBERLAIN, THE PRISON-HOUSE, THE PLACE WHERE JOSEPH WAS.

AND THE HIGH CHAMBERLAIN ASSIGNED JOSEPH TO THEM AND HE MINISTERED TO THEM, AND THEY STAYED A GOOD LONG WHILE UNDER GUARD.

AND THE TWO OF THEM DREAMED A DREAM, EACH HIS OWN DREAM, ON A SINGLE NIGHT, EACH A DREAM WITH ITS OWN SOLUTION—THE CUPBEARER AND THE BAKER TO THE KING OF EGYPT WHO WERE HELD IN THE PRISON-HOUSE.

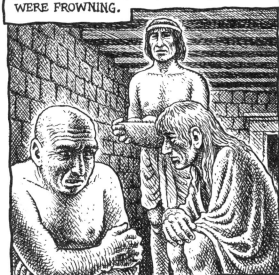

AND JOSEPH CAME TO THEM IN THE MORNING AND SAW THEM AND, BEHOLD, THEY WERE FROWNING.

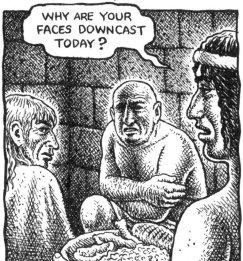

AND HE ASKED PHARAOH'S COURTIERS WHO WERE WITH HIM UNDER GUARD IN HIS LORD'S HOUSE, SAYING...

WHY ARE YOUR FACES DOWNCAST TODAY?

AND THEY SAID TO HIM...

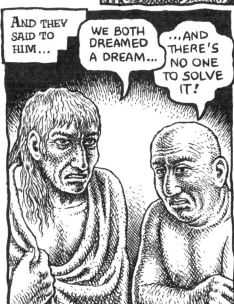

WE BOTH DREAMED A DREAM...

...AND THERE'S NO ONE TO SOLVE IT!

AND JOSEPH SAID TO THEM...

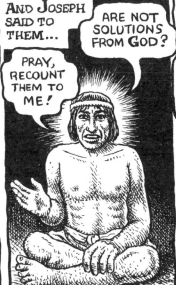

ARE NOT SOLUTIONS FROM GOD?

PRAY, RECOUNT THEM TO ME!

AND THE CHIEF CUPBEARER RECOUNTED HIS DREAM TO JOSEPH AND SAID TO HIM...

BEHOLD, A VINE WAS BEFORE ME! AND ON THE VINE WERE THREE TENDRILS, AND AS IT WAS BUDDING ITS BLOSSOMS SHOT UP! ITS CLUSTERS RIPENED INTO GRAPES!

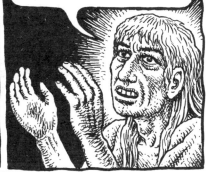

"AND PHARAOH'S CUP WAS IN MY HAND. AND I TOOK THE GRAPES AND CRUSHED THEM INTO PHARAOH'S CUP."

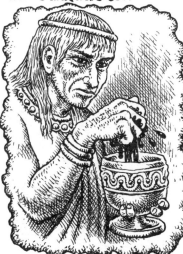

"AND I PLACED THE CUP IN PHARAOH'S PALM."

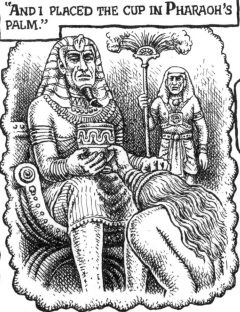

AND JOSEPH SAID...

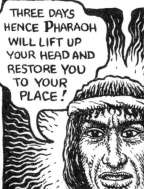

THIS IS ITS SOLUTION: THE THREE TENDRILS ARE THREE DAYS.

THREE DAYS HENCE PHARAOH WILL LIFT UP YOUR HEAD AND RESTORE YOU TO YOUR PLACE!

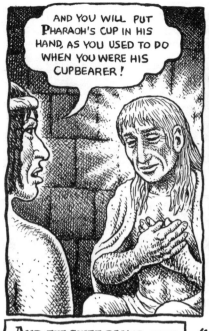

AND YOU WILL PUT PHARAOH'S CUP IN HIS HAND, AS YOU USED TO DO WHEN YOU WERE HIS CUPBEARER!

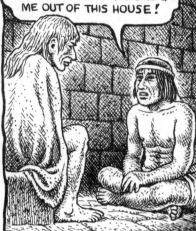

BUT IF YOU REMEMBER I WAS WITH YOU ONCE IT GOES WELL FOR YOU, DO ME THE KINDNESS, PRAY, TO MENTION ME TO PHARAOH AND BRING ME OUT OF THIS HOUSE!

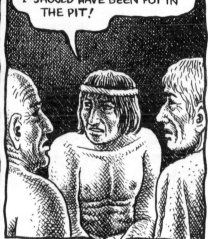

FOR INDEED I WAS STOLEN FROM THE LAND OF THE HEBREWS, AND HERE, TOO, I'VE DONE NOTHING THAT I SHOULD HAVE BEEN PUT IN THE PIT!

AND THE CHIEF BAKER SAW THAT HE HAD SOLVED WELL, AND HE SAID TO JOSEPH...

I, TOO, IN MY DREAM— BEHOLD, THERE WERE THREE OPENWORK BASKETS ON MY HEAD...

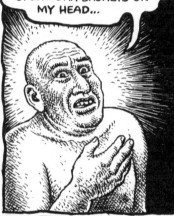

"...AND IN THE TOPMOST WERE ALL SORTS OF FOOD FOR PHARAOH, BAKER'S WARE, AND BIRDS WERE EATING FROM THE BASKET OVER MY HEAD."

AND JOSEPH ANSWERED AND SAID...

THIS IS ITS SOLUTION: THE THREE BASKETS ARE THREE DAYS.

THREE DAYS HENCE PHARAOH WILL LIFT UP YOUR HEAD FROM UPON YOU AND IMPALE YOU ON A POLE, AND THE BIRDS WILL EAT YOUR FLESH FROM OFF OF YOU!

AND IT CAME TO PASS ON THE THIRD DAY, PHARAOH'S BIRTHDAY, THAT HE MADE A FEAST FOR ALL HIS SERVANTS.

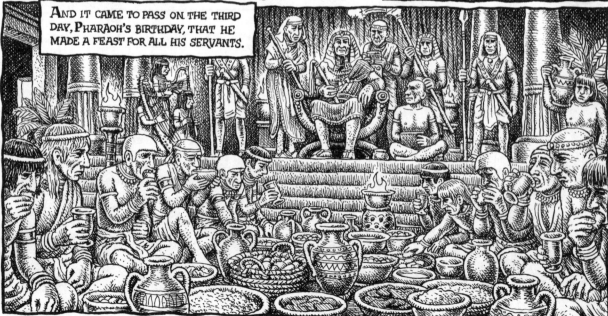

AND HE LIFTED UP THE HEAD OF THE CHIEF CUPBEARER AND THE HEAD OF THE CHIEF BAKER IN THE MIDST OF HIS SERVANTS.

AND HE RESTORED THE CHIEF CUBBEARER TO HIS CUPBEARING.

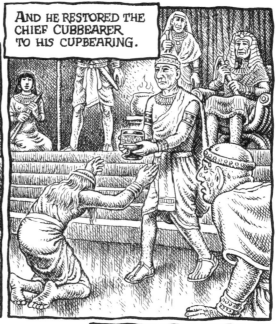

AND HE PUT THE CUP IN PHARAOH'S HAND.

AND THE CHIEF BAKER HE IMPALED— JUST AS JOSEPH HAD SOLVED IT FOR THEM.

BUT THE CHIEF CUPBEARER DID NOT REMEMBER JOSEPH, NO, HE FORGOT HIM.

Chapter 41

AND IT CAME TO PASS AT THE END OF TWO FULL YEARS THAT PHARAOH DREAMED...

...AND, BEHOLD, HE WAS STANDING BY THE NILE. AND, BEHOLD, OUT OF THE NILE CAME SEVEN COWS, FAIR TO LOOK AT AND FAT IN FLESH, AND THEY GRAZED IN THE RUSHES.

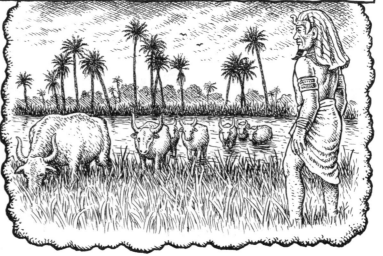

AND, BEHOLD, ANOTHER SEVEN COWS CAME UP AFTER THEM OUT OF THE NILE, FOUL TO LOOK AT AND MEAGER IN FLESH, AND STOOD BY THE COWS ON BANK OF THE NILE.

AND THE FOUL-LOOKING MEAGER-FLESHED COWS ATE UP THE SEVEN FAIR-LOOKING FAT COWS.

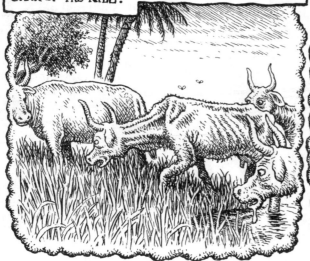
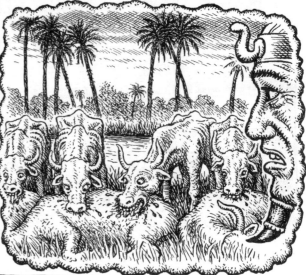

AND PHARAOH AWOKE. AND HE SLEPT AND DREAMED A SECOND TIME, AND, BEHOLD, SEVEN EARS OF GRAIN CAME UP ON A SINGLE STALK, FAT AND GOODLY.

AND, BEHOLD, SEVEN MEAGER EARS, BLASTED BY THE EAST WIND, SPROUTED AFTER THEM.

AND THE MEAGER EARS SWALLOWED THE SEVEN FAT AND FULL EARS.

AND PHARAOH AWOKE AND, BEHOLD, IT WAS A DREAM. AND IT CAME TO PASS IN THE MORNING THAT HIS HEART POUNDED...

...AND HE SENT AND CALLED IN ALL THE SOOTHSAYERS OF EGYPT AND ALL ITS WISE MEN, AND PHARAOH RECOUNTED TO THEM HIS DREAMS.

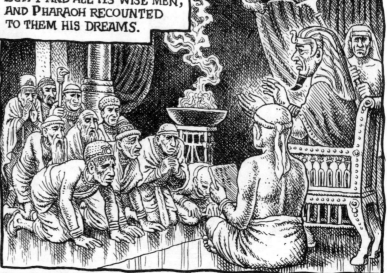

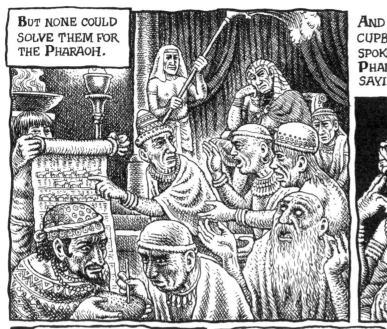

BUT NONE COULD SOLVE THEM FOR THE PHARAOH.

AND THE CHIEF CUPBEARER SPOKE TO PHARAOH, SAYING...

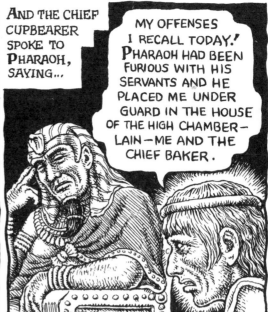

MY OFFENSES I RECALL TODAY! PHARAOH HAD BEEN FURIOUS WITH HIS SERVANTS AND HE PLACED ME UNDER GUARD IN THE HOUSE OF THE HIGH CHAMBER-LAIN—ME AND THE CHIEF BAKER.

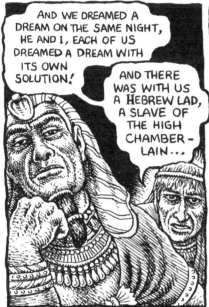

AND WE DREAMED A DREAM ON THE SAME NIGHT, HE AND I, EACH OF US DREAMED A DREAM WITH ITS OWN SOLUTION!

AND THERE WAS WITH US A HEBREW LAD, A SLAVE OF THE HIGH CHAMBER-LAIN...

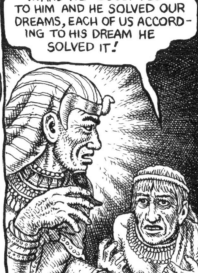

...AND WE RECOUNTED TO HIM AND HE SOLVED OUR DREAMS, EACH OF US ACCORDING TO HIS DREAM HE SOLVED IT!

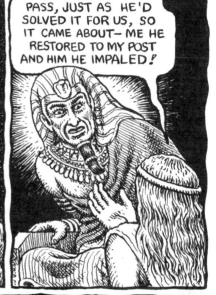

AND IT CAME TO PASS, JUST AS HE'D SOLVED IT FOR US, SO IT CAME ABOUT— ME HE RESTORED TO MY POST AND HIM HE IMPALED!

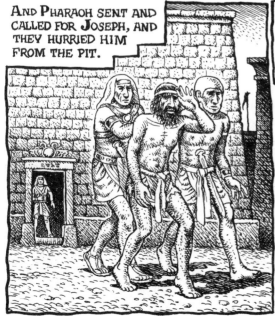

AND PHARAOH SENT AND CALLED FOR JOSEPH, AND THEY HURRIED HIM FROM THE PIT.

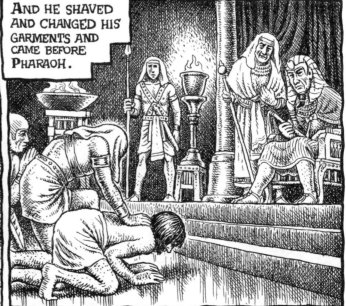

AND HE SHAVED AND CHANGED HIS GARMENTS AND CAME BEFORE PHARAOH.

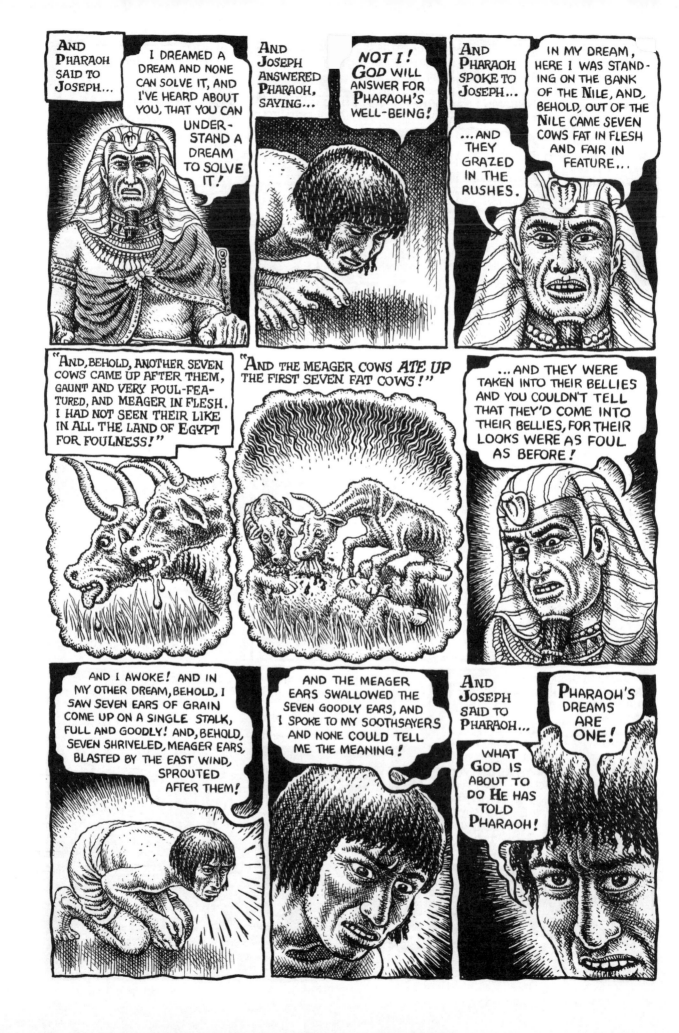

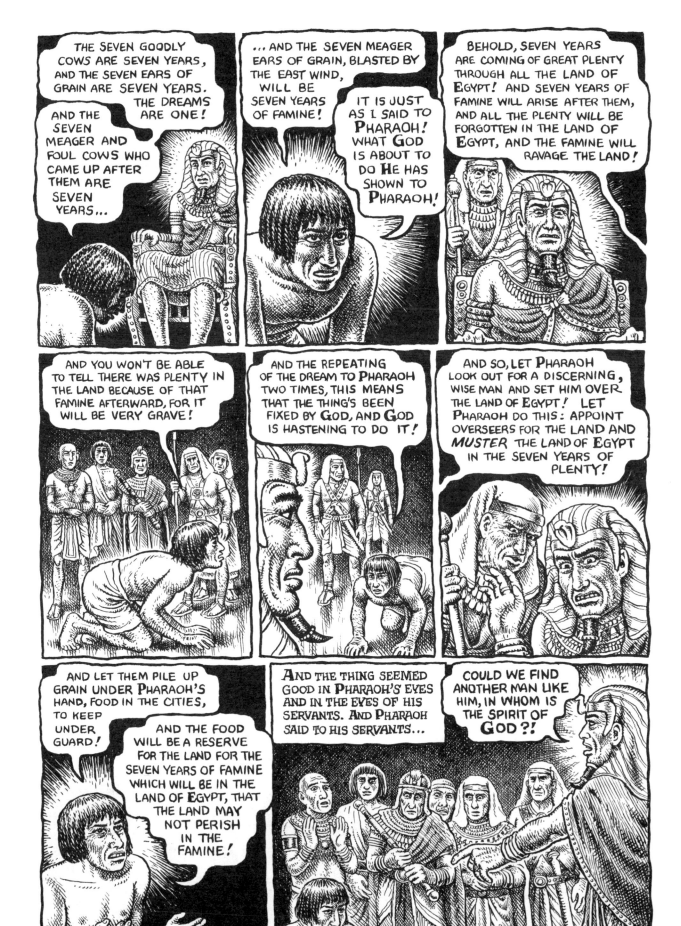

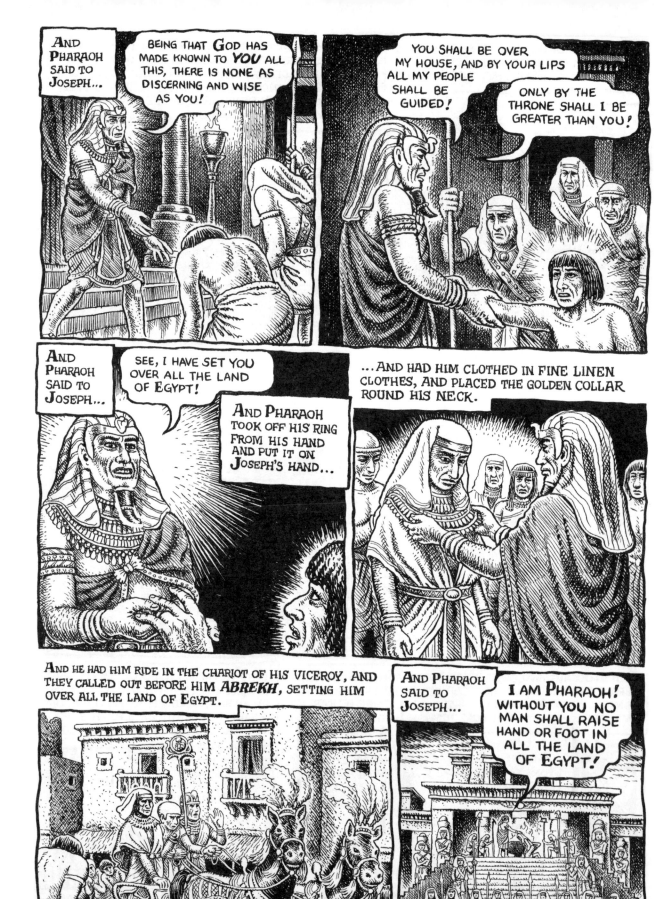

AND PHARAOH CALLED JOSEPH'S NAME ZAPHEN-ATH-PANEAH, AND HE GAVE HIM ASENATH, DAUGHTER OF POTIPHERA, PRIEST OF ON, AS WIFE...

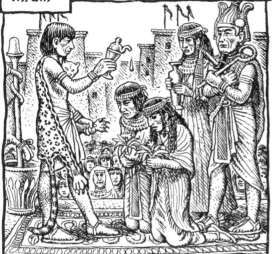

...AND JOSEPH WENT OUT OVER THE LAND OF EGYPT. AND JOSEPH WAS THIRTY YEARS OLD WHEN HE STOOD BEFORE PHARAOH, KING OF EGYPT, AND JOSEPH WENT OUT FROM PHARAOH'S PRESENCE AND PASSED THROUGH ALL THE LAND OF EGYPT. AND THE LAND IN THE SEVEN YEARS OF PLENTY MADE GATHERINGS.

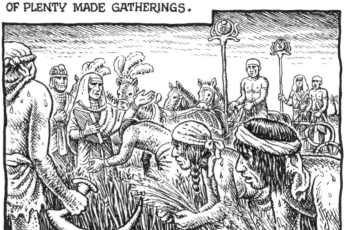

AND HE COLLECTED ALL THE FOOD OF THE SEVEN YEARS THAT WERE IN THE LAND OF EGYPT AND HE PLACED FOOD IN THE CITIES, THE FOOD FROM THE FIELDS ROUND EACH CITY HE PLACED WITHIN IT.

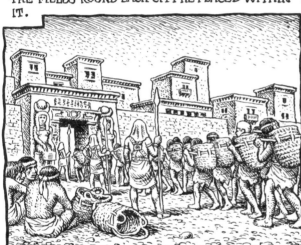

AND JOSEPH PILED UP GRAIN LIKE THE SAND OF THE SEA, VERY MUCH, UNTIL HE CEASED COUNTING, FOR IT WAS BEYOND COUNT.

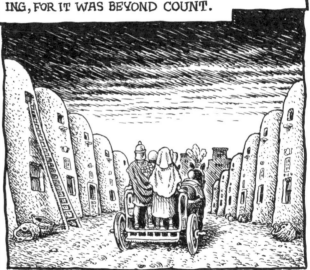

AND TO JOSEPH TWO SONS WERE BORN BEFORE THE COMING OF THE YEAR OF FAMINE, WHOM ASENATH, DAUGHTER OF POTIPHERA, PRIEST OF ON, BORE HIM.

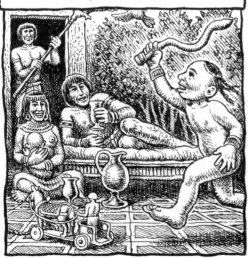

AND JOSEPH CALLED THE NAME OF THE FIRSTBORN MANASSEH, MEANING, GOD HAS RELEASED ME FROM ALL THE DEBT OF MY HARDSHIP, AND ALL MY FATHER'S HOUSE. AND THE NAME OF THE SECOND HE CALLED EPHRAIM, MEANING, GOD HAS MADE ME FRUITFUL IN THE LAND OF MY AFFLICTION.

AND THE SEVEN YEARS OF PLENTY THAT HAD BEEN IN THE LAND OF EGYPT CAME TO AN END. AND THE SEVEN YEARS OF FAMINE BEGAN TO COME, AS JOSEPH HAD SAID, AND THERE WAS FAMINE IN ALL THE LANDS.

BUT IN THE LAND OF EGYPT THERE WAS BREAD. AND ALL THE LAND OF EGYPT WAS HUNGRY AND THE PEOPLE CRIED OUT TO PHARAOH FOR BREAD.

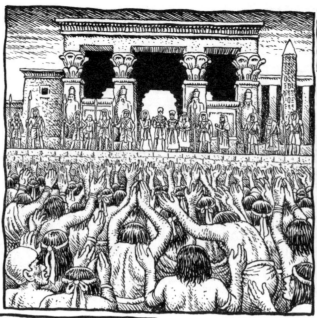

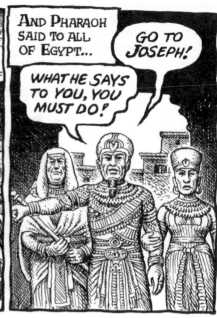

AND PHARAOH SAID TO ALL OF EGYPT...

GO TO JOSEPH!

WHAT HE SAYS TO YOU, YOU MUST DO!

AND THE FAMINE WAS OVER ALL THE LAND. AND JOSEPH LAID OPEN WHATEVER HAD GRAIN WITHIN AND SOLD PROVISIONS TO EGYPT.

Chapter 42

AND THE FAMINE GREW HARSH IN THE LAND OF EGYPT. AND ALL THE EARTH CAME TO EGYPT, TO JOSEPH, TO GET PROVISIONS, FOR THE FAMINE HAD GROWN HARSH IN ALL THE EARTH.

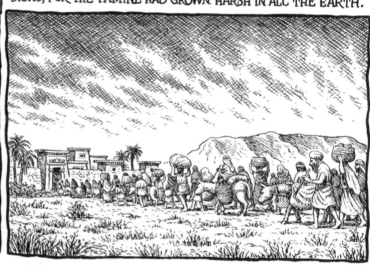

AND JACOB SAW THAT THERE WERE PROVISIONS IN EGYPT, AND JACOB SAID TO HIS SONS...

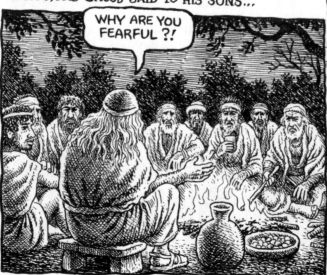

WHY ARE YOU FEARFUL?!

AND HE SAID...

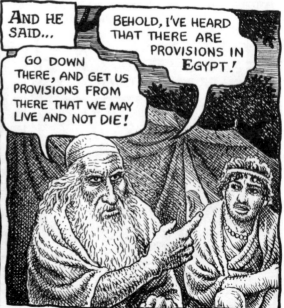

BEHOLD, I'VE HEARD THAT THERE ARE PROVISIONS IN EGYPT!

GO DOWN THERE, AND GET US PROVISIONS FROM THERE THAT WE MAY LIVE AND NOT DIE!

AND THE TEN BROTHERS OF JOSEPH WENT DOWN TO BUY GRAIN FROM EGYPT. BUT BENJAMIN, JOSEPH'S BROTHER, JACOB DID NOT SEND WITH HIS BROTHERS, FOR HE THOUGHT, LEST HARM BEFALL HIM.

AND THE SONS OF ISRAEL CAME TO BUY PROVISIONS AMONG THOSE WHO CAME, FOR THERE WAS FAMINE IN THE LAND OF CANAAN.

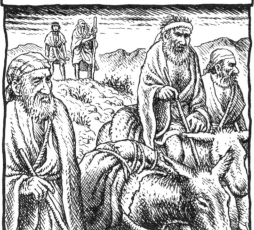

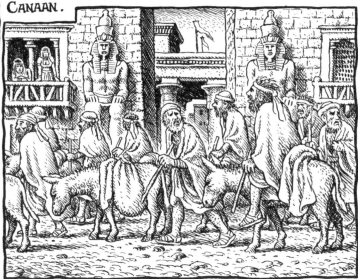

AS FOR JOSEPH, HE WAS THE REGENT OF THE LAND. HE WAS THE PROVIDER TO ALL THE PEOPLE OF THE LAND.

AND JOSEPH'S BROTHERS CAME AND BOWED DOWN TO HIM, THEIR FACES TO THE GROUND.

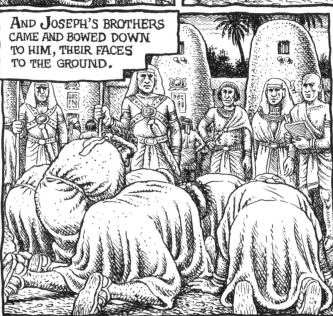

AND JOSEPH SAW HIS BROTHERS AND RECOGNIZED THEM.

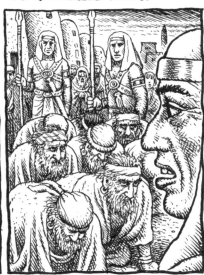

AND HE PLAYED THE STRANGER TO THEM AND SPOKE HARSHLY TO THEM, AND SAID TO THEM...

WHERE DO YOU COME FROM??

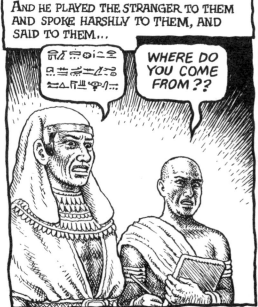

AND THEY SAID...

FROM THE LAND OF CANAAN...

...TO BUY FOOD!

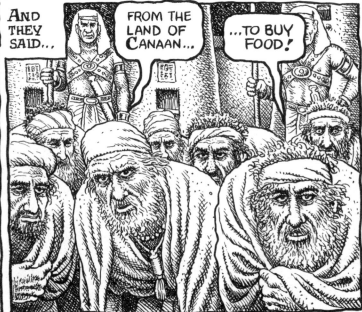

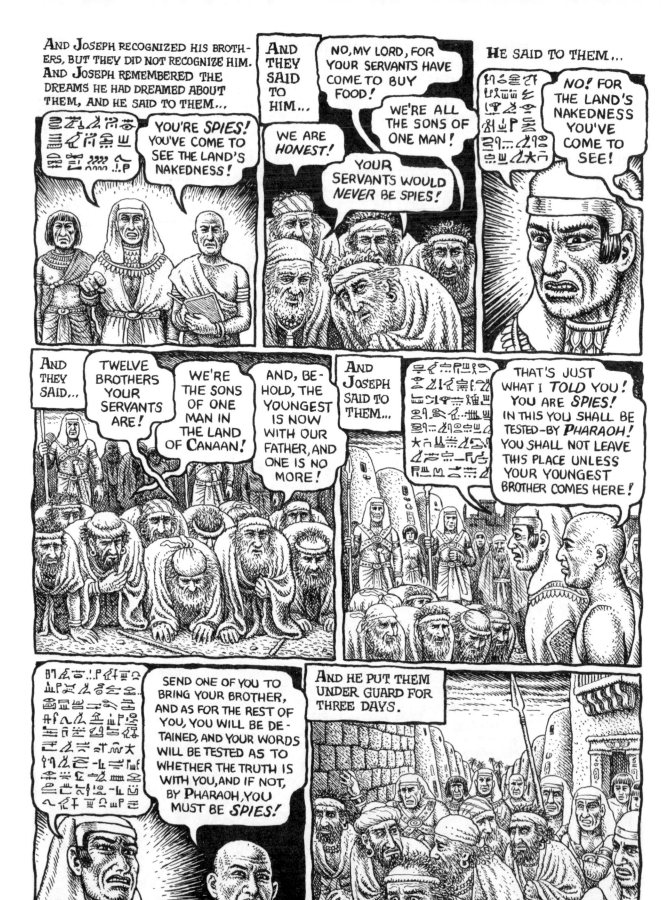

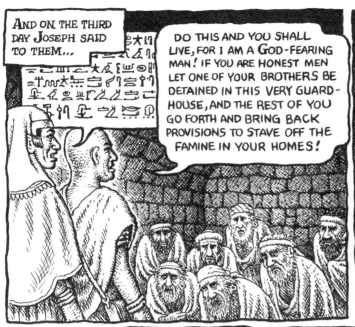

AND ON THE THIRD DAY JOSEPH SAID TO THEM...

DO THIS AND YOU SHALL LIVE, FOR I AM A GOD-FEARING MAN! IF YOU ARE HONEST MEN LET ONE OF YOUR BROTHERS BE DETAINED IN THIS VERY GUARD-HOUSE, AND THE REST OF YOU GO FORTH AND BRING BACK PROVISIONS TO STAVE OFF THE FAMINE IN YOUR HOMES!

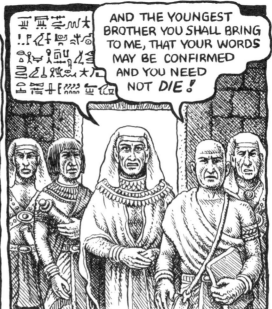

AND THE YOUNGEST BROTHER YOU SHALL BRING TO ME, THAT YOUR WORDS MAY BE CONFIRMED AND YOU NEED NOT *DIE!*

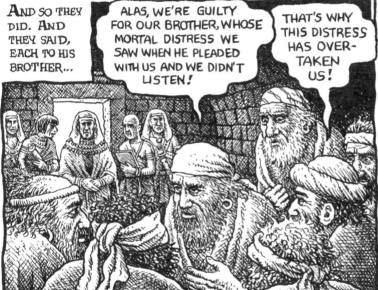

AND SO THEY DID. AND THEY SAID, EACH TO HIS BROTHER...

ALAS, WE'RE GUILTY FOR OUR BROTHER, WHOSE MORTAL DISTRESS WE SAW WHEN HE PLEADED WITH US AND WE DIDN'T LISTEN!

THAT'S WHY THIS DISTRESS HAS OVER-TAKEN US!

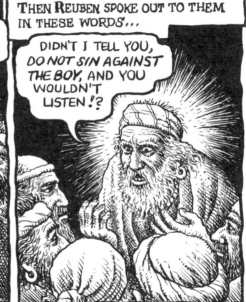

THEN REUBEN SPOKE OUT TO THEM IN THESE WORDS...

DIDN'T I TELL YOU, *DO NOT SIN AGAINST THE BOY,* AND YOU WOULDN'T LISTEN!?

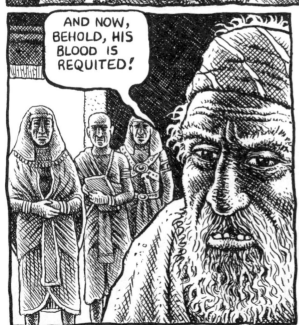

AND NOW, BEHOLD, HIS BLOOD IS REQUITED!

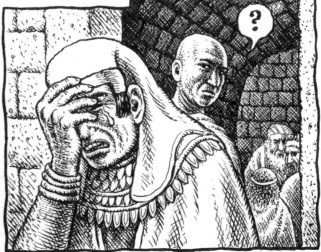

AND THEY DIDN'T KNOW THAT JOSEPH UNDER-STOOD, FOR THERE WAS AN INTERPRETER BE-TWEEN THEM. AND HE TURNED AWAY FROM THEM AND WEPT.

AND HE TURNED TO THEM AGAIN AND SPOKE TO THEM, AND HE TOOK SIMEON FROM THEM AND PLACED HIM IN SHACKLES BEFORE THEIR EYES.

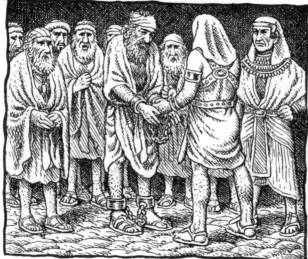

AND JOSEPH GAVE ORDERS TO FILL THEIR BAGGAGE WITH GRAIN AND TO PUT BACK THEIR SILVER INTO EACH ONE'S PACK, AND TO GIVE THEM SUPPLIES FOR THE WAY, AND SO HE DID FOR THEM. AND THEY LOADED THEIR PROVISIONS ON THEIR DONKEYS AND THEY SET OUT FROM THERE.

THEN ONE OF THEM OPENED HIS PACK TO GIVE FEED TO HIS DONKEY AT THE ENCAMPMENT, AND HE SAW HIS SILVER, AND, BEHOLD, IT WAS IN THE MOUTH OF HIS BAG.

AND HE SAID TO HIS BROTHERS...

MY SILVER'S BEEN PUT BACK AND, BEHOLD, IT'S ACTUALLY IN MY BAG!

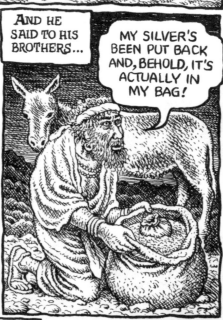

AND THEY WERE DUMBFOUNDED AND TREMBLED, EACH BEFORE HIS BROTHER, SAYING...

WHAT IS THIS THAT GOD HAS DONE TO US?!

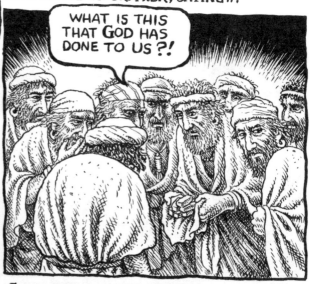

AND THEY CAME TO JACOB, THEIR FATHER, TO THE LAND OF CANAAN.

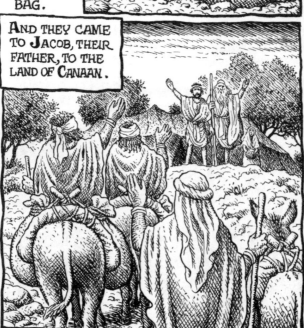

AND THEY TOLD HIM ALL THAT HAD BEFALLEN THEM, SAYING...

THE MAN WHO IS LORD OF THE LAND SPOKE HARSHLY TO US AND MADE US OUT TO BE SPIES IN THE LAND!

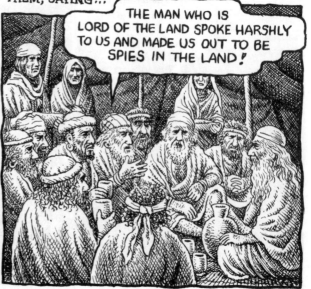

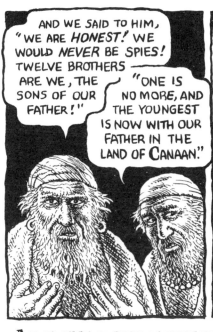

AND WE SAID TO HIM, "WE ARE *HONEST!* WE WOULD *NEVER* BE SPIES! TWELVE BROTHERS ARE WE, THE SONS OF OUR FATHER!"

"ONE IS NO MORE, AND THE YOUNGEST IS NOW WITH OUR FATHER IN THE LAND OF CANAAN."

AND THE MAN WHO IS LORD OF THE LAND SAID TO US, "BY THIS SHALL I KNOW YOU'RE HONEST: LEAVE ONE OF YOUR BROTHERS WITH ME, AND TAKE PROVISIONS AGAINST THE FAMINE IN YOUR HOMES AND GO!"

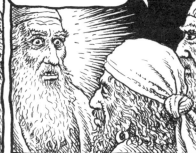

"AND BRING YOUR YOUNGEST BROTHER TO ME THAT I MAY KNOW YOU'RE NOT SPIES BUT ARE HONEST!"

"I SHALL GIVE YOU BACK YOUR BROTHER AND YOU CAN TRADE IN THE LAND."

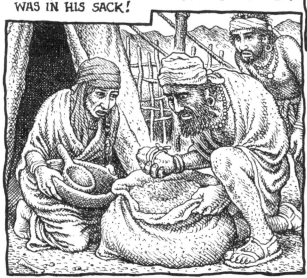

AND IT CAME TO PASS AS THEY EMPTIED THEIR SACKS, BEHOLD, EACH ONE'S BUNDLE OF SILVER WAS IN HIS SACK!

AND THEY SAW THEIR BUNDLES OF SILVER, BOTH THEY AND THEIR FATHER, AND WERE AFRAID.

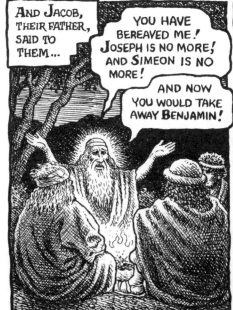

AND JACOB, THEIR FATHER, SAID TO THEM...

YOU HAVE BEREAVED ME! JOSEPH IS NO MORE! AND SIMEON IS NO MORE!

AND NOW YOU WOULD TAKE AWAY BENJAMIN!

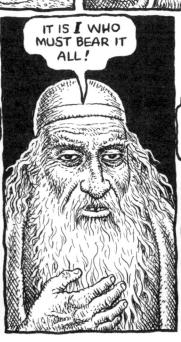

IT IS *I* WHO MUST BEAR IT ALL!

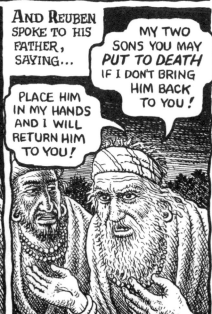

AND REUBEN SPOKE TO HIS FATHER, SAYING...

PLACE HIM IN MY HANDS AND I WILL RETURN HIM TO YOU!

MY TWO SONS YOU MAY *PUT TO DEATH* IF I DON'T BRING HIM BACK TO YOU!

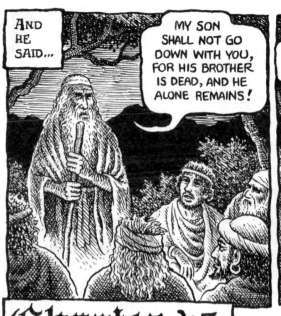

AND HE SAID...

MY SON SHALL NOT GO DOWN WITH YOU, FOR HIS BROTHER IS DEAD, AND HE ALONE REMAINS!

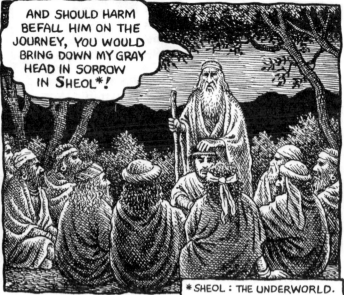

AND SHOULD HARM BEFALL HIM ON THE JOURNEY, YOU WOULD BRING DOWN MY GRAY HEAD IN SORROW IN SHEOL*!

* SHEOL : THE UNDERWORLD.

Chapter 43

AND THE FAMINE GREW GRAVE IN THE LAND.

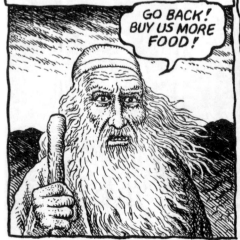

AND IT CAME TO PASS WHEN THEY HAD EATEN UP THE PROVISIONS THEY HAD BROUGHT, THAT THEIR FATHER SAID TO THEM...

GO BACK! BUY US MORE FOOD!

AND JUDAH SPOKE TO HIM, SAYING...

THE MAN SOLEMNLY WARNED US, SAYING, "YOU SHALL NOT SEE MY FACE UNLESS YOUR BROTHER IS WITH YOU!"

IF YOU'LL LET OUR BROTHER GO WITH US, WE'LL GO DOWN AND BUY SOME FOOD, BUT IF YOU WON'T LET HIM GO, WE WILL NOT GO DOWN!

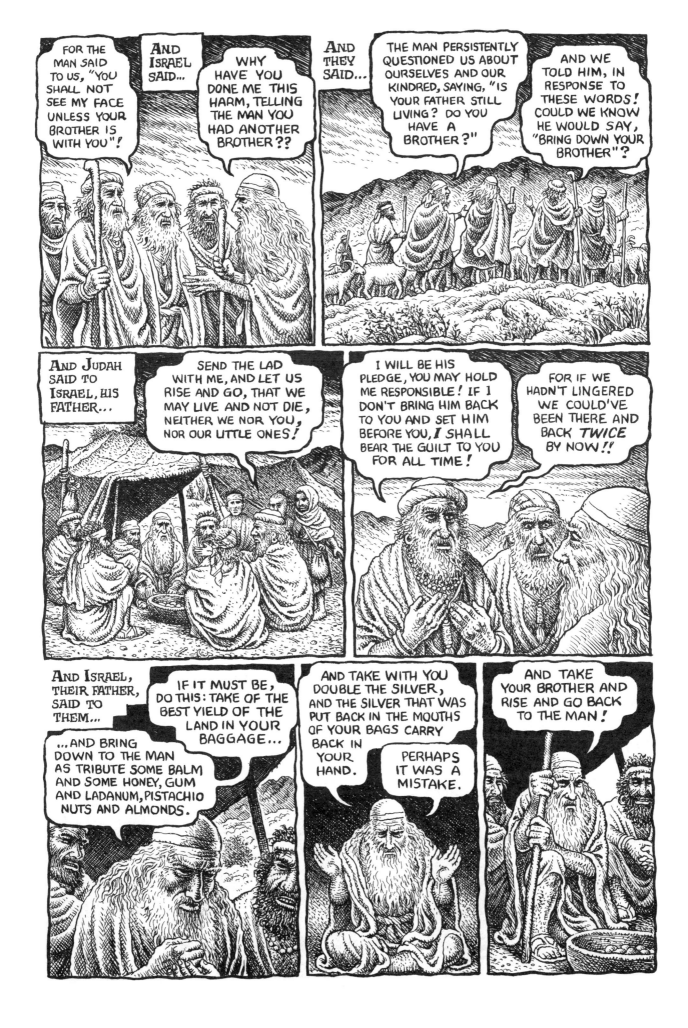

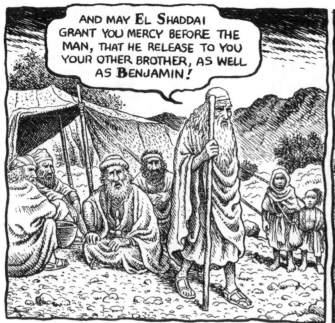

AND MAY EL SHADDAI GRANT YOU MERCY BEFORE THE MAN, THAT HE RELEASE TO YOU YOUR OTHER BROTHER, AS WELL AS BENJAMIN!

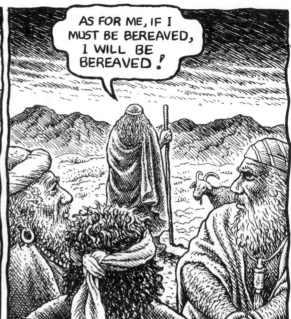

AS FOR ME, IF I MUST BE BEREAVED, I WILL BE BEREAVED!

AND THE MEN TOOK THIS TRIBUTE AND DOUBLE THE SILVER THEY TOOK IN THEIR HAND, AND BENJAMIN, AND THEY ROSE AND WENT TO EGYPT AND STOOD IN JOSEPH'S PRESENCE.

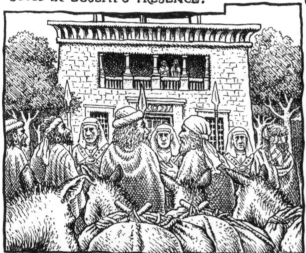

AND JOSEPH SAW BENJAMIN WITH THEM.

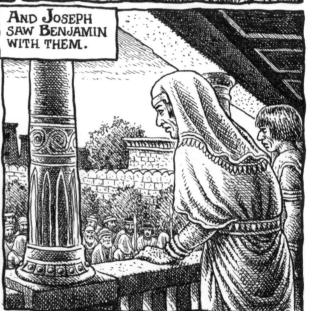

AND HE SAID TO THE ONE WHO WAS OVER HIS HOUSE...

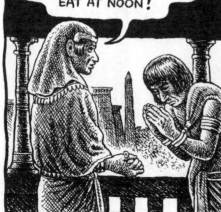

BRING THE MEN INTO THE HOUSE, AND SLAUGHTER AN ANIMAL AND PREPARE IT, FOR WITH *ME* THE MEN SHALL EAT AT NOON!

AND THE MAN DID AS JOSEPH HAD SAID, AND THE MAN BROUGHT THE MEN TO JOSEPH'S HOUSE.

AND THE MEN WERE AFRAID AT BEING BROUGHT TO JOSEPH'S HOUSE, AND THEY SAID...

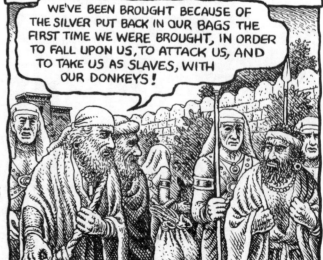

WE'VE BEEN BROUGHT BECAUSE OF THE SILVER PUT BACK IN OUR BAGS THE FIRST TIME WE WERE BROUGHT, IN ORDER TO FALL UPON US, TO ATTACK US, AND TO TAKE US AS SLAVES, WITH OUR DONKEYS!

AND THEY APPROACHED THE MAN WHO WAS OVER JOSEPH'S HOUSE, AND THEY SPOKE TO HIM BY THE ENTRANCE OF THE HOUSE. AND THEY SAID...

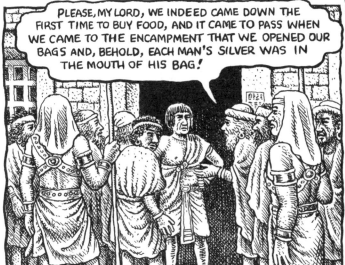

PLEASE, MY LORD, WE INDEED CAME DOWN THE FIRST TIME TO BUY FOOD, AND IT CAME TO PASS WHEN WE CAME TO THE ENCAMPMENT THAT WE OPENED OUR BAGS AND, BEHOLD, EACH MAN'S SILVER WAS IN THE MOUTH OF HIS BAG!

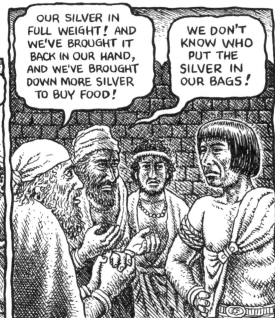

OUR SILVER IN FULL WEIGHT! AND WE'VE BROUGHT IT BACK IN OUR HAND, AND WE'VE BROUGHT DOWN MORE SILVER TO BUY FOOD!

WE DON'T KNOW WHO PUT THE SILVER IN OUR BAGS!

AND HE SAID...

ALL IS WELL WITH YOU, DO NOT FEAR! YOUR GOD AND THE GOD OF YOUR FATHER HAS PLACED TREASURE FOR YOU IN YOUR BAGS! I HAVE DULY RECEIVED YOUR PAYMENT!

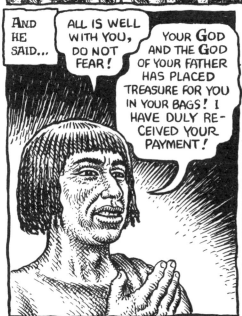

AND HE BROUGHT SIMEON OUT TO THEM.

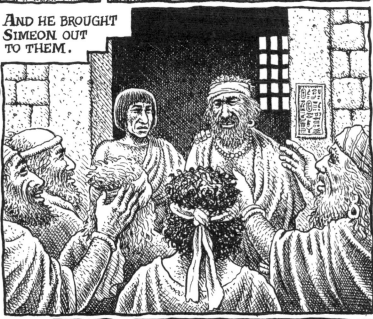

AND THE MAN BROUGHT THE MEN INTO JOSEPH'S HOUSE, AND HE GAVE THEM WATER AND THEY BATHED THEIR FEET, AND HE PROVIDED FEED FOR THEIR DONKEYS.

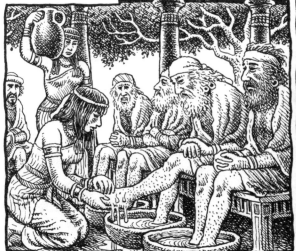

AND THEY LAID OUT THEIR TRIBUTE TO AWAIT JOSEPH'S ARRIVAL AT NOON, FOR THEY'D HEARD THAT THEY WOULD EAT BREAD THERE.

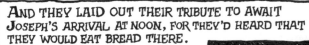
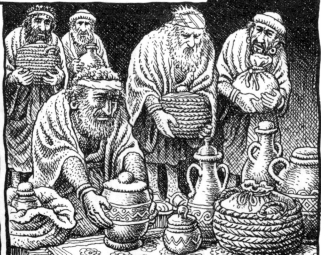

AND JOSEPH CAME INTO THE HOUSE, AND THEY BROUGHT HIM THE TRIBUTE THAT WAS IN THEIR HAND INTO THE HOUSE, AND THEY BOWED DOWN TO HIM TO THE GROUND.

AND HE ASKED HOW THEY WERE, AND HE SAID...

IS ALL WELL WITH YOUR AGED FATHER OF WHOM YOU SPOKE?

IS HE STILL ALIVE?

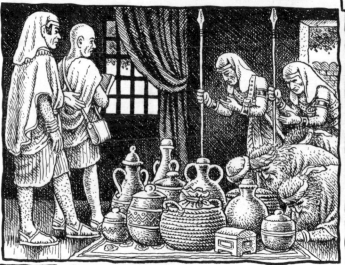

AND THEY SAID...

ALL IS WELL WITH YOUR SERVANT, OUR FATHER!

HE'S STILL ALIVE!

AND THEY DID OBEISANCE AND BOWED DOWN.

AND HE RAISED HIS EYES AND SAW BENJAMIN, HIS BROTHER, HIS MOTHER'S SON, AND HE SAID...

IS THIS YOUR YOUNGEST BROTHER OF WHOM YOU SPOKE?

AND HE SAID...

GOD BE GRACIOUS TO YOU, MY SON!

AND JOSEPH HURRIED OUT, FOR HIS FEELINGS FOR HIS BROTHER OVERWHELMED HIM AND HE WANTED TO WEEP.

AND HE WENT INTO THE CHAMBER AND WEPT THERE.

AND HE BATHED HIS FACE AND CAME OUT AND HELD HIMSELF IN CHECK AND SAID...

SERVE BREAD!

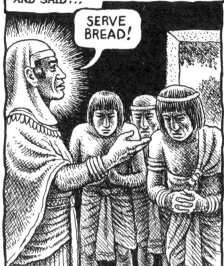

AND THEY SERVED HIM AND THEM SEPARATELY, FOR THE EGYPTIANS WOULD NOT EAT BREAD WITH THE HEBREWS, AS IT WAS ABHORRENT TO EGYPT.

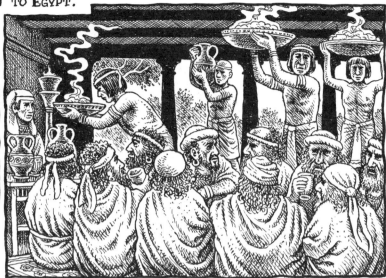

AND THEY WERE SEATED BY HIS DIRECTION, THE FIRST-BORN ACCORDING TO HIS BIRTHRIGHT, THE YOUNGEST ACCORDING TO HIS YOUTH, AND THE MEN LOOKED AT ONE ANOTHER IN ASTONISHMENT.

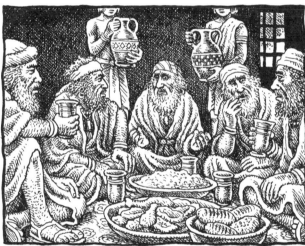

AND HE HAD PORTIONS PASSED TO THEM FROM HIS TABLE, AND BENJAMIN'S PORTION WAS FIVE TIMES MORE THAN THE PORTIONS OF ALL THE REST.

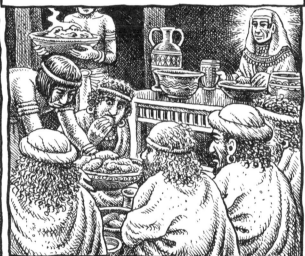

AND THEY DRANK, AND THEY GOT DRUNK WITH HIM.

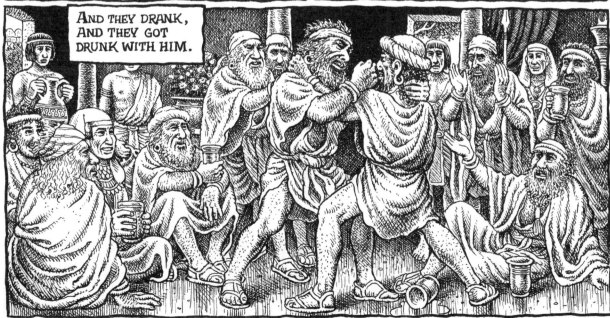

Chapter 44

And he charged the one who was over his house, saying...

FILL THE MEN'S BAGS WITH AS MUCH FOOD AS THEY CAN CARRY, AND PUT EACH MAN'S SILVER IN THE MOUTH OF HIS BAG!

AND MY GOBLET, THE SILVER GOBLET, PUT IN THE MOUTH OF THE BAG OF THE YOUNGEST, WITH THE SILVER FOR HIS PROVISIONS!

AND HE DID AS JOSEPH HAD SPOKEN.

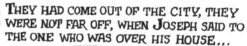

The morning had just brightened when the men were sent off, they and their donkeys.

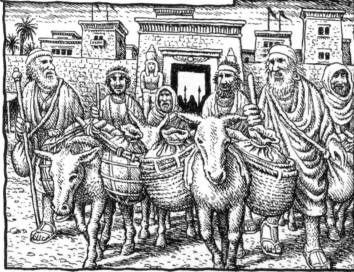

They had come out of the city, they were not far off, when Joseph said to the one who was over his house...

RISE, PURSUE THE MEN!!

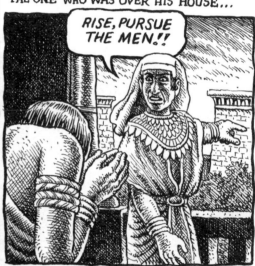

AND WHEN YOU OVERTAKE THEM, SAY TO THEM, "WHY HAVE YOU PAID BACK EVIL FOR GOOD?"

"ISN'T *THIS* THE ONE FROM WHICH MY LORD DRINKS, AND WHICH HE ALWAYS USES FOR DIVINATION? YOU'VE WROUGHT *EVIL* IN WHAT YOU DID!"

And he overtook them.

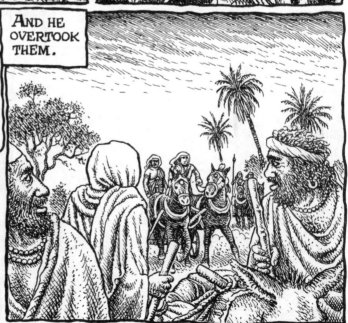

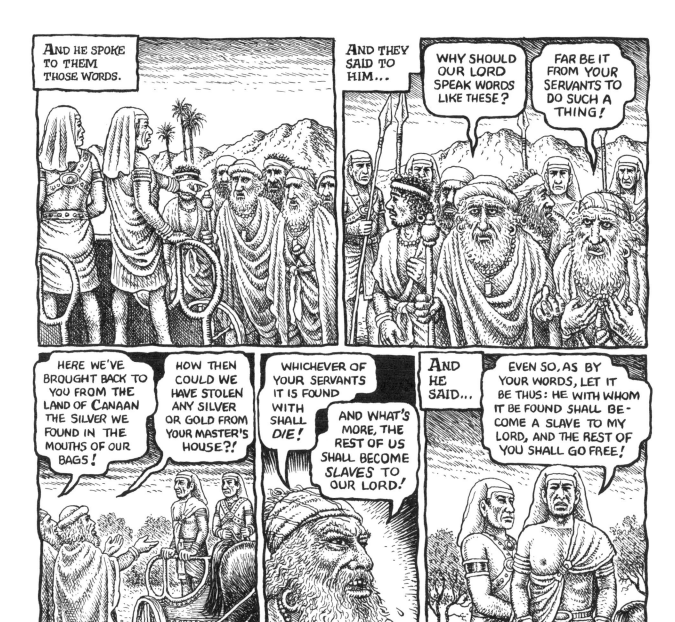

AND HE SPOKE TO THEM THOSE WORDS.

AND THEY SAID TO HIM...

WHY SHOULD OUR LORD SPEAK WORDS LIKE THESE?

FAR BE IT FROM YOUR SERVANTS TO DO SUCH A THING!

HERE WE'VE BROUGHT BACK TO YOU FROM THE LAND OF CANAAN THE SILVER WE FOUND IN THE MOUTHS OF OUR BAGS!

HOW THEN COULD WE HAVE STOLEN ANY SILVER OR GOLD FROM YOUR MASTER'S HOUSE?!

WHICHEVER OF YOUR SERVANTS IT IS FOUND WITH SHALL DIE!

AND WHAT'S MORE, THE REST OF US SHALL BECOME SLAVES TO OUR LORD!

AND HE SAID...

EVEN SO, AS BY YOUR WORDS, LET IT BE THUS: HE WITH WHOM IT BE FOUND SHALL BE-COME A SLAVE TO MY LORD, AND THE REST OF YOU SHALL GO FREE!

AND THEY HURRIED AND EACH MAN SET DOWN HIS BAG ON THE GROUND AND EACH OPENED HIS BAG.

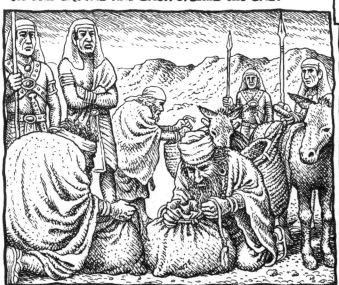

AND HE SEARCHED, BEGINNING WITH THE OLDEST AND ENDING WITH THE YOUNGEST, AND HE FOUND THE GOBLET IN BENJAMIN'S BAG.

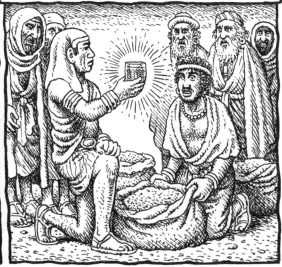

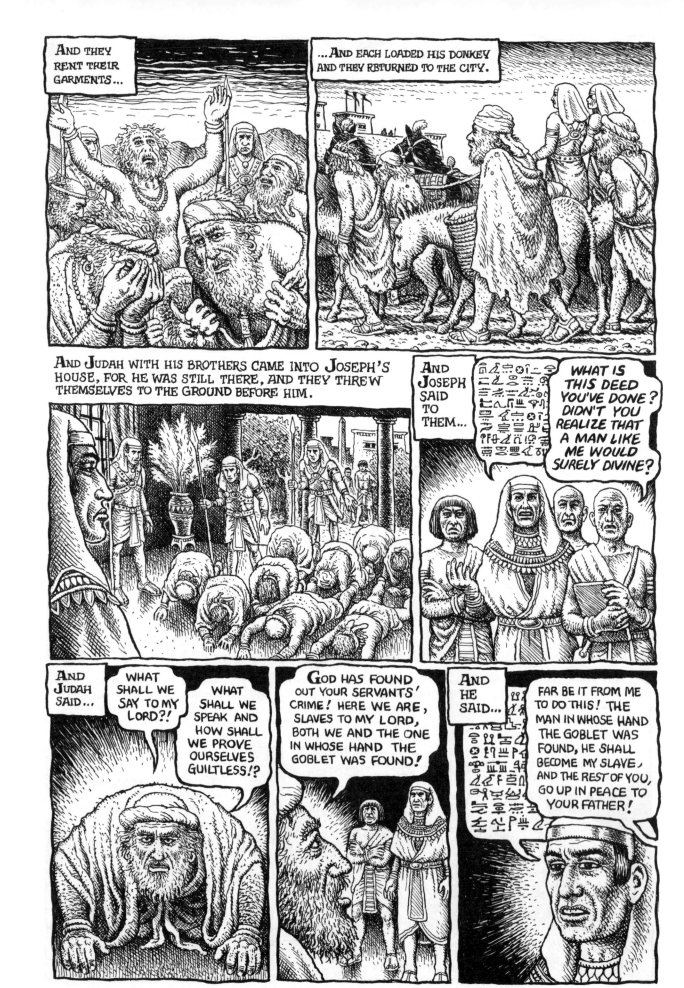

AND JUDAH APPROACHED HIM AND SAID...

PLEASE, MY LORD, LET YOUR SERVANT SPEAK A WORD IN MY LORD'S HEARING, AND LET NOT YOUR WRATH KINDLE AGAINST YOUR SERVANT, FOR YOU ARE THE EQUAL OF PHARAOH! MY LORD HAS ASKED HIS SERVANTS, SAYING, "DO YOU HAVE A FATHER OR ANOTHER BROTHER?"

AND WE SAID TO MY LORD, "WE HAVE AN AGED FATHER AND A YOUNG CHILD OF HIS OLD AGE; HIS FULL BROTHER IS DEAD; HE ALONE IS LEFT OF HIS MOTHER, AND HIS FATHER DOTES ON HIM." AND YOU SAID TO YOUR SERVANTS, "BRING HIM DOWN TO ME, THAT I MAY SET MY EYES ON HIM!" AND WE SAID TO MY LORD, "THE LAD CAN'T LEAVE HIS FATHER! SHOULD HE LEAVE, HIS FATHER WOULD DIE!"

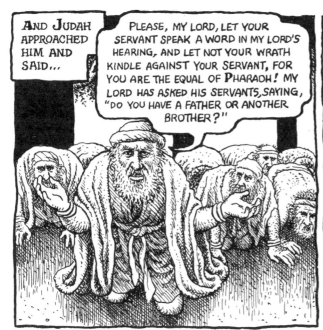

AND YOU SAID TO YOUR SERVANTS, "IF YOUR YOUNGEST BROTHER DOES NOT COME DOWN WITH YOU, YOU SHALL NOT SEE MY FACE AGAIN!" AND IT CAME TO PASS WHEN WE WENT UP TO YOUR SERVANT, MY FATHER, THAT WE TOLD HIM THE WORDS OF MY LORD.

AND OUR FATHER SAID, "GO BACK, BUY US SOME FOOD!" AND WE SAID, "WE CANNOT GO DOWN; ONLY IF OUR YOUNGEST BROTHER IS WITH US CAN WE GO DOWN! FOR WE MAY NOT SEE THE FACE OF THE MAN IF OUR YOUNGEST BROTHER IS NOT WITH US!"

AND YOUR SERVANT, OUR FATHER, SAID TO US, "YOU KNOW THAT TWO DID MY WIFE BEAR ME, AND ONE IS GONE FROM ME, AND I THOUGHT, OH, HE'S BEEN TORN TO SHREDS, AND I'VE NOT SEEN HIM SINCE!"

"AND SHOULD YOU TAKE THIS ONE, TOO, FROM MY PRESENCE AND HARM BEFALL HIM, YOU WOULD SEND DOWN MY GRAY HEAD IN GRIEF TO SHEOL!"

AND SO, SHOULD I COME TO YOUR SERVANT, MY FATHER, AND THE LAD BE NOT WITH US, SINCE HIS LIFE IS BOUND TO THE LAD'S, WHEN HE SAW THE LAD WAS NOT WITH US, HE WOULD DIE, AND YOUR SERVANTS WOULD BRING DOWN THE GRAY HEAD OF YOUR SERVANT, OUR FATHER, IN SORROW TO SHEOL!

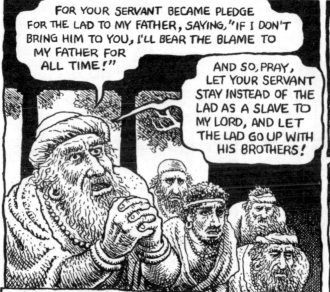

FOR YOUR SERVANT BECAME PLEDGE FOR THE LAD TO MY FATHER, SAYING, "IF I DON'T BRING HIM TO YOU, I'LL BEAR THE BLAME TO MY FATHER FOR ALL TIME!"

AND SO, PRAY, LET YOUR SERVANT STAY INSTEAD OF THE LAD AS A SLAVE TO MY LORD, AND LET THE LAD GO UP WITH HIS BROTHERS!

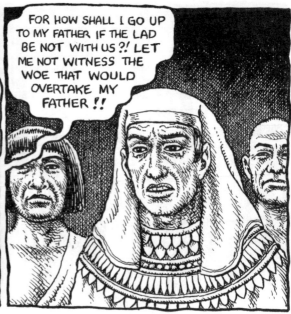

FOR HOW SHALL I GO UP TO MY FATHER IF THE LAD BE NOT WITH US?! LET ME NOT WITNESS THE WOE THAT WOULD OVERTAKE MY FATHER!!

Chapter 45

AND JOSEPH COULD NO LONGER HOLD HIMSELF IN CHECK BEFORE ALL WHO STOOD ATTENDANCE UPON HIM, AND HE CRIED...

CLEAR OUT EVERYONE AROUND ME!

?!
?!
?!

AND NO MAN STOOD WITH HIM WHEN JOSEPH MADE HIMSELF KNOWN TO HIS BROTHERS, AND HE WEPT ALOUD AND THE EGYPTIANS HEARD...

AND THE HOUSE OF PHARAOH HEARD.

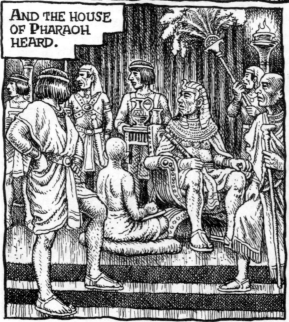

AND JOSEPH SAID TO HIS BROTHERS...

I AM JOSEPH!

IS MY FATHER STILL ALIVE?

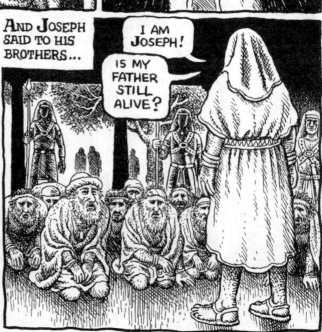

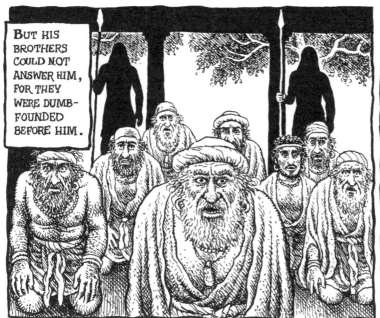

BUT HIS BROTHERS COULD NOT ANSWER HIM, FOR THEY WERE DUMBFOUNDED BEFORE HIM.

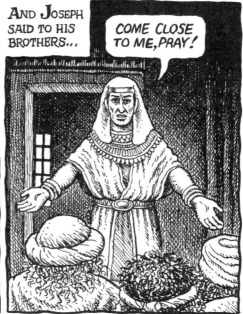

AND JOSEPH SAID TO HIS BROTHERS...

COME CLOSE TO ME, PRAY!

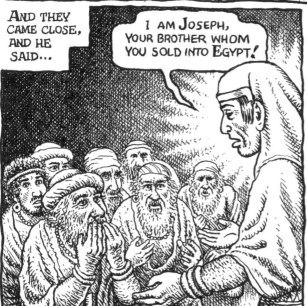

AND THEY CAME CLOSE, AND HE SAID...

I AM JOSEPH, YOUR BROTHER WHOM YOU SOLD INTO EGYPT!

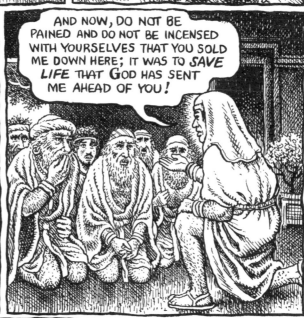

AND NOW, DO NOT BE PAINED AND DO NOT BE INCENSED WITH YOURSELVES THAT YOU SOLD ME DOWN HERE; IT WAS TO *SAVE LIFE* THAT GOD HAS SENT ME AHEAD OF YOU!

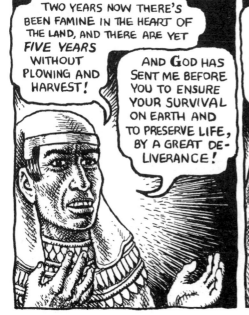

TWO YEARS NOW THERE'S BEEN FAMINE IN THE HEART OF THE LAND, AND THERE ARE YET *FIVE YEARS* WITHOUT PLOWING AND HARVEST!

AND GOD HAS SENT ME BEFORE YOU TO ENSURE YOUR SURVIVAL ON EARTH AND TO PRESERVE LIFE, BY A GREAT DELIVERANCE!

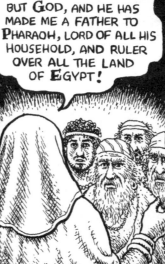

AND SO, IT WASN'T YOU WHO SENT ME HERE BUT GOD, AND HE HAS MADE ME A FATHER TO PHARAOH, LORD OF ALL HIS HOUSEHOLD, AND RULER OVER ALL THE LAND OF EGYPT!

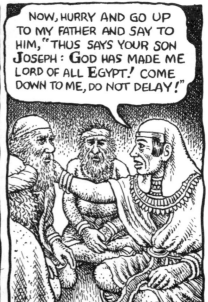

NOW, HURRY AND GO UP TO MY FATHER AND SAY TO HIM, "THUS SAYS YOUR SON JOSEPH: GOD HAS MADE ME LORD OF ALL EGYPT! COME DOWN TO ME, DO NOT DELAY!"

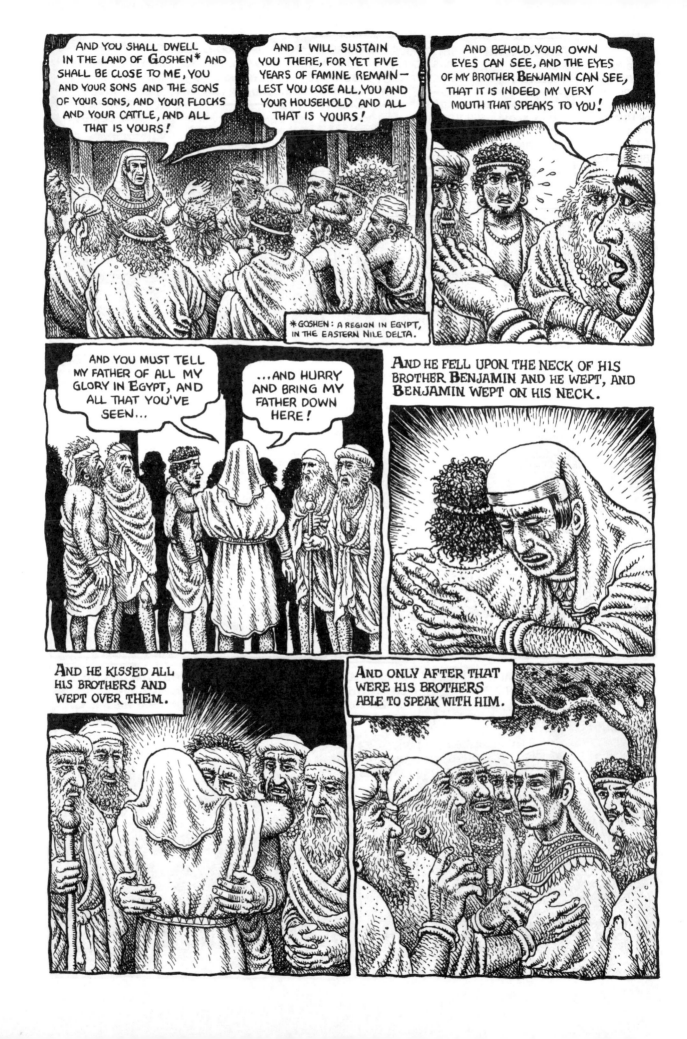

AND THE NEWS WAS HEARD IN THE HOUSE OF PHARAOH, SAYING, "JOSEPH'S BROTHERS HAVE COME!" AND IT WAS GOOD IN PHARAOH'S EYES AND IN HIS SERVANTS' EYES.

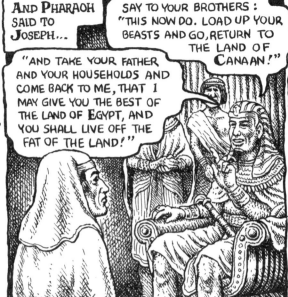

AND PHARAOH SAID TO JOSEPH...

"AND TAKE YOUR FATHER AND YOUR HOUSEHOLDS AND COME BACK TO ME, THAT I MAY GIVE YOU THE BEST OF THE LAND OF EGYPT, AND YOU SHALL LIVE OFF THE FAT OF THE LAND!"

SAY TO YOUR BROTHERS: "THIS NOW DO. LOAD UP YOUR BEASTS AND GO, RETURN TO THE LAND OF CANAAN!"

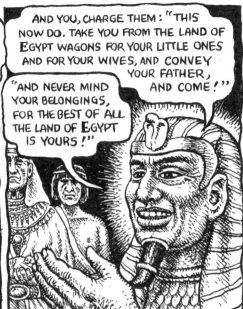

AND YOU, CHARGE THEM: "THIS NOW DO. TAKE YOU FROM THE LAND OF EGYPT WAGONS FOR YOUR LITTLE ONES AND FOR YOUR WIVES, AND CONVEY YOUR FATHER, AND COME!"

"AND NEVER MIND YOUR BELONGINGS, FOR THE BEST OF ALL THE LAND OF EGYPT IS YOURS!"

AND SO THE SONS OF ISRAEL DID, AND JOSEPH GAVE THEM WAGONS, AS PHARAOH HAD ORDERED, AND HE GAVE THEM SUPPLIES FOR THE JOURNEY.

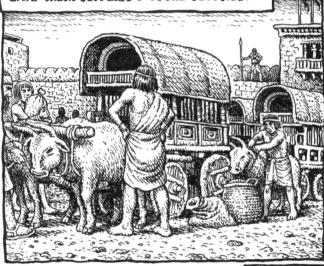

TO ALL OF THEM, EACH ONE, HE GAVE CHANGES OF GARMENTS.

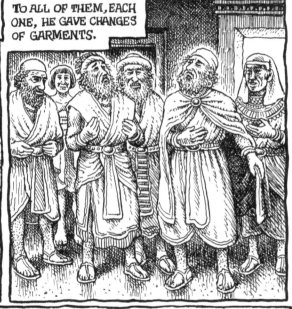

AND TO BENJAMIN HE GAVE 300 PIECES OF SILVER AND FIVE CHANGES OF GARMENTS.

AND TO HIS FATHER HE SENT AS FOLLOWS: TEN DONKEYS LADEN WITH THE BEST THINGS OF EGYPT, AND TEN SHE-ASSES LADEN WITH GRAIN, BREAD, AND PROVISIONS FOR HIS FATHER FOR THE JOURNEY.

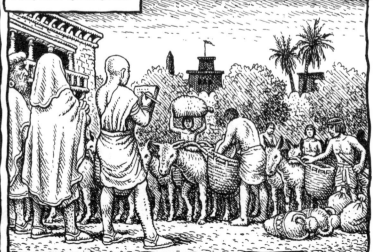

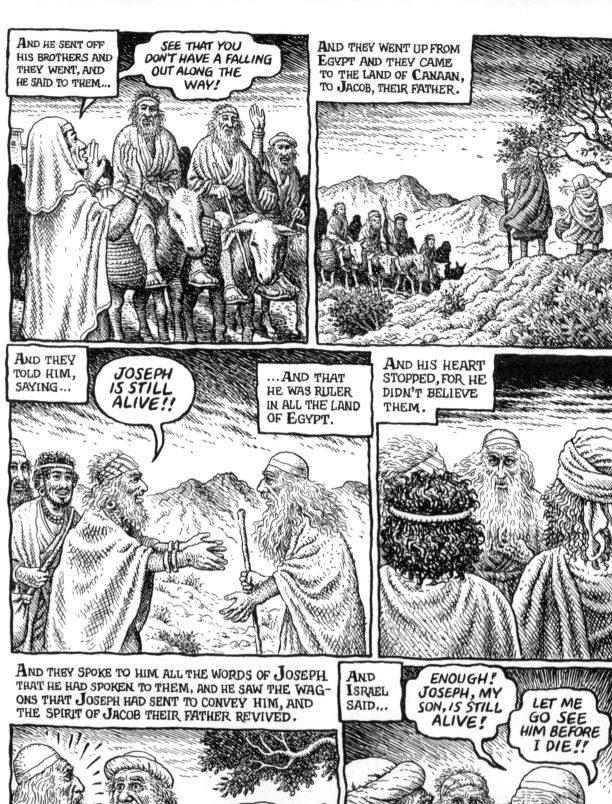

Chapter 46

AND ISRAEL JOURNEYED ONWARD, WITH ALL THAT WAS HIS, AND HE CAME TO BEERSHEBA, AND HE OFFERED SACRIFICES TO THE GOD OF HIS FATHER ISAAC.

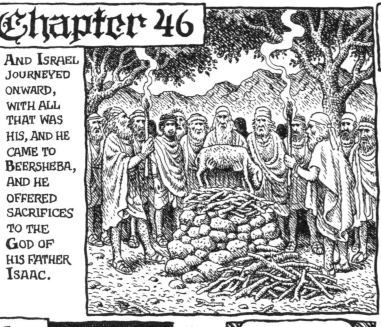

AND GOD SPOKE TO ISRAEL THROUGH VISIONS IN THE NIGHT...

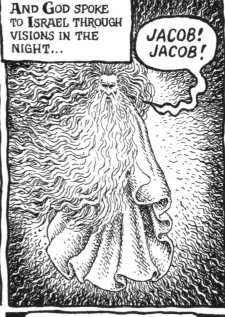

JACOB! JACOB!

AND HE SAID...

HERE I AM!

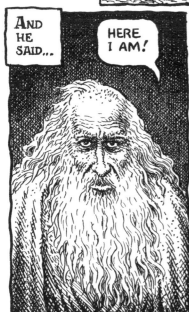

AND HE SAID...

I AM THE GOD, GOD OF YOUR FATHER! FEAR NOT TO GO DOWN TO EGYPT, FOR A GREAT NATION I WILL MAKE YOU THERE!

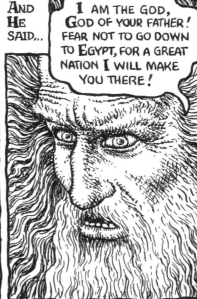

I MYSELF WILL GO DOWN WITH YOU TO EGYPT AND I MYSELF WILL SURELY BRING YOU BACK UP AS WELL, AND JOSEPH SHALL LAY HIS HAND ON YOUR EYES*!

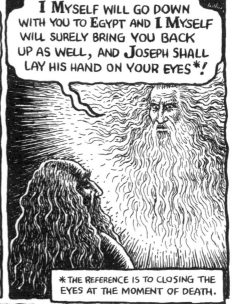

* THE REFERENCE IS TO CLOSING THE EYES AT THE MOMENT OF DEATH.

AND JACOB AROSE FROM BEERSHEBA, AND THE SONS OF ISRAEL CONVEYED JACOB THEIR FATHER AND THEIR LITTLE ONES AND THEIR WIVES IN THE WAGONS PHARAOH HAD SENT TO CONVEY HIM.

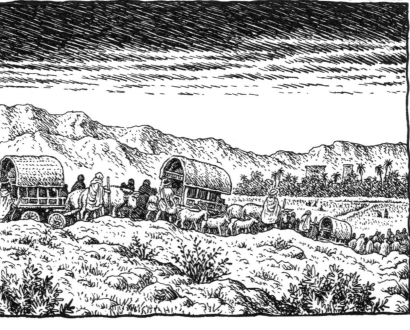

AND THEY TOOK THEIR CATTLE AND THEIR SUBSTANCE THAT THEY HAD IN THE LAND OF CANAAN AND THEY CAME TO EGYPT, JACOB AND ALL HIS SEED WITH HIM. HIS SONS, AND THE SONS OF HIS SONS WITH HIM, HIS DAUGHTERS AND THE DAUGHTERS OF HIS SONS, AND ALL HIS SEED, HE BROUGHT WITH HIM TO EGYPT.

AND THESE ARE THE NAMES OF THE CHILDREN OF ISRAEL WHO CAME TO EGYPT, JACOB AND HIS SONS...

JACOB'S FIRSTBORN, REUBEN, AND THE SONS OF REUBEN; ENOCH, AND PALLU AND HEZRON AND CARMI.

AND THE SONS OF SIMEON; JEMUEL AND JAMIN AND OHAD AND JACHIN AND ZOHAR AND SAUL, THE SON OF THE CANAANITE WOMAN.

AND THE SONS OF LEVI; GERSHON, KOHATH, AND MERARI.

AND THE SONS OF JUDAH; ER AND ONAN AND SHELAH AND PEREZ AND ZERAH—AND ER AND ONAN DIED IN THE LAND OF CANAAN.

AND THE SONS OF PEREZ WERE HEZRON AND HAMUL.

AND THE SONS OF ISSACHAR; TOLA AND PUVAH AND IOB AND SHIMRON.

AND THE SONS OF ZEBULUN; SERED AND ELON AND JAHLEEL.

THESE ARE THE SONS OF LEAH WHOM SHE BORE TO JACOB IN PADDAN-ARAM, AND ALSO DINAH HIS DAUGHTER, EVERY PERSON OF HIS SONS AND DAUGHTERS, THIRTY-THREE.

AND THE SONS OF GAD; ZIPHION, AND HAGGI, SHUNI AND EZBON, ERI AND ARODI AND ARELI.

AND THE SONS OF ASHER; IMNAH, AND ISHUAH, AND ISHVI AND BERIAH AND SERAH, THEIR SISTER.

AND THE SONS OF BERIAH; HEBER AND MALCHIEL.

THESE ARE THE SONS OF ZILPAH, WHOM LABAN GAVE TO LEAH HIS DAUGHTER, AND SHE BORE THESE TO JACOB, SIXTEEN PERSONS.

AND THE SONS OF RACHEL, JACOB'S WIFE, JOSEPH AND BENJAMIN.

AND TO JOSEPH WERE BORN IN THE LAND OF EGYPT, WHOM ASENATH, DAUGHTER OF POTIPHERA, PRIEST OF ON BORE TO HIM, MANASSEH AND EPHRAIM.

AND THE SONS OF BENJAMIN; BELA AND BECHER AND ASHBEL, GERA AND NAAMAN, EHI AND ROSH, MUPPIM, HUPPIM, AND ARD.

THESE ARE THE SONS OF RACHEL WHO WERE BORN TO JACOB, FOURTEEN PERSONS IN ALL.

THE SON OF DAN; HUSHIM.

AND THE SONS OF NAPH-TALI; JAHZEEL AND GUNI AND JEZER AND SHILLEM.

THESE ARE THE SONS OF BILHAH WHOM LABAN GAVE TO RACHEL HIS DAUGHTER, AND SHE BORE THESE TO JACOB, SEVEN PERSONS IN ALL.

ALL THE PERSONS WHO CAME WITH JACOB TO EGYPT, ISSUE OF HIS LOINS, ASIDE FROM THE WIVES OF JACOB'S SONS, SIXTY-SIX PERSONS IN ALL. AND THE SONS OF JOSEPH WHO WERE BORN TO HIM IN EGYPT WERE TWO PERSONS. ALL THE PERSONS OF THE HOUSEHOLD OF JACOB COMING TO EGYPT WERE SEVENTY.

AND JUDAH HE HAD SENT BEFORE HIM TO SHOW HIM THE WAY TO GOSHEN, AND THEY CAME TO THE LAND OF GOSHEN. AND JOSEPH HARNESSED HIS CHARIOT AND WENT UP TO MEET ISRAEL HIS FATHER IN GOSHEN.

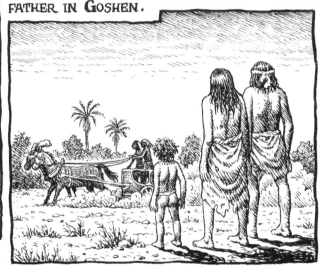

AND HE APPEARED BEFORE HIM...

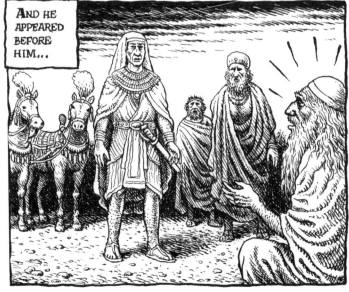

...AND FELL ON HIS NECK, AND HE WEPT ON HIS NECK A LONG WHILE.

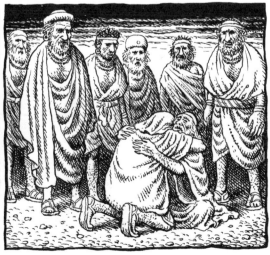

AND ISRAEL SAID TO JOSEPH...

NOW I CAN DIE, AFTER SEEING YOUR FACE, AND KNOWING THAT YOU'RE STILL ALIVE!

AND JOSEPH SAID TO HIS BROTHERS AND TO HIS FATHER'S HOUSEHOLD...

LET ME GO UP AND TELL PHARAOH, AND LET ME SAY TO HIM, "MY BROTHERS AND MY FATHER'S HOUSEHOLD WHO WERE IN THE LAND OF CANAAN HAVE COME TO ME!"

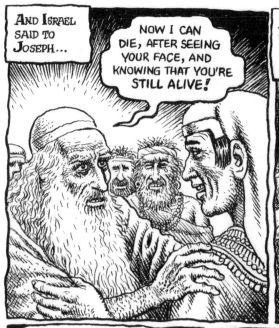

"AND THE MEN ARE SHEPHERDS, FOR THEY'VE ALWAYS BEEN HANDLERS OF LIVESTOCK, AND THEIR SHEEP AND THEIR CATTLE AND ALL THAT IS THEIRS THEY'VE BROUGHT."

AND SO, WHEN PHARAOH SUMMONS YOU AND ASKS, "WHAT IS IT YOU DO?" YOU SHOULD SAY, "YOUR SERVANTS HAVE BEEN HANDLERS OF LIVESTOCK FROM OUR YOUTH UNTIL NOW, WE AND OUR FATHERS AS WELL," THAT YOU MAY DWELL IN THE LAND OF GOSHEN.

FOR ALL SHEPHERDS ARE ABHORRENT TO THE EGYPTIANS!

Chapter 47

AND JOSEPH CAME AND REPORTED TO PHARAOH AND SAID...

MY FATHER AND MY BROTHERS AND THEIR FLOCKS AND THEIR HERDS AND ALL THAT IS THEIRS HAVE COME FROM THE LAND OF CANAAN, AND NOW THEY ARE IN THE LAND OF GOSHEN!

AND FROM THE PICK OF HIS BROTHERS HE TOOK FIVE MEN AND PRESENTED THEM TO PHARAOH, AND PHARAOH SAID TO HIS BROTHERS...

WHAT IS IT YOU DO?

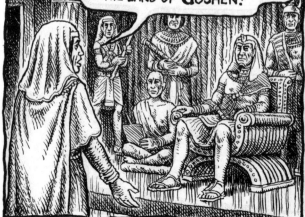

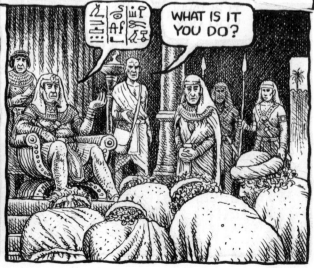

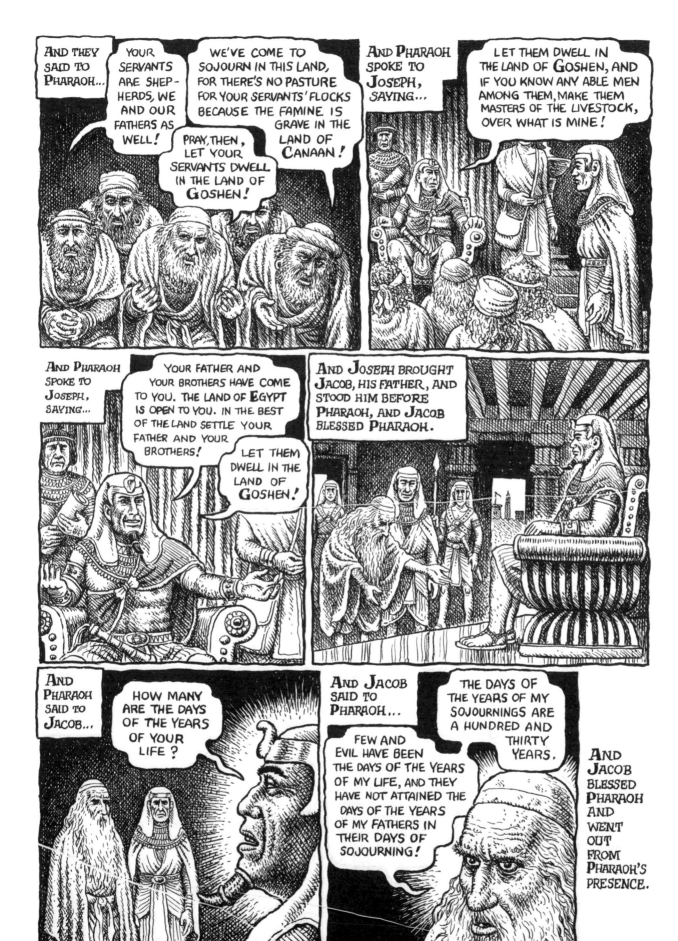

AND JOSEPH SETTLED HIS FATHER AND HIS BROTHERS AND GAVE THEM A HOLDING IN THE LAND OF EGYPT, IN THE BEST OF THE LAND OF RAMESES, AS PHARAOH HAD COMMANDED. AND JOSEPH SUSTAINED HIS FATHER AND HIS BROTHERS AND ALL HIS FATHER'S HOUSEHOLD WITH BREAD, DOWN TO THE MOUTHS OF THE LITTLE ONES.

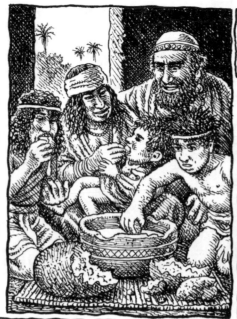

AND THERE WAS NO BREAD IN ALL THE EARTH, FOR THE FAMINE WAS VERY GRAVE, AND THE LAND OF EGYPT AND THE LAND OF CANAAN LANGUISHED BECAUSE OF THE FAMINE.

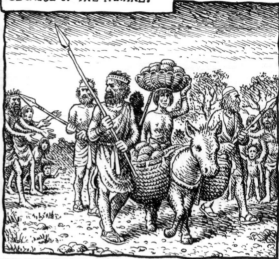

AND JOSEPH COLLECTED ALL THE SILVER TO BE FOUND IN THE LAND OF EGYPT AND IN THE LAND OF CANAAN IN RETURN FOR THE PROVISIONS THEY WERE BUYING, AND JOSEPH BROUGHT THE SILVER TO THE HOUSE OF PHARAOH.

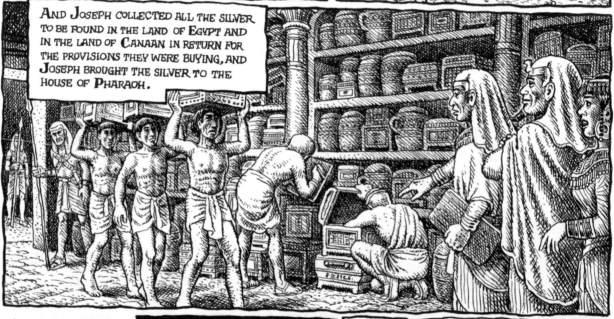

AND THE SILVER OF THE LAND OF EGYPT AND OF THE LAND OF CANAAN RAN OUT, AND ALL EGYPT CAME TO JOSEPH, SAYING...

LET US HAVE BREAD, FOR WHY SHOULD WE *DIE* BEFORE YOUR EYES?!

FOR THE SILVER IS ALL GONE!

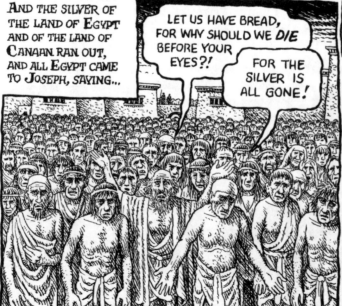

AND JOSEPH SAID...

LET ME HAVE YOUR LIVESTOCK, THAT I MAY GIVE YOU IN RETURN FOR YOUR LIVESTOCK, IF THE SILVER'S ALL GONE!

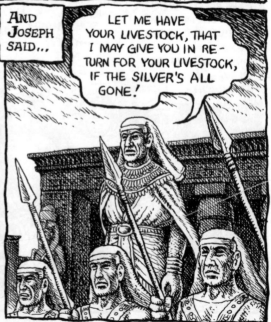

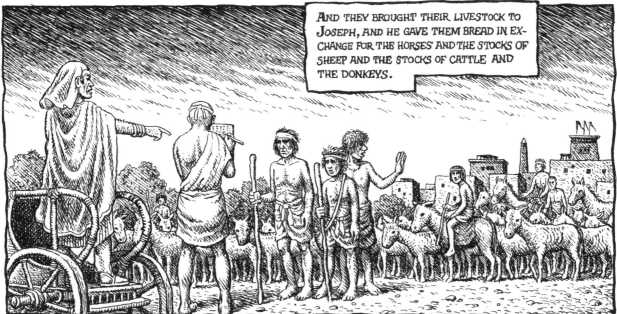

AND THEY BROUGHT THEIR LIVESTOCK TO JOSEPH, AND HE GAVE THEM BREAD IN EX-CHANGE FOR THE HORSES' AND THE STOCKS OF SHEEP AND THE STOCKS OF CATTLE AND THE DONKEYS.

AND HE CARRIED THEM FORWARD WITH BREAD IN EXCHANGE FOR ALL THEIR LIVESTOCK THAT YEAR. AND THAT YEAR RAN OUT AND THEY CAME TO HIM THE NEXT YEAR AND SAID TO HIM...

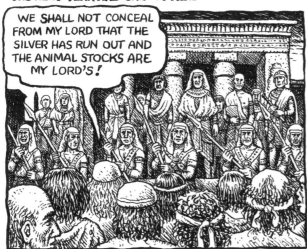

WE SHALL NOT CONCEAL FROM MY LORD THAT THE SILVER HAS RUN OUT AND THE ANIMAL STOCKS ARE MY LORD'S!

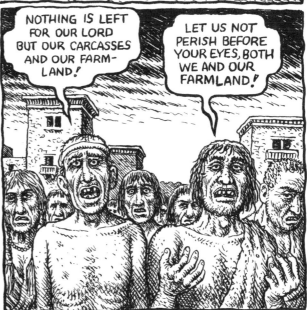

NOTHING IS LEFT FOR OUR LORD BUT OUR CARCASSES AND OUR FARM-LAND!

LET US NOT PERISH BEFORE YOUR EYES, BOTH WE AND OUR FARMLAND!

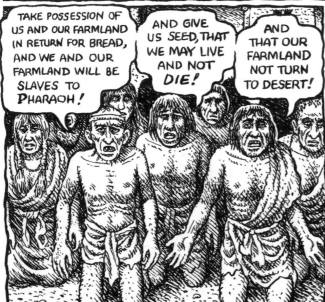

TAKE POSSESSION OF US AND OUR FARMLAND IN RETURN FOR BREAD, AND WE AND OUR FARMLAND WILL BE SLAVES TO PHARAOH!

AND GIVE US SEED, THAT WE MAY LIVE AND NOT DIE!

AND THAT OUR FARMLAND NOT TURN TO DESERT!

AND JOSEPH TOOK POSSESSION OF ALL THE FARM-LAND OF EGYPT FOR PHARAOH, FOR EACH EGYPT-IAN SOLD HIS FIELD, AS THE FAMINE WAS HARSH UPON THEM, AND THE LAND BECAME PHARAOH'S. AND HE REDUCED THEM TO SERVITUDE, TOWN BY TOWN, FROM ONE END OF THE BORDER OF EGYPT TO THE OTHER.

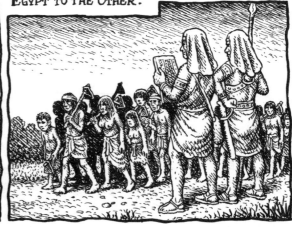

ONLY THE FARMLAND OF THE PRIESTS HE DID NOT TAKE IN POSSESSION, FOR THE PRIESTS HAD A FIXED ALLOTMENT FROM PHARAOH, AND THEY ATE FROM THEIR ALLOTMENT THAT PHARAOH HAD GIVEN THEM. THEREFORE, THEY DID NOT SELL THEIR FARMLAND.

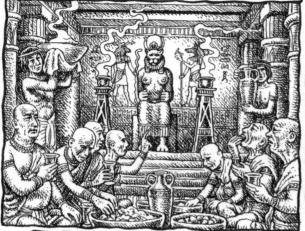

AND JOSEPH SAID TO THE PEOPLE...

BEHOLD, I'VE TAKEN POSSESSION OF YOU THIS DAY, WITH YOUR FARMLAND, FOR PHARAOH!

HERE IS SEED FOR YOU TO SOW THE LAND!

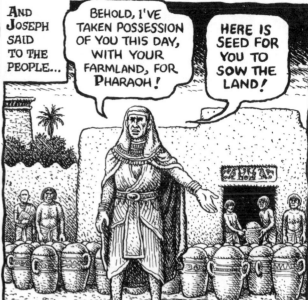

AND WHEN THE HARVESTS COME, YOU SHALL GIVE A FIFTH TO PHARAOH, AND FOUR PARTS SHALL BE YOURS FOR SEEDING THE FIELD AND FOR YOUR FOOD, FOR THOSE IN YOUR HOUSEHOLDS AND FOR YOUR LITTLE ONES TO EAT.

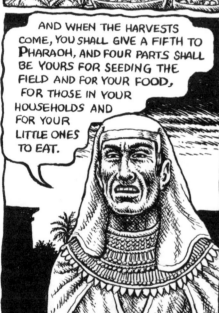

AND THEY SAID...

YOU HAVE KEPT US ALIVE!

MAY WE FIND FAVOR IN THE EYES OF OUR LORD, IN BEING PHARAOH'S SLAVES!

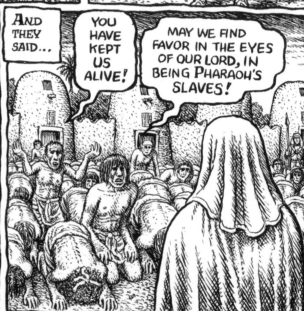

AND JOSEPH MADE A FIXED LAW, TO THIS VERY DAY, OVER THE FARMLAND OF EGYPT, THAT PHARAOH SHOULD HAVE A FIFTH. ONLY THE FARMLAND OF THE PRIESTS, IT ALONE DID NOT BECOME PHARAOH'S.

AND ISRAEL DWELT IN THE LAND OF EGYPT, IN THE LAND OF GOSHEN, AND THEY TOOK HOLDINGS IN IT, AND WERE FRUITFUL AND MULTIPLIED GREATLY, AND JACOB LIVED IN THE LAND OF EGYPT SEVENTEEN YEARS, AND JACOB'S DAYS, THE YEARS OF HIS LIFE, WERE 147 YEARS.

AND ISRAEL'S TIME TO DIE DREW NEAR, AND HE CALLED FOR HIS SON, FOR JOSEPH, AND HE SAID TO HIM...

IF, PRAY, I'VE FOUND FAVOR IN YOUR EYES, PUT YOUR HAND, PRAY, UNDER MY THIGH AND ACT TOWARD ME WITH STEADFAST KINDNESS — PRAY, DO NOT BURY ME IN EGYPT!

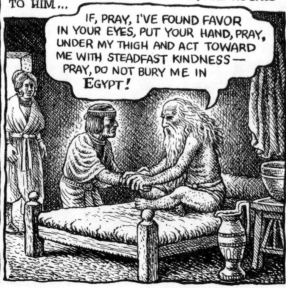

WHEN I LIE DOWN WITH MY FATHERS, CARRY ME FROM EGYPT AND BURY ME IN THEIR BURIAL PLACE!

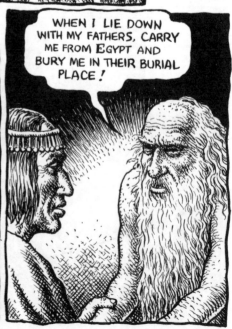

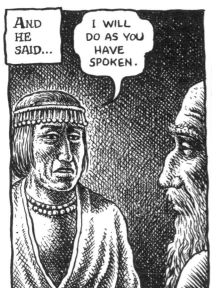

AND HE SAID... I WILL DO AS YOU HAVE SPOKEN.

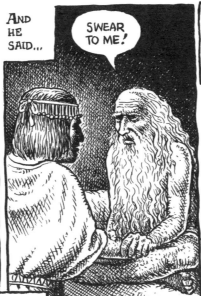

AND HE SAID... SWEAR TO ME!

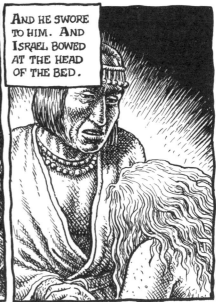

AND HE SWORE TO HIM. AND ISRAEL BOWED AT THE HEAD OF THE BED.

Chapter 48

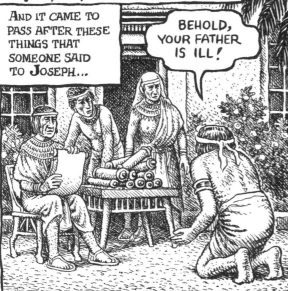

AND IT CAME TO PASS AFTER THESE THINGS THAT SOMEONE SAID TO JOSEPH...

BEHOLD, YOUR FATHER IS ILL!

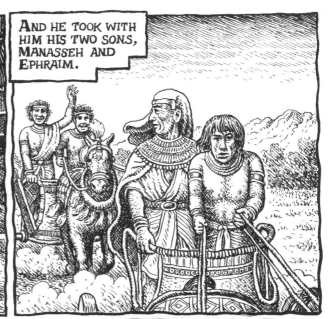

AND HE TOOK WITH HIM HIS TWO SONS, MANASSEH AND EPHRAIM.

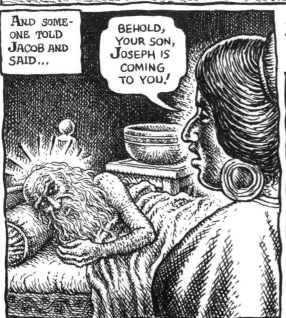

AND SOMEONE TOLD JACOB AND SAID...

BEHOLD, YOUR SON, JOSEPH IS COMING TO YOU!

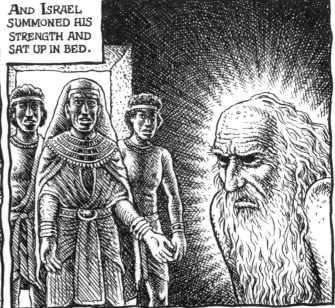

AND ISRAEL SUMMONED HIS STRENGTH AND SAT UP IN BED.

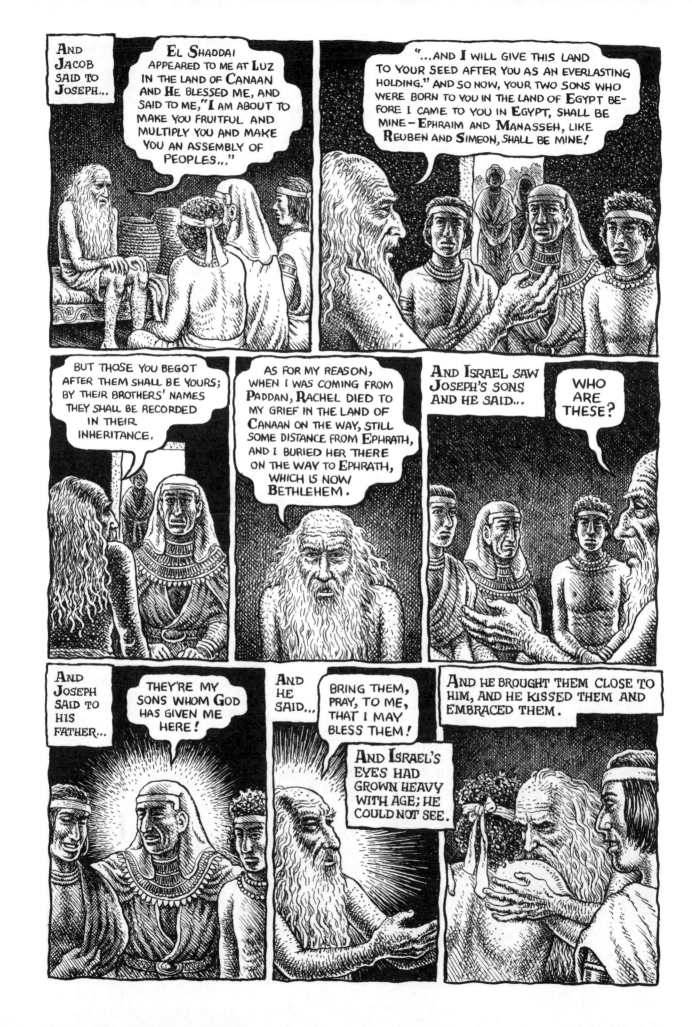

AND ISRAEL SAID TO JOSEPH...

I NEVER THOUGHT I'D SEE YOUR FACE AGAIN, AND, BEHOLD, GOD HAS ALSO LET ME SEE YOUR *SEED!*

AND JOSEPH DREW THEM OUT FROM HIS KNEES, AND HE BOWED, HIS FACE TO THE GROUND.

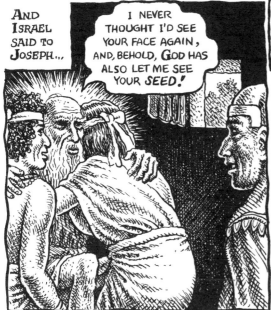
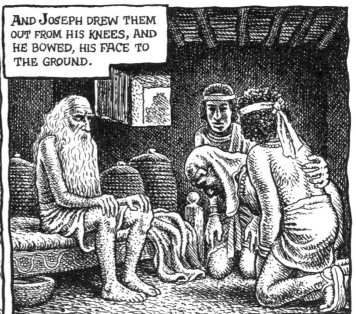

AND JOSEPH TOOK THE TWO OF THEM, EPHRAIM WITH HIS RIGHT HAND TO ISRAEL'S LEFT, AND MANASSEH WITH HIS LEFT HAND TO ISRAEL'S RIGHT, AND BROUGHT THEM NEAR HIM.

AND ISRAEL STRETCHED OUT HIS RIGHT HAND AND PLACED IT ON EPHRAIM'S HEAD, THOUGH HE WAS THE YOUNGER, AND HIS LEFT HAND ON MANASSEH'S HEAD—HE CROSSED HIS HANDS—THOUGH MANASSEH WAS THE FIRSTBORN.

AND HE BLESSED THEM AND SAID...

THE GOD IN WHOSE PRESENCE MY FATHERS ABRAHAM AND ISAAC WALKED, THE GOD WHO LOOKED AFTER ME ALL MY LIFE TO THIS DAY...

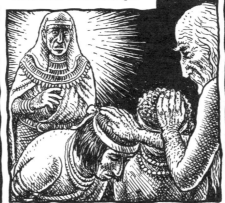
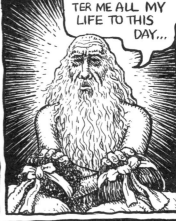

...THE MESSENGER RESCUING ME FROM ALL EVIL, MAY HE BLESS THE LADS, LET MY NAME BE RECALLED IN THEM, AND THE NAMES OF MY FATHERS, ABRAHAM AND ISAAC, LET THEM BE TEEMING MULTITUDES IN THE MIDST OF THE EARTH!

AND JOSEPH SAW THAT HIS FATHER HAD PLACED HIS RIGHT HAND ON EPHRAIM'S HEAD, AND IT WAS WRONG IN HIS EYES, AND HE TOOK HOLD OF HIS FATHER'S HAND TO REMOVE IT FROM EPHRAIM'S HEAD TO MANASSEH'S HEAD.

AND JOSEPH SAID TO HIS FATHER...

NOT SO, MY FATHER, FOR THIS ONE IS THE FIRSTBORN! PUT YOUR RIGHT HAND ON *HIS* HEAD!

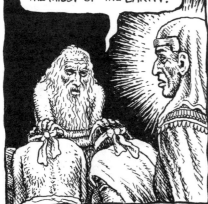
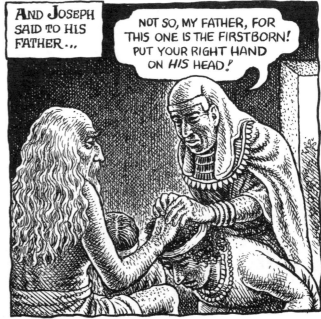

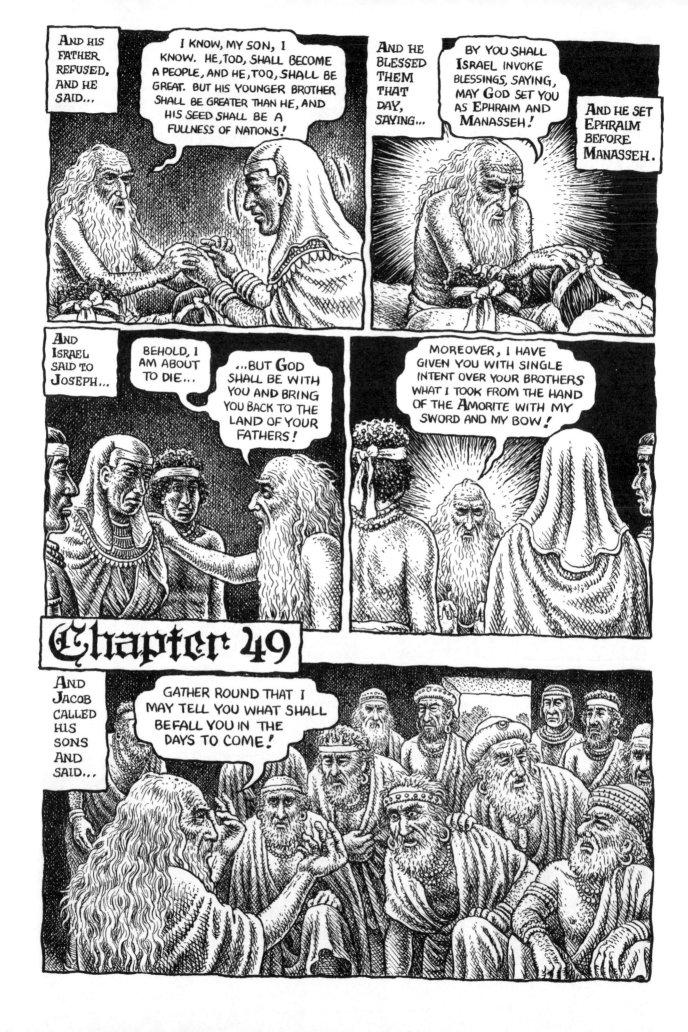

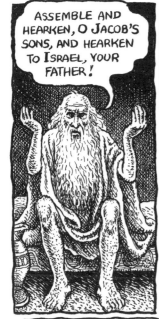

ASSEMBLE AND HEARKEN, O JACOB'S SONS, AND HEARKEN TO ISRAEL, YOUR FATHER!

REUBEN, MY FIRSTBORN ARE YOU! MY STRENGTH AND FIRST YIELD OF MY MANHOOD! PREVAILING IN RANK AND PREVAILING IN MIGHT!

UNSTEADY AS WATER, YOU'LL NO MORE PREVAIL!

FOR YOU MOUNTED THE PLACE WHERE YOUR FATHER LAY! YOU PROFANED MY COUCH! YOU MOUNTED!

SIMEON AND LEVI, THE BROTHERS — WEAPONS OF OUTRAGE THEIR TRADE! IN THEIR COUNCIL LET ME NEVER SET FOOT, THEIR ASSEMBLY MY PRESENCE SHUN!

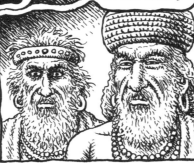

FOR IN THEIR FURY THEY SLAUGHTERED MEN! AT THEIR PLEASURE THEY TORE DOWN RAMPARTS! CURSED BE THEIR FURY SO FIERCE, AND THEIR WRATH SO REMORSELESS!

I WILL DIVIDE THEM IN JACOB, SCATTER THEM IN ISRAEL!

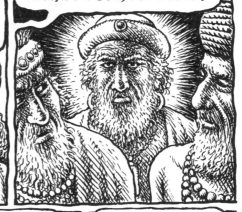

YOU, O JUDAH, YOUR BROTHERS SHALL ACCLAIM, YOUR HAND ON YOUR ENEMIES' NAPE! YOUR FATHER'S SONS SHALL BOW TO YOU! A LION'S WHELP IS JUDAH! FROM THE PREY, O MY SON, YOU THRIVE!

HE CROUCHED, HE LAY DOWN LIKE A LION, LIKE THE KING OF BEASTS, AND WHO DARE AROUSE HIM?! THE SCEPTER SHALL NOT PASS FROM JUDAH, NOR THE MACE FROM BETWEEN HIS LEGS...

...THAT TRIBUTE TO HIM MAY COME, AND TO HIM THE SUBMISSION OF PEOPLES! HE TETHERS TO THE VINE HIS DONKEY, TO THE GRAPE-BOUGH HIS DONKEY'S FOAL!

HE WASHES HIS GARMENT IN WINE, HIS CLOAK IN THE BLOOD OF THE GRAPE! O EYES THAT ARE DARKER THAN WINE AND TEETH THAT ARE WHITER THAN MILK!

ZEBULUN NEAR THE SHORE OF THE SEA SHALL DWELL, AND HE BY THE HAVEN OF SHIPS, HIS FLANK UPON SIDON!

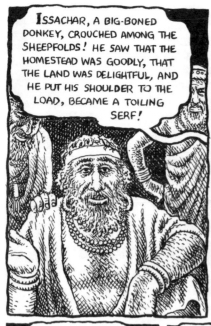

ISSACHAR, A BIG-BONED DONKEY, CROUCHED AMONG THE SHEEPFOLDS! HE SAW THAT THE HOMESTEAD WAS GOODLY, THAT THE LAND WAS DELIGHTFUL, AND HE PUT HIS SHOULDER TO THE LOAD, BECAME A TOILING SERF!

DAN WILL GOVERN HIS PEOPLE AS ONE OF ISRAEL'S TRIBES. LET DAN BE A SNAKE ON THE ROAD, AN ASP ON THE PATH, THAT BITES THE HORSE'S HEELS SO THAT ITS RIDER IS THROWN BACKWARDS!

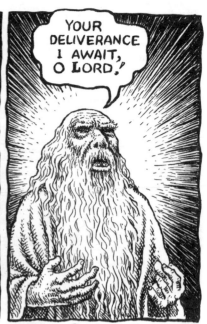

YOUR DELIVERANCE I AWAIT, O LORD!

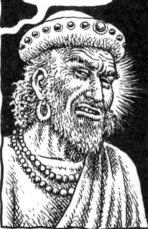

GAD SHALL BE HARASSED BY RAIDERS, YET HE SHALL HARASS THEIR HEEL!

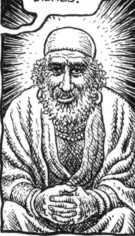

ASHER'S BREAD SHALL BE RICH, AND HE SHALL BRING FORTH KINGLY DISHES!

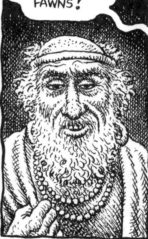

NAPHTALI, A HIND LET LOOSE, WHO BRINGS FORTH LOVELY FAWNS!

A FRUITFUL SON IS JOSEPH, A FRUITFUL SON BY A SPRING, DAUGHTERS STRODE BY A RAMPART. THE ARCHERS SAVAGED HIM, SHOT ARROWS AND HARASSED HIM!

BUT TAUT WAS HIS BOW, HIS ARMS WERE MADE FIRM BY THE HANDS OF THE CHAMPION OF JACOB, THROUGH THE NAME OF THE SHEPHERD, AND ISRAEL'S ROCK!

FROM THE GOD OF YOUR FATHERS, MAY HE AID YOU, SHADDAI, MAY HE BLESS YOU—BLESSINGS OF THE HEAVENS ABOVE, BLESSINGS OF THE DEEP THAT LIES BELOW, BLESSINGS OF BREASTS AND WOMB!

YOUR FATHER'S BLESSING SURPASSED THE BLESSINGS OF TIMELESS HEIGHTS, THE BOUNTY OF HILLS EVERLASTING! MAY THEY REST ON THE HEAD OF JOSEPH, ON THE BROW OF THE ONE SET APART FROM HIS BROTHERS!

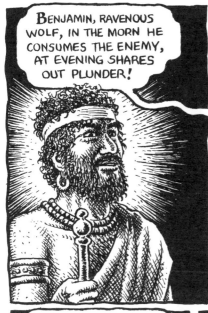

BENJAMIN, RAVENOUS WOLF, IN THE MORN HE CONSUMES THE ENEMY, AT EVENING SHARES OUT PLUNDER!

THESE ARE THE TRIBES OF ISRAEL, TWELVE IN ALL, AND THIS *IS* WHAT THEIR FATHER SPOKE TO THEM, BLESSING THEM, EACH ACCORDING TO HIS BLESSING, HE BLESSED THEM.

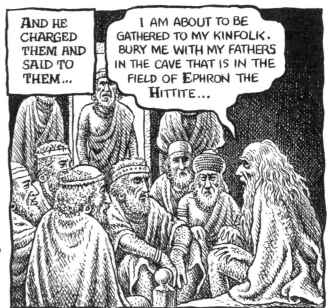

AND HE CHARGED THEM AND SAID TO THEM...

I AM ABOUT TO BE GATHERED TO MY KINFOLK. BURY ME WITH MY FATHERS IN THE CAVE THAT IS IN THE FIELD OF EPHRON THE HITTITE...

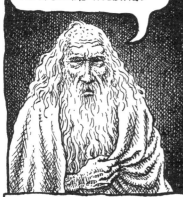

...IN THE CAVE THAT IS IN THE FIELD OF MACHPELAH, WHICH FACES MAMRE, IN THE LAND OF CANAAN, THE FIELD THAT ABRAHAM BOUGHT FROM EPHRON THE HITTITE AS A BURIAL-HOLDING.

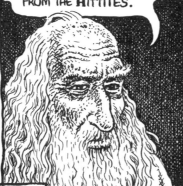

THERE THEY BURIED ABRAHAM AND SARAH, HIS WIFE, THERE THEY BURIED ISAAC AND REBEKAH, HIS WIFE, AND THERE I BURIED LEAH—THE FIELD AND THE CAVE WITHIN IT, BOUGHT FROM THE HITTITES.

AND JACOB FINISHED CHARGING HIS SONS, AND HE GATHERED HIS FEET UP INTO THE BED, AND HE BREATHED HIS LAST, AND WAS GATHERED TO HIS KINFOLK.

Chapter 50

AND JOSEPH FLUNG HIMSELF ON HIS FATHER'S FACE AND WEPT OVER HIM AND KISSED HIM.

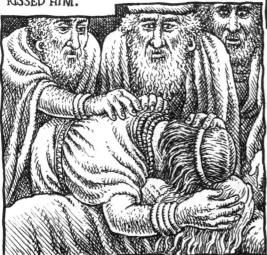

AND JOSEPH CHARGED HIS SERVANTS, THE PHYSICIANS, TO EMBALM HIS FATHER, AND THE PHYSICIANS EMBALMED ISRAEL.

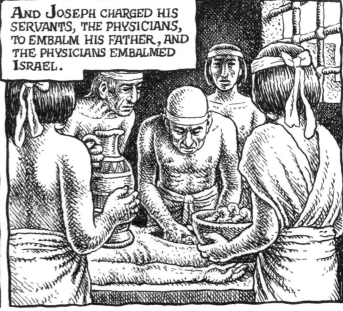

AND FORTY FULL DAYS WERE TAKEN FOR HIM, AS SUCH IS THE FULL TIME OF EMBALMING, AND THE EGYPTIANS KEENED FOR HIM SEVENTY DAYS.

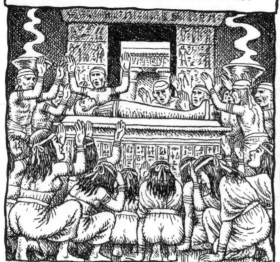

AND THE DAYS FOR KEENING HIM PASSED, AND JOSEPH SPOKE TO THE HOUSEHOLD OF PHARAOH, SAYING...

IF, PRAY, I'VE FOUND FAVOR IN YOUR EYES, SPEAK, PRAY, IN PHARAOH'S HEARING, AS FOLLOWS: "MY FATHER MADE ME SWEAR, SAYING, BEHOLD, I AM ABOUT TO DIE."

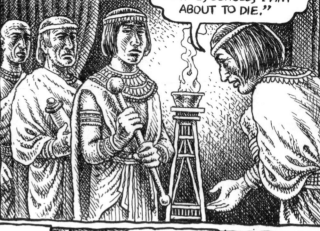

"IN THE GRAVE I MADE READY IN THE LAND OF CANAAN, THERE YOU MUST BURY ME." AND SO, LET ME GO UP, PRAY, AND BURY MY FATHER AND COME BACK.

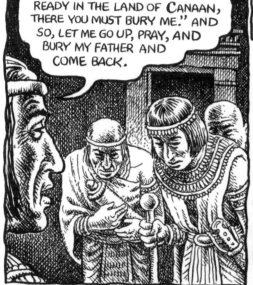

AND PHARAOH SAID...

GO UP AND BURY YOUR FATHER AS HE MADE YOU SWEAR!

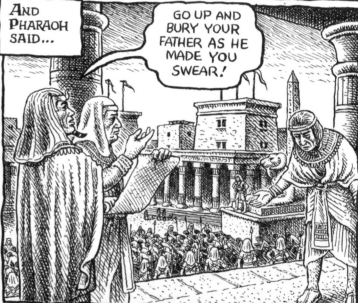

AND JOSEPH WENT UP TO BURY HIS FATHER, AND ALL PHARAOH'S SERVANTS, THE ELDERS OF HIS HOUSEHOLD, AND ALL THE ELDERS OF THE LAND OF EGYPT, WENT UP WITH HIM, AND ALL THE HOUSEHOLD OF JOSEPH, AND HIS BROTHERS, AND HIS FATHER'S HOUSEHOLD.

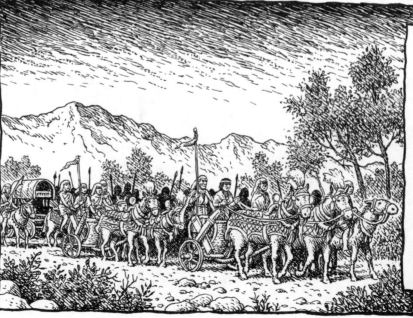

ONLY THEIR LITTLE ONES AND THEIR FLOCKS AND THEIR CATTLE THEY LEFT IN THE LAND OF GOSHEN. AND CHARIOTS AND HORSEMEN AS WELL WENT UP WITH HIM, AND THE PROCESSION WAS VERY GREAT.

AND THEY CAME AS FAR AS GOREN HA-ATAD, WHICH IS ACROSS THE JORDAN, AND THERE THEY HELD A GREAT AND SOLEMN LAMENTATION, AND PERFORMED MOURNING RITES FOR HIS FATHER SEVEN DAYS.

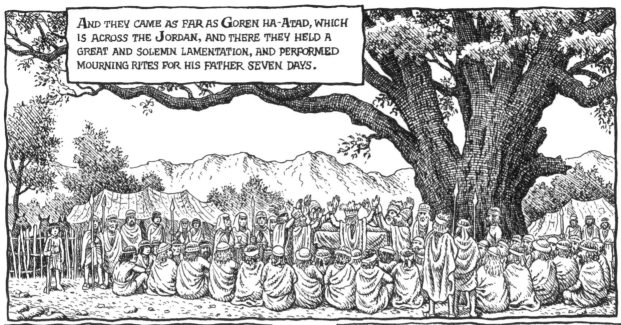

AND THE CANAANITE NATIVES OF THE LAND SAW THE MOURNING IN GOREN HA-ATAD AND THEY SAID...

THIS SOLEMN MOURNING IS EGYPT'S!

THERE- FORE IS ITS NAME CALLED ABEL- MIZ- RAIM,* WHICH IS ACROSS THE JORDAN.

* ABEL- MIZRAIM : INTERPRETED AS "THE MOURNING OF THE EGYPTIANS".

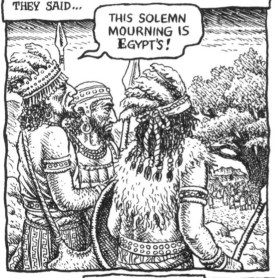

THUS HIS SONS DID FOR HIM JUST AS HE HAD CHARGED THEM. AND HIS SONS CONVEYED HIM TO THE LAND OF CANAAN AND BURIED HIM IN THE CAVE OF THE MACHPELAH FIELD, THE FIELD ABRAHAM HAD BOUGHT AS A BURIAL-HOLDING FROM EPHRON THE HITTITE, FACING MAMRE.

AND JOSEPH WENT BACK TO EGYPT, HE AND HIS BROTHERS AND ALL WHO HAD GONE UP WITH HIM TO BURY HIS FATHER, AFTER HE HAD BURIED HIS FATHER.

AND JOSEPH'S BROTHERS SAW THAT THEIR FATHER WAS DEAD, AND THEY SAID...

IF JOSEPH STILL BEARS RESENT- MENT AGAINST US, HE'LL SURELY PAY US BACK FOR ALL THE EVIL WE CAUSED HIM!

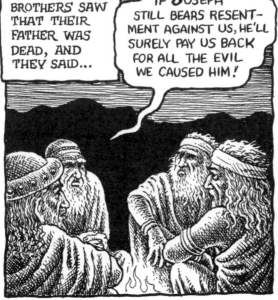

AND THEY SENT A MESSAGE TO JOSEPH, SAYING...

YOUR FATHER LEFT A COMMAND BEFORE HIS DEATH, SAYING, "THUS SHALL YOU SAY TO JOSEPH, WE BESEECH YOU, FORGIVE, PRAY, THE CRIME AND THE OFFENSE OF YOUR BROTHERS, FOR THE EVIL THEY'VE CAUSED YOU!"

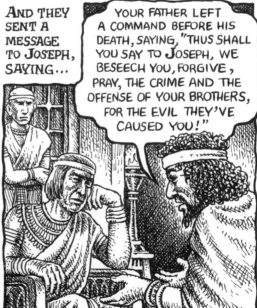

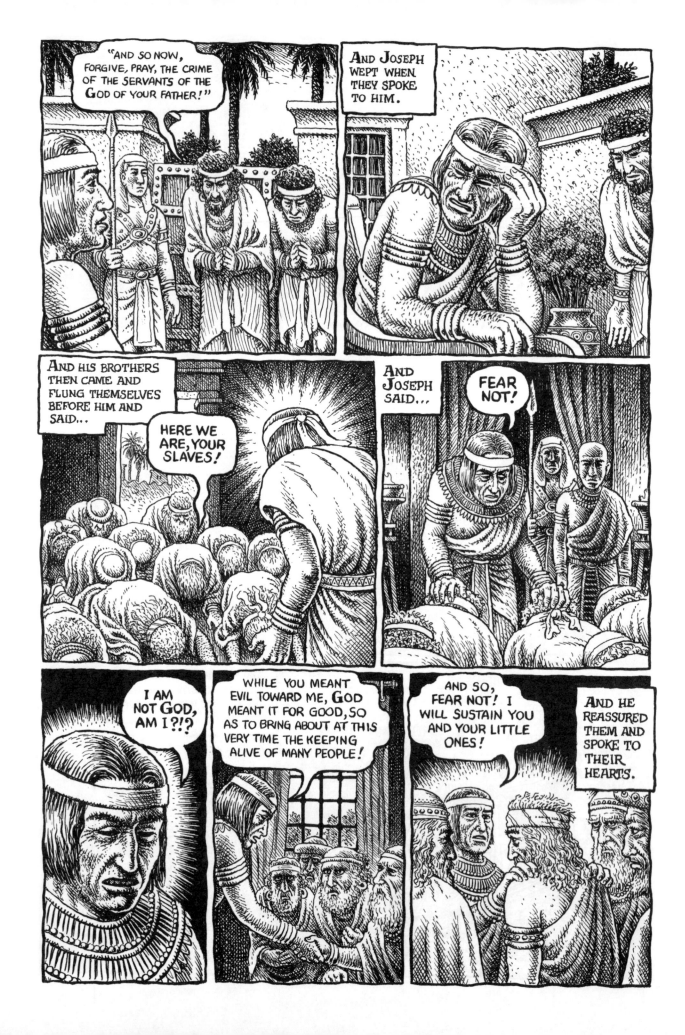

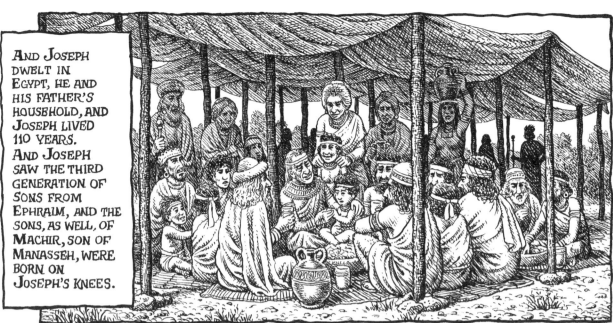

AND JOSEPH DWELT IN EGYPT, HE AND HIS FATHER'S HOUSEHOLD, AND JOSEPH LIVED 110 YEARS. AND JOSEPH SAW THE THIRD GENERATION OF SONS FROM EPHRAIM, AND THE SONS, AS WELL, OF MACHIR, SON OF MANASSEH, WERE BORN ON JOSEPH'S KNEES.

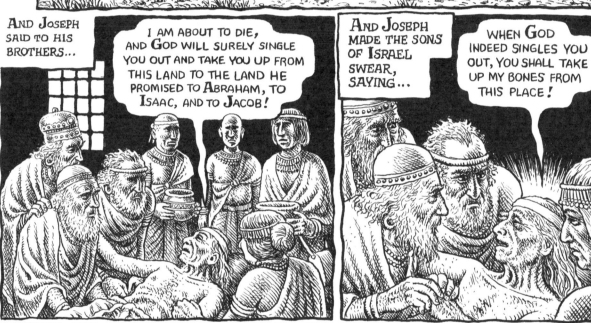

AND JOSEPH SAID TO HIS BROTHERS...

I AM ABOUT TO DIE, AND GOD WILL SURELY SINGLE YOU OUT AND TAKE YOU UP FROM THIS LAND TO THE LAND HE PROMISED TO ABRAHAM, TO ISAAC, AND TO JACOB!

AND JOSEPH MADE THE SONS OF ISRAEL SWEAR, SAYING...

WHEN GOD INDEED SINGLES YOU OUT, YOU SHALL TAKE UP MY BONES FROM THIS PLACE!

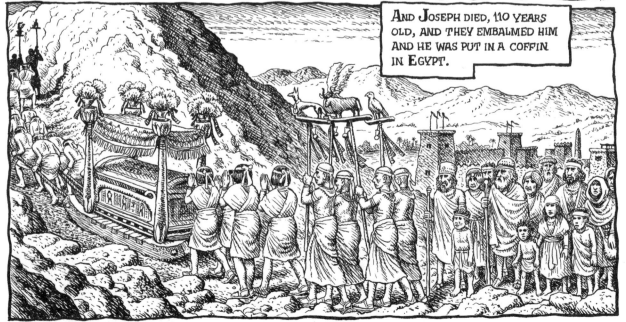

AND JOSEPH DIED, 110 YEARS OLD, AND THEY EMBALMED HIM AND HE WAS PUT IN A COFFIN IN EGYPT.

COMMENTARY

In setting out to illustrate the Book of Genesis, I quickly learned that I had to read the text very carefully and closely in order to render as accurately as possible the words that were actually written there. In the process, I discovered many subtle and surprising things. I also did a lot of background reading, and had for many years already been interested in the early cultures of Sumer-Akkad, Babylon, and Assyria. There are a number of parallels between the stories in Genesis and the old myths of Mesopotamia. Inscribed in cuneiform writing on clay tablets, some of the Sumerian myths date from as far back as 2000 B.C.E., some even centuries earlier. That's 2000 years before the Age of Augustus and 1500 years before the Golden Age of Greece! No one knows exactly how old the stories in Genesis are, especially the early chapters, but many scholars believe that some of them were first written down around 1000 B.C.E.; and then around the sixth century B.C.E., the entire "Torah," or the "Five Books of Moses," were finally compiled by the priests of the Israelite nation. The Torah is made up of Genesis, Exodus, Leviticus, Numbers, and Deuteronomy.

What's remarkable about the Torah is the unbroken longevity of its preservation as a book that is used, read, studied, and interpreted. These writings were never buried and then rediscovered later. They are the oldest texts in continuous use in Western civilization. It's no wonder that people believe them to be the word of God. Why else would they have survived for millennia while the stories of the gods and heroes of Egypt, Babylon, and Assyria were buried and forgotten along with these mighty empires? And the old stories of the Hebrews are so compelling and appealing that they also became the foundation of Christianity and Islam, the other two strongest religious traditions of the Western world.

COMMENTS AND OBSERVATIONS ON THE CHAPTERS

CHAPTER 1—The Creation: "Let there be a vault in the midst of the waters." After closely reading the beginning of the Creation, I suddenly imagined an ancient man standing on the shore of a sea, and gazing out at the horizon, and seeing only water meeting the sky. It appears to him that somewhere off in the vast distance the water curves up and forms a bowl-like "vault." The "heavens" are a hollow space in this vault. The "dry land" is floating in an infinite sea. If you dig down deep enough in the ground, you will come again to the water that underlies the "dry land." The sun, moon, and stars are suspended in the hollow "vault." The universe beyond is just a solid mass of water.

CHAPTER 2—After the initial account of the seven days of Creation, another entirely different story of Creation begins. In the second story, God creates the man first, then the animals, and lastly the woman. Biblical scholars say that the Book of Genesis was a blending of at least three different written sources, maybe more, and

that these were "redacted"—meshed together, abridged, put in a certain order—later by the priests of the Israelite religion, during or just after the "Babylonian Exile," circa 600–525 B.C.E.

CHAPTER 3—"Now the serpent was the most cunning of all the beasts . . ."

I took the liberty of drawing the serpent with arms and legs, although nowhere in the text is he described that way. But it is at least implied when God condemns the serpent to crawl on his belly and eat dirt forever after.

Concerning Eve and the tree of knowledge, it is interesting that among the myths of Sumer there is the story of the goddess Inanna, who nurtures a tree in her "pure garden." "In its base a snake-that-knows-no-charm has made its nest . . . in its trunk a demon-maiden has built her home." But the "demon-maiden" didn't make it into Genesis—she got left on the cutting-room floor.

CHAPTER 6—"The divine beings": In the ancient world everyone, including the Hebrews, believed in the existence of multiple gods and demigods. Nowhere in Genesis does it say that the god of the chosen people is the only god. He is their god. In the Hebrew he is called "Yhwh" (Jehovah) by one of the original writers, and "Elohim" by another. Other times he is called "El-Shaddai," which may mean "god-of-the-mountain." In chapter 14, Abraham swears an oath to "El Elyon," the "god most high" of the Canaanites. Every tribe, every city-state, had its "god most high" in its pantheon of gods, demigods, demons, and spirits.

CHAPTER 8—After the Flood has subsided, Noah and his sons offer an animal sacrifice, a "burnt offering," in gratitude to God. God smells the "sweet savour" of the meat and decides that he will never again "curse the ground on man's account." Why is God so moved by the aroma of cooking meat? In the more elaborate Flood story of the Sumerians, from which the Genesis story was likely derived, the Noah character, whose name is Ziusudra (or Uta-Napishti in the later Babylonian version), also offers a sacrifice after the Flood. The gods who caused this terrible cataclysm had been away from earth during the unpleasantness, "lying like dogs curled up in the open," and they were hungry. "The gods did smell the savour sweet," and they "swarmed like flies around the man making sacrifice."

CHAPTER 9—After all the traumatic events of the Flood, poor old Noah gets drunk and staggers around naked in his tent. He is seen by Ham, one of his three sons. Ham tells the two other sons that he has seen his father naked. They tell their father, and the next day Noah curses Ham and Ham's son Canaan; "the lowliest of slaves he shall be to his brothers." Thus were black Africans later designated as the descendants of Ham by white Christians, this biblical passage serving as a righteous rationale for their enslavement.

CHAPTER 10—Referred to as "the table of nations," this is a noble effort by the ancient Hebrews to trace the origins of all the important tribes and people known to them, all the way back to the three sons of Noah: Ham, Shem, and Japheth. They, the Hebrews, trace themselves directly back to Shem. From this, I presume, comes the term "Semite," as "Hamite" refers to the people of Africa. Japheth? I don't know.

CHAPTER 11—This litany of begots takes us from Shem down the generations to Terah, the father of Abraham. Terah lived in the city of Ur, which was the chief city of Sumer-Akkad around 2000 B.C.E., the approximate time period in which some scholars believe the story of Abraham begins. The mention of Ur has set off numerous scholarly speculations about the origins of Abraham's family. Some claim that Terah was a high priest of the temple in Ur. The "Midrash" says he was a seller of idols, and that's how I portrayed him. Some say Sarah, Abraham's wife, was a priestess belonging to the Sumerian matriarchal tradition. Many scholars insist that this family had to be of some importance, that they could not have been just common, lowly herdsmen. In any event, there is some historical connection between the family of Abraham and the already highly advanced urban civilization of the city of Ur.

CHAPTER 12—"And the Lord said to Abraham, 'Go forth from your land and your birthplace . . .'" From this point on the story is all about God's singling out of Abraham and his clan, "blessing them" and giving them a special claim to the land of the Canaanites. We have already been assured that the Canaanites are of no account to God, as Noah had cursed Ham's son Canaan, condemning his descendants to be slaves ever after. Throughout the rest of Genesis, God repeats this "covenant" over and over to Abraham, to his son Isaac, and to Isaac's son Jacob. "I give you this land." "Be fruitful and multiply."

But right away there's a knotty problem having to do with the women. There's a lot of trouble with the women and the production of sons to carry on the family lineage and God's great mission. Many odd events and curious tales are told that don't quite add up somehow. Why does Abraham tell his wife, Sarah, to tell the Egyptians that she is his sister? What is the point of this story? These puzzles and mysteries were cleared up for me by a book called *Sarah the Priestess* by Savina Teubal (1984). She exposes the underlying, buried, hidden, distorted sense of these stories about the women—Sarah, Rebekah (Isaac's wife), Rachel and Leah (Jacob's wives)—in a powerfully cogent manner. Suddenly layers of cobwebs are removed, centuries of dust, and some of the earlier lost sense of them is revealed.

About ten years ago I got into a heated argument with a strong-minded woman friend of mine about the Sumerian bricklayers. Years later we laughed about it: how could we have gotten so worked up about the Sumerian bricklayers?! Now I realize why. We were locked into nothing less than the eternal push-pull between man and woman. We'd been discussing the emergence of the early civilizations and the monumental buildings they'd erected in their city-states, awesome feats of organized labor. I argued that these great works obviously had to involve enforced slave labor, that slavery played an important part in the rise of civilization. She argued that maybe the building of the temples and ziggurats of early Sumeria were a cooperative venture based on a mutual, voluntary, religious/social vision. Maybe, she asserted, the people even enjoyed this enormous task, creating together their magnificent works, a display of heroic collective effort. I vehemently countered with, "You think those Sumerian bricklayers did their work voluntarily of their own free will? I doubt it!" But she insisted that it was possible. I thought she was just being contrary, and so we went round and round. Now I realize that we were both right, and both wrong. I was looking at it from a male, patriarchal point of view, while she was envisioning it from a female, matriarchal perspective. I thought only of kings and conquest and

enslavement; she saw it in terms of family, community, civilization as an evolution of homemaking on a large scale. In fact, as it turns out, it probably *was* like that in the early period—a mutual, collective, voluntary effort.

The historical record shows that in the earlier millennia of this development in Mesopotamia and Egypt, there existed a powerful matriarchal order alongside the patriarchy. They coexisted in relative harmony until the size and power of these organized city-states became so great, probably due in part to this male-female balance, that the military elites finally became supreme. The matriarchy was then gradually suppressed, armies of slaves were brought in, kings were declared divine, and property became more important than people. The passing of property and estates and high position to the sons became the thing of primary importance in these larger, stratified societies. Matriarchal imperatives could not survive in this environment. It was then that domination and submission and military conquest took firm hold of civilization. In Mesopotamia this trend culminated in the Assyrian empire, 800–600 B.C.E., a ruthless, completely militarized society that went about slaughtering entire cities, and leaving mountains of corpses. But back in the days of Abraham, around 2000 B.C.E., matriarchy was just in the beginning stages of being suppressed, and the struggles and assertions of the female characters are all about this, as Savina Teubal so clearly explains.

In chapter 12, why does Abraham seem to be pimping his wife off to the Pharaoh of Egypt in exchange for camels and slaves? It doesn't really make much sense as it is written, and the morality of it is murky indeed. Unless perhaps it is a distortion of an older legend, twisted around to fit the later, patriarchal paradigm. Even we modern sophisticated people have trouble wrapping our minds around the idea of a society in which male and female power are equally balanced, with male and female traditions existing side by side, separate but working together. This idea seems too advanced, even now, to ever have existed in the past. But, in fact, there is abundant documentation that it did exist in the Middle East in the third millennium B.C.E. Those early civilizations were also driven by a strong belief in magic, spiritual powers, dreams, visions, oracles, spells, and curses. Women with "powers" of this kind were elevated to special, high places. There were temples and rituals and rites that only women were allowed to perform. There were ranks and hierarchies of temple priestesses. The highest of these priestesses, in those early days, were regarded with the same reverence as, or possibly even more than, the kings, chieftains, and high priests. They stood in for the powerful goddesses, representing them in solemn rituals. They had their own special sacred places of power, sacred groves, and even entire cities.

One of these rituals, described by Savina Teubal, gleaned from the cuneiform tables, was the "hieros gamos," the "sacred marriage" in which any powerful man who wanted to be given a position of leadership had to be "invited" into the bedchamber of the high priestess, "guardian of the grain stores," and he had to meet with her approval. If somehow he failed the test, it went bad for him. The high priestess "chose" him. In this ritual, she represented the "most high" goddess. The sexual energy between them would then bring into the man a higher, divine power, bestowing on him a demigod status. Or not. Later, when the patriarchy ruled supreme, this tradition degenerated into a situation of "temple harlots."

Savina Teubal suggests that Sarah, a woman of "elevated religious status within her community," was brought by Abraham to Egypt and presented to the Pharaoh, perhaps to perform the "sacred marriage" ritual with him. It makes sense that Pha-

raoh would not be made aware of a Hebrew woman's presence in his vast realm, no matter how beautiful she was, unless she was a personage of some importance. But the "sacred marriage" did not go well for the Pharaoh. He finds out that Abraham is Sarah's husband, not her brother. He must make peace with this powerful woman and her husband. They receive valuable animals and human slaves, as compensation for his embarrassment. Sounds plausible.

CHAPTER 13—Abraham takes Sarah to "dwell by the Terebinths of Mamre," a sacred grove. Here Sarah stays for the rest of her life, and when she dies, she is buried in the cave of Machpelah "facing Mamre."

CHAPTER 16—Sarah is "barren," unable to produce children, especially sons, for Abraham. But if in fact Sarah was a priestess, she was not permitted to have children until after her time as priestess was fulfilled. But Sarah is still passionately determined to "build up her house," and so she unites her Egyptian handmaid with her husband, and the handmaid, Hagar, becomes pregnant. Hagar's overweening pride in carrying Abraham's child then angers Sarah and she is banished to the desert. Abraham can do nothing, though it is his child Hagar is carrying. Why is that? The answer is, because Hagar's proud behavior is a threat to Sarah as the matriarch of the family. Hagar may usurp her position, and so she must go!

CHAPTER 17—God, an extremely patriarchal deity, assures Abraham that "kings shall come forth" from him, but part of the deal is that Abraham must be circumcised, and all the members of his clan group, "even slaves," must also be circumcised. Any male not circumcised "shall be cut off from his people." Thus the cutting of the foreskin becomes an initiation rite, branding these males as members of God's chosen people as well as ensuring that the rights to the land God has given will be handed down to the male descendants. A triumph for patriarchy.

CHAPTER 19—After the destruction of Sodom and Gomorrah, there is the bizarre story of Lot and his two daughters, who escape to the mountains. Lot's wife has been turned to salt, and the daughters are concerned that there are no men around to mate with them and to carry on their family's lineage. The older one initiates a scheme, suggesting that they sleep with their own father, first getting him drunk. The plan succeeds, and both sisters have sons by their father. This is not so shocking in the context of matrilineal descent, in which the father is less significant than the mother. Later on in the Torah, under the laws of Moses, such incestuous behavior was forbidden.

CHAPTER 20—Again Abraham tells the king of Gerar, concerning Sarah, "She is my sister." Again the king, Abimelech, "took Sarah." Is this another performance of the high priestess's role in the "sacred marriage" ritual? Again, the king learns that she is Abraham's wife, this time in a dream in which God himself appears to the poor king. Again, things go bad for him. He can't get his wife or any of his slave-women pregnant. But this time, when he calls for Abraham to give him a dressing-down, we learn that Sarah is "in point of fact" his sister, his father's daughter. This, too, would be shocking if it were true. Is Abraham lying? But if looked at in the context of matrilineal descent, again, it is acceptable. But King Abimelech, a patriarchal king, is

still disgraced, and again, Abraham is compensated, this time with a thousand pieces of silver. Abraham then intercedes with God, and the king's women are once again receptive to his seed, and babies are born.

CHAPTER 21—Sarah now has a son of her own, and she again asserts her matriarchal imperative by ordering Abraham to "cast out this slavegirl and her son." Abraham is pained by this as he has some attachment to Ishmael, his first son, but God tells him, "Whatever Sarah says to you, listen to her voice." This time, matriarchy wins, and Hagar and Ishmael must leave. It is Sarah, not Abraham, who ensures that her son, Isaac, will inherit God's promise to Abraham. As Savina Teubal points out, "The ancestors of the Hebrews are only those whom the matriarchs accepted as members of their descent group." But the messenger tells Hagar that God will also "make of him, [Ishmael] a great nation." The Arab peoples believe that they are the descendants of Ishmael.

CHAPTER 23—"And Sarah died in Kariath-Arba, which is now Hebron, in the land of Canaan." Evidently, Sarah was a woman of such great importance that an entire chapter is devoted to her death and burial. Abraham, who seems at this point to be living apart from Sarah, comes to Hebron and wants badly to see Sarah buried near Mamre, the sacred grove where she resided, and he bargains hard with the Hittites for her burial site in the cave of Machpelah.

CHAPTER 24—Abraham dreads the possibility that his son Isaac will take a wife "from the daughters of the Canaanite in whose midst I dwell." He sends his servant to the land of his birthplace to find a wife for Isaac among his own kinship group. The servant travels to the city of Nahor and finds Rebekah, "who was born to Bethuel, son of Milcah, the wife of Abraham's brother, Nahor." Rebekah is deemed the perfect match for Isaac, but the servant must deal with Rebekah's mother, and brother, Laban. Bethuel, the father of Rebekah, is nowhere in sight. When Rebekah receives gifts from the servant, she runs to tell "her mother's household." This is, again, a very matriarchal situation. It is not clear if Bethuel is dead or just of no consequence. At one point in the narrative, it says, "And Laban and Bethuel answered and said . . ." Shortly after, the text describes the servant handing out gifts to "her brother and her mother." No gifts for Bethuel? Robert Alter, in his translation, believes there is a strong case for this "and Bethuel" line being "a later scribal or redactorial insertion." This is one of the few cases in which I took a liberty with the text. I left out "and Bethuel" altogether. It was just those later scribes trying to shore up the patriarchy!

At the end of chapter 24 Isaac brings his new bride into the tent of his dead mother, Sarah, "and took Rebekah as wife." Was this act meant to place the mantle of Sarah's high priestess position on to the shoulders of Rebekah?

CHAPTER 25—"And Abraham took another wife." After the death of Sarah, Abraham takes Keturah as wife, and she produces six sons for him. The text gives their names, yet nothing more is said of these six sons of Abraham, "the father of his people." It would seem that it is not the descendants of Abraham that are of primary importance, but those of Sarah!

In this chapter too, we learn that Rebekah is, like Sarah, "barren." Is this another incidence of the priestess role and the prohibition against having children that was

part of it? In this generation there is open competition between the matriarch, Rebekah, and the patriarch, Isaac, over which of their two sons, Jacob or Esau, will inherit the "birthright," the right of the first born to inherit his father's estate. Rebekah is stronger than Isaac, and so it is Jacob, the second born, and her favorite, who inherits the birthright.

CHAPTER 26—The "she's my sister" routine occurs for the third time in Genesis. This time it's Isaac and his wife, Rebekah, and this time it really is a lie, as Rebekah is only a distant cousin to Isaac. The king is again poor old Abimelech, but in this instance there's no mention of any "taking" of the woman in question by the king. Still, even though the king is angry, he makes himself the protector of Isaac, and Isaac therefore prospers "in that land." Was there another "sacred marriage" between high priestess Rebekah and the king that was suppressed by the later scribes of Israel-Judea?

CHAPTER 27—Rebekah shows incredible force and determination in having her favorite son, Jacob, receive the blessing from his father. She concocts an elaborate deception of her husband, and when Jacob shows fear that his father will perceive the deception and curse him, she shouts at him, " 'Upon me your curse, my son! Just listen to my voice and go!' And he went." At the end of this chapter she again tells Jacob, "listen to my voice," and orders him off to her brother Laban in Haran. A tradition in matrilinear societies involved sending the son off to his mother's kinship group to live with them and find a wife among them. This practice lingers on today in some remote corners of the world.

CHAPTER 28—Jacob's life struggle is characterized by his act of pushing up great heavy stones and making them into memorial markers. He performs this feat altogether five times throughout the story of his life. The second time it seems it's to impress the "comely" and "well-formed" young shepherdess, Rachel. And the last time he heaves up a stone, it is to mark the grave of his beloved Rachel, "on the road to Ephrath."

CHAPTERS 29 and 30—The story in these chapters seems almost intentionally meant to provide bedroom-comedy relief. But who can say how such a tale was received by its ancient listeners? Did they laugh? We'll never know. It is the bizarre story of two women competing with each other to bring sons into the world for one man. Two handmaids, or slavegirls, are dragged into the situation. The two wives compete for Jacob's sexual services, a bargain is struck, and Leah, the less favored but more fertile of the two, says to Jacob, "You must come in unto me, for indeed I've hired you . . ." As with his powerful mother, Jacob seems again overwhelmed by these strong, determined women, and does as he is told.

CHAPTER 31—When Jacob decides it's time to get his family away from his conniving father-in-law, Laban, Rachel steals the "household" gods from her father's house just as they're about to depart. Savina Teubal suggests that Rachel, in this act, is attempting to carry with her some vestige of her traditional role as a guardian of

these "household gods" which were most often female deities. In chapter 35 Jacob asserts his rising patriarchal power by demanding from his clan that they turn over all the "alien gods" in their possession, which he then buries in the ground. The women could not have been happy about this turn of events, this male interference in their traditional spiritual practices. Archaeological digs in the Middle East have turned up thousands of these small "idols." The majority of these figurines are representations of popular goddesses.

CHAPTER 32—The text tersely states: "And Jacob was left alone, and a man wrestled with him until the break of dawn." Jacob manages to overpower the "man," who turns out to be a divine being who then tells Jacob that his name "shall no longer be Jacob, but Israel." When Jacob asks the divine being for his name, the reply is "Why should you ask my name?" This is a curious exchange about names. Somewhere I read of one scholar's interpretation, which made sense. The spirit being, who tells Jacob, "You have struggled with divine beings and won out," is giving Jacob *his* name. I have come across references to similar occult experiences such as this in a few different cultures, including the American Indians. The spiritual seeker, in a place of lonely solitude, usually at night, encounters a being, often a dark being who menaces him, and forces him to engage in what seems to be a life-or-death wrestling match, which goes on for the whole night. The seeker often emerges from this struggle injured or traumatized, but a spiritual "ally" has been acquired. The seeker is never the same afterward, but has acquired a "power" of some kind. There's the legend of the old-time blues singer who goes to a deserted "crossroads" at midnight, where he waits until a "big black man" comes, and from this "devil" or spirit being he learns to play the guitar. This idea probably hearkens back to some old African spiritual practice or magic ritual, similar to Jacob's struggle with the "divine being."

CHAPTER 38—Tamar, another fiercely determined woman, takes it upon herself to ensure the survival of her lineage. She disguises herself as a "cult-harlot" (maybe the real story was that she, too, had some religious position in a temple) and tricks her own father-in-law, Judah, into having sex with her. It is from her son Perez, again one of a set of twins, that the later kings of Judea are descended.

CHAPTERS 39 through 50—These last chapters of Genesis are taken up entirely with the story of Joseph, one of the twelve sons of Jacob, and are all about his rise to power in Egypt, his conflict with his brothers, the resolution of that conflict, and the last days of Jacob. As Jacob was forever pushing up heavy stones, so Joseph is often seen weeping. He is a sensitive man who is moved to tears many times in his life story.

Joseph becomes the Pharaoh's chief minister of finance, and exercises his position with brilliant ruthlessness, ultimately subjugating the entire population of Egypt (except for the priests) for the Pharaoh. But toward the end Joseph shows signs that he is weary of worldly power. In the very last chapter, when his obstreperous brothers fling themselves at his feet and proclaim, "Here we are, your slaves," he says to them, "I am not God, am I?!" And, "fear not." Joseph has learned a much finer humility than the fear-driven kind shown by his barbaric brothers.

— R. Crumb, Feb. 2009